THE IMPORTANCE
OF BEING ICELAND

SEMIOTEXT(E) NATIVE AGENTS SERIES

Published by Semiotext(e)
2007 Wilshire Blvd., Suite 427, Los Angeles, CA 90057
www.semiotexte.com

Excerpts from COLLECTED POEMS by James Schuyler. Copyright (c) 1993 by the Estate of James Schuyler. Reprinted by permission of Farrar, Straus and Giroux, LLC.

Special thanks to Robert Dewhurst and John Isaac.

Cover Art by Dan Asher. Antartica, 2000.

Back Cover Photography by Alice O'Malley
Photos on pages 4–5, 12, 363 by Eileen Myles.
Design by Hedi El Kholti

ISBN: 978-1-58435-066-8
Distributed by The MIT Press, Cambridge, Mass. and London, England
Printed in the United States of America

10 9 8 7 6 5 4 3 2

THE IMPORTANCE OF BEING ICELAND

TRAVEL ESSAYS IN ART

Eileen Myles

CONTENTS

PEOPLE

TALKS

TRAVEL

BODY

MOVING PICTURES

BLOGS: 2004–2006

Já fúlt erða[1]

(All scream)

víst komu Rússarnir, Kanarnir
Nasistarnir og Víkingarnir
og Norðmennirnir sem tóku yfir
jafnvel Írskir munkar í kajökum
reyndu við okkur
en nei við vorum sterk og nú erum við ung, gröð
og rík
Björk er best í heimi
betri en Beck
og sterkari en Madonna
Sko við urðum aldrei mállaus
með okkar mikilfenglegu fornu
og ástkæru tungu hlæjum við að núverandi ástandi
Þið haldið að við séum döpur og sorgmædd
Nei
Þið haldið að við séum örugg og vitlaus eða typplaus
Nei
Þið haldið að við lifum í einhverju fúlu kolniðamyrkri
Nei, það er kvenlegt, það er ungt, það er ríkt

Það er gamalt.
Við erum ekki frosin, við erum ekki muldrandi
Þögn, við erum einsog Geysir, við erum spúandi eldfjöll
Og jafngömul erum við sjálfri jörðinni; já og það er satt
við erum köld.
köld,
köld

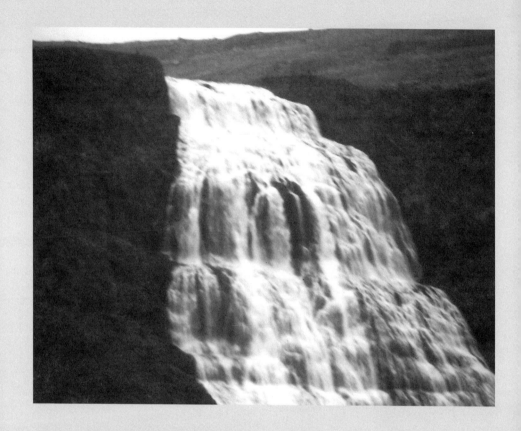

1. Yes we were pissed / (All scream) / The Russians landed and the Americans landed / and the Nazis and the Vikings landed / and the Norwegians took over / even some Irish monks in a curragh / had a time with us / but we stood strong and now we are famous and / rich / Björk is the world's brightest star / Better than Beck / stronger than Madonna / Now without ever having to become dumb / Inside the well of our very great and ancient / language we laugh at the current situation / You think we are sad and melancholy / No / You think we are stable and irrelevant / No / You think it is always terribly dark where we are / No it is female, it is young, it is rich / It is old. / We are not frozen, we are not murmuring / Silence, we are guy geyser, we are volcanic / We are old like planet itself; and yes you are right / we are cold, / cold, / cold.

— From "Hell," a libretto by Eileen Myles, 2004
Translated by Kristin Omarsdottir

ICELAND

As an American I come from a largely classless nation. That's the official word on who we are as a people. Citizens of the luckiest country on the planet, the freest—land of opportunity. Some of us carry this idea of things into our adult lives while wondering at stray or continually repressed moments why it doesn't feel that good. I feel all right today and in the course of my education or in spite of it I did learn about class and I am happy to announce that there actually is a class structure in America. I mean I had always known about the rich and the poor and certainly communism. Our books in school contained cartoons from communist newspapers that showed laughing people having dinner while other people crawled around outside living on the street. Not so far off the mark, it turned out. It just took the Bowery a while to catch up. Maybe my class problem growing up was that I never knew where to put us, the Myleses. I was sitting on the beach with my sister only yesterday, or last month or last year discussing the problem. At 59 I've come to identify myself as working class though kind of middle now. I'm a poet and a novelist, one-time college professor, among other things. Generally as many things as possible.

But the poet part is what I lead with, what gave me my life, my vote, more or less. The thing is if you learn how you fit in a culture fairly late (and I'm thinking your mid-twenties is actually quite late in terms of development) you will probably spend the next bunch

of time sort of exploding with the news while variously attempting to wedge your way into the imagined cultural body you think you need to belong to whether it's a loosely organized one like the art world, the poetry world, or the gay community.

Belonging is definitely the problem for a very good reason. The working class prepares you to be a player in a very unspecialized arena. Because you have been educated to support the way the world turns. If there were lighthouses you'd run them. If there were fish you'd catch them. You'd stop crime, type the letter, not write it. You'd care for the patient not diagnose. Maybe catching and caring are two ways to think of the powers of the working class. This thought brings me closer to what I see as the importance of being Iceland. In desiring access to these aforementioned worlds (art, poetry, politics, etc.) you are breaking the code of the working class by aiming to be a big cheese. I always wanted a bite of that cheese and once I realized that I was a member of the working class, subject of teevee dramas and less likely a writer of them I thought well being a little cheese would be okay. I suppose the real function of this (probably only internal) humility was to not get scared and stop wanting (or writing) altogether. Above all it seemed important to succeed, that is, to go ahead. I'm writing now and always have been writing this book. This is the introduction to it. This book is what I've been writing for years. Between things. Sometimes I got paid, sometimes not. I've never thought that distinction was formal at all. Though often it meant whether I could write something or not. Writing for pay is a little "pitchy" that's all. They say no, you say well how about this. The power of money creates a kind of movement. You adjust or quit. And when a poet friend referred to some reviews of mine as "commercial" I realized I had hit yet another class wall. Iceland will give this dilemma its home. And a class of its own. Which is language.

Was there ever any language to talk about the thing you wanted? Not as a woman but kind of plus, somehow. Because to come to

New York when I did (or you did) with steely but modest ambitions was not impossible, but kind of alone feeling. Everything I thought I knew was wrong. Here one was *supposed* to seek out people who had things you wanted, here you tried to draw attention to yourself, here you were exposed to things constantly about which you knew nothing. The earlier style of viewing unfamiliar things as weird was useless because in many ways I had moved here to be weird. So for the next thirty years or so I would alternately feel and become first large then small, quiet then loud, drunk then sober, discovering as part of the class voyage that many (but not all) people in the worlds I entered were middle if not upper middle class. Even beyond. The biggest Marxists cheerfully explained that this or that had happened to them because of somebody they had known at *Harvard*. You would think Harvard was where they had a spiritual awakening they were so proud of it. It was how they respected each other. It made them plausible. So who was I? How could I turn into something vaguely familiar, though hopefully not useful. Luckily there was television. It showed me that I could be a character. Television contained vaudeville. Which means "voice of the city." A working class person might do this or that. I drank a lot in those early years so of course *she* got drunk. The picture got more and more complicated as the activities increased and the totem pole of self expanded, was amended, and new notions were continually introduced. It worked out.

In three short years I was gay, sober in less than ten, I began performing instead of reading my poems and even tried talking for a while, improvising, moved by performers like Spalding Gray— and also by the legend of how writers and anarchists in the 19th century traveled and gave talks. I could do that. Talking led me to run for political office, I ran for president, which for a long while was probably the most famous thing I'd done. Just as teevee was kind of magnetic and shiny so was the idea of being a candidate—

rather than only going behind the curtain and pulling the lever. It seemed a profound act to say *this type* exists. It felt impersonal. It was my Harvard. Vote for me.

Since I was simply glad to have my name in the New York telephone book when I arrived why wouldn't I want my name on the ballot. But to achieve that meant ONLY gathering signatures for 18 months, which would have erased the opportunity to give speeches. And speaking was the point. So I campaigned to be a name you wrote in. Some of the pay-off was that at ages 40 and 41 I was a youthful candidate. I *could* run for president. Weirdness I've learned always pays off. It was a moment when things piled up. And another one was Iceland.

Iceland is, as you know, a country. The first thing everyone knows or doesn't know about Iceland is that it's not Greenland. Greenland is colder than Iceland though it seems like their names are reversed. If you look at Iceland's name in Icelandic it looks like Island and for the purposes of this book the unresearched fact is enough. Iceland *is* an island and I suspect its name comes from the word island not the word ice. The other thing you'll hear from anyone about Iceland is they stopped there on their way to Europe cause the tickets were cheap. Iceland is ideally situated between Europe and North America. It's kind of a pit stop place, a gas station so to speak and so it's been strategic during times of war. The US had a base there for a long time. In a moment of desperation the Prime Minister tried to sell it to Russia. Ugh.

Keflavík mostly feels like one of the least interesting places in the world, which is an American gift to be able to construct such a thing. Really if you travel here outside the interesting American cities and ignore all the natural beauty of our country you'll see that America is rapidly becoming this place which is nothing, but Iceland is not.

I went to Iceland in 1996 in many ways because of my interest in small things, including my own small presidential campaign.

There's a writer Robert Walser who was Swiss and wrote around the turn of the 20th century. For all intents and purposes he was 19th and I'd like to propose that the 19th century is the century of the working class. We were invented by Karl Marx (like he's our Santa and we're the elves) during it and also if you come from an uneducated household (and by uneducated I mean not college educated and I'd like to point out that since in our democracy the only free education is 8-12 the plan for most Americans is that they *be* "uneducated." That's the idea. Land of the free. Free to be dumb), a household that nonetheless does love art and books well then probably that family's idea of literature and your access to books will be excessively bound up with the past which if you were born in 1949 means the 19th c. was exactly as far away from you as the 21st. You had a choice. The 19th was as likely as the 21st c. It was the planet you were flying away from. Krypton to your Superboy, a place you would always associate with home. It was Charles Dickens—known to be great by educated and uneducated people alike. It was the decade of Louisa May Alcott. We all read *Little Women.* We got our female idea of being writers from Jo's attic writing studio: rats, apples, ink, and all at the time of the civil war. Jo *was* great but we have been given so little to fantasize about. And what there is is antique.

For all these reasons (i.e., sentimental attachments to the past) working class intellectuals like big words and their sentence formation is excessively ornate. It's what they think of as "smart." Pomposity. It's an embarrassing condition of being unsophisticated and not knowing what is truly smart which is simplicity and modernism; certainly it was twenty years ago when I learned to write. But the working class person is above all afraid to seem dumb so in acting "smart" and footnoting everything they betray the insecurity and weightiness of the unexperienced conclusion, which is an imitation of what writers are like. In general I think writers are

not smart. They are something else and each writer can fill in a word here, but smart is not what that word is.

The smallness of Robert Walser who began writing in 1910 is a growing phenomenon. He came to Berlin on the heels of his older brother Karl Walser who was involved in theater. Robert Walser quickly began publishing short pieces in the feuilleton, the art pages of German newspapers. Everyone cool then including Kafka and Robert Musil and Karl Kraus and invariably some women (though I don't know who they were) were in these short pages. All these people read each other and Walser might've started off with great seriousness, the seriousness of the 19th c., but quickly he aimed to be silly. (It was his only way to be modern.) A theater review of his might become a review of the audience, a certain red-faced fat woman said this and a pretentious general turned and said that. Sneezed or did something else bodily.

The 19th was still a century of horses. It's how people got around. Walser wrote little pieces that had sudden shifts in mood, that got waylaid from their original intention, that began thinking about themselves, the sentences. Or even the pencil he was writing with. These pieces would often end abruptly. During this same period he wrote a number of novels, some of which are gettable, some are lost. It's questionable to Walser's biographers whether he had a sex life, but the movement of his narrative is often obstructed or rerouted in response to a girl. (As a lesbian I identify with this but I will follow up on it elsewhere. Probably years from now in a volume of linked novellas entitled *Three Wives*.)

Finally whether in response to the city or something else Walser began to go for walks. He would go off for the weekend on long hikes and reported everything that happened during the walk in a haphazard way. Jesus might be seen down below out the window of a guesthouse standing under a streetlight. The largeness of his work was that Jesus could be an incidental character, could be minor. A

napkin could be gigantic and on the corner of one could be a novel and down on the wet coffee-stained bottom was a play. Then maybe a poem or two. What's exciting about his work (besides how good it is) is how permeable its borders are in terms of scale. I think he had a hard time making money so he began to live in tinier and tinier rooms and he left Berlin and returned to Switzerland and then even his handwriting grew tiny.

My interest in Robert Walser connected me to a curator, Hans Ulrich Obrist (HUO). The art world was discovering Walser in the '90s and what they called his microscripts were reproduced gigantically on the walls of a gallery and there was a walking museum in Switzerland that I think was a project of Hans Ulrich. Hans is Swiss. Most importantly Hans Ulrich was embarking on a project called Do It. It was a neo-fluxus thing. Fluxus was engaged with the notion of "concrete" art. Which was about how some mid 20th century composers used electronic media in composition: a recording of rain becomes a piece in itself or an element of it. The idea was later expanded by Allan Kaprow to mean "happenings"—multimedia productions that relied on the live connections between one media and the next to make meaning. Media could be performers, bodies, words as well as excitable '60s analogue technology. To Kaprow "concrete" referred most specifically to the elaborately improvised and poetic nature of all these connections. It has as its intellectual basis a trembling belief in the communal value of the situations the choices get made in. That's really where it's at. In 21st century terms we'd say it's about their inbetweenness.

So Hans calls. He says that the first Do It show will be at the Kjarvalsstadir Museum in Reykjavik. His voice was so fast and scratchy on the phone. On my answering machine. Some already antique mid-nineties technology. Will it be cold? It was in March. No it was going to be about ten degrees colder than here (the east coast of America which is New York). It was like a very grey spring.

I once met the artist Jim Dine and he told me something very useful, which I've thought about though mostly ignored. Only go to places where you're invited. He meant countries. I have some travel stories that fortify the wisdom of his thought but Iceland was the one that shows its truth. Looking around in Iceland I thought: I am on a junket. I felt *extremely* invited: as poet, art writer, a dyke, and especially a former presidential candidate. What Hans had in mind when he called me is none of my business.

Do It was a set of instructions solicited from a group of contemporary artists (including myself) for works to be assembled or fulfilled by other local artists so that in each subsequent installation around the world the show would change. I never knew if there were other Do Its after Reykjavik but during this one HUO proclaimed Iceland to be the most 21st c. country in the world. That was enough. It wasn't Europe and it wasn't North America. Was it Atlantis?

Hans was kind of young and made being a curator look like a spiritual vocation. He had one shirt, a dark striped one, and he wore a suit jacket and spoke very fast mostly about rhizomatic issues. He eventually published a small orange book about the entire Do It project (in which I explain how to run for president of the United States) but right now there was just this show.

I remember riding happily from the airport and seeing grey and gold, the predominant colors of this country. I thought of some fiction by Büchner, a story called *Lenz*. Iceland was mountainous, and its sky was a gloomy pearl.

Have you been here before, Eileen, asked the museum's red-headed curator. His name was Gunnar. I had not. I had a tiny hotel room in Reykjavik that in later trips I've not been able to place. On a junket you can entirely lack a map to pin your experiences on. A van picked us up in the morning and swiftly we moved through the close streets, which opened at the low brown modern museum we were presenting in. Iceland was a dream country. And I've returned

to the museum since then but that time it sat in the middle of an empty plain on a stony island in the middle of nowhere. I loved the setting. The not knowing what would happen next. The literal event, the opening, was quickly gotten over with. There was a jetlag day and then there was the opening. I'm not an artist so I never had one before. I recall the handsome wooden realization of one piece. Icelanders totally know how to make a big box. It was just (the instruction mode makes you inclined to say "just" about everything. Though unlike modernism in which fools will say a child could do it, in postmodernism it's generally a question of *which* child: i.e., fame) a big bin containing native produce. And there were apples in this bin though I don't think now that apples grow in Iceland. Maybe it was a joke. Icelanders *are* big jokers. Of course! It was a bin of imported fruit. At first I thought everyone I met here was kidding. Though I have to admit I think that everywhere. It's a way to understand reality. Hah.

The people at the opening at some point in time had all lived a few blocks from me in the East Village. We talked about how the neighborhood was changing. Steina Vasulka now lived in New Mexico with her husband, Woody. Steina is this seminal video artist of the Nam June Paik moment whose work was these elemental panels of fire and water.

Lava too which is Iceland's version of molding clay. Lava is everywhere here. Like an ominous clock that has stopped. Iceland's dark grey sweater is everywhere covered with bright green lichen. These landscapes folding all over the country (I almost said planet) say what's churning underground, what's running things. Unsteadiness is the country's deepest force. It's the youngest country in the world, errrk, pulling apart. Iceland's getting larger. Turn the faucet and a rotten egg smell gushes out. It's proof. A city of hotels where the water is always too hot. In the days that followed we saw waterfalls and geysers. Maybe Iceland is a more efficient America. Rather than

having Hawaii *and* Yellowstone *and* New Mexico, Iceland has compacted it all into one island. Glaciers too. America *has* glaciers right.

Steina talked about her years of working at The Kitchen which she co-founded and how awful nonprofits are. I know, I said, shaking my head. It's like having the same horrible ex. I remembered the weird name on the Kitchen's mailings next to the indicia: Haleakala Inc. I thought that was Hawaiian I cried, hitting my head. Steina grinned.

The Icelandic artists at the opening had lived in LA. They went to CalArts. They had lived in Paris. They spoke French, German, Danish, Norwegian, and English. Not in that *European* way that implied you were an American idiot for only knowing one language. We were in their country, Iceland, which is above all not an irritated place. No one was mad you didn't speak Icelandic. That was it. Iceland was forgiving. All languages were other languages here.

There was a panel the next day or some other day and though it was easy at the opening to say I'm part of the show, after the panel I actually met my first Icelandic writer, Kristin Omarsdottir and in the ten years since we've become friends. I feel that we are really good friends but Kristin's hard to stay in touch with and then a very chummy e-mail comes sailing onto my computer like we spoke yesterday. What I am most proud of claiming is that she is a female writer I increasingly understand over the years. You know how you can't just meet someone in their country a few nights and then your country.

You have to repeat the experience a number of ways, to begin to compare the person to people you know, to have that *aha*, and then realize that that impression is also wrong. Slowly the new friend begins to appear in your imagination like a kind of geological event you've never encountered before. That's pretty much how I experience Kristin by now. She's very funny which is hard to get in translation though I always felt her timing.

Initially dour and heavy but then you realize she's kidding. Maybe. Finally you can tell by the way other people sidle up that a person is funny and charming. And bad. Most of all very *bad*. Or maybe I mean good. That night we were exposed to Icelandic nightlife.

I was palling around with Kristin and a visual artist Haraldur Jonsson. Haraldur looks like a slightly Slavic looking Christopher Isherwood. I met Björk at a party last year and when I dropped Haraldur's name she blurted he's my best friend. I think that meant she likes him. Haraldur instantly told me about White Nights which I assumed was like in Russia where in June it stays blue till morning. No in Iceland it means suicide. Oh that kind of white. *You* have a nickname for it. We were standing in a three level bar that looks like a pub and then a lounge and then a disco. It was delightful. I felt untrapped.

It was called Club 20 and the red-checked tablecloths and large black and white photos of drag queens on the ground floor were an homage to Max's Kansas City. It wasn't pathetic it was sweet. Someone was explaining to me who the Vikings were. They must have liked me or were drunk cause otherwise how boring, right. To explain such a thing to a poet on a junket. Vikings were homesteading Norwegians. Really. That's all. I had kind of understood that they "came down." You know. From Greenland to Iceland to Ireland and beyond. Taking captives and leaving sperm. Cause you could see it. Which is how I think we got on the topic. The place looked like Dublin, maybe Liverpool. The fashion was good, people were red-haired, dark-haired, and blonde.

Suddenly a wand passed over the assorted crowd and everyone I knew was massively drunk. They were simply raving. They looked mad, of course, speaking only Icelandic to each other. Drunkenness is like watching people drown. They grow unsteady and their eyes are reeling around. Issuing epithets to each other. At jagged moments you think you are the subject but irretrievably each person

is dog paddling, treading water, bobbing, falling away. Alone, I yelped. I study this because I am an alcoholic, though I no longer drink. Drunkenness fascinates me. For one enormous second. It was their winter nightlife and it was time for me to go.

I stumbled up those same streets in the morning into an antiquarian bookstore that sold postcards of 19th century people standing around geysers erupting on an open plain. I felt a kinship with generations of tourists, even local sightseers. The sky was gently water-coloured. I bought a few. And I liked my postcards too much to send. A few years later I was teaching college in California. I had so many walls there and when the art ran out I installed this bit of Iceland. An abstract pattern of postcards with their ink pen addresses on the back. I'd stare at the pale unreadable messages. These were like the geysers I brought home.

I'm not sure if I'm telling a story or unveiling my mania. It's often suggested that Iceland is Scandinavia, but it is not. Though obviously it can get filed that way. There were no native people here. No original population decimated by European settlers. There was nothing. Just a lonely planet in the twilight zone. It reminded me of a sci-fi comic book I read years ago where the rocks were the people and they were quietly waiting for the settlers to go away. One Norwegian colony failed and then another. Irish monks came in curraghs. The original language of Iceland was Old Norse. Like Montreal French the old language persists and what that means is that an Icelandic schoolchild can read the runes in a Danish museum though a Danish adult can't. It's sort of like Hebrew. A trusty old language. In the middle ages there was an Icelandic poet in every court in Scandinavia. Iceland evolved as the keeper of Scandinavia's sagas as well as inventing prose, which the sagas happen to be written in. If you teach fiction, they're great to use. Nothing psychological here. Just action and law. Think NYPD for a moment. It kind of works.

This is parliament they told us on one of the van tours. We were standing on a ledge in a giant rock formation. I was with Hans and a couple of the other European men on the tour. Erwin Wormer an Austrian artist. He was a conceptual artist and a working class guy. He told me about explaining one of his pieces to his dad who's like maybe a butcher when suddenly a light went on in his father's eye. Hey, you're pretty smart, the dad smiled. He decided that his son was a con, like Erwin was selling the Brooklyn Bridge to those fools. The only part his father missed was that art is a willing transfer of belief. We just stood there and stared.

Tribes gathered in this hall of stone to make the year's decisions. When the Norwegians took over and then the Danes the Althung stopped but later it just began again. It's deep in the consciousness of the people. Even this connection between the sagas and the law. The culture you tell yourself. Eventually the parliament moved indoors to Reykjavik. For hundreds of years they had been on a three-year cycle. Someone called The Law Speaker stood here reciting one third of the law so everyone could check his memory. And if you think about it, so everybody would know the law. Then they applied it.

People were drowned or banished to the highlands, which is the lumpy empty interior of Iceland. It looks like an abandoned planet. (I've yet to get to the highlands and hope the friend who offered to give me a tour of them won't immigrate due to the crisis.) In 1965 and 1967 twenty-five American astronauts rehearsed the first moon landing here. Which was celebrated by artist Aleksandra Mir who arranged an Icelandic screening of her own video *First Woman on the Moon* (shot on a Dutch beach) and invited The Icelandic Love Corporation to perform a ritual piece at this event Mir called *Top Secret*. Gudmundur E. Sigvaldason, the geologist who was an advisor for the astronauts' visits, was on hand to give his account. Unfortunately the head of the gallery got drunk and tried to take over the show at which point everything fell apart.

The highlands today sometimes get used for fashion shoots. But it's too Goth. Dark sadness never sells anything though people are drawn to it for itself. It's like the old (and preferred) idea about poetry. That it's pathetic. Music, on the other hand, knows how to circulate melancholy. Sigur Ros's videos are really successful. Iceland feels like my perfect girlfriend. She's not poor, but she remembers it. Foreign investors might be recoiling from her now but with the collapse of Iceland's economy a lot of tourists are heading to Iceland like Penelope's suitors.

In 1996 Iceland's president was female. Which seemed less about feminism and more about practicality. Looking at a handful of kronur I don't see rulers or even deities I see fish. Fish is where Icelandic money has always come from. So are the fish on the coins literalness or deadpan humor. The difference is subtle here. W.H. Auden (who himself was of Icelandic heritage) reported in his *Letters from Iceland* that in the depths of WWI some British lunatic delivering goods suddenly declared himself King of Iceland (like it was only for lack of someone thinking of it) and he was swiftly taken away in chains. Though the people were mostly poor in Iceland's past (there are even jokes—I think it's a joke—about poverty in the 18th c. census. One man gets identified as "Jon: landless prankster") there were also a lot of rich farmers. Who bought books. Iceland has always had a remarkably high rate of literacy. Today it's 100%. There just may not always have been a lot of light for reading.

When times were hard (and you were lucky) people ate dry fish. Rotten shark too. Icelandic people still smirk about the secret disgusting things they eat at home. It must be fish. In the design show last year at the Kjarvalsstadir there was a Lego-type toy for kids made out of fish bones. Icelandic children had always played with fish bones "when the country was poor" the label explained. It's hard to say what's sentimentality, what's superstition, and what's real. To an outsider, I mean. Which is kind of the music of a unitary-class society. They know

what it means. A show in New York depicted a wild haired artist (Magnus Sigurdarson) in a series of photos about a lost Icelander on the beach outside hotels looking tragic like he had fallen out of another time and landed in South Beach. Another artist filled a vitrine with photos and stories about oddballs from Icelandic history. The title of the show came from a performance artist who played on the readily available emotions to be found in her local audience. The exhibition was at Luhring Augustine and it was called *It's not your fault*.

That first time in Iceland I was licking my wounds from a breakup so bad I had to call the cops and afterwards I lived through an even more bitter experience with the lesbian community's response to my action. I had been part of that community for more than twenty years. Now I learned there were unspoken laws and I had broken them by calling the cops on my violent girlfriend. As lesbians we were in opposition (always) to the police and therefore had to work our problems out privately in "the community." Some of this feeling I knew was about the ugly history of homos in America. Those famed police stings on gay bars. And anyone political (including myself) had been jailed on several occasions for civil disobedience. But this was violent crime and I had been the victim. But most of the angry people in the community were younger than me. They hadn't been getting busted pre-Stonewall. So I smelled a rat. If any of them had a problem I felt certain that there was a ready system of privilege for them to draw upon—lawyers, family friends, people they went to college with, husbands and wives. None of these social networks were ever publicly acknowledged in "the community." No one I knew had ever gone to jail for drugs for instance. Meanwhile US prisons are loaded with black and Hispanic men and women who in many cases did a lot less buying and selling of drugs than my friends. This is in fact the American way—and meanwhile I was being blamed for being so stupid (as in lower class) as to find myself in a violent situation, to

not to have known it *inherently*. In my subsequent years of thinking it over I wondered if anyone actually believed that lesbians were not entitled to the use of the court system, the police department that had worked so well for me, the hospitals and schools. . Did they really believe we were supposed to reinvent these institutions on our own. It was no community. That's all.

I was listening to Zizek in this video about Kant. Kant's very odd sense of public and private was being delightedly explored by Zizek amidst much nose rubbing as a possible future application of communism, not the state kind but a new kind which was sounding like our only hope. To Kant the private included the state, the universities, all the machinery that is known to be public to us. The places where thinking was done. That was private. What would be public instead in this new economy would be how that private machinery connected to the most naturally excluded member of society. Whoever that might be. I applauded that notion, almost a Fluxus thing, how Zizek and Kant understood public, a communal public. Whether it's one person or a class of persons standing outside the actions or the thoughts of their government or community today. Pull in that public. The landless prankster or the dislocated artist, the petitioning lesbian. I'll take that.

Kristin is hard to pin down. About when she will arrive in New York. She might be in Barcelona, yes yes for a little while. In Canada for a residency. But then she is home. She's not so easy to reach in Reykjavik. I was getting embarrassed on my second trip. I was staying in a guesthouse on her suggestion, and I went to Stykkishólmur to see Roni Horn's water library and Kristin suggested I contact this older writer, Braggi, who gave me a tour of the town where he grew up, he even pointed out his childhood window. Then he served tea and set out a feast.

He showed me the books he'd written including one which was a book of nicknames. On the inside flap there was a picture of him

as a child which Sigur Ros used in the design of their new CD. And how is Kristin Braggi asked. And how is Kristin asked Gudrún Minervudóttir, the writer in residence downstairs from the water library (Vatnasafn—I'll write more about this later …) which is perched over a harbor, Breidhafjordhur, where boats cross to Flatey, a small island, then continuing to the other side, a town, then the West Fjords which will be as far as this story will go right now. How is Kristin …

Finally back in Reykjavik I was invited to go to Kristin's girl-friend's house and met her girlfriend's mother too. It was raining that day (as it did every day for two weeks straight on this trip two summers ago) and the plan was that we would all go to the country and pick blueberries. It was a typical event. Everyone knew the appropriate gear for this adventure and my friends Glenn and Thórhallur were game and of course Thor knew Kristin, he called her Stina and everyone bent over the low bushes in the grey rain. We are too late I think, said Kristin. These bushes have been picked but a cry of success from over there sent a pair then three in that direction. I had my notebook out and each time the rain struck a letter it would smear aesthetically. I became glad. Blueberry picking seems to be an Icelandic national sport—have you ever picked blueberries Eileen—well yeah there was a pond near where I was a kid no those were raspberries but the interlocutor was already head down over bushes and rocks in the horrendous rain. In the same way that the wand had passed over the bar my friends were now gone and a bunch of sentimental Icelandic people were laughing and talking among themselves picking blueberries in the rain as they did in the early fall all their lives. No to be truthful nobody had done it for a few years.

You should really think about coming at Christmas Eileen, said Thor. You'll walk through Reykjavik and look through the windows and every house is the same. All the teevees are on watching the same shows and all the people at the table. He smiled and he continued

to walk vigorously towards wherever we were going but his smile was a little grim.

Because this is Iceland too. This sameness and the sameness that feels about to change. Maybe it's the sameness Iceland will be returning to. The nation of migrators has been receiving waves of immigrants—from Poland mostly and Eastern Europe, but Southeast Asians and a growing Muslim population too. But as the economy teeters many of the newcomers are leaving. Icelanders though are a little bit like poets who are by and large good at being alone. On the world's second biggest island (next to the British Isles) in the middle of nowhere.

Thor says Icelanders look like this. He makes a dumb cow face. You can pick an Icelander out. They stare at you. It is not an urban face. We are not sophisticated people. I'm thinking that one laughs at one's family, one's tribe as a kind of solidarity. The names we call ourselves when we are together are how we knot the blood ties of family. The violence of these words in other people's mouths never sits the same. So … what if you had a whole language to yourself. Not just a few words. Because nobody speaks Icelandic except the people here and when they meet each other round the world. It's such a specific kind of belonging. The only thing that it resembles (other than a belonging I desire) is this piece I read once in the *Times* magazine about these kids of gay parents who are forming support groups when they come of age because the singularity of their conditioning in its jarring encounter with the "normal" edges of the world needed "articulation" in early adulthood. The writer of the article said that these kids were more like an immigrant group, that they had a specific kind of "nationality" among themselves, a *gift* of a sort that needed to be acknowledged as opposed to being liberated from. No one is asking Icelanders to assimilate.

Not yet. When you look at a culture that has developed on its own with its own unique resources there's been a question, certainly

during its decades of affluence, of whether it will wind up a geological theme park of white difference or a laboratory for how the world could change. If it has a chance. There's an implicit hopefulness in the fact that Iceland is still growing. The word that means how the continents separated is occurring to Iceland's landmass continually and around the edges of the island islands have sprung up and disappeared as recently as the '70s. In the 18th c. there were volcanic eruptions that created darkness over much of the country. Volcanic ash blew to Europe causing massive crop failure and starvation. What is sometimes called the Little Ice Age may have begun in Iceland. The first "Irish Potato Famine" could have been triggered by the smoke and ash. The connected and the disconnectedness of landmasses on our planet is part of our planet's history. My history. It's very stirring to see.

One can visit Vestmanneyar Island today and walk up a hill to a house still covered by lava and partially excavated. The upside of this underground activity is that large thermo plants nestled in the mysterious green landscape pump underground hot water to every house in the country providing a cheap and clean boundless source of heat. Even the front steps of homes in Reykjavik are ice-free because local design decrees that this same hot water runs under the city's steps. Tourists are told repeatedly to stop buying bottled water here where nothing you could buy except when you are buying the exact same thing, bottled, is as good as Icelandic water which is about the best in the world coming fresh down the mountains every day. These things are told to you in an almost dour fashion, like yes my tits are huge, I've heard that all my life, because people are used to their national strangeness being synonymous with some of the most uniquely untouched circumstances in the world.

And tourists still go missing every year. They hike across glaciers without guides and the glaciers are actually full of holes. You have to know them I've been told. I heard about a dog falling down one and they could hear it barking for a couple of days but they couldn't help

it. They kept throwing down meat with sleeping pills embedded but the dog was too freaked to eat. It's hard for people to grasp that someplace so close to the rest of Europe could be suddenly dangerous. For hundreds of years those mysterious highlands surrounding the glaciers were where criminals, "outlaws" were sent. In a place like Iceland, the out part of outlaw becomes literal. Outside the law you are in the highlands. One might survive on berries and roots and whatever creatures lived out there. There are stories of a man or a woman who's survived for forty years in the highlands alone or that there were tribes of people living like that. They're a little bit like Irish tinkers, but off-road. I guess now they call them travelers.

I often think of Roni Horn out there sleeping in a cot next to a glacier. Abjectly I keep comparing my own limited Icelandic experience to hers. Roni's the better man I'm sure but there's something a little chilling about Vatnasafn, her temple on the hill over the harbor. Her water library in Stykkishólmur. It used to be a working library but they took out the books and brought them down the hill. I wrote a piece about the library for Open for Design who I was blogging for last year. You can read this piece later if you want. I am always glad to have a little bit of work. The money yeah, but even more the focus.

I drove to Stykkishólmur with my friends Glenn and Ruri. The ride was great. Ruri knew a woman who was married to the big genome man who was "a genius." There. *That's* their house. We had to decide whether to stop or not. We kept going. The genius part meant he was bad at parties and always had the right to leave the room. I was dying to meet him and she said she could still arrange it. To ask him questions or to see if he would walk away. I'm sure you know that Iceland was the site of this big study of the gene pool because there had been so little change in the island's population for about 1,100 years. On my last trip I met Olafur Gunnarsson, an Icelandic novelist (and Jack Kerouac's translator) who told me they discovered that Icelandic women are Irish whereas Icelandic men

come from somewhere around the Black Sea. I can't find this information anywhere on the web but I do like it.

We had to put on these blue booties just to walk on the water library's floor, which was covered with English and Icelandic words. Weather words. We all had some cake across the street and they left. I crossed the street to the truly mundane space that is the town of Stykkishólmur's new library at the bottom of the hill.

Actually I'm more in support of a library being a boring building like this. Do you really want to read and think and get introduced to the world of inner space in an architectural marvel? It seems like too much. I think beautiful libraries are for people who are not working. Funders and trust fund babies. Think of Seattle. I mean I love libraries. They are among my favorite places in the world but in a culture that's unwilling to do anything for the homeless (I'm talking about America, now) the library has become their public resting place. The only rule in the contemporary library is that you don't act too crazy. In Iceland I don't think they even have any homeless. Whereas in America they really ought to offer cots and lunch.

I was working in the library in Provincetown yesterday and I encountered an utterly new problem: a loudmouth librarian. They have a new library there and it's pretty empty—it's acoustics were bad and she was instructing the other two librarians about the big Mary Oliver spread they needed to do for women's week and I could hear even when she paused and rubbed her nose. The whole library was like an early Laurie Anderson piece.

I'm a writer, I said to the librarian in Stykkishólmur. A writer wants to be loved by librarians. Plus I had a purpose. In my hometown library in Massachusetts I always say you should carry my books. They look at me and then they give me some cards to fill out. I don't know ISBN numbers so I ask can I mail them. They say yes and nothing ever happens. And don't ever tell a writer you bought her book on sale at the library. That is the worst information of all.

The librarian in Iceland warmed when I told her I was published in *Stina*, the pink Icelandic journal in the rack at the door. Stina is the nickname for Kristin. I get enthusiastic about sending the librarian in Stykkishólmur all my books. We will buy them she says smiling and then hands me the key to Vatnasafn. The key was glowing. I was spending an extra day here because I had to creep around upstairs like an art writer when no tourists were around. Then go to Flatey, the island out there. Kristin said I should go.

The librarian asked me for a 200-krona deposit for the key. It was pouring out again and I walked back up the muddy hill to Vatnasafn and knocked on the downstairs apartment door. Gudrún Minervudóttir, the writer in residence, was being visited by her friend Imma Magnadóttir, an artist I already met in Reykjavik. Everyone smiled at my having just left about three bucks for the key to a space worth millions.

Upstairs was the tiny temple with twelve glass columns filled with water from Iceland's twelve glaciers, which are at this moment melting. In 2006 there was a phone number you could call and listen to it. That just seemed too much. Iceland is beginning to do the wrong things (or the typical things—like everybody else) like Alcoa built a whole series of dams that will toxify a few clean rivers. Does *anyone* even Iceland have a few clean rivers to spare. I picture Alcoa rubbing their hands. There was a show in Reykjavik called *O Natura* or *Alas Nature*. It was a terrific show. I thought it was an odd translation, the Alas part but it turns out the Icelandic artists were sad. Alas was exactly what they meant. They have managed to keep their own sentimental landscape intact for this long. I think of my hometown gone, or different. And they are thinking thousands of years. It's all our country, isn't it? Isn't that why we love Iceland, our planet? Its empty achy poet's song.

Katrin Sigurdardottir's piece was a mountainous landscape on a loft-like platform that was like a miniature train set. You climbed up

a ladder and stuck your head through a hole to see it and it wasn't until somebody did the same on the other side of the landscape that you realized you had become a monstrous human head invading the world. It was like an environmental joke. The piece has shown all over the US and Europe but it feels different here.

Roni's temple is a beautiful protest piece. Roni's frustrated which I understand. It's wrong, what Iceland's doing, or I guess the government but countries, perhaps all countries, are ultimately stupid. Think about a country. The idea of reducing everything in a place to one thing, a government, to speak with other blurry entities. Meanwhile everyone's got this extension cord to everyone else's economies. It's fucked.

The British are mad because they can't get their money out of Icelandic banks. Iceland was getting attacked by British hedge funds in the spring. Like gnats. For a decade or so the country enjoyed being rich. I feel I've probably caught Iceland on a collection of good days. That seems right.

The night alone in the temple was eerie and glamorous though it couldn't match how the day got reproduced a zillion stretchy ways in the glacial columns.

The bay, the town, the boats, the day danced surreally in the artist's morbid lens. At night the art turned back on itself. You got the dark harbor and the elegant room facing the bay with dozens of inset lights on the ceiling and one enduring mustard stripe in the column which was the vertical icon for the vulcanized rubber floor and a fragment here and there of a word: cold, grim, hot. But you know—words don't do it. They don't. They never say enough. Ask any writer. Language just fails. It's no place at all.

Roni Horn had a show in Reykjavik days before I arrived called *My Oz*. I thought that's strange. Is it not colonialist? People assured me she had brought a lot to the country so she can call her show whatever she wants. *Our Roni* they call her.

The words on the floor don't look very durable. The Icelandic art I've seen is rough and tumble. Either absolutely not sentimental or meant for touching. Haraldur draws your blood in a piece and he gives it back. That seems fair. I can't imagine drunks in little booties lugging their coffee urns into Vatnasafn. That's the idea.

Once the water library is no longer a star it will return to its local uses—morphing into a community space for girls' chess clubs and AA meetings. Absolutely. A setting like this could get any number of Icelandic drunks sober. There are a lot of them. Drunks like to sit in pretty places imagining the wreck of their lives. Vatnasafn like a big sad aquarium. Maybe that's what Roni was thinking when she designed it. Two moves ahead. That's what I'm thinking about up here at night. It's a monument to melancholy and recovery *and* hope for the world. I'm just grateful it's not a restaurant. That's probably what the town was thinking when they took all the books out. Look: a million dollar location.

I should be the next writer up here. I sat for a while in the night watching a spider crawling under the chess table while I imagined the Icelandic/American reading series I would curate. Gudrun downstairs said it was amazing that America has so many writing programs for us to teach in. No I assured her. It's really bad.

But let's face it. Iceland (at least up until this economic debacle) is hot. Didn't Yoko Ono do something about John in a lighthouse here? Richard Serra installed a lightning rod on an island. Olafur Eliasson sprays water and mist all over the world. It began *here*. You look at this landscape and you feel sublime things. It's like if America still looked like the Hudson River Valley and painters from all over the world kept coming to paint it. Icelandic artists seem to take a split screen approach to the beauty. The Icelandic Love Corporation, this quartet of young women, do public actions, videotape themselves in furs doing rituals on an arctic cliff. It's like *A Hard Day's Night* but Iceland is their fame. They make sumptuous sculpture out of ravens

and licorice and the Reykjavik fire department shoots off a giant volume of water while an opera singer puffs out her chest and wails. Haraldur installed a sound piece of a baby crying under some rocks in an island close to Reykjavik. It's sort of perfect and creepy. They are playing with the environment, as opposed to installing. It's a lighter, conscious use. It's like art citizenry; Iceland is their currency and their sophistication, which is just incredibly cool. I suspect we're approaching the dawn of some of them becoming more overtly political artists. First the environment, now the economy. Getting pushed.

When I returned the key the librarian would not look my way. I had forgotten to return it two days ago and went on my jaunt to Flatey. Her reaction puzzled me. So I lurked. I *used* to be loved. Then she gave it to me straight. It was dirty. It was dirty I repeated as I considered my disgrace. There was grass and mud on the floor she hissed. I thought about my travels the day before, the wet grass that was now in my cuffs. But I hadn't been to Flatey yet. How did it happen? I accepted the 200 kronas in disgrace. My feet were still wet. Now I was getting sick.

I'm sure Roni Horn has really good boots on *all* the time. Grass does not stick to her. If she trails mud her assistants put it in envelopes and save it for her archive. Enough.

This entire second trip to Iceland, the one that wasn't a junket was hard. My companion in each and every single way on this trip was water. I had been pedaling around Reykjavik in the rain on Kristin's bicycle. Sailing from one storm to the next. This is unusual, said the man who ran the guesthouse. Usually summer is good in Iceland. He offered a maternal smile. Pity for both of us. The rainy days in Reykjavik were great for art. I sat on beanbag chairs in a museum with Kristin and Haraldur. The walls around us were saturated with soft pink balloons like the gentlest most gigantic breasts. Three of us bobbing in the darkened screening room. It was amniotic feeling.

Meanwhile my house in San Diego was on the market. In Iceland in the rain I was getting e-mails from Craig, the cheery broker, that it was not looking very good, Eileen. I was so ready to go. I had been living there for five years. Unless you want to lower your price again which I don't think you're going to want to do. Right, Craig.

It just made me want to go to the gym but there are no gyms in Iceland. Well there's the gigantic world gym on the other side of town which I rode to once in a monsoon and for 60 dollars a pop I could work out *there* everyday. Finally you do what the Romans do. You do what Roni Horn does. You go swimming. I hate swimming. Every ten years or so until I die the idea burbles up in me. A psychic once told me *my voices* were saying I want to swim, I want to swim.

And Reykjavik has a perfect pool in every neighborhood. With outdoor hot pots where people of all ages gather to soak and chat during the day and after work. These people are perfectly unfriendly. Nobody stares and nobody says hello. It's a great country to live around if you like being lonely and I do. So I went to the famous pool in photographs by (I can't say her name again) that is the most relaxing pale green and the lockers are lovely and wooden and every single detail makes you feel glad and cared for. Outside there's a big basket full of water wings for kids. Not dreary military looking ones but new bright plastic flower ones. Kids use them and return them and no one steals or breaks them or writes on them. I'm thinking this is the glory of a homogenous culture. It's not public school, it's not private school. It's *our* school. Who would you be wrecking things *at*? I think that is the one thing that's truly missing in Iceland. The appropriate object of anger.

I'm thinking of the film *Reykjavik 101* in which the young man visits his extended family over the holidays and they are beaming placidly around the table and the couch and certain family members say the same things over and over again for years.

Humorously, I mean, in the movie. You see the years flip by. Then one Christmas he picks up a gun and blows them all away. But even in the film it's a fantasy. In reality I think he would be more likely to kill himself or you know go to art school in New York (anything!) but not shoot the family.

Water was my friend. The rain was not. I did not bring a raincoat, I did not have waterproof boots or any boots and I brought a rolling bag. Flatey was a tiny island, covered with bright green grass and black sand. Beautiful old Icelandic houses, bars, a church. I got off the boat and stood. I looked up the hill. I looked back at the boat. I could just turn around. I walked up the hill. The road was black mud gravel. I already knew about the Hotel Flatey. Hotel Flatey is wired. That was my direction. The Flatey plan was to walk around, spend the night, e-mail my Roni Horn piece then travel onwards across Breidhafjordhur Bay—to catch the last bus of summer to the West Fjords and to Isafjordur.

Well. Sometimes the way I travel makes me feel very young. Or just old and unprotected. Dumb. Cause I'm rolling my bag up the hill feeling like a fool cause the wheels don't like gravel and the bottom of my bag's getting torn and it's pouring. There are weirdly pointed roofs in Iceland. The angle is extreme (I'd say 45 degrees) and it's beautiful. Very beautiful like a calm acid trip. I'd like to build a house like that somewhere. And there are black houses. It would look bad on Cape Cod but here's it's wonderful. At the hotel I learn that the film people are through shooting but what this means is that the hotel is now ready to close for the season. But it's only August 29th! The woman shrugs and goes, still. Still. I should go through my notes. Roni Horn has that word on the floor. All her words are weather words. I know why.

I decide to take a walk. I ask at the Hotel Flatey if I can leave my bags here. I'm frightening. They say yes and I walk up the hill. It's a tiny island surrounded by sea. And suspicious sheep are glaring at me

at every turn. An important monastery was here in the 11th c. and there are ruins on a cliff I want to see. I get to a point on the path over a black beach. There's a sign. A nice wooden sign. Something about migratory habits and area not open to the public on these dates and we are in those dates. A young man who was also on the boat comes up behind me to the sign. He's not acting like I'm standing there. He's French. All his clothes are black and waterproof. It's perfect. I say to him it's closed. At least that's what I think it means. He then reads the sign as if he's helping me out. And then he walks off along on the path. I stand there. I watch the black dot of him. Smart, young, dry, male. I could follow. But *I* was here first. I stand and the rain is hitting my face lightly. What the hell I am doing here.

Returning to the hotel area I see a little yellow tractor that says TAXI on its side and it's loaded with luggage. I'm thinking now I'll just return to Stykkishólmur on the next boat. Because I have to send the piece to OFD. I ask the taxi man if he will take my rolling bag down to the boat. He asks me who I'm with. I'm, I'm, I'm just with myself. I'm a journalist I say hotly. He's loading the film people's stuff and then they're all heading down the hill as me and red roller are bumping along under a perfect grey sky.

The island remains black and grey and green. And I love the perfection of Iceland. The taxi's hard yellow is blaring in the midst of everything else. The island's complete silence. Anything technological here looks cool. It's not like I can't understand why the art stars all want to make monuments in Iceland. It's like a cemetery. And *this* is a sad poet comic book. It better be waterproof. Days later in Reykjavik I'm looking at tractors in a dealership window they're so beautiful. There's a farmhouse I can stay at I'm told. I walk in. It's just bedrooms in someone's house. Kind of depressing.

I nearly stayed in a place like this in Stykkishólmur but I got the kill-myself feeling there. *That's* how I got all the mud and grass on my pants. Walking around in the rain trying to get inside. Not that

I would really kill myself in Iceland but it would begin the decline. The farmhouse had no e-mail and I have to send my piece in.

It's always so good on the boat.

Pitchy

Most likely we travel to exist in an analogue to our life's dilemmas. It's like a spaceship. The work for the traveler is making the effort to understand that the place you are moving through is real and the solution to your increasingly absent problems is forgetting. To see them in a burst as you are vanishing into the world. Travel is not transcendence. It's immanence. It's trying to be here.

Walking to the toilet on the boat back from Flatey I realize with delight that I can watch movies all day long. A guy is playing a movie on his computer and I nod. That's been my salvation on this trip. Traveling or everything it seems is very lonely. Until I realized I can just rent a film every day. I can always watch television. And be with my family. In the flicker of the hearth. Even as I close the bathroom door behind me I see a movie on the big screen in the ship's viewing room. People get on the boat sit down and watch a film. I guess that's about living on an island. Or an island next to an island. There's always plenty of water here. Water and film are inter-changeable. The movies are all in English—the subtitles in Icelandic. So everyone is watching a subtitled film but me. Every-where in the world. This is not supposed to be something to cheer about but it is a bland American premium. We may not have health insurance but we have made our language the equivalent of free hot dogs everywhere. For *us*. I was reading *The Uncertain States of America* where Paul Chan quotes Walter Benjamin saying that "places" are melancholy. I'm saying something slightly wider. Life is melancholy now. Only in pictures do we free ourselves. So I'm puzzled by my inability to pick up a camera. Though on the boat I write, I

shoot. On the boat let's face it I'm held. In its waves, its vagueness, in its water. I see only water. Water doesn't answer. No land ahead. Just water. So my dilemma shrinks to secondary and abstract. How will I live? I want to stay in this primary thing that moves.

When I get back to Stykkishólmur I don't know what to do. I stay at the same trim little modern hotel and finish my piece. A nice little desk. I have a tiny thin thermos and the woman at the desk lets me fill it with hot water for tea. What will I do tomorrow? I could return to Reykjavik yet I'm near Snaefellness the dead volcano in *Journey to the Center of the Earth*.

There's something so strange about that book. My aunt cleaned rooms at Harvard and lived with her family in a three-decker in Somerville. In the hallway to their apartment was a bookshelf and a trickle from somewhere else fed that shelf. Books—some from my older cousin's boyhoods—but also sometimes from Harvard. I was a sci-fi buff. There was this one book I picked up and didn't finish. It seemed too old for me. I was under ten. But it was a strange and wondrous anxious space I've searched for for years. It seemed to exist in some adult abstraction about time and feelings of lostness about where you were. Like I was in a dream and there was the pressure in it to continue; also the pressure to stop and finally the pressure to stop prevailed. The kid put the book down. But I remembered for years being inside of something that had no name and for so long I wondered what that book was and how would I ever find it. All I remembered distinctly was a feeling and a beach. But also a feeling of being *inside* which was strange. In preparation for the trip I was on (the second trip: the non-junket) I read Jules Verne and damn if that passage wasn't there. It was about standing on the beach of the underground sea. In an Iceland where Jules Verne had never been. I felt the traveler's fear and even recalled their excited experience of knowing something that nobody else knew. In a fictional way. It felt like parenting my own

mind to be reading that passage again. I had this beautiful arrival before I even left.

It was the movie version that actually introduced me to Iceland. 1959. Pat Boone had his shirt off rolling down a white dune of salt. Arne Saknussem, the evil Icelander, kept trying to hurt him and steal the expedition away from Pat and his Professor/boss, James Mason. Best was the end when Pat Boone, shot out of the mouth of a live volcano, lands naked in the branches of a tree on the grounds of an Italian convent. Boone humorously holds a goat to his crotch as he exits making awkward apologies to the giggling nuns. I mean I could just go back to Reykjavik, yet there I was getting back on the boat because the West Fjords I had been told was the place I *had* to go.

On a trip you have these guides and there's something intuitive about knowing whose advice to take. I could hear Imma saying Isafjordur. Yes the countryside there is the best in all Iceland and I could also remember her saying they were making a film there and she was right. She had smiled when she said it.

I was happy. I was back on the boat. I was writing about Flatey when we passed. I was taking a picture. I also felt a little inclined to give it the finger. I love islands yet they are truly are the most suicide-prone places in the world.

When I got to the other side I saw nothing. I mean nothing. This place makes Flatey look full. The boat's still there. I go up the hill for some reason but up there, there is no reason. It's raining.

There's a few guys standing by a rusty corrugated building and I ask them when the bus comes. They say over. Summer's not over I say foolishly. One guy looks at the other. I'm in a limited English situation. I'm out of the cities. Gone, over he says with an arm gesture meaning it's fucking raining, there's no tourists just you.

I learn about a café about 6 kilometers away and the road parts there. I'm thinking about hitchhiking. I can't believe I'm doing this.

It's pouring. I have a broken umbrella and a small backpack this time. I have my computer and some underwear. Left the rolling bag in Stykkishólmur. I begin to walk. There aren't any cars, or houses or people or animals. Just big rain and hills. I would call this area kind of grey green. Not beautiful. Dull. *Dauflegt.*

I have tea at a window in the café and also ask the woman at the desk about men with cars. The bus drivers are off now for months. One might want to drive me. The woman is helping but the best I get is $200 for an hour and a half drive. Or maybe it was $300. I can't remember. I'm fat in grant money, I'm fat like a tick, but this seems immoral. To pay so much. To get ripped off.

I decide to spend the night—maybe write a little when a white truck pulls up for gas. I run out and a blonde guy filling his tank gives me an odd-toothed grin and I say Isafjordur and he grins and nods and points his thumb towards the truck. I jump in the cab.

We drive through the most gorgeous landscape I've ever seen. It was a landscape hard to believe. The man's name was like Vik. He was a farmer and the son of a farmer. And his father was a farmer too. He laughs about it with his eyes on the road. He drove up and down these rolling curves over bright green mountains and fjords and waterfalls. Incessantly plural. And something hydroelectric would come up every now and then. He called out the names of the fjords to me. That is Egil's Fjord. Do you know Egil's saga. Well I know some of the sagas. I've heard of it. He smiled. I even napped. In the bright lichen covered landscape I bobbed and drooled. It sounds like a baby but I think I felt like a man. I think a man is safe like this in the world and a woman never is. So it was a masculine feeling when I woke up. I opened my eyes. And there it was again. Magnificent. A waterfall. And then he stopped.

I took some pictures along the way though that's when one of my cameras failed. Here's one though. It's a waterfall coming down a mountain in blurry stripes the worst picture in the world but it

didn't look like that. Most astonishingly this landscape is alive. The bigness of it going on. I was in awe of my farmer friend and anyone to have grown up on this land and to have that be the history of your family in some way seems almost not worth thinking about it's so wonderful and strange. It's a fixity I can't rewrite. I can know the television set. I can know the boat. I tip my hat. To the unknowing. Like there's a glass wall in my intelligence in my reaching for it. I learned more about the West Fjords I'll tell you in a bit. The most amazing part. I had come to the perfect part of the country to learn and to hold more and when he introduced me to the fjords I understood of course that these were super heroes. That there was actually pride still in their names. I mean the words attached to the land.

In Isafjordur I stayed in a wonderful stylish postmodern hotel under a massive over-hanging fjord and the town felt really flat and low because of its setting. The ride had been so good I didn't care. I kept playing it back. It was raining. I went out to get food. Had a fast food burger in a little bright café with a lot of video games. And it was full mainly of teenagers with nice haircuts, good to watch. The place rented videos. I got one and some candy and I returned to the swank hotel that reminded me of Switzerland. The candy was Polish. Polo something.

I watched the movie with Johnny Depp and thought. Or continued playing back. To feel the variation in the landscape, up and down the curves was like drawing. It's the tack that's made me want to sail, when I've lived near the ocean. That would be writing. To have an up and down beside myself. To know it publicly.

The final piece of Isafjordur was that the plan had always been to fly back to Reykjavik. The planes are reliable and cheap. Smugness reigned when I returned. Big kudos from my small social set in Reykjavik for being adventurous to have gone to the extreme and distant part of the country. I thought I needed to go away.

Isafjordur has a rock festival in the spring and I would like to return. There's a bigger one in Reykjavik in the fall and if I time it right I can see Aurora Borealis. I was looking up that first night in Reykjavik outside the bus station. Hoping for those green stripes in the sky. It was too early in the fall. So I have to return.

Amy Sillman invited me to her studio to tell her art students about poetry. This is like last week and during my warm up she nervously asked if I was going to tell them about language poetry. Like that was the good food they needed to get. I said something but I should have complained. I mean I kind of stand on assembling identity as a way to find knowledge. I'm Icelandic. I mean as an object of mediation. I mean I'm *not* not a Language poet. Click on the country on your desktop and it opens on everything else. A country is an icon, a portal it seems.

David[1] died in 1993. He read wrote and translated a phenomenal number of poems, articles, stories in the years then months preceding his death. I carted some of it away, a handful of the books on my shelf are his. Mostly unread. He was obsessed with Icelandic sagas for a while which are the first written prose stories we have. There's a big debate among scholars about whether they were a written work or a transcription of oral tales. I say what's the difference. What I like is the notion of an "immanent saga." That's a story known regionally by all in several versions. And if you're not telling it locally you tell it a little different again. Ultimately if you were going to write one version you would need to capture both approaches so the local version would include what's in it for everybody, and yet each turn would also be a little bit out. You would feel yourself standing in both kinds of community (knowledge) by the time the story is done. Written down I mean. The motive for collecting, for writing, I think, is to show the entire approach.

1. Rattray.

I took the book. David spoke about these Icelandic couples, old people who traveled around the country on winter nights a man and a woman reciting as a team these ancient poems in some kind of chant song. The idea moved him in a special way. I felt like it was a reflection of he and his wife Lyn, reunited in the last years of his life before he died.

I've read the one saga he gave me: Njal's saga and Njal dies in his own house, set on fire by the enemies who pursued him. The couples I think David was into sang *tvisongur*, a really old kind of song; I'm guessing and are a part of Icelandic history, though they pretty much stopped existing by the 1920s.

But all over Iceland before it achieved nationhood in 1936 it was like New York between the wars (and now again) when no building occurred. I mean any island even Manhattan has a way of staying on a tune much longer than anyone else until that tune is the tune of the place itself. In Icelandic churches since they lacked organs and vaulted roofs that amplified they even determined the kind of singing that went on in a person's body. Churches were turf, not resonant, so the singing occurred only in the throat and the chest because something has to vibrate but not the building. It's us, the singers.

All the churchgoers were singing the same hymn not the same notes or tunes. No organ tone set the pitch so they would find it instead among themselves. People were literally singing their hearts out. When the organ was introduced in the 30s some of the older people stopped going to church because the idea of everyone singing the same tune at once seemed "obscene" to them, it offended their Icelandic sense of religiosity, or privacy, or just their under-standing of what being part of a community could mean. The radio also upset the applecart with the same songs played over and over with those same versions and the same notes. It's amazing to think about what the radio might have upset. I'm getting this from all sides.

I heard about this singing, and then I read about it,[2] and finally the book I read was co-written by a composer[3] that my friend Mark[4] studied with. These rediscoveries are not accidental. There's an imprecise mourning needed to see where we are now. I think it's like the species rediscovering itself. Learning to be stubborn in our awkward speaking and hearing. All over the world regional accents are vanishing because of the homogenizing power of announcers' voices normalizing everything, until everything started to go away. The landscape and the voices. There's an ecology of sound. Of speech. We have to think about what English does. Riding roughshod over national poetries that since the room is small and no one's in there why not step out to the bright light of day and write in English, think like us. Speaking the language of the global crash. People are standing outside in Reykjavik, demonstrating, demanding the Prime Minister steps down. I can't read the signs but I get it.

All over Iceland since the 14th c. there was this kind of epic poetry singing called *Kvaedaskapur*. It continued to exist till around the 20s and 30s when it began to be codified in terms of pitch and musical contours. The distinguishing characteristic of the singing was a variable voice, which always sang the poem with differing melody. Sameness however was requested of the singers when they were recording. But they were intrinsically doing something else. The writer described the singer gritting his teeth to complete a line. They talk about "the substance" of the poem, even that the words and voice can be "weighed" and were related specifically in some way to personal life, age and environment. And that the style that continued longer in this region (West Fjords) than anywhere else was perhaps because of its physical isolation. Though I'm also thinking of

2. *Kvaedamadur*, Hreinn Steingrimsson.

3. Stephen "Lucky" Mosko.

4. So.

the contours of the land. Which I heard. I haven't heard this poetry singing (yet) so the idea has its maximum effect on my thinking at this moment. I'm making it up what it sounds like though two of the last living Kvaedamadur say that that is exactly how they began to do it. One man explained, "I think it has to be in a person a little."

A Kvaedamadur sings both traditional poetry sagas and also writes his own new poems. Typically the Kvaedamadur denies authorship. He (or she. There were female Kvaedamadur too) didn't steal it. He just didn't *write* it. Maybe the implication being the poem just kind of grew. Typically a Kvaedamadur would go into a kind of trance state for seven months of the year (just in the evenings if I'm getting it right. Or maybe evenings were when he would perform for other people). The light would be dim in the house and the little bit there was would be for him to lean over the text and read and sing. So the thread of the group would not be the light but the sound of his voice. Like a kind of limited, local radio. The Kvaedamadur would be at work during the day, he would sing all day long. The author of the book said that he interviewed one of these last guys and there would be long pauses between his answers and then the interviewer realized that the man was speaking in verse. He lived in poetry all day long. It was his water, his language. He would be in a fishing boat and would be singing the third stanza of a poem all the way to shore, again and again and singing the last stanza as he landed. It sounds like the poems are a kind of metric verse, counting is okay, but how they are sung is the lively part. The irregularity of that. Poets write poems for the singer: to make room for them in the poem. Each song has a kind of pitch that runs through the whole song and the melody embellishes it. The singer drops his energy at the end of the line but several people in the room come in (vocally) and sing the end of the line for and with him. They hold him up so to speak. One man said though he was referring to breath to his power, which faded as he grew old that what one chiefly needed to sing *kvaeda* is courage.

ART ESSAYS

(2007)

PLAY PAWS

I kind of acted like a gross guy with Sadie's new video. Trotted it around like the new girl in tow. So of course I even did watch it in bed with the new girl and (how guy of me is this?) she's *so* much smarter than I am. She used a lot of field recordings said Paige[1] quietly. Field recordings? What's that?

By the time I got back to California I was having dinner with Susan and Darwin and Taylor, friends of mine who happen to be a nuclear family. I figured they would have a whole entire other perspective on Sadie. Stupidly I told them I was writing about her video so anything you say might wind up in my piece. That was real brilliant of me. They promptly shut up.

There's a lot of sex—gay sex—in *Play Pause*. I keep wanting to call it *Play Paws*. Because it's fun. If you look at all of Sadie's work in a great rush you begin to see that her earliest videos are like comic books. Or circus. The bold kid titles for each little video: pure cartoon. The scribbled ransom note dialogue is like cartoon bubbles, but torn instead of drawn and stuck on the inside of her film. Cough I mean video.

Anyhow I'm watching *Play Pause* with my family and prior to this viewing I had been entirely approving of how Sadie scattered moments not so much of pussy-eating or fucking but about to

1. Gratland.

(pussy-eat or fuck) throughout her video. I've been kind of obsessed for a few years now with this thing Robert Smithson liked, an idea which *he* lifted from an anthropologist, Anton Ehrenzweig, that cultures can generally be divided into two types—ones with a buried god, and the ones with a strewn one. I'm thinking about sex here in place of god and in the case of Sadie thinking that though there are artists who might actually bury their sexual content in their work (like a dog buries a bone), other artists let the sex be strewn throughout their productions. Of course all in vastly different proportions. The thing about gay content is that it's so often strewn instead of buried because you know if it's buried then you wind up in a don't ask don't tell kind of situation. It's the straight way of being gay, pretty much, and of course what's implied by that approach is a whole lot of invisible power, i.e., I think that only the implicitly powerful can readily bury their sex or their gods and not feel somewhat erased themselves as a result.

Lesbian content always pretty much has to be visible; that's how it goes. But Sadie's distribution of the item seemed to me to be on the order of like lesbian ripple or chip. A lesbian ice cream *flavor* pretty much, rather than, you know, head-on lesbian shit and so on.

But when I watched it with my family, well.

It was just kind of still. These are hip people but I know everyone was thinking is it okay for me to be watching this with my kid, my parents, my friends. That quiet thought was cycling through the room. I went ha-rumph. *My friend* (I meant Paige) described these as field recordings. That's interesting said Darwin who is a scientist. For *us* pretty much anything done outside of the laboratory is in the field. Which is the world. And then I think well this work of Sadie's this extremely I think allegorical cartoon of this phenomenal moment we are all living in is a fairly scientific work. Though geeky play science. Also like Smithson! Certainly Sadie rides her bike around Chicago or wherever, this generic depressed fertile

Midwestern city and obviously for some of that time she's traveling around with a tape recorder like Alan Lomax. Getting a folk recording of the world. How it was. Sadie tells me that she started with the sex which is so funny. She drew it first. I thought it was strewn, erupting, every once in a while like a huffy little volcano. But when I watched it with my friends I was actually closer to the truth—of the piece. Sadie built a world around the real and imagined sex—the inside of the world that we know. She constructed a tiny town. But sex is the train. The game. The reason. Everyone has sex, even if they don't. She pointed out to me that it was kind of generic sex. Afterwards or before. The sex is actually never happening. People are exposed, ready or else spent. And so she was thinking that that makes the sex a little more universal perhaps. She didn't use that word, but I think she meant user friendly. It's like the sex pushed play pause like the sex was kind of god. And God says, Hey Honey I'm going to go out and get some cigarettes maybe something for us to drink but you know since there aren't any stores or other people or bars I'm going to have to make them so it might take a little while. So I think this is a video generated by an act of love about to happen. And the skies came first too. Those strange sifting metal sculpture skies. I think about sitting on a plane in one of those wonderful composed moods you get flying. I look up and the— what do you call, it the fin of the plane—had a raccoon. Look there's a raccoon out there I said to no one into my little micro-phone probably in a poem. Sadie has some people having sex on the fin. No this is not subtle this is a couple actually fucking. Let me look again. In one of Sadie's earlier films the entire screen gets filled by a fish. Just swimming around in the water. It was perfect. Films are wishful, aren't they. It's just a wish floating around. A gay teen decides to stay home from school and make her *own* world. I told Sadie about how the most famous people I knew in New York Allen Ginsberg and Andy Warhol always went around with a camera. I'm

looking at you buddy. That's what's going on here. Everyone was staring at Sadie when she was a kid. Trying to figure out what sex she was. So she just went and made her own fameful representation. Initially she kind of joined the staring people and her camera was staring at her but then it started moving around, and slowly she began to replace herself. I notice in her films that when her face is talking there's no mouth on the screen. So to me the film was all mouth. Like the missing mouth was the film's moons. It's rings. And later she made masks. And a pencil drawing a line. Soon the world was drawings on walls, signs on stores, and stores that were closed, just signs. That's a real depressed city. Ads selling things that weren't there. Remember when the world became an ad for the web. Around 1998 I think. It was great but it was hard to know anymore which world came first. Then eventually Sadie was gone. In her work. No Sadie to be found. But wasn't Sadie *always* a mask.

I drove my truck to the beach last week. I'm in San Diego. The beach is everywhere here. I sat in my truck with my computer on my lap and I pushed the button (well the picture of a button on the screen) and I watched *Play Pause* surrounded by the gleaming ocean with streams of late afternoon light jumping around on it. A film is an ocean, right. This is real, and this is real. The setting was perfect. Balanced. Some people think the world stopped a few years ago. Certainly that world that we know is gone. It seems to me that when I look at all of Sadie's work she's always taking something away to make everything else move. Someone said that this video is sad. And it is. Listen to the music at the beginning while the train rattles by in our eyes. And then there was sex and she put the world back and probably we can have everything when we're ready. If we know what to push.

(2002)

TAYLOR MEADE'S APARTMENT

There is so much stuff in Taylor Meade's apartment that you begin to suspect everything in it is "old friends." Ones who don't mind lying all over each other. Shoes and newspapers and bowls of cat food and then you kind of want to lie down on them too. The floor is quite literally a half-inch of cat litter. On purpose. That's *their* fault he says, pointing to the roof. They were making some rep-a-a-i-r-rs and there was a lot of debris—asbestos, really awful stuff, so I covered it with litter. The cats like it. Feels like a beach. Smirks. Taylor has an incredibly elfin quality.

Do you mind if I step on your bed? He does mind so I took off my black flip-flops and began to prowl around. His bedroom is to the left of the front door. A wall with a big opening divides it from the rest of the apartment. How much do you pay? Do you mind? $265.19. A rent-stabilized apartment means just that. What it costs stays almost the same—though ages slightly every day, every minute getting older. The rent doesn't so much increase as ripen. His 265 sq. ft apartment is now worth about $1 a foot, he tells me Patti Smith gleefully computed.

Patti isn't there, but his place has a wildly populated feel. Like the toys dance all day long. Piano music playing softly in the background, turning chaos into preparation. His bedroom is described by an angle which "becomes" bed (Eileen: Futon? Taylor: Foam), a small flattened territory which graduates into a wave of continuous

stuff and when I say stuff I mean a black 1990 Business Diary, a pink-pilled blanket, an old towel with a carrot print and slithery greens, a fat color-xeroxed manuscript copy of Taylor's memoir: *Son of Andy Warhol*, an opened bio of Brando (E: "Did you meet him?" T: "No, but I saw him on stage in *Streetcar Named Desire*. He was a great live actor, but he didn't seem to know it"). Two remotes, lots of manila envelopes—piles of them, a large floral pillow, and five or six skyscrapers of black videotapes, grey socks, white socks, underwear. Everything sloshing up against the bottom and the sides of a black filing cabinet, half opened. The drawers themselves are stuffed with white and yellow papers and marked on the outside by peeling stickers—Superman, a polar bear sticker—and on top a small teevee and VCR sit, plunked at bed-eye level. Aimed towards the stillest point on the bed is a clamp lamp. Next to it a very large water jug with a black metal clamp attached to its handle. Why?

It's quiet here. It feels nice. "My neighbor, a very famous sax player, John Stubblefield, agreed to play in his front room, if I keep my teevee down. I watch it till 5 AM," he growls. "I love teevee,"he admits, tenderly. There are words all over the walls. What's that? An arc of numbers 1 through 9 cascades across and down the edges of an art poster for a show called *Young America: A Folk History*. He looks for a moment. "I try to stay calm. I try not to have a wet dream. I'm extremely Presbyterian. I told Lou Reed, with me the petit mort is the grande mort. He got it." Right, my head bobbing, I think I don't. Can I say that, I ask, writing it down. "Sure," flings Taylor, luxuriously. In big black letters on the wall facing the prone flaneur it says "TEAR APART / MY BRAIN AND MAKE / ME A POET." The wall is bulging under the words, then is diligently plastered along its cracked seams. It's grey in washes, flecked by sporadic bits of tape. It's a beautiful wall, one you'd looked at for days doing drugs, or after sex you'd watch the curls of cigarette smoke flutter between "brain" and "make." Then in blue magic marker

it says: 6:50 p.m. September 12, 1989. "That's when I tried to stop thinking. I have total recall—so I have to keep clearing." Lower, I read: A quarter to five p.m. March 17, 1993. "It helps for a couple of hours," he adds.

Running across the greenish wall he shares with the musician neighbor there's a thin strip of metal with a few coat hangers tingling off it for years. Former loft bed? I step out and two white baby fans are twirling my way. Just missed stepping on one of his cats. The oldest one is a scrawny but serious redhead, Big Boy, who has lived here, like Taylor, for 23 years. The younger ones are invisible until I leave. Yet it is absolutely as much their home as his. It's uncanny; the things own the place, the cats do—there's no overriding sense of Taylor's dominance. It's cozy in time. The fridge packed tight. Is the milk fresh? "I drink a lot of chocolate milk, a quart a day." There's beer and donuts, champagne and juice. Defunct gas pipes cut diagonally across the long room ending in windows and a tiny bathroom. Hanging on the line is a seersucker suit, a ski sweater and a hat, a faded jean jacket and a yellowed sweatshirt. Are these real clothes? I ask. They really look like props. "I don't wear the suit anymore." Taylor's wearing a red and white pin stripe shirt and baggy Dockers. Black tortoise shell glasses. Taylor's a prep—wasn't that the Warhol thing? His dad was a lawyer who promised to buy him a farm if he agreed to go to Cornell for agriculture, the final catch being Dad would retire there. Taylor chose to study at the Pasadena Playhouse instead. Nice view, I tell him.

"Orchard Street is zoned for one story," he explains, "so I've always seen a lot. Except they built that and ruined it," indicating a dumb pink building another block over. Yet the view is playful. The bright yellow and red sign for Marcoart radiates cheer. "These are the original shutters?" Stupid question. The wooden shutters hang precariously, a soft green, not distressed but mossy and melancholic. I'm thinking the Tenement Museum of the Lower East Side is a

block away. Their perfectly restored apartments have these exact shutters hanging in their windows. These are them without inter-ruption—they've never left.

Taylor Meade was born Dec. 31, 1924 in Detroit. The sky today in New York is blue as hell. It's a beautiful day says Taylor. He's sweetly watering kitty grass, bright green strings of it sticking up in the air. It cures the cat's asthma, he says. Leaning against the wall are loft ladders! Which I haven't seen for years. Two of them for climbing up an imaginary bed from the mid-'70s when every apart-ment in the neighborhood had a loft bed. He looks distractedly like what am I talking about—he hadn't noticed the ladders until this moment. Then he remembers. The cats use them as scratching posts. Totally clawed.

Nice tree. Uh-huh, he purrs. "It's where I'm going to watch the last leaf fall. You know *that story*. The woman who stuck a painted leaf on a tree so her husband wouldn't *go*." Taylor chuckles darkly. A bright series of paintings hop along the wall. "I love to paint—I mostly work with a palette knife." "Oil." What's that line, I ask, cause it doesn't look like paint. "Oh it's one of those … Sharpie? Yes, Sharpie." It's a nice big painting—waves of dark bright orange, long squiggling drains of Sharpie and then some moustaches and clouds. It's called "Lion." In fact it says Lion right on it. Taylor isn't willing to let things get too abstract. He sells these for about 800 to 1500 bucks. Below them is a big browning landscape which actually gives the apartment more space. With its mesas and lurid blue skies. Sort of an ad. An old one. Taylor reputedly used to have torn out pages from *Architectural Digest*, photos of beautiful rooms, tacked to the walls of his apartment. I went in looking for that, but it isn't here. Yet it's almost like the whole apartment's become an illustration of that irony. He's an actor and he lives in a constantly shuffling, growing set. It's the most active passive place I've ever seen—exactly like a beach. A fall beach full of stuff you can shuffle past alone.

There's a low black bookshelf under the art. Jam-packed with Ellery Queen and Hitchcock novels. "They belong to a poet, Stephen Paul Miller. Do you know him? He's a college professor. I do know him, and I run into Stephen that very night.

I start pulling back. Looking for a long picture. It's one big flow. An electric piano is nestled in the middle of the room. Do you play this? I *can play* but I just improvise. My mother played very well. She died when I was thirteen. I see shoes, phonebooks. Lots of water bottles, a magenta package of cotton swabs. It's still very hot in here. I guess it's time to go. Do you write here I ask, closing my book. I used to live on West 70th St. I wrote a lot there. I'm working on a big book—a total autobiography. Maybe if you turn that light out, it'll feel cooler.

I'm back at the windows again. There's a stool with a yellow corduroy cushion, then a window seat where the cats peek out at the pigeons. I say the word "radiator," like a final note. "I'm top floor," says Taylor, "I get all the heat." The phone rings. I hope it's Jackie Raynal. I want to go out for a while. "Good news!" It's one of those electronic ads. "You've won a vacation to the Bahamas. Just call Ramada 3-222. Yes, 723-222." The phone rings again. It's Bill Moyers. No I'll be away that Sunday. I'll be back in the evening. I'm holding the door. Well you can call me then, he says. He's seeing a lot of people, Taylor shrugs, placing the receiver down.

(2003)

IT'S A WONDERFUL WAVE: NICOLE EISENMAN

The first time I saw Nicole Eisenman, herself, was at a group show at the Drawing Center in '92 or '93. I had already encountered some of her drawings at Trial Balloon, the tiny gallery run by Nicola Tyson on lower Broadway, which was then the exploding epicenter of a moment that could be described as when feminism went "cultural." Feminism's third wave, which is often considered no wave at all, is loaded with names that everyone knows: Sadie Benning, Cathy Opie, Kathleen Hannah, Zoe Leonard, Rose Troche and Gwen Turner, of course, and Nicole. This wave definitely trafficked in what you'd call female subject matter but a lot of the work was pretty abstract as well (Nicole's wasn't ... I think) but the standout feeling about this crew of female artists was that they were absolutely *in* the art world, not outside of it. And there was a reckless largeness both about the work and the lives. More than having arrived, this generation of artists simply *was*.

That night, Nicole came late to the opening. She had painted a gigantic mural on the long wall of the Drawing Center, the first of her murals I'd seen, and the story was she had basically moved into the gallery, had been there day and night painting her tumultuous picture and there was even some gossipy excitement about whether she would finish it on time. The very nature of a mural is performative. Like a large newspaper, it seems. Masculine, perhaps.

"I honestly never work like this at home," she tells me, jokingly, on the phone. "And it's such a shame. I'd be so productive."

"Well, it's like you obviously need a huge studio with many people walking around."

"And talking to me and asking me questions. Acting really interested. It's also flattering too."

Indeed, in this setting a female artist becomes a temporary man—doing large, juicy, significant work that presumes attention and engagement. There's no doubt that the artist's body had been in the space. After the fact the mural looms like evidence. The public space had been, for a while, the artist's studio. Nicole was the show's star that night in the early '90s and everyone was milling around. So, where was she? When she did show up, moments before the opening's end, she looked a little removed—saying hello to people, but not entirely there. She wore a black shirt, her hair was kind of Wildean and awkwardly she was carrying a red rose. The rose was perfect. I don't know if her girlfriend gave it to her, or what, but that rose was so like her arrival out of a cab in the black shirt, looking exceedingly pale—the flower was thin and dark and thorny. That rose was pure punk. I could go on, but I won't. Nights don't end, they fall apart.

Of all the artists I've ever known Nicole Eisenman has always had the gift of unselfconsciously converting her own self-consciousness into yours, so that in some way the whole practice of installing herself, moving into the gallery for days and painting a wall, a performance she mounted next at Trial Balloon, then in museums and galleries all over the world—the basement of the Whitney Biennial and now here at Cornell—that torrential effort somehow stood in for all of us and our new-found presence. At the center of the painting at Trial Balloon, I remember it well because I wrote about it then, but also because it was such an allegory of her career—the cartoon girl in hot pink in a hot pink sports car has just

arrived at the finish line and she's surrounded by her pit crew which was a mob of females of all stripes, the ubiquitous Amazons in all of Nicole's work who ironically imply a limitless past to the scene, all the attendees are pure audience, everyone is cheering her on. Nicole Eisenman's not so much a hero as an instigator. She's manifesting trouble that's already there, that preceded her. On the phone I reminded her of a photo shoot she orchestrated about five years ago (she called it *The Accused Pinball Machine*, collapsing the Jodie Foster movie of the same name with a good-time pinball outing among friends). She had rounded a few of us up to carouse and posture menacingly around the figure of a tall pinball-playing dyke, the writer Laurie Weeks. Laurie kept banging the machine with her crotch and we all hooted and egged her on like a gang of female rapists. I think the shoot was to become some kind of poster for a show. But the poster, even the photos never materialized, the shoot devolving into a disagreement between Nicole and the photographer about whose work the photos finally were. Yet we had piled into the gallery willingly that afternoon to be part of what Nicole put in motion and we trusted her impulse implicitly. We *were* it. Nicole tells me that while she's working on a mural, she's its foreground. Later on, when the people arrive we replace her. Probably you're standing among her drawings and paintings right now. She worked nine twelve-hour days to create the one in the Johnson. Nowadays when she comes to work she stays at a hotel. I said you're like a band that used to sleep on the floor when you toured, and now you stay in hotels. That description didn't really thrill her. She claims she didn't know in the past that there was another way to accomplish such major and evanescent work. Plus if you habitually work where you live, then of course you should live in a gallery while you're working there. Meanwhile, the art world has changed again. Now it seems everyone moves in. People in galleries will cook for you, people sleep there. Some invite you in for a personal conversation,

a love analysis, a love experience. It's not punk at all. We've gone from raw to real. How about that neurotic actor the *Times* was so crazy about who was performing in his apartment. It was a long complaint about his career, which in fact he was inventing. Which was not exactly new, or as Nicole put it: "Everyone's reinventing the wheel."

Her orange epic on the wall of the Johnson is of course a crashingly funny send-up of the potential melancholy of a ten-year show: *The USS Williamsburg Crashing into the Shores of Fame.* A couple of facts make this painting and its title even pithier. Apparently it was reported a couple of years ago that there were more artists living in Williamsburg than there were in Venice from 1700 to 1800, "the glory days of Italian art." Are some or *all* of these aspiring young artists Nicole Eisenmans? By portraying these masses in conjunction with what is effectively a retrospective of her own drawings and paintings she's advancing the boundaries of pluralist stardom. Where she used to signal the outrageous (and genuine) ambitions of the girls, now she is allegorizing the entire romance of the artist in New York who desires fame—artists, female and male alike. It's a witty self-critique that only she would have the chutzpah to mount. It's a reflection on the sudden point in a life or a career when we first see ourselves in the young, those who come after or right next to us. Like cars pulling up to a light. All of which reminds me of a drawing in the show: *Self-portrait as 1131 Blondes.* The drawing is a detailed Woodstock of teeny pathetic faces (all Nicoles) lined up in mouse-rows surrounded occasionally by a glowy aura—some color: blue or yellow (blondness!) sluicing around a couple of the rows. The faces teeming like pixels. Faces practically turned into words. A feeling builds as you wander through her drawings that helplessly you have become a complicit reader. Some of her paintings' vignettes: a house trembling with antennae; the little girl dragging a big naked lady off into the sunset—all of these pictures

beckon you into an inexplicably familiar reality. Sometimes her titles (*Got me a big girl!*), with their extra twist, hustle you in. You're down in your friend's basement looking at porn, but it's about everything. Or else this show is simply a fantastic diary of lesbian pictures, which, unbelievably, she shares.

The second story behind the boat crashing into fame is that a boat called the USS Williamsburg actually did exist. First it was the property of the US Navy. Then it retired into the life of being President Harry Truman's pleasure yacht, then it was a working boat, on some kind of scientific mission about plankton, and it ultimately wound up abandoned on a beach in Italy. Just like the boat's journey from public to private, her work constantly expands and contracts. Nicole tells me that every art student she's ever had feels a need to explain why they are "going to Williamsburg" or else why not. I feel sure that she's painting with them.

I'm curious about this tendency of Nicole Eisenman's work to be choral, to portray her own tendencies generationally, or in a public or blurry allegory. She tells me she likes "making faces that have no personality," that we might say echo the historical conditions of American mural painting. When I asked her who she meant she said "a lot of these painters are unknown, I mean, if you go into any post office that was built before the '50s, you'll see one of those murals I'm talking about. There's you know thousands and thousands of them in the United States and like Rockefeller Center. Nobody knows these people's names." It occurred to me that there's something so important about the anonymity. "Do I *try* to be generic," Nicole wondered out loud.

I think of the sepia memory painting of little girls hawking lesbianism in "our gang" fashion on a 40s street corner like they knew they had something even cooler than lemonade. It's sentimentally boisterous work for a past that never was. And that very absence, our knowing this scene hasn't occurred retrieves it from

kitsch. I realize I've ignored a question I think about a lot—whether Nicole Eisenman's drawings and paintings and murals in fact constitute a major body of female work, even lesbian work. Perhaps her work allows us to keep avoiding those categories as a guarantor of our continually enacting these dreams. Is that what collectors do from another impulse? So much in her oeuvre goes against the grain of whatever museums do. Ending things? Instead she posits a museum, or a school full of holes. In paintings (*Hunting* and *Fishing*) in which strange white-clad females descend on the male explorers stringing them up over gaping holes in the icy ground, or the monochromatic sketch in which men are systematically "captured" … the drawing then instructing that their penises be "cut off," followed by an instruction to "stuff penises," and finally "attach." Well maybe it would be un-American to deny an artist freedom to do that. An American artist who only wants what everyone wants. Like the Williamsburg young who are mostly all agreeing to be "in the game." For a significant decade, Nicole Eisenman's been operating within a culture where no one really wants to talk about what's done to women, in our families, at our jobs, in a state of war, in the art world, in the bedroom and every-where else. By now the words just feel redundant in the face of all that we know, but then the knowing starts to feel redundant too. Where does awareness go in this space of official public blindness of "how it is." Maybe it's perfectly reasonable to corral a space within that same vast American silence and in it make a vivid proposal of what anyone would do, in response, if they could. Wouldn't anyone, everyone? When we look at this work. Didn't we fight back?

(1999)

THE FREE SHOW

Free show—25 visual artists, poets, writers and persons were invited in the summer of 1999 to contribute a piece to curator poet and artist Sal Randolph, for the purposes of exhibition in a show. People will be invited to attend in the fall of 1999 and are free to take what they like from the exhibition. The curator admits the show might vanish right away, though some of the participants have given multiples of their work, or more than one piece.

To understand why an artist would organize a "free show" in the last months of the 20th century I wound up sitting in Sal Randolph's studio one afternoon—goofing around, picking stuff up, and perusing. How about your name. Why Sal?

"Well" … she cocked her head and thought … "The name Tod was kicking around in our family, but my cousin got it. I was known as Sarah, Sally. So I dropped the diminutive 'ee.'"

I get it—Sal. Seizing on the same one-syllable strength as her cousin. Not Ajax, not Comet, but Tide. I pictured "Sal" written in thread on the pocket of her shirt. And then I could begin.

Sal Randolph's *last* installation was a "Free Store" which was held at Schoolhouse, a gallery in Provincetown, Mass. on the tip of Cape Cod.

It's odd to think of Provincetown, such geographical extreme, a tiny place, a sandbar, really, as the beginning of America as we know

it; but it was: the Pilgrims landed here. Tons of them died that first winter and then they hightailed it to Plymouth, but this was the place where "it," America, maybe even global capitalism, began.

Of course there were free shows all over the place about thirty years ago, in the '60s, but you know that was the past, and it means something different now. Free does. Food came flopping down from the skies at Woodstock, oranges and Drakes cakes, and people were naming their babies "Free." There were "the Diggers" who styled themselves after British anarchists and the group was involved in meeting the needs of a moment-by-moment "free" society. If one was not involved in the processes of capitalism the very timing of one's existence would begin to slow down, alter, and then of course there were drugs.

I was getting my hair cut once on St. Mark's Place and a Polish barber told me, as we looked out his big store window at tourists and students and punks, that the streets were once flooded with barefoot young people and their eyes were like this: he made a twirling motion with his fingertip. "Wow," I said looking out onto that different street. "Yup, it was something," he smiled, snip snip snip.

It's funny, I think of the institutions that moment spawned. Free schools of all sorts. The non profit art world was an invention of the sixties—the NEA—so we are standing in the wake of that world, and I don't think the proprietor of the Free Show feels nostalgic, or is interested in summoning it back. Uh uh.

And, after all, who *are* these artists. People who learned useless skills in an abundant economy, that was distributed differently than it is now, and now are competitively or gently trying to stuff themselves into the shrinking number of spots on bookshelves, screening rooms and walls. Potentially a lot of art is waste, wasted labor, wasted intellection, and of course mountains and mountains of stuff gets made—so let's just give it away. Always, the artist seeks new ways to distribute.

I was handed a map of the East Village in 1910. This is 25 years ago, and the history professor I worked for wanted me to go to the institutions that had survived and see if I could get in their files and find out who used each one of them, who was in their community. We wanted evidence of how and where people met. The idealism of the Boys Club of America might interlock with the caring approach of the Lutheran Middle Collegiate Church. The postmodern approach to truth is based in neighboring beliefs, rather than absolutes. Who sat next to who. Who met in the food line. And where did their old clothes go? It certainly seems that American democracy is best observed in the ways we dispose. The only way I could enter the Protestant churches of my neighborhood when I was growing up was to go to their rummage sales.

Julian Schnabel found the plates for his first famous paintings at the Goodwill on 21st and 8th Avenue in New York. An art neighborhood, Chelsea, has since crept up around the site of that purchase. The huge flea market on 27th Street, nearby, is an amazing (and expensive) array of bicycles, furniture, and clothes.

I remember Jim Shaw's *Thrift Store* paintings turning the heads of the art world in 1991. Not "bad" paintings he had made himself, but a show of paintings he "found" over the years. He put them on the wall in Metro Pictures and the gesture was stunning. In the '90s, maybe in reaction to the art boom of the '80s, artists began to put more junk in their shows, plop a couch or two between the ironic paintings, inhabit the gallery space with a living-room sensibility—spray-painted cassette racks, one artist leaned an electric guitar against the wall. Among other things, this new "ease" reflected the freedom of the artist. Her reconstituted relationship to "things."

Part of the act of art is hiding the expense involved in putting up a show. Either the gallery or the individual must absorb the considerable outlay for even just printing, framing. "I bet she made

a bundle," people might sniff walking away from a successful show, yet it's always a shot in the dark, especially considering the maxed out credit cards of many who either before or after had to go and proofread into the night, or teach about art, or do contracting ... jobs, whatever the culture will buy from them—the invisible sacrifice always exists, like a halo around the beautiful show. As does the extended community buzzing, also hoping to enter the orbit, attain the elan of the unique individual capable of conspicuous graceful waste, or even the quick study who managed to sell sea shells by the seashore—Jim Shaw's worthless paintings transforming the value of "found" once and for all—or just for a while.

Because more and more, art really isn't what's sold. Valuable paintings and sculptures continue to arrive in the key galleries in New York and LA and because of the names and the agreed upon status of their makers, the skill of the dealers, money does eventually get exchanged, but a lot of art these days is just advertising—for what? A kind of experience, for vision.

Painters began to make films and the world the camera grazes on continues the values and beliefs and aesthetic of what has already come to be disparagingly known as "wall art." Everyone, more and more everyday, is obsessed with "vision." That's what the painter-turned-filmmaker wants to hear people say. You've got to give him that—Schnabel's got a vision. Every artist, every writer, every movie star wants to enter reality deeper and bring everyone with them—have a teevee show, a magazine, or open a store. Everyone wants to start a club somehow, have a world, say come on in. You're home. Inside my head.

"These are your friends?" I inquire about the list for the show. The inventory is beginning to pile up in Sal's studio. A bra, a pile of multi-colored condoms, dominos, a plastic angel pissing. "They are people I wanted to play with," she says, shrugging. "It's not curated visually."

Do you know who the wreckers were? Because I think Sal Randolph's Free Show could only happen here. There were islands in the 17th century along the still only partially inhabited East Coast which had no trees, and so they built their houses with the wood of boats that crashed. There were people who walked the shores of beaches of the entire coast, looking for barrels of goods, even the remnants of sails to make their clothes. I think The Free Show is about nature.

I kept asking Sal for a poem, because she told me a lot of the meaning of the show resides in her history as a poet, the linguistic principal of assemblage, and even poetry's existence as a gift economy. "Yes, yes," she said and led me over to her computer where she's distributing her poems now.

"Let me show you something." Our talk returns to the same level of saturation again and again. She flips on her iMac and the beeps and growling voices begin to churn. The poem plays like a continuous song. I like it. There's a camera jacked into the computer and she's shot that—a wall of bright yellow pipe cleaners. "I go swish swish," she says alluding to her camera style and then it winds up there.

The screen is a semi-abstract gauze and pattern of something blue, pink, and white. "That's that," she says pointing to a photograph of some landscape on the wall. This is great, I tell her. Isn't it like the light shows of the '60s—the drugs and the music got sort of organized by the computer, slightly capitalized? I think it is, she admits. We sit there enthralled. We're a community of two at the Fillmore East on a bright Saturday afternoon in Provincetown.

We can go forward in history, and we can also go back. Kurt Schwitters (1887-1948), a German multi-media artist, took the second syllable (Merz) of the German word for business (Kommerz) and attached it to everything he did: the Merz-poem, Merz-painting (Merz-bild), and even a series of huge installations inside his home:

the Merzbau. Yet he said that his entire history came out of a series of landscape paintings he made in his twenties. All art, he believed, is based on measurement, adjustment.

I think he was making money. Walter Benjamin says that money was the first reproduced art. The first multiple. As I flip through Sal Randolph's slides—the little bags of green stones, language on tags, an excess of pink pillows, a table of flattened images, a procession of thoughts and things and photographs—an obsessive "make as many as you want" economy—it all comes down to dough, or nothing at all.

Sal's project converges at the root of money and postmodern art and avant-garde friendship. Another word for coins is "specie." It just means "of a kind." All of our assembled stuff will hang on a wall for a pristine moment this upcoming fall. Then the wreckers, the viewers, the community will start taking it down. In a tide of consumption The Free Show will vanish. Like a name bobbing somewhere in a family. The people who come to the show will distribute the art. They'll take it home, they'll put it on a shelf, they'll throw it away, they'll save it. The pieces will wind up everywhere. It's about us.

(2005)

PAUL LEE'S PIRACY

Paul Lee's work excites me because of its disproportionate or maybe inverse relationship to scale. I saw a group of tiny photo collages of his a year or two ago—the exhibited pieces were composed of small bits of photographs, rearranged into versions that often included a pearl among their parts. My response to these first pieces was to want to hug the work yet it was so small. I felt larger and bulkier than usual. My body was troubling and felt oddly squeezed out of the contraption of his photo culture as if I myself were the pearl.

Paul Lee is a poet. His work strikes me as one of relationships, and I think the material differences from piece to piece are secondary, which is why his work seems to me to be so—would it be modern and extraordinary? It's post-technological, it's not of this world, though he's thinking intensely about it.

What's in it? Like the ocean for instance, or cameras. What's in them, or how are they in us. In whatever we make or do we are always exploring codes—imposing them, reassembling them. I delight in the cadences of Paul Lee's language while all these operations are happening. He's not a large man and is even relatively young. I went to see his work in Brooklyn about a month ago. His building was near the subway stop called Atlantic/Pacific, and I was a little taken aback at the suggestion of a meeting of those bodies. Though they probably do meet somewhere on the globe, but not in

their enormity. They probably meet when they finally get small or insubstantial, about to go away. But the words themselves are huge. Their names, Atlantic and Pacific always feel permanent—only carrying a sense of oceans at their peak, no other point.

I climbed up the steps to his building and I had about an hour, having gotten lost coming here and packing my day as I do into ridiculously small intervals so any wandering at all creates an incredible squeeze somewhere else. But Paul's work squeezed right back and the hour I spent there felt huge.

By and large he sums his work up as video and sculpture. Yet he trails in and out of various media: on the wall of his studio were a procession of raised collages—pale photographs of ocean on cardboard almost like an aerial view of a skateboard loop half built—as if you threw the project into the hands of Frank Gehry or someone and these were their working models and they pinned them vertically on the wall—these seas stick out. It's like furniture.

Paul says he's trying to construct a flat world in order to open it. I wondered if he would also consider that he is stealing worlds to create new ones out of them. I ask him the obvious if he likes Joseph Cornell because where Cornell used a golf ball or a ping pong ball, Paul uses a tiny pearl. But my comparison is plodding because the pearl is less a thing and more a bit of a doorway in this world, a lens. The pearl is placed in the eye of one of his other repeating elements, men, specifically a young French boy lifted from a fashion magazine who appears continually in Paul's videos and in the wall collages and in the books he also makes and the young man's eye is a pearl— which is where I began to fall most grandly down the rabbit hole of possibilities in this work—are the pearls always cameras? Are we being watched or saved or something?

I mentioned already (I think) that he also makes books—thickly overlaid books—of dots and cameras, of large black lenses that move wildly around the page, as you turn them. The video he

showed me next seemed a reenactment or a reinterpretation of the book, with "bootlegged" sound—of a 16-millimeter projector running, maybe attempting to make the video feel as retro as the book though for me the book had an actually more "advanced" feel than the video. It gave that same kind of grunty body feeling I initially described as some kind of sexual metaphysical unnnh. The book's unnnh is one of created excess, photos and cameras begin to pile up, cascade in a slow animation, not at all Muybridge but instead being the private experience of a film that you can stop and start—a dream that beckons very differently from the "taken hostage" viewing experience of film.

Instead the feeling is surpringly roomy. There's a nostalgia for the sea, film, photography, and handsome men. All his work seems like a meditation on what seeing brings us and what it doesn't. His own relationship to this wryly-conducted experiment is an indelibly perverse one. He's walking through an assembled history of ideas about seeing. And he's capturing pictures from it as a dandy might. Perhaps in the way a pirate is a dandy. With the tattoos and the parrot and the satanic wink. Paul's whole project is about looking back at the dream of representing the world as if we had by now gone far beyond, and we have. And the sea is a constant symbol for all that as well. Perhaps we're just out there going around and around it.

Because smack in the center of his room is a cardboard box painted light blue. In it are remnants, curling pieces of paper, and each was covered with photographs of the sea (again.) Where did you get those, I asked. Oh off the web, he smiled.

It was his answer to where most of this stuff came from. So you go "in there" to get pictures of out here. You print them out again and again. First you make them 3-D, like raising the sea again. And then you throw your scraps into a box and paint it blue. As if the question were can you take the color out of the sea, and then hold it in blue. Returning the color somehow.

Another piece was a curlicue pattern of burned matches growing into gorgeous filigree. All stuck onto a little rectangle, like a painting, but not. Again, a collage, I guess.

Finally he showed me a couple of heavy cameras made out of clay. Like puppets. Heavy as shit, and painted brown. And then all stuck with bright white feathers, fluffy and pretty. Sell me that one, okay? He did. It sits on my teevee. It's called *Native* which my friends all think is wrong; they're probably right. I love it. It's the heaviest camera in the world and I think it can fly. He calls it *Native* cause it's home everywhere. I didn't ask, it's just what I think. Clay cameras are actually very old.

(2007)

EVOLVING WATERS

At an earlier point in her career Roni Horn lived in a lighthouse. A few years later in Stykkishólmur, a fishing town south of Reykjavik, she looked up and saw this weirdly nautical looking building perched on a hill overlooking the harbor. The building she learned was in fact a library. At that moment a concept was put into motion, one that got realized in Iceland this spring. She created Vatnasafn, a library of water. Which sounds relaxing but in many ways it's a piece made at a point of crisis which is not relaxing but historic and poetic instead.

Horn's public statements for about the last ten years in the Icelandic press have been ever more fiercely green. Iceland, she feels, as the youngest country in the world now has the opportunity to not squander its radiant obscurity on becoming industrialized and polluted so late in the game. Like Ireland, Iceland is a formerly depressed country that has found an economic tiger in its belly for two decades and suddenly the world wants to buy. Rather than railing at the situation Roni Horn (with 30 years of friendship and travel and art here) has made something that allegorizes her concerns (If you don't save the glacial waters, or worse if nobody can, I will!) with tyrannical elegance. Twenty-four glass columns of glacial waters gathered from that many sources on this volcanic island stand tall. The columns are placed randomly in a room that faces the bay, the window bows out and goes nowhere but keeps seeing

somehow. And each of the columns have an optical effect, other columns get reproduced in them, as does the day and at night the 24 recessed lights in the ceiling glimmer in the columns like polka dots and I'm in there too, I admit. And believe me, so is she.

The floor I'm standing on is a vulcanized rubber, a mustardy-honey color. It has a beeswax feel, like you could easily leave an impression (groan, I did) and its surface is scattered with words, weather words in English and Icelandic. Ones we know like "ill" begin to look strange. Is it because the words are moving on their own—sluicing around with another language. I get it. Like an ill *wind*? And Icelandic words like "terrific" (*rosalegt*) and warm—my friend Ruri got visceral about the translation process. You'd watch language grimacing and rejoicing through her till it *burst* out. *Ili* means "like warm," she finally shrugged.

The inside outsideness—of words and weather and how a building can be a boat and a library full of silence *and* speech *and* no books except ones Horn created (talks and diaries)—though the texts for the time do deepen and articulate the experience of being in the space. *Weather Reports You* for instance is a compilation of Icelandic accounts of how weather surrounds and affects them. It's a participatory piece of local sculpture. The last story was told by a man in his '90s who had worked in a lighthouse for 35 years (weather was always "perilous," he said of his long watch) and soon afterwards he died.

Yet I was a *little* troubled in some ways by Vatnasafn's preciousness—oh you know the little blue plastic slippers I needed to slip on to step on the floor, carefully avoiding those scuffable-looking words, though Glenn, an American, who lives here with his partner Thor, said the blue booties *were* typically Icelandic so later as I was padding around in the space at night it was a more humorous experience than off-putting. The ongoing plan of Roni Horn's evidenced by the two matching chess tables flanking the most spacious and

luminous room is for the water library to eventually be in real use by the community—i.e., yoga classes, AA meetings, and town affairs. Downstairs a writer in residence, Gudrun Minervasdottir, was already finishing a new book. And the Stykksholmur's girls' chess club is ready to rock since the Icelandic female champion has signed to start a program here. Turns out women in Iceland play just as much chess as men, but like female drinkers they tend to do it at home. Gudfridur (Lilja Grétarsdóttir)'s goal is to get them out. I totally wish they were here. I was dying for a game in that austere empty space.

Chess, Gudfridur explains, is inherently Icelandic, meaning "the Icelandic style of silent understatement." At which you can't help but grin. One approaches a lot in this country with trepidatious awe (all the ash, the loneliness, the intensity) only to realize the Icelandic approach is also quietly witty—what is that word—? *Glettio*. A slow sort of humor that's elegant *and* pathetic *and* reliant like language and time and landscape—we hope.

ROBERT SMITHSON:
THE COLLECTED WRITINGS

About 25 years ago a friend showed me a book on Robert Smithson, an artist who had died only a couple of years back. You would like him, said John. What I saw was a photograph of Smithson's work— a series of mirrors plunked down in a wilderness that looked like the Southwest. Are the mirrors still there, I asked. No, John said, in a tone that suggested that their absence meant something too. I still think of that vista contained in the photograph as one of the loneliest things I ever saw. Even if the mirrors were no longer there, I think of them as always there. In a glance, perhaps.

I picked up Smithson's *Collected Writings* last July in the MOCA bookstore. I've avoided becoming familiar with his work all these years because of that sense of sadness I associate with it. I carry some vestige of that small peek before the book slapped shut. When people mentioned Smithson, I just nodded.

His film *Great Spiral Jetty* is practically an art school cliché. Initially, Smithson built a coil of boulders and dirt into a spiral reaching out into the Great Salt Lake in Utah. He is shown walking across those well-documented rocks on the cover of this book and the photo also deploys another part of his myth, the famous doubling he's become associated with—a doppleganger of his walking figure is reflected in the waters surrounding the jetty. Smithson later shot the huge stone spiral from overhead, swooping down in a helicopter and pulling back up. The film is made up of many more

things than those aerial shots. "Manyness" is a Smithson signature. Even more so is the word "crystalline," a glacial and impersonal concept of his which disdains viewing existence from a single portion of time and space. Smithson died only three years after he completed the *Great Spiral Jetty*—in an airplane crash while scouting another site. "Work on this scale doesn't end with a show," he once said in an aside, while describing the process of clover-leaf dives in a plane over the land masses he documented. "It has a way of generating movement."

The sadness his mirror piece evoked in me is exactly in response to this durational quality in art, of which he writes elsewhere: "poetry is a dying language, not dead one." There's a silent grandeur to his massively impersonal work. Even if the spiral jetty is already gone, it was never really "there." The true ground of all of Smithson's art and thought is the dialectic between the art in the mind and the art in the world, the work drawing the viewer along a path of creation and destruction and calm. This man was a kid who, way back when, was far more delighted by the Museum of Natural History than the Met. After an initial bout with painting in his early 20s, he rejected both painting and sculpture, but particularly painting as being "diseased." After "photography" which "turned the world into a museum … after the gas ovens and Hiroshima," to paint was to be involved in covering a rotting corpse. Yet he accepted implication in this horror. "We are all dead," he says.

Smithson began to refocus his own work as looking at seeing, and then seeing through—or more simply as "exploring the apparatus I'm being threaded through." Which in part meant looking at the gallery and museum culture of his time.

Reading Smithson today I get a second glimpse at the New York I stepped into in the '70s. In 1974, I was dumbfounded by the art on the walls and galleries of Soho—pencil-drawn diagrams, lucite geometric forms, or else just dirt on the floor. Like any

suburban hick, I thought where's the art. Yet I allowed those weird interior vistas into my consciousness, seemingly undigested, and those sights altered my view of the world. I accepted "conceptual art" like I did the protest culture surrounding the Vietnam war ten years before, not really experiencing it directly very much, but more profoundly along the edges of my awareness. Which is fine, says Smithson.

In the textbook Smithson begins with his beautifully simple idea of Sites and Non-sites which are three-dimensional maps of the places he traveled to, as well as being his own '70s artist hands-on project to undo the death grip the art institutions had on the artist—a way of linking the inside of the gallery with the rest of the world. The center with the periphery. Smithson did this so literally that you could almost miss his point. And there were many.

What actually carried him away from the studio and the loft was an opportunity offered him by the architects of the Dallas Fort Worth Airport to be an artist consultant on their project. Though Smithson's many thoughts and ideas officially "came to nothing," the whole rest of his career was the result. He became familiar with a world of blue prints and measurement, building materials and vast expanses of land. He was offered an opportunity to work on a scale that many artists would find daunting. It strikes me that that he was not so much brave as innocent. An only child, actually a "subsequent"—one who comes after an earlier sibling has died—Smithson was empowered by his parents to plan the family vacations which were essentially road tours of US state parks, meteorite craters, and rock formations. Melancholia was probably along for the ride. Feeling is never alluded to in Smithson's work, but his art is habitually composed of pulling away, then coming back.

After the airport gig, he stayed with that problem of how to bring the periphery to the center. He had imagined doing something on the fringes of the airport, but who would see it? He could

put teevee cameras out there. Soon this evolved into the practice of surveying a place, a quarry, a lake, and gathering lava, rocks, and dirt and sending them back. These substances without meaning or limits (words) would be contained in bins or frames or simply contained by the gallery itself. Smithson couldn't miss that this practice was linguistic. The place itself, the quarry etc., was the Site. The aestheticized remains became the "Non-Site," almost the metonym of the place. This ritualistic operation would be articulated by him again and again. Each act would begin with a plan—a large vague plan perhaps. A desire for land, for wetness. He talks about Alexander the Great stopping to watch mangroves build islands. If you don't scoff at Smithson's ability to manipulate scale at the wink of an eye (which was always the allure of the Museum of Natural History to him as a child, it had both cavemen and spacemen, i.e., Fred Flintstone and the Jetsons), you will envy this '70s Alexander. Picture him raising his hand, stopping the troops and getting out of his car, then roping his wife in who habitually recorded (or captured) each of his moves in a photograph or frame of film, casually springing him toward the mythic, because this capacity of his to be simple and grand at once ("The earth is an island') is, well, poetic.

I don't think it's corny to mention that Smithson was a Jersey boy delivered by Dr. William Carlos Williams who many years later regaled him about a number of things including how Ginsberg used to come at all hours of the night, and that Hart Crane was always inviting the doctor into New York to his fairy parties. Both men were deeply interested in geology, were intimately acquainted with the strata of a place. Taking a long view of Smithson's concerns, one can readily conceive of being human as being imprisoned by time. Smithson wanted to return time to the artist, letting one's moments be the studio—that space was the corpse and that time was always alive, connecting forwards and backwards like infinity, and that one deserved to stand in that and redistribute that back to one's culture.

It's interesting that this lavish utopian perspective sprouted in a Manhattan where people lived in such large places, lofts of thousands of square feet for cheap, and yet everyone was thinking about time, space was just shit. That physical excess could yield such rich thought. This book is comprised of the articles he wrote—so many fun ones, written alone as well as in concert with other artists—Judd, Carl Andre, Sol Lewitt ... all of these guys were writing, words were the ground of the work, even more than the material it was "made of," and seeing these writings supplies a missing link in the explanation of how we wound up with the art and poetry culture of today. No one who knows the '70s really has to ask where Language poetry comes from. It was part of the work. Language was sculpture and vice versa.

Interviews comprise another huge third of *The Collected Writings* and Smithson was a great talker. I've read hundreds of pages of him by now (I lost my first copy of this book in the Denver airport, I think. That copy had my notations and underlinings and even one bad poem was written on the inside back cover). I've reread Smithson and re-marked him as well. I've had the experience of seeing the same beliefs and constructions and responses come up differently and similarly again and again so I began to feel the shape of the particular mind working—in this case, it's the poetics of art, not poetry. He has very definite teachers. Anton Ehrenzweig, who wrote a book called *The Hidden Order of Art,* is a huge influence and Smithson says that "one chapter's particularly good called *The Scattered and the Buried God.*" Cultures, he learned from Ehrenzweig, lean toward one or the other type of worship. Either acknowledging invisible value, or distributing god somehow. I suspect the whole cult of abstraction and commodification in art that his generation so passionately opposed would be considered of the "buried" sort and he personally was much dedicated to undoing art's confinement. "Scattering and containment are a dichotomy. Scattering is vitalistic," he insists.

In all his endeavors, Smithson wanted to forget Europe and Western civilization and especially the Renaissance which implied a rebirth—a second birth in his family, maybe his own? That culture was dead by now, and he wanted to push further back. He felt buoyed: "if the roots of art could be planted in something deeper and old, like paleolithic drawings that are rooted in necessity, not portable abstractions."

The end of this book holds all the writings of Smithson's that never saw light of day. Some of them are goofy and jejune and one or two are brilliant. "From Ivan the Terrible to Roger Corman or Parodoxes of Conduct in Mannerism as Reflected in the Cinema" (1967) is an article in which he explains that there are pictures and paintings and pictures are conceptual. A face in a picture, say Parmigiano, or Byzantine art is not a drawing but an idea, ultimately, language. He says that "the visual has its origin in the enigma of blind order—which is in a word language." Smithson's first big piece after he stopped painting was called "The Enantiomorphic Chamber" and it's about undoing the stereoscopic basis of seeing, creating not exactly blindness, but heading that way.

There's a whole strand here, at this most obscure and geeky end of the book—and also throughout, developed by means of a series of quotations from artists like Tony Smith, philosopher George Kubler—even Alexander Graham Bell turns up, not as the inventor of the telephone but as one engaged in building "stacks of successive instants of speech."

Smithson's method of writing is unique—where a quickly engineered set of associations begins to build language as you would build buildings, a quick suggestion that "the skyline is a sentence." Smithson urges "why not reconstruct one's inability to see? Let's give passing shape to the unconsolidated views around a work of art, and develop a type of anti-vision or negative seeing." Writing *is* such blindness, I think he meant. His life's work, the sculptures, the

youthful poems, the abandoned paintings, the figure echoing on the cover of this book. The city that remained when he fell from the sky. Smithson spoke about Williams's interest in the falls outside of Rutherford, as well as the relationship of those falls to *Patterson*, Williams's opus. Then he pointed out that "incident itself means 'falling.'" The very things in Williams's landscape become language and then return to landscape again. Smithson's legacy may exactly be this feat of de-accessioning, a lifelong act of mourning borne slightly over his head. Scale was just a way of focusing his thinking. Coming in close, then pulling away. The earth is a dot, he wrote.

(1995)

SARAH'S SMOKE

I went to art school because they had the good parties she said and then many years passed and she came up with this collection of quietly garrulous white paintings, and they are hanging here in her studio like a real bunch of oddballs, more like statuary, pretty mute. Underneath the surface of her big white paintings there's leaves moving, like a park or something. There's two big white ones pressing together like twin beds. I've never seen white paintings seem like such things. Not things about white or paint or austerity, but things about silence. Female silence. Steam. Hungry walls or paper, waiting. One can reduce the marks of paint or language to a single thing, a grubby little signature in time. But what's the thing that's just before. Her paintings hold a moment with awkward care. It's a comfy, itchy, prescient moment. I remember her paintings several years ago, black, and there were teeny pictures in them— riches, jewels, and occasionally an angry word, slut or something, was scrawled across. Clearly those paintings were after sex. In the throes of its pain. Do these have titles? I think of this as Maresfield Gardens and she told me some anecdote about living there, some place in England where she's not living now. She's pointing at a small one, Primrose Hill, two shades of white I see as sky and mud. I think of these as halls, she says. Even though it's outside. There's still a small picture inside every one, like a memory, making it hum with many stories, told or not. Her autobiography is ultimately

mute. I saw this house by the side of the river (Cold Harbour) and its walls were torn out. You could see its wallpaper. I thought of it as art. It was this completely decayed place. I had gone down there on my bike. I saw it as my first adult experience, this vision of a house.

Sarah Rapson's sort of a dandy, but a female one which is about a powerful lack of plumage, which is meanwhile nearly sprouting from the top of her head. Many of her paintings are accomplished by a pile of them (paintings) being nailed together and then hung. It's like the princess and the pea. To be real she explains. I'm not a painter to do a big abstract thing, a huge single effort, but I'm fooling around with that. She smiles. These are sheets she points out and looking closely at the painting's edges you see the faint blue lines of its trim. Someplace there's a scorch which implies ironing board. It's not an ironic attempt to aestheticize domesticity, but a lumpily awe-inspiring job. Is it possible for paintings to feel like something's rubbing from inside. The noise of that, not exactly some anchoress etching her messages, no. But she told me quite a lot about the time before she became really sexual, there was this time of simply being nothing. Were you waiting? No, I just wasn't anything at all. She didn't offer me a drink, any tea, and certainly not any big fluffy bismark like the painter who died. To her credit it didn't even occur to me to ask for some treat, to be thirsty. Do you smoke I asked Sarah. No, she replied. Did you quit. No I just never did. Looks great, she admits. I'd probably love it. She laughs at a vice untried.

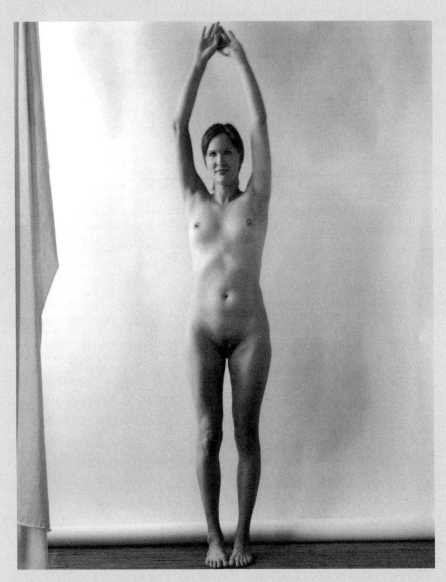

Page Reynolds by Alice O'Malley.

(2008)

BEING IN (A COMMUNITY OF ELSEWHERES)

Standing in the room last April in New York with several hundred people their identities changing slightly then utterly in the course of the night I had a special feeling that had everything to do with the changing several hundred people in the room AND who the people were on the wall—Alice O'Malley's photographs—because they had given the room back to us. The room was kind of craggy and new, the latest manifestation of a space (Participant, Inc.) dedicated to work that has to do with what people are doing and feeling, unchangeable work in a way, hung here and the gallery looked stylishly incomplete and really *was* that way and would stay like that for a while. Alice's photos are about being one of us. Some of whom are gone but we replace ourselves all night like that night in the gallery. And just as much it's about the room and the light in the day she took the photographs. There's something very abstract about her work, something evanescent that makes us willing to stand in front of a camera, to get it right, how we are. And Alice does.

The room felt like a hall of mirrors. Some people think these photos are about vanishing places and times but what I feel is this bouncing presence. In Alice's—whether one is standing naked with your hands in the air or covered in tulle (Antony) or at the end of your unbelievably big shoes (Tom Cole) the person is wired inside and out. Page (Reynolds) stands luminously naked one afternoon. She raises her arms and smiles. Energy moves in the stillness of the pose. Alice always gets that. The sweetness in the extremeness outside.

WHAT I SAW

I think one of the reasons William Pope.L's *A Negro Sleeps Beneath the Susquehanna* is in my opinion the finest piece of performance art I've ever seen is that by its "end" it existed in its own category—one of sublime artifice. Practically religious art. Because all the elements were carefully chosen and exquisitely played and then he left us. The end of the piece didn't exist so it almost had a religious note. Certainly musical. Well let me back up.

The piece took place in the context of a residency. Maybe that's important too. To perform in a residency is a thing in itself. A group of us had been invited to spend two weeks in residence at Cowan, a leafy park-like place used for conferences and stuff and it was close to (or part of) the campus of Bucknell which is in way southern Pennsylvania. In Amish country, so the land is yellow and green and rolling. Farm country and it's not far from Gettsyburg, the site of one of the worst battles of the civil war.

The idea was for each of us to create a piece during our residency and show it at the end. People were living on the site of the conference center mostly. Which meant they sort of lived in barracks and never really got away from each other. I know we ate, but I don't remember how meals occurred. There were these sort of dining rooms in their barracks. William and I lived in the Poet's House much nearer the Bucknell Campus. I think because he was working on a novel and I was writing too there was a sense that we needed

work spaces rather than the great outdoors like sculptors and photographers. And this was a great reversal from most artist colonies where writers get like a little ledge to work on in their bedrooms and sculptors and painters and composers get big studios by the sea or something. Here the writers got a house and it was great.

But I had no idea what William was working on. I think he was making paintings in the basement and I don't remember ever seeing them. Or maybe I did. I think they were abstract paintings.

On presentation day (when people's spouses came and so did the public and obviously whoever was paying for our residencies ...) one went to see Carol Hepper's artificial tree installed in the middle of the land, and Paola in a pale pink dress leaped out from behind trees in a riveting and esoteric fashion. Barbara Pollack's fuzzy polaroids. Then I feel we went away before we came back for William. We knew he was doing a performance. There was a sound of an engine of some sort over by the river and this was actually the first time I knew there was a river here. I guess I hadn't been so interested in the land. When we got closer we saw that it was William lying down with his face in a mound of flour, white flour, breathing into it and just by existing making his face not so much white, as not so black, but powdered looking. I was impressed at this point by his comfort in getting down into it, a willing abasement. The breathing went on for a while and then he got up. He was now sitting up at a table and began speaking into the microphone instead of breathing into it.

I remembered that he kept uttering the word crab. That his language felt broken even when it was whole. Wish *I* could dream. That was something he said again. It was like entirely subjunctive speech. It was his but it was like he was saying it for him. He was carrying it for himself. That his capacity to speak seemed central to the nature of the piece. That the words could be forced to come if he and we were patient enough to wait for them. I just saw a musician perform like this the other night. The song was all broken. It was

really painful though constant. But he had us. I would love to read a novel William would write. After some reading he put some big boots on, tall rubber boots. Or maybe he was already wearing them. He had some silly thing on his back, like a fanny pack, but it was a rubber one. He wore a jock. Everything he had seemed ready to float. In retrospect his voice had been really loud when he was sitting at the table. It seemed to echo deeply. I think this because the rest of the piece was silent though I felt I still could hear it. It was quietly booming now.

He seemed to look, kind of weaving around for more things to use, to pick up, something to do, but he just wound up in the water and planted there were some pieces of mirror. A large rectangular piece that he mounted on his back and it had like lines, probably tape running across so it wasn't sheer but mostly broken-looking. And he started walking down the river. He was staggering. I never thought of it till now as like a crucifix, the burden of it, I mean. He was stumbling either from its weight or from the unevenness of the river's surface. But the mirror reflected the trees on either side of the river. It reflected the sky for a moment. It felt very emotional, right away. Like familiar like you already knew it. I keep remembering as I write this that there was a full moon tonight. In New York. A very special one, bigger than it will be for more than two years. I forgot to look. The mirror on William's back sometimes felt like he was carrying the river, that he was the river himself that he *was* it. He seemed to vanish into everything there was, walking further and further away from us. The voice was gone but you still felt it. And the breathing too. He could do this. The performance didn't so much end as leave us. It was an astonishing spectacle somehow. And I wound up feeling very very sad. I thought about how Mark Twain stopped writing *Huck Finn* for ten years because he didn't know what to do with Huck and Jim when they got to the river. The residents and the visitors were just sitting there. There was nothing to photograph anymore. Because he was gone. We kept looking down the river but that was it.

(1993)

PRINTS OF WORDS

When I came to New York in the '70s I was tremendously excited because everywhere—on the subways, posters on walls, graffiti—language was everywhere in this town and I loved that because language was *mine*. Most of it was advertising something, even the kids who wrote it, but you don't come to New York if you don't like advertising and I was definitely pleased. It was and remains a rich experience. Now it's in the galleries, too. I've heard people complain they're sick of standing in galleries reading. I spent the last few weeks doing exactly that, being a poet looking at how visual artists use words in their prints. Often I got to sit down. I brought my coffee and was incredibly careful.

I started with Hannah Wilke at Ronald Feldman. Mark laid the print down on one of those beautiful pieces of furniture with so many thin drawers. I began counting, something I never do when I look at poems. In general, visual artists are more anal about language than poets are. It's the thingness of words that they're after and thingness often comes in pieces. Hannah Wilke chose 16 words in 1978, Hannah-Wilke-type words: thank you, archangel, epiphany, orphan, bacchanal, chance, thanatosis, enchantment, etc. You'll notice that all these words have "h," "a," and "n" in them. You might also consider that Hannah's name is a palindrome, going both ways. SO what she did in a raised grid yielding 16 squares was: take each word and line it up six times (Hannah has six letters) with the

necessary letter (the "H" in epipHany) capitalized as well, so you get a shape that resembles an arrow or an angel and the diagonal spine of it reads Hannah. The typeface of the whole is like that of a wedding invite, so it's as if 16 birds flew by 16 windows and cooed someone's name. It's spiritual advertising, I think. Soul effigies made out of words. Bye Hannah!

I moved on to Solo where I wanted to spend my whole life making prints. All the tables and the presses were open and ready, it seemed. Lesley Dill makes "poem sculptures" out of the poems of Emily Dickinson which already quake with their own transcendent energy so Dill ties them down I think. Take *Poem Eyes* in which twin strings of translucent paper bear lines like "Much Madness is divinest Sense—/ To a discerning Eye—" at the end of which is an eye and a smudge as pupil which I suspect is a fingerprint. It's nice. The materials of her sculpture, the allusions they make, are more interesting than what she does with the poems. They are literally mined for ore, and recast as a drooling nerve, or in *Poem Hands* the lyrics are bright red type running down the fingers of two paper hands on strings. Yet Dickinson's poems are rods for a kind of invisible lightning and by making the rods hand-shaped, etc., Dill makes them attract less or differently, I think. I wonder if she realizes it's a form of rewriting.

Oddly enough, *Poem Ears*, which boasts a long fixture dangling from one inner ear looping up around another right next to it, saying: "I heard, as if I had no Ear / Until a Vital Word / Came all the way from Life to me / And then I knew I heard," works very well indeed. The lines are too oracular to be overwhelmed by a couple of ears. Dill vanquishes her own work in this effort. Which I think is the goal of collaboration, to produce something quite seamless. Otherwise the work gets reduced to a souvenir. There is a heart in the bodice of *Poem Dress* and the veins, like lines of a sentence being diagrammed, carry the words *Ouch, Ouch, Ouch!* On their wrinkly

way the words become anthems, clichés, banners, mottos over a door, all tantamount to the enforced beauty of schoolchildren standing up to recite an Emily Dickinson poem after lunch. Did she mean it that way? Would you? It is taking a work of privacy and in another privacy redoing it, weighting it in some ways, not others, and sending it off to work.

I really applauded Christian Marclay taking as his paper the Beatles' *White Album* of 1969, taking a whole bunch of them in mint and some in coffee-stained and party-stained condition (one has a little ballpoint doodling on it—"Liz"? Remember people who used to put their names on all of their records?) making us notice that each bears a tiny stamp that says "stereo" and "The Beatles" is embossed on the lower center of the album cover and then Marclay intervenes and embosses in bigger letters some lyrics: "Take a good look around you," "Fixing a hole in the ocean," "Oh yeah oh yeah oh yeah." One savvy little line per print. These dirty white album covers, opened flat and framed in glass, are both evocative and conceptual like leaving some text in the wilderness. Sort of like your cat, they've had a long private life indoors. Everything will be revealed, they seem to announce, even "the lyric" which Christian Marclay has advanced into text. Sometimes the record label comes through too, another embossed shape, a small dark halo. These prints are so cool. Elegance over real funk, not valorizing one or the other.

The very soul of poetry is the list. Conceivably every poet is making an abridged list of all creation, filling in a little over here, not mentioning what will only bog you down. The best poetry keeps moving at all costs. Most lists in poets' hands are highly elaborated and understated, in fact, downright solipsistic. So as to be generally unrecognizable to the non-poet. The list poem had its heyday in the mid-'60s in the hands of such list masters as Ted Berrigan, but every poet I know has a list or two up her sleeve. It's an exercise and an end in itself and a plain cold list, as Williams's

famous note to his wife Flossie suggests, can clearly be a poem: "This is just to say / I have eaten / the plums / they were in / the icebox…"

Annie Sprinkle conflates her list (*101 Uses for Sex or Why Sex is So Important by Annie Sprinkle*) with funny bar signs or T-shirts you see on St. Marks Place (3 Reasons Why Beer Is Better Than Women, stuff like that) which is sort of a way of undercutting the seriousness of her project and when it cuts loose from the under-cutting you're surprised. Each of her 45 uses (she admits she uses sex to avoid finishing things, i.e. this list) begins with the word sex so it's a chant as well. I like the risk Annie Sprinkle takes here (and everywhere she goes) of being big, by again and again being Annie Sprinkle. If a fool would persist in her folly she would be wise, and I find her list eventually hits the mark and the lacquered print does, too, because it's so adamantly tacky. In the midst of such Sprink-lesque lines as "Sex to cure an asthma attack. I saved a man's life once" (#16), the everyday "uses" we all know about like "Sex to create life" (#21) or "Sex as an expression of love" (#38) ring kind of alien and new. I wish she didn't use the word "End" at the end. This artist thinks everything is true and she makes that notion work for her. Her name at the end would suggest multiplicity.

The Ed Prints are stunning in their virtuosity. They are happily described in their cardboard folder as a suite, and they live up to it. Looking at them in this format (you sit down, Hudson of Feature sets up a nice little wooden table for you and a chair and everyone thinks you're an installation) one can easily imagine the artist, Kay Rosen, a genius, facing a blank piece of paper, a rectangle, and then she imagines a margin on all four sides so it's a poetic situation, yet it's public—a print is intended to go on a wall, isn't it? So her page is more like a movie screen, or a sign. There are five lines on each of six prints. The colors of the prints change. They move from white to gray to cream to black and back to white. It's a typographical drama. "Blanch/arose/Rosa/blanch-/ed. Ed!" Names are both actions

and identities. "Ed" is the star of the *Ed Prints* as well as being the "ed" which ends every past tense verb. All readers subliminally know the rules because it's a comic book. One that's all balloon, no illustration. It's a noir little drama, with typical demands, i.e., that all letters must get to the right-hand margin at the same time, but still when you see D E A D stretched out, all alone on the line, it seems like more than mere justification. When the typeface goes down, the voices are soft, uppercase means loud. Kay Rosen's brilliance for me is an incredible economy which turns every minor detail, for example the hyphen after "blanch," into a stuttering hyphen in "MURmur- / ed ED:" and sets up "M-murd- / erer!" later on. Absolutely nothing is wasted, everything that can be transformed, is. Also, each print is titled, giving an extra layer of meaning to each moment. They're scenes: "Surprise," "technical difficulties," "sp-spit it out," "Blanks I," "Blanks II," and finally "Ex-Ed" which reads like this: "memorx / memoxy / memxry / mexory / mxmory." These are piled up vertically so it looks like bingo (who won?) but if your reproduce it on your word processor, it's also about moving the cursor down the row of words. It's a memory inside a machine, or a fiction created by one. Was there ever an Ed? Cause now he's just an X. I think of this artist's name. Kay is simply a letter, right? The first poem people hear is their own names and some react to that memory all their lives. "bullet / riddl- / ed, ED / SHOT / BACK." Yay, Kay.

Al Taylor's etchings were all done in 1991. What we've got is a series of prints which are essentially patterns of stains, splotches hugging one another or the border of the prints, yet strewn about enough to hold the rectangle in sufficient tension—these are nice abstract pieces, but the kicker is the splotches have names—there's a dot called "Minnie," a sweating complicated dot on dot called "Bruce," "Tammy" is shaped like a pear, and so on. In another print a whole constellation of drips is dubbed "Cookie." The gallerist told

me all sorts of people, *doctors*, even, respond to these prints and I imagined another slew of private names—lungs, pancreas, and liver, otherwise known as Susie, Milton, and Gonzalez. Taylor calls his prints *Pet Names*, underlining the degree to which we all live in an affectional universe. I'm glad he only did this for one year, but it points up the crucial moment of trivializing anything before it's passionately rehabilitated. I'm thinking of abstraction. Language putting the lid on it. Then maybe it opens up differently. Thanks, Al. And nice meeting you, Rodrigo, Casper, Dinko, and Martini.

Really, Kenneth Goldsmith's words to me are purely decorative, the most so of the lot. The first of three prints reads like this:

B / BE / BEA / BEE / C / D / DEE / E / G / GEE / P / PEA.

What's that? And behind it in a paler version of the same typeface is another list (and bear in mind, these words are wider) with "chartreuse / vitreuse" and other such soundalikes ending with "verbal abuse." A score for Goldsmith's poems was recorded by vocalist / composer Joan La Barbara. And Sylvia Heisel's making a dress. I know Sylvia. I would probably enjoy all of these products but what I really love is Goldsmith's beautiful typeface—certain details of it, they seem like architectural details—the bar of the H, one leg of the V being merely razor sharp lines and the other limbs of the letter thick and colored in a pulsing charcoal-tone that made me think about buildings, stone, and this same gray is utterly emphatic, almost black in the top layer. It's figure / ground poetry (imagine the front layer as the lead singer), even more clatteringly so in a second horizontal print with easy rhymes, "get thee to a nunnery / misery loves company" and underneath it sings: "I'm so hot to trot / it's not a whole lot." Goldsmith's lyrics lead with their chin—don't listen too hard, it's avant-pop, delivering as its final line "and that is poetry." Oh really? Poetry by a good-looking well-dressed person

who reads really well. It's sort of elegant and to demand more, I suppose, is no less witless than to ask that all great poets be good-looking, though some certainly are. Stepping back I have to say I like this clatter and this elegance, look forward to hearing the CD and seeing the dress.

Christopher Wool's *Run Dog Run* is probably so famous now it's stupid to describe it. I think of it as the essentialist poem of the 20th century. Three words written on a wall and one used twice. The shape of our view is rectangular. Poster-shaped. We come in closer, we move to the left or the right. That's it, there's no way out. This is really such a desperate work. The meaning is flattened out which makes "run dog run" more meaningful like the pores of someone's face magnified are no less human, but horrifyingly so. He doesn't care about order, Christopher Wool, I was told when Claudia at Luhring Augustine laid these three giant offset prints on the floor. The me looking is a camera wandering over the edifice of the message. The silence gets louder. The ugly gleam of light in this blown-up photograph of "run dog run" reminds me of police photographs, clammy crime videos. Poor little 20th century dog running around in circles, 1993, almost out of work.

Then I went to see Leone & Macdonald's prints at Fawbush. These prints are extremely evocative to me for reasons mainly having to do with childhood. One Christmas we found under the tree a wood-burning set, a bunch of little tools with blades of varying widths and electric cords coming out of the cork-handled end. The kit contained some flat pieces of wood with drawings on them so we were being encouraged to do some kind of paint-by-number thing. We never did get the hang of it. Mostly it was just scary. My brother would plug one in and in a few minutes he'd say, Look, and push the blade into a clown's nose on the wood and a smell would arise and it carried the implication that my brother, no small sadist, could do that to my skin and we all just declared a

cease-fire on that toy, but my mother claimed there was a time when we all really wanted it, but I don't remember that. I just knew it came and nothing followed—a dangerous toy. Leone & Macdonald have made brands out of parts of the Gregg shorthand system; the symbols for labia, semen, and other libidinous players are then pressed onto lush nubby paper that curls. In some cases the heat of the brand has pushed through the handmade French paper. In the attic where the wood-burning kit lay, my mother stored her typing and shorthand books from high school. She took business courses and was a secretary during the war in a contractor's office in Boston. She wore big hats, crossed her legs, open-toed shoes on her feet, and took dictation in this code. Leone & Macdonald insist that Gregg shorthand represents the law. I called my mother up to see what this language meant to her. Oh, you'd get more money she said. I called the Stenotype Academy of New York and they said that Gregg shorthand hasn't been used in courtrooms for almost 60 years. They said the majority of users of Gregg in the past were always women. Working class women, I asked, pushing my agenda. Women who needed the money said the woman on the phone. Macdonald's mother is a poet. I asked my mother if she'd recognize any dirty words in shorthand. Probably not, my mother said. Send them to me, she sighed, I'll take a look.

Glen Ligon uses two different texts by Zora Neale Hurston and one by Ralph Ellison. In all three prints he uses texts that are about being colored (Hurston) and invisible (Ellison). In all three cases he eradicated the text, which makes sense in a deadpan way in Ralph Ellison's which begins "I am an invisible man" and the text sits there utterly black and raised against a black background. The svelteness and the completeness of the statement is equal to the ridiculousness of making Ellison invisible twice. Zora Neale Hurston's "I do not always feel colored" and "I feel most colored when I am thrown against a sharp white background…" start off in black stenciled

lettering against white and of course go all black and illegible. Again, I wonder if Glen Ligon would have made these works if Hurston and Ellison were living writers. I can only imaging Ralph Ellison going But I said that!, or Hurston wondering if he got her point. Ligon explains these prints as being about "becoming colored" but you know I think that's a weak pun. The explanation sounds better than the work. Which is kind of the opposite of Leone & Mcdonald where the work is better than the explanation. What Ligon is really doing is illustrating texts that were doing quite well by themselves. I mostly appreciate the artists who use their own words, or their collaborator's, or appropriated well so no one anywhere is inadvertently silenced. Meanwhile, I'll just go back to those famous streets where 1.6 million adults, I've been told, can't read a thing.

(1997)

A TREATMENT OF
SUSANNA COFFEY

Sometimes when I'm in love with a person I want to hold their head. I want to feel the weight of their skull in my hands, I want to touch this incredibly tender and strong case for the brain, the mind, their spirit. It's definitely the place where tenderness and violence meet in this feeling for the head of a beloved.

I was standing in a gallery one Saturday morning and I was reading some poems. I stand there in front of people and I open my mouth and my work comes out.

This gallery hadn't had many readings. In fact it was their first, and I had been told by a number of people that I would like the work of the artist who was showing there that day—Susanna Coffey—she does self-portraits.

And certainly this had all been planned on the phone, all the heads holding the receivers to their ears, nodding and smiling and making notes on the counters in front of them.

And now everyone was sitting on long wooden benches in front of me, it was very spartan and it was a cold January morning and all these people, mostly women, were sitting on benches in front of me, looking at my face and those words coming out in the morning. And there were paintings all over the walls, small ones of a woman's head.

I met Susanna Coffey after the reading; she was sort of blondish, hair pulled back, those kind of blazing eyes, and she became "real" to me.

A couple entered the gallery during the reading. The woman wore a big fur coat, the man had on a suit and an overcoat and they began looking at the show, circling the room, walking in front of me and behind me. It didn't seem to occur to them that I was doing anything at all. And actually, I didn't mind. Their presence made my reading be less art, more something else. It felt strong.

I was held by the power of the tiny head on the wall, tiny little female gods, murmuring softly among themselves, holding up the integrity of the bright white winter space.

Obviously a head is power. The speaking head, but even more the head in silence. "She shot me a look." If she's any good, the talk stops, whatever it is. We know silence holds power, it's equated with awe; the grander feelings like fear and love. I think of the ancient world as silent.

In part, because of how *Satyricon* began. The pale frescoes looming behind the film's titles and in moments Fellini would animate them—the human or mythic figures would dance their fates, but now they stood timeless on the wall of the screen that heralded the film.

I walked into an Alex Katz show one day in the early '80s and it was pouring rain outside and those huge faces seemed to tower over the city and day somehow, and though I wasn't exactly "triumphant" over the weather when I stepped out again, I felt primal too, a little bit of awe, Alex Katz's huge faces had done that for me.

Susanna Coffey tells me she modeled. What woman hasn't, in one way or another.

A head in a towel and the shadow of an eyelash, her face in the morning, and the background coming apart, some bitty sparks of hair, no background, a bare chest and the tipped chin makes a beard. The fool—the nerve of it. To be powerful in such a silly green hat.

Just a touch insane with her pretty hair, and the face's molten shadows … the light shifts, surely the face must change. Day, seasons. We see ourselves in others' sunglasses. A face practically filling a green screen. Just prior to an accusation. Yellow, or gold. Lift the box, and the day distances. A woman in purple. Any queen could pose this way. Her gilded eyelids. A marvel. Is the face flattened by the columns of hair, a red downpour? Gleeful? The yellow buds in her garland resemble the fruits on the wrist of the woman I know. I've forgotten their meaning. The knitted hat, an old woman.

I'm looking at a bunch of slides on my kitchen table and there in the dark square of the plastic viewer was my face. "I felt like I really got something in that moment … about your work. People probably always tell you these kinds of things." She nods.

I'm sitting with her at an outdoor cafe about four years after we met and the day is drenched in Provincetown sunniness, a different kind of almost white light. I'm thinking we both look a little bit older, and she talks and talks and this time I'm silent. She tells me that she was inspired by West African masks of women, she saw them so long ago and they possessed an absolute presence.

"So that's how you got into this?" I asked. She tells me about art school in the early '70s. "Oh what were they talking about … specificity … check your corners."

The corners of the painting. "Yes," she smiles. It seemed she had to choose between the "art room" and the "women's room," and she decided to paint women, that was her step. "The West African head is a subject, not an object. I can never forget that."

So she gets up in the morning and she looks in the mirror. Do you meditate? Oh yes. Often she spends hours in the studio, seven hours, looking at herself. Today she has red hair. I look and look. Her red hair falls on her face. We talk about eye color, contacts, that's my new idea, she says. Green ones, blue.

Sitting in her presence. "One tooth slightly over the other," I'm thinking that the self vanishes as you "take" the person's parts, one by one. The little head vanishing and receding into a painted emulsion, the two beady eyes.

Some of the drawings I looked at in Provincetown, actually prints, reminded me of the quick line drawings of Zen teachers who look like owls, or the shroud of Turin—the slightest flurry of paint, the impression of a face.

Years of them. The hats come on and off, the background grows solid, brown, withers and ricochets back. Designer sheets? We laugh but what did it mean, which designer? I forget. The self vanishes. And the woman's head?

It's about power. I asked her and she smiles. You hardly ever see a woman looking back at the viewer or just being there, "safe," having her interiority. "We have earned it," she said at one point, and I wrote that down.

It's kind of a toast, her painting. Susanna Coffey is a product of her time. Her relentless self-portraiture is utterly female—plus an excessive form of minimalism.

The female head surrounded by all the space in the world, take by take, the endless repetitions are about a tremendously archaic woman, an empress, a silent storyteller. The grim woman standing in front of the tenement window is great. Stare too long and like any repeated word, the face becomes nonsense, then rhythm, then song, and nothing at all, white noise, gone.

It's the hideous head full of worms, the death of the hero, of greatness.

Women's faces have always been shields. For "humanity" to hide from its own changing nature? The big nothing? Andre Breton's incantation... "My wife, my wife..." as she whorls and snickers hissing. The creature.

Susanna Coffey sat there in her silver bracelets, telling me

about her art, and my hand moves quickly across my pad, writing words, mostly useless, "the longitudinal lines of her wrinkles, a face is lines…the ball of her chin."

A woman sits in her studio quietly looking in a mirror, then painting herself. Day after day, to stand there unraveling—to reveal! Emptiness? No end? Who would want that?

She says her life is absent of personal relationship. Yet I adore the silent poem of this. To hold her own head …

Cut, cut, cut …

ABOUT MARTHA DIAMOND

One morning I had breakfast with friends of mine, poets who also write about art. We all got heated and animated pretty quickly, switching the topic constantly from whether we could handle another cup of coffee without blowing up back to how awkward it feels to write about another artist without being able to respond as an artist to their art. Let's face it, they're hiring writers, not poets. A poet I know, James Schuyler, told me about writing a catalogue in which he was specifically invited to write poems in response to the work in question. He did it, cautiously, one of our great poets who's written "about" art for the greater part of his life, finally responding in his original medium to the art in question. He said he always writes in poems initially, but then "turns" it into prose. It's an act of translation, it seems to me. That initial response, the poet's notes, are an independent work of art, an act of perception, the poet as camera, recording his or her own responses to an art object without going the next step and flattening the response into conventional prose. It's actually a terrible sacrifice the art world demands of poets, the virgins thrown into the volcano, so that the shiny painting and sculpture of their time will have its equivalent in print, sort of. The poets will have backed off from the spikiness of their own perceptions for the glory of instantly appearing in print at all, and for the glamour of being associated with such state-of-the-art art as modern art and even the small sum we receive for writing the average short

review. Of course we like art. But that's not the point. My notebook is filled with poems too. It hasn't been a great poetic age of late, it's been an age that's non-verbal, media-oriented, ultra-visual and naturally pro-money, so no one really understands the loss, only knows that poetry is something art writers do when they are young. Or behind the art world's back.

> Back to
> the animus
> grid
> the city's
> smiling face
> a hail of
> birds revolt
> fly out
> something simple
> to keep the baby amused
> we tied it
> to her wrist
> and it
> flew away.

> Still, Gong, the city clock rang on,
> the minutes the seconds all
> had their say

> Once in a while
> you look real
> close, a
> fingernail an MCMXLIV
> you know it's borrowed time
> but it's

time, wild
 & wooly to forge our
faith &

family by,
 to buy
a tractor to be serene.

For the lack of a new world religion, Martha Diamond seems to be painting "the present," whether it's big or little parts of buildings, specks of dust (or paint-strokes) floating in a raspberry sky, or moments of this stretch of time reaching out of the 20th century into the 21st. You can't see that much in one canvas but you can feel the reach.

I don't like to appear cosmic in public, says Martha Diamond. Well, who would? Or what would the paintings—if I were writing a novel, what would the paintings of someone named Martha Diamond look like? She's kind of a super hero, tough, pop, but without the black outlines. But broad, very broad. Her paintings, I mean. And no people, just things. Things that feel like people. How people live and what they live with. She calls a painting *Silhouette*. It goes like this: Make three windows at the top of an imaginary house. With beautiful wavy hair. And each window is a kind of painting, a sweet thought. One feels grateful for painting. At its best it's beautiful and reckless and orderly. You don't want to be scared. You want to be excited, ennobled, teased alive. Buildings, live beings. And blue and yellow racing diagonally through the sky. It's easy to say "sky" here.

The rupture with reality one feels when writing about art is that there is a tendency to make manifestos out of someone else's play. The Living Theater marching off into the sunset armed with the words of Artaud. But those words, that was his play, his theater.

It's like spending a month in someone else's house. I never saw that chair before. It's too much at once. Stick by stick, you accept it—someone else's furniture. Then it's time to go. It's like life. All these containers we live with, art, other people's homes. You'd think we were being groomed for something.

What can I tell you about it, says Martha Diamond. It's a procedure.

I get the feeling she'd rather be talking about something else when she shows me her paintings. It seems so stupid, I think she's thinking, to be talking about them and looking at them. Martha Diamond doesn't listen to music when she paints. I don't know how long it takes for her to "make" a painting. There were giant holes in our conversation. Often Martha Diamond says something she wishes she hadn't said, but what she won't say is so much more interesting. They're so slow she says of her paintings, but I think she means "being" them, not her actual painting time. Colors are slow, not all of them—red is fast, blue is slow—a litany of color-times dissolved in my mind where things frequently dissolve—it reminded me of Rimbaud's system: "E" is blue, "A" is red. It set off a pinwheel in our dialogue. But she really meant it. When you step into a freshly hung show and you can smell the paint you know that some colors are slow.

These paintings don't work on the floor. I helped her lift them onto milk crates where they looked, well, radically different, finding their own gravity distinctly apart from anything but each other. I went into the bathroom where I was reading in a magazine about "Intersalt," a world health organization for cross-cultural comparisons. "Intersalt" is a good title for one of her paintings.

Then Martha Diamond left me alone in her studio. I was armed with a cup of black coffee and a green pear. I whirled around looking at the paintings, avoiding the piles of rust-colored paint like little brains that sat in a variety of spots all over the room. Lots of white chairs. Some of her paintings wash up on you: City-futurist ice floes!

Orderly crashing waves. Martha Diamond is a Taurus. Only an earth sign could make water so solid. Or buildings so fluid.

> many saviours new heroes
> flying by in the future city,
> they are out
> there gleeful
> they are
> coming

Her *Midtown* looks like a shopping bag. Black crosses in a pattern, making a testament, a red one, then a small blue square, a private room on the right. Did you say commuter or computer, Martha. She rhymes in her paintings. Shapes echo, expand, shrink. But there's an abiding sense of security. She makes simple systems. Her directness is what I admire. There's no translation here.

And no handles either. You've got to take the time. Put your body in relation to them. A painting called *Token* has four gangly bells within a tingling present that's also occupied by a set of white lines—venetian blinds? You can almost feel a cool wind. Would tugging on one of the "bells" adjust them? Adjust the breeze? She talks about how patterns become monumental. You can lose the scale, but keep the attraction.

Then there's *Carriage*, the raspberry skies I mentioned before. "It" floats, a tension on tension. Isn't that what music is? Or is it completely relaxed? One of the most puzzling pieces in her studio, *Guard*, reminded me of an earlier one, *Edifice*, a semblance of tweedy branches, stripped down to receive the wind. Here it's got its winter hat on. She takes a tectonic approach to, well, everything, but here to the tips of buildings. Because Diamond's paintings are so persistently slow, they reveal and conceal their secrets within the

patient duress of time. Like John Ashbery who easily shifts from god to Daffy Duck in a single poem, Martha Diamond shows glee in these canvases, confidence. Conceding herself the time to make them, she flips "it" over, the semblance she's playing with—are these windows? Well what if they were checks.

Like her painting she talks in broad strokes. She described some painting she likes as "phony." So synthetic. You can see how they're made. "Phony" is a great word, when you use it that way. Like the activities of childhood were phony, endlessly open-ended, kind of utopian.

So … what if checks rule, growth upon growth, creating a gargoyle, yet plush, full of humor. And try not to enjoy the literalness of the yellow background painted earnestly around the conglomerate. At her most fanciful we wind up with a kind of hippy architecture, like Gaudi. I could stand a whole show of this, wrapped structures, but instead I turned to something more "factual." A painting called *Facade* comes in real close at the ludicrous spectacle of architectural detail, gray, recessed, then prominent. A big solid squiggle. Going on into a larger structure, then the net. There's a silent story-telling going on. Once there was a city, but now this macro-shot of cornice is something more hallucinatory. Meanings shift dramatically like the progress of words in time. "Sky-scraper" used to mean the tallest mast of a sailing ship. The ships have left, but unwittingly we still refer to them when we name what we see.

Am I writing a parallel universe of words to accompany her paintings? You bet. It's an undersea voyage, kind of a swim through an abandoned hulk, but it's abandoned to the future, not the past. It's a comic utopia, of necessity. When we're talking, when we're choosing, when we're looking and walking we don't always say the right word, we say the next word. Often it simply gets us through to where we wanted to go. The wrong word drops off like a withered branch, soon enough. Here we are, in the new place now.

Pandora's box wasn't really a box, it was a vase. Some say it was a gift to Prometheus's brother, some say she was a gift. Some say she carried nothing, but the things that were contained in the box or vase she contained in herself. Some say all the things inside her were evil. Some say they were good. But she let them all out. By accident, they say. Or out of curiosity. Then she closed the box, the vase, her body, her mouth just in time to keep "Hope." Maybe that was all she ever carried. Maybe that was who she was.

The last two paintings I looked at on Wednesday were in that fabulous corner room of the Robert Miller Gallery, at the corner of 57th and Madison. A perfect place to watch the world go by. It did. Last Christmas I passed a crowd of people around lunch time, I was in a rush, and there he lay, hit by a bus, a young man partially covered by a sheet. You could see his tasseled loafer sticking out. His rimless spectacles a foot away from his still fingertips.

There are painters who burn themselves out says Martha Diamond. We all know who they are. A great and crude painter like Van Gogh. Systems are a good thing she says. Two young guys carried out the last two paintings I saw that day. Hmmm she is getting away from buildings. This big gray one—what is that, a crystal geyser, an explanation of heat? What does symbolic mean? When a dog salivates when it hears a bell … is that symbolic?

They brought out the last painting. A young woman in black brought me a cup of coffee. "Dancing sticks," I wrote, "a sublime nervousness, a caginess." One stick's moving out of the field of vision, (oops I mean the frame), another hovers horizontally at the top of the painted blue space she's made for them. I think of worship. Martha Diamond says of her work it's slow. How fast is invisible? How can we look at that at all? I watch the traffic moving by in the street. John at the gallery says that accident last Christmas wasn't the only one he's seen. It's a rough corner. There are reasons for looking and feeling and thinking about things that are invisible. In fact there's room for it now.

PEOPLE

DANIEL DAY LEWIS

EILEEN: The thing about actors everyone wants to know is what their real hair looks like. I almost laughed when you came to the door because it felt like a punch line, a kind of "fuck you."

DANIEL: For years I just left my hair alone. That way, I knew at least I'd have enough for what was needed when I went to work [laughs]. So this must be a "fuck you." Certainly, it happened the moment we finished shooting in Rome. I had quite a lot of hair and I was glad to just get rid of it.

EILEEN: You were shooting part of *Gangs of New York* there?

DANIEL: We shot the whole thing at Cinecittà.

EILEEN: How was that?

DANIEL: There was a kind of magnificent irrelevancy to what we were doing. We were trying to inhabit a different world and a different place. There's no correlation between urban Rome and the Five Points. You're surrounded by distractions. So much of your energy goes into ignoring the stuff that you don't need to see.

EILEEN: As in the people and the environment beyond the set?

DANIEL: Yeah, all the peripherals. When I'm working I try to stay in places where, if I can't be reminded of what it is that we're doing,

at least I don't want to be taken too far away from it. We found a place outside of the city where you don't have to be overwhelmed by all that beauty. That helped. Otherwise, it would have been impossible to make that daily transition.

EILEEN: I have several myths about actors that I wanted to unload. One thinks of actors as the abstemious or the excessive type. Like, Richard Gere only drinks tea, and Richard Burton has a heart attack and dies. What's your relation to excess?

DANIEL: I have, in the past, been very attracted to it. There were long periods, years and years ago, living in places full of kids like me, where that was all we thought about, all day long. But I've always been able to read the danger signs in the nick of time—I have a very strong will. When the time comes to clean up, I know how to do it. I saw enough casualties and I just knew I didn't want to take the experiment a bit further. But I still get an inordinate amount of pleasure from those moments when you do allow your will to bend. What about you?

EILEEN: I'm not so fortunate. I made the assessment in my thirties that I was going to die, so I basically threw the whole lot of it out the window. My intake has been reduced to the question of whether I'm on caffeine or not. Which is not to say that my behavior or personality or attitude can't be as excessive as any substance. But when I walk through this neighborhood I see Fanelli's, and I have this wonderful memory of tripping my skull out there. Also, I'm 52—into your forties you can't really hold it the same the way.

DANIEL: Probably about seven or eight years ago I thought, "I'd like to see through relatively clear eyes now." I've seen through various veils and I find it kind of depressing in the end. I just didn't want to do it anymore. I have no interest in drugs. I started early too, when I was a kid. It felt like it had been a long time [laughs].

EILEEN: At least from my observation, when people are older, something ugly happens and it seems like the drug talks more than the person does.

DANIEL: Some people find that they need it for whatever work they're trying to do. I never had any desire when I was working. That's when the puritan reappeared—start pounding the track and getting rid of it all.

EILEEN: Did you feel that the work was the high?

DANIEL: I don't know if it was that, or because I wanted to do the work very much and I was single-minded about it, and quite proud as well. I suppose it was some sense of obligation.

EILEEN: Who do you do the work for?

DANIEL: It was never a selfless thing, and it still isn't. I'm not sure that it could be. People say, "Oh, you haven't worked for a while, don't you owe it to …" [laughs] The only reason you can make that offering is because you choose to indulge a very personal compulsion. You have to recognize it when it's there and leave it well alone when it isn't. I realized quite early on that this slow-burning revolution—this compulsion—was not endlessly replenishing. That idea goes against everything that happens when you start to get work. They fling it at you and it's tempting—you never know when the next thing is going to happen, and I didn't.

EILEEN: Was that intimidating?

DANIEL: I had some breaks early on, so everything seemed to be going well. When a lot of my contemporaries came out of college they were stopped in their tracks, they couldn't get a bite anywhere. That was waiting for me further down the road. It was quite shocking, just sitting around thinking, "What am I now? I'm apparently useless to anybody."

EILEEN: Is it because you weren't getting a bite, or a bite you wanted?

DANIEL: Both. I had been lured into doing something that I was of two minds about, and it was disastrous. Not the result, but the feeling that it left me with. I felt so demeaned in some way. Maybe it's just because I'm very lazy [laughs], but I started to take long periods between things.

EILEEN: In some weird way, the spaces between the work are what's really interesting.

DANIEL: Definitely. That part is obscured when you're young because your drive is always leading you from one place to another. It's the resting places or the periods of lying fallow where you do the real work.

EILEEN: The thing that's scary about not doing anything, or not doing what people are inviting you to do, is you feel like you are facing death in a way.

DANIEL: Yeah, I think you're right. It's a little death and you have lots of little practices. How do you work?

EILEEN: I started writing poems in my twenties, and it got to be how I made a map of the world. That's always happening, though it does stop sometimes. I started writing fiction slowly in my thirties, then that became novels. Making a living as a poet is a huge trick, so I stumbled into being a performance artist, teaching journalism, reviewing art. I'll be very, very busy, but at the end of the year, I'll think, "What did I do this year?"

DANIEL: There's so much movement, especially in this country. People are traveling everywhere all the time, very much locked into the road that they're on. We've been living in Connecticut for the last few months and there's this stillness there which really appeals to me. It's the same in Ireland. It's not uncommon for actors to be

strangely antisocial. A lot of actors that I've worked with seem to enter into this feverish society for a time, and then they retreat. I feel that in my guts. I have to get away from all that frenzy.

EILEEN: As an actor, you're agreeing to do something that is very mute in a certain way. It's been determined what you say and where you walk, yet you have to make that come alive.

DANIEL: That's the meter and the discipline within which you struggle, and if you are lucky, find your own freedom. That's the game—and it is won long before you ever come face to face with a camera.

EILEEN: How?

DANIEL: In those quiet months before you approach the thing, the dreaded beast, you begin to enter into a world that isn't entirely yours. People are always trying to read some sort of craziness into that, but it seems logical to me. You just start taking steps towards that other life. Of course, you never entirely give over your own life or your own self. You never relinquish everything. There's an exchange that takes place at certain moments. You don't know how it happens, or where, but you think you've traveled a vast distance— at the time you felt that you were living in another place. That's where the joy of it is.

EILEEN: That's wild.

DANIEL: For some reason, because acting is such a strange thing to do, most people find it reassuring to imagine that you can just switch it off or switch it on. "One minute he was just joking around, the next minute, wow, he was like somebody else." Some people can do that. Maybe they've done all that interior work and they're confident that they can make that transition in an instant. I take my hat off to them, but that seems stranger to me.

EILEEN: Frightening, in fact.

DANIEL: Yes, and yet what most people appear to be more intimidated by is the notion that you might actually want to enter into the world and stay there once you found it, even if it's painful and intimidating. You might just want to stay in there for a while and see what happens.

EILEEN: I'm thinking that performance is a weird combination of being very vulnerable and very powerful. At the height of the AIDS thing, there were a lot of poet memorials where we would all get up and read our friend's work. It was amazing because it was like putting on the bear's cloak and doing a dance. You knew the guy, you listened to him, you hung out with him, you heard him read his poems all the time, and then when you got up there, you realized you were trying to put the guy's body on, and it was very awkward.

DANIEL: I read the piece you wrote about Jimmy Schuyler in *Index*—about the reading he gave. I enjoyed that.

EILEEN: Thank you. That was one of the most incredible readings I've ever been to. It was really primal.

DANIEL: I used to go to quite a lot of poetry readings and I haven't been for a long time. When I was a kid I really enjoyed them. We saw more poets at that time, when my dad was alive. There would always be someone in and out of the house. Philip Larkin, a guy called George Macbeth.

EILEEN: Your dad was the Poet Laureate of Great Britain. What was he like?

DANIEL: He was a very sweet man. He had been smothered by his own dad, so he felt he had to ride his children on a long leash, give them a little more space than they wanted. I don't want my kids to have to miss me the way I miss my dad. The way I miss my dad is the way you miss a person that was not really there.

EILEEN: Was he busy or not there?

DANIEL: He was there, and he was preoccupied. The gist of it is that I didn't discover him, and I miss not having had that chance.

EILEEN: Do you like to read poetry? Who are you reading now?

DANIEL: I'm reading a book about the relationship between Matisse and Picasso, at the moment. It's part interesting and part not so interesting. I'm reading very slowly—not devouring it in a way I like to when I'm really onto something.

EILEEN: Are you dogged?

DANIEL: I am dogged but I kind of hate being that way. You should be really into a book, and read something else if it's not working. But I come back to it, page after page.

EILEEN: My girlfriend can skim. She just dives right in and finds what she wants. I'm like, "How can you do that?" I can't even skim a paper. I really am very nervous about the Sunday *Times*.

DANIEL: [laughs] You don't want to get into it—it's like a tunnel.

EILEEN: A tunnel of rage and irritation.

DANIEL: I was glad when somebody called recently and wanted advice about a poem that they were looking for. I hadn't read any poetry for a while, so I started looking through a few volumes to find something, and that was really nice. When you pick up a volume of poetry, you can feel the weight of it. It has to be an act of will for me to start, and when I do I'm always so grateful.

EILEEN: Do you believe in god?

DANIEL: I'm still not sure. I suppose I'm a die hard agnostic. I don't know. Do you?

EILEEN: I think I do, because I like the feeling of saying so. I grew up very educated to believe, Catholic school and all. I bumped up against religion again some years later, and took it on when I would take anything on. Then I just started to think, "Maybe I do believe." I like praying.

DANIEL: I never took the habit.

EILEEN: The habit of prayer or the habit of religion?

DANIEL: I certainly prayed from time to time, but it was not something that I was brought up to do. We prayed at school, but I had no real religious education. Most of my contemporaries in Ireland are ferocious lapsed Catholics who exercise as much energy in despising the religion as they would in staying with it, so it's a full-time job. I think I'm a pagan, probably. If ever I took to religion it would probably be pre-Christian, but I'm quite ritualistic about clothes.

EILEEN: How do you dress?

DANIEL: I tend to wear the same thing over and over again. I find uniforms. I don't know what they mean or what the intention is, but I find things that I wear until they fall apart.

EILEEN: You just drive it into the ground.

DANIEL: Yeah, and then there are clothes I don't wear at all. I've always been fascinated by suits. I think that has something to do with my father and my grandfather, who both dressed rather beautifully in thick, indestructible suits.

EILEEN: Do you possess suits like that, or in fact theirs?

DANIEL: No, I don't have theirs. I have one or two of my own. I had a pair of my father's boots, they were called Campus Leaders. He toured in the States, spent six or eight months here when I was very young. He came back with *The Freewheelin' Bob Dylan* and a pair of

boots, which actually look like the boots that Dylan is wearing on the album cover. I still have that record. My dad, who was already in his sixties, said, "You've got to hear this guy, he's a real poet." He just took to him. After my dad died, I started to wear those boots, and I wore them and wore them and wore them. I was heartbroken when they just couldn't be repaired anymore.

EILEEN: That's really great, wearing your father's shoes into the ground. As an actor, you get completely immersed in a reality that you can't go back to. Does any of it stay with you?

DANIEL: I think it does in a certain way—you recognize a quality that isn't yours and you explore it. Maybe there is something altering in that. It could be a system of ethics that isn't your own, it could be a metabolism or some lightness of spirit or nobility, or some psychotic rage. As much as it is like a fucking corset around you, it's sad because it doesn't belong to you. There's something that you borrowed for that time that is tremendously liberating.

(1996)

TORY

It swallows up everything I am, this box
This box a blood test, this box, an abstraction,
This box a coffin of sorts
That buries inside my body the antibody HIV;
My body's counterbody, the proof, nonproof,
A footprint, this root, merely a photograph of a root,
A photograph of a dead tree.

— from "Jade"

I met with Tory Dent at Chelsea Foods on 8th Ave., a smallish European-feeling restaurant, a mostly beige place with good food. The tables are close together, there's plenty of light since it faces onto the street. I taped our interview and I was instantly worried since there was no separation from the sea of small but constant sounds—our own eating and talking and that of our neighbors as well as the non stop light rock station playing oldies. I do like this place a lot but it was running interference and meeting Tory Dent was like that too. A slim auburn-haired woman, I found her almost over-articulate if that's possible with nonetheless huge gaps in what she was willing to talk about or thought was worth discussing. Then I became attuned to her style of severity and profusion. The balance was similar to that of her poems and I was already a fan. Tory Dent is a Ph.D. candidate at NYU, and she seemed by nature a scholar.

And a Pisces—she dives right in. "People with specialties in other centuries are bored by the idea that yours might be in the twentieth century." I chimed in that ours was a century of revelation. "Of activism," she added. "Very unrepublican," I asserted, thinking of a panel at the Donnell I had just been on. Composed of conservatives and progressives discussing censorship and after the conservatives had roundly trashed Karen Finlay *and* Robert Mapplethorpe *and* Julian Schnabel *and* Eric Fishl I had a sudden realization that it was the 20th century itself that the folks on the right didn't like. And if that was true, and by now they were discussing Michelangelo, why would they like its art? Indeed, and as Tory Dent surged ahead of my references and asides to explain her particular interest in the problems of female representation in art and the need for an examination of the political repercussions of redressing that kind of representation and a further questioning of what kind of political awareness … that might bring about change … she took a breath— "I'm exploring that topic to my heart's content." Her exploration (and for the purposes of this essay, I'm referring to her poetry, this book) is utterly fascinating because hers is not a 20th century mind, it strikes me, but one full of the past and its parables. Tory Dent is a self (and constantly) proclaiming atheist, steeped in Christian lore, an academic and a poet, "a straight white girl," and a seemingly diehard individualist who is living daily with the HIV-virus.

The poem I quote at the top of this piece, "Jade" is her book's penultimate. In it she uses the familiar trope of boxes in boxes and they function in "Jade," like a single stripe for art and time. Perhaps it's her background in visual art (which she's looked at and written about for years) but she uses her words as material, a thinking substance. Like Gertrude Stein, but in a fashion that's more about detail and self-consciousness, entrances and exits, more femme and less about pulsing along. So what we wind up with is this Baroque landscape of feeling. A word she uses that sums this feeling up is

"tenebrism." It's an illuminated melancholy or gloom that sur-rounds the jumble of trees, feelings—a quality of music that communicates the muted pain suffusing her representation of our moment. I think of this quality as her emblem, or web. And like all landscapes, she's in it. "My sense of ongoing assemblage." Like Stein she builds by repetition. "I read a lot of Robert Lewis Stevenson. He was one of my greatest influences. The childlike refrain. I had a toy desk," she recalled, "with magnetic letters and I would play with [them] for hours ... the red "m," the yellow "c." I was 3 or 4 years old. I don't think my life has changed much. I like to write critically, I like to write prose. I have different histories of practice. I don't see one being my favorite or my essential. Poetry pertains to everything."

In some ways I was more curious about how this book was put together, than anything else. The order of the poems is immensely satisfying. It opens with "Words Aren't Cheap" which is dedicated to Richard Horn (who died of AIDS) and she states what are essen-tially the two obsessions of this book: the love of words and the persistent truth of this poet's HIV status. That the book's first poem zeros in on its subject matter (mortality) by following the logic of AIDS in another, exposes immediately a sense of assemblage we're not often treated to in a first book of poems. "We don't know what its like / for the world to underworld into your enemy overnight" she sings and shakes a painfully unparticular meaning out of her friend's death: "it doesn't matter what you died of. We love instead as representative of you / the entire loaf of sky. / all specious things as if they were trees, / even the incredibly ugly skyscraper / because we regard it ... in the way and not in the way / you did." The slim tail of the poem flickers as it swims away. Leaving us with ripples of presence and absence, the deeper poetic meaning of this book.

What follows is a bountiful ride through some of the most exciting new verse anyone's written in a very long time. "Spared"

narrates the mundane though emblematic experience of having one's haircut. "My hair," she begins, "my hair ululates like a cut peony that only dogs can hear." It's cartoony, fantastic and abstract like the postmodern eye that moves through all these poems hedging and revealing. She poses the unreality of herself, as "shorn locks," against the "cruel and exemplary barber [who] appears mountainous against the cacti of my form." All the while clinging to her title like it's a life-boat—or a refrain. "When will I know if I've been spared? When I will I know that I won't lie / with a tube in my throat, the weight I was at fourteen years old / the KS lesions, leeches fulminating my body." Her rhymes clatter in silence, "my hair" growing insistently loud, rhyming with "spared." We are reading the construction of a life force in all its glory—a representation. "Let my hair grow livid and flamboyant," she trumpets. The bigness of her imagery is matched by an emotional gigantism throughout that sustains the immensity of the threat she's experiencing—"they've lined us up, *those people* [my emphasis] … counting every third person to be dragged out and shot." One is seduced early on by the spectacle of her … is there a poetic equivalent for mise en scene? And once "you're in it" her fantastic landscape, then the feverishly direct almost childlike questioning begins, the "when will I know," etc. This is not "AIDS writing," but writing *with* AIDS, so that the irreducible situation of being positive is given all the unedited dimension that it occupies in the writer's psyche. Her MO is expansionist, though it usually takes an absence as its starting place. One need only think of the source of her title—*What Silence Equals.* "Death" completes the phrase and it has been repeated on thousands of teeshirts and banners across the country since the mid-eighties.The minimalist aesthetics of activism (which grow flamboyant through numbers and mass gesture and the demand for access to the message machine of the media) are taken up and toyed with, flung, stretched and amplified by a single artist with a vast

imagination. Tory Dent was quite clear in our conversation that for her, writing, which *includes* writing about being HIV-positive, is her healing *and* her activism. "HIV is being represented more and more in the media—Jonathan Demme. Society is caught in this conundrum where they think witnessing is actually activism. 'Oh now we're getting a closer more realistic sense of what it actually must be like,' so that they think they're *actually* doing something about it. People will have a sense that it's the past when it's actually happening right now. It's a nostalgia genre. I tested HIV positive on April 12, 1988. Over a payphone. There's no part of my life partitioned from it, there's no part of my life liberated from it, not the part of me that's straight, not the part of me that's a woman, not the part of me that's a writer, not the part of me that's someone's friend, not the part of me that's someone's daughter … I'm just waiting to get out. Death is not my idea of getting out. I'm not just waiting for the vaccine. I'm waiting for a degree of social awareness. I've seen the degree of knowledge change, but I haven't seen the degree of fear change, very much."

"How powerful am I, Doctor?" It's eerie, her persistent voice with its mixed qualities of irony and straightforwardness. Throughout this book Tory Dent has strewn tales of punishment: doors with rocks piled upon them pressed on witches' chests, and the word "noyade" (one condemned to death by drowning) occurs twice here. The disaster-prone landscape oddly buoys up an effervescence of hope or at least a strong sense of waiting. Hers is a melodramatic verse yet its punched through with holes so that every image has its opposite raining through—"the consultation room blurs around us as for a noyade / does the ocean." A place of "hope," a doctor's office, becomes a chamber of horrors, yet this tinny, echoing female voice presents a challenge to the fortress of Western medicine. "You who know and do not know the body, how powerful are we …" By naming all her worst fears, plucking disasters out

of history—plagues, tortures—and linking her own dilemma to them, she is historicizing rather than romanticizing the condition of her life. She's "de-othering" herself, by contextualizing her suffering and gaining power through the breadth of her vision. The permissiveness of her darkness is strong.

In "Accidental Poetry" she's written the prototypical Twentieth Century poem. She starts with an inventory of tiny damage: "Countless pinpricks mar the body a hundred years ahead of their time / Parables break like wet sticks, torn ligaments." Through an arrangement of sound (sticks, pinpricks) and meaning: small breakages, we segue into a more modern skein of things, action: "I talk on the phone, jot a memo, communicated to you what I mean, the blameless arena where as spectator / I participate in the Christians thrown." There's a brisk consonance, where ancient signs and modern methods of "reaching out and touching someone" merge into a single sign for communication. Which Tory Dent uses to skid to martryology again. There's a sanitizing of horror, a loss of affect in our century which is subsequently being ripped wide open, gutted, in order to understand ourselves and our new dilemma. Tory Dent is quietly at the helm of these kinds of efforts. She sort of a hostess of hyperbole. Moving her poem along, she proclaims, "So semaphoric systems flail in the twilight." Twentieth Century boring? Our options are limitless and breathtaking: "While I, a seraph fated to fly backwards in order to move forward / like Hebrew or the helical structure of DNA, / concede to the holy, to the literate, to the blank; / to the dead animal who, in my flying, I'm fated to imitate."

"Only Human" is a curious phrase at best, but on a day when the cover of the *New York Times* showed a photo of thousands of humans trampled by their own fleeing kind it's a welcome relief to see it explored piecemeal in Tory Dent's poem of the same title. Her "Only Human" is a poem of betrayal, addressed to an absent lover whose defensive litany ("I'm only human") gets bandied about.

"The older I get the weirder I think people are frankly," the poet admits. "The more like animals who herd suddenly away / at the slightest stir from the bush. It was the way I changed hallucinically before you, / my wool-colored hair matted and graying, / my blue eyes circling like crazy dice in my head. / All that materialized before you was somebody HIV positive, another one of those silhouetted figures interviewed on David Susskind." She plummets through all her languages: journalese, scholarese, tough girl speak, so intent is this poet on getting it right. All her practices momentarily come to the fore in an assembled attempt to scale the peaks of an emotion, to keep pitching forward relentlessly until the entire effort is essentialized into a single thing, "like a bottled note ejected on a deserted shoreline."

"If you cut off my ears I will listen with my eyes. Not unlike the commonfolk / plucked from the village arbitrarily,one late December night, / stripped to the flesh and heaved high into the freezing air / upon a whittled stave, tall and sharp, thrust deep into the asshole / they die by degree, ever so slowly and often only / (if not by freezing first, which if merciful, God deems) / when the wooden point finally pierces the brain, brain-dead already / from the mauve anticipation and ear-splitting perquisite of pain." (from "The Murder of Beauty / the Beauty of Murder") There's nothing like this in the poetry world. There was in the past—Gongora, parts of Mayakovsky. In the world of visual art there's Millie Wilson who constructed a show designed to elucidate the public fascination with the lesbian serial murder, Aileen Wuornos and Wilson's show contains a piece, a plastic pyramid for sitting on which was used to punish so-called witches. Simon Leung, a conceptual artist, is obsessed with pin pricks: on the body or paper or in the walls of clubs that cater to the desire for anonymous sex and there they're called glory holes. The moment we are living in is full of the groans and shrieks of a culture at sea with questions of love, sex, disease,

and desire, how do we differentiate them and do we need to. The sirens we hear, women, homosexuals, and all the pioneers of our time, are calling for a culture big enough to contain or embrace or encompass the shapes and needs of all our bodily destinies. It demands an extravagant poetry. Like Foucault, an oft-cited hero of these same communities, Tory Dent charts her own waters. She's a poet of brilliance and shadows, philosophy and fragmentation, of less and ness. She is the new museum and she is its docent. She's the bottle and the beach, the poem received.

(1983)

THE SONNETS

Innocence gleaned, annealed!

anneal-to free from internal stress by heating and gradually cooling. 2. to toughen or temper, as the mind. 3. to fuse colors onto by heating. To kindle, to burn, akin to fire.

"You know, I find this book incredibly sad," I said, waving my copy of *The Sonnets*. "I always did," he replied, "but I thought it was me." I walked around conversing with Berrigan one day and it was the perfect day for it. Universal Limited Art Editions was doing a show of their first ten years. I saw *Stones*, the O'Hara / Rivers collaboration. "Poetry belongs to Me, Larry, *Painting* to you ..." The flipness of O'Hara, Berrigan's light-footed hero. "I like to beat people up." Heavy. I never beat people up. Oh, he was just kidding. I know, I know, it's a variation on a line.

"See, see, and this one with Williams in it, you take the middle lines, yeah, those two, and then you read the ones in back of them, yeah, those two, and it's really a regular poem, it's very straight-forward," I was told proudly. This is a few years ago and someone *very* informed was just getting warmed up to telling me where every line in *The Sonnets* comes from. "*Some* I was told," he boyishly admitted, "but others I found!" "He stole all those lines," someone else informed me. That really changed my life.

Now when I see someone's library the first thing I want to know is "Did you buy these?"

It's interesting if you compare O'Hara's vividness, his being-in-life, to Berrigan's "Now I rage in a blue shirt at a brown desk/ in a bright room." It's like Buck Mulligan's tower in *Ulysses*. First I read the book, then I saw the movie, then I went to Ireland and saw the tower. When I look back on it it's the movie I'm seeing. Andre Bazin calls movies a plastic art like a death mask and peculiarly that's the kind of art I think *The Sonnets* are which is why they strike one as so oddly sad. I think I was thinking when I was ahead. They're monuments written by a young man walking through the graveyard of literature. And if you talk to Ted Berrigan about *The Sonnets* today you'll find that unlike talking to most poets about something they wrote 20 years ago you'll find yourself talking about something strangely alive that he was certainly there for like when Boston beat New York three to one. *The Sonnets* in reading and rereading always possesses that terrific smack of impersonality, absence of passion, principles, love … *Ouch*, who wrote that?!

(2001)

JIMMY: JAMES SCHUYLER AT DIA

As an institution, poetry is a drag. Always I am reminded of the words of the great James Schuyler: "I think anything that's all poetry is boring, don't you, babe?" And Jimmy gave his first reading fairly late in life, at the old Dia, the most unforgettable reading I'm sure I'll ever be at. Imagine New York's finest singer has never worked live. Everyone from near and far was lined up on Mercer Street that Spring night in the late '80s to hear those poems aloud for the first time. Jimmy was shy. I guess that was it. And he was a genius, our genius—that feeling radiated in the smiles and fiercely lit eyes of everyone leaning outside the building smoking and waiting and greeting each other. It went without saying that we were about to get something that had no relation to obligation.

The night was pure bliss. We flooded in, and the room filled rapidly. There was a wash of blue light behind Schuyler, who was sitting on the stage like a big bullfrog. He was kind of tubby at that time in his life, with dark overgrown eyebrows. He read in an ordinary way, and everyone who knew him already knew his voice, and I suppose some had come to hear just that—only knowing his poetry, not knowing him. The room was so comfortably defined as a cult, the cult of Jim. The reading wasn't short, about forty-five minutes long. But he read some of my favorites, and they all sounded grand—though immediate, no special effects, plain diction. The strangest and loveliest moment was the end. He

stopped and smiled, and we began to applaud. And we continued. The fullness of our pleasure was this pounding surf of delight. It went on and on, like a line that stayed constantly at the peak of praise. It seemed we would clap all night. He smiled, and his smile collapsed, and we went on. He smiled again. We wouldn't stop. He looked away, smiled out, and the frantic pink energy of human explosion filled the room. We didn't know how to get out of it. The feeling was free. The line, the tide, stayed high for maybe ten minutes. It was the longest applause and the most unconsciously glad one I ever heard in New York.

(2001)

TODAY'S POETS: ALICE NOTLEY & ANN LAUTERBACH AT DIA

Today's poets were Alice Notley and Ann Lauterbach, compatriots for years, though you really couldn't find two women from the same world doing it any more differently than these two. Alice is like a raving desert flower, a mad, lamenting, essentially 11-year-old brat in the middle of her life. Ann is cool elegance with a glint. She won the big award, the MacArthur, and you think about that when you watch her read.

Ann directs the show with her left hand. It's a tic some poets have—it's like, have you ever watched that weird mouth thing bass players do? Stand-up bass players. Eyes closed, lips twitching, widening and pushing into some imaginary genital in the air. Are they chewing? Nursing? Is it some kind of mathematical fuck farm? Ann does this conductor thing, which is to pinch her index finger against her thumb. Kind of constantly, so you get this picture of her describing reality in a very stitch-by-stitch way. It's like language comes tumbling out too fast, and she's trying to direct traffic. I myself only do this at the curves, so I won't tip over. Ann is keeping time, and there's a lot of it.

I forgot to say that before the show began, Charles Bernstein did the introductions. Charles is like the King of Language, a poetry movement he and Bruce Andrews invented which essentially means "Keep the bodies out, mind is talking now." He wore a black and white plaid shirt, and he made a joke about the design of the room.

Dia designs everything—Dia's rich—so no space is left uninflected by high-end art.

Jorge Pardo did this, explained Brighde Mullins, the uber-madchen of the Dia poetry scene, he designed the space where the reading was held. Brighde is a remarkable curator with untrammeled poetic taste. Dia's poetry mansion belongs to no school, it seems. So she introduced the art, and then she introduced Charles, who made some bad joke about having also been designed by Jorge. Ann Lauterbach made a crack too. Poets are so competitive. The room had a glistening tiled floor with mild orange bricks, and pale green ones, and yellow yellow yellow. It felt like rest period in kindergarten, and a bug, a small black bug with wings, strolled from a green tile to a yellow one while Ann read.

Ann's hair is crew cut and boyish. Her glasses are half-moons and root-beer colored. She's constant, her music, she fills the room. I think her work is pure conjecture. I feel like she's trying everything on. At one point she says that something in a poem is anamorphic. Which means a gleaming object in the foreground of a painting that you realize, when you stroll to the side, is a scary skull. Aha! That's what Ann's going for. A sneaking inference of death. I feel suspicious of a class act, but when I hear the notion reinforced, even if it's out of the corner of the eye, that everyone's going to croak, then I say, "Alright, Ann, keep stitching."

Alice, I have known since I was two. She feels that way. She's been through hell lately. Just lost her husband, the poet Doug Oliver, and not that many years ago Ted died, her first husband, Ted Berrigan. Like it or not, all of it adds to Alice's air of authority. She is our Jackie Kennedy. Alice uses the world in her work in loose, hysterical grabs. When she was a young mother in Chicago twenty years ago, she wrote a book called *Alice Ordered Me to Be Made*, which took her baby son's pink skin, some baby babbles and lost mittens, and swiftly tied it all up with a chill Chicago wind, and you

thought, "Well I guess everything's poetry if you know how to say it." She does.

For a while, Alice was my teacher. She is also everyone's older sister. Her hair is black and dappled white. Kind of Pan, I think. And rather than having a skull for a muse, she chats up Robert Mitchum. There's a conversant quality to her work, her voice warbles just as Ann's indicates. The "other" is always pleasantly in the air, some butch guy pushing back on her assertions, but she's unstoppable and torrential this night.

And how about us? Well Ann held the room captive, kind of in awe. When she walked away from the podium, it occurred to me that she has the best "I just did something good" grin. Whereas Alice, who I thought demanded a lot more—often she becomes wildly incomprehensible, pushing listeners way beyond the normal expectations of an audience's patience and stamina—left the podium giggling, "I just did something bad." Alice doesn't give a shit, which among today's poets is a beautiful thing to see.

At the dinner afterwards, Ann told a story which opened the possibility that she may have slept with Bob Dylan some time in the distant past. Her eyes said no, as she could see I was growing excited at the thought, but still I'm not so sure.

(1993)

THE ART OF THE REAL

Ntozake Shange's new book of poems is a sexy, discomfiting, ener-gizing, revealing, occasionally smug, fascinating kind of book. "She's like Patti Smith, isn't she?" Joseph, a young poet I met in Boulder this summer, exclaimed. It was a connection I hadn't made and yet it explains something else about who Shange is, besides being the poet who made it big in the mid-'70s with her Obie Award winning play, *For Colored Girls Who Have Considered Suicide When The Rainbow Is Enuf.* Is it poetry? I wondered when I first encountered her work in a small but crowded reading upstairs at the Gotham Book Mart in 1975. She sounded great and she looked great and a few blocks away at the Hotel Diplomat Patti Smith also looked and sounded great. Smith, I was convinced, was poetry, though my roommate's boyfriend Herbie adamantly disagreed. Today I'm not so sure about Patti Smith, but Ntozake Shange's new work evokes in me a profound yes.

All of the poems in *The Love Space Demands (a continuing saga)* take up with the world. The riveting *crack annie* takes on the news, a crack mother who sacrifices her seven-year-old's pussy to her dealer, and the lead poem of the book, "irrepressibly bronze, beautiful & mine," was written to work with Robert Mapplethorpe's *Black Book.* It dives in unabashedly: "all my life they've been near me / these men / some for a while like the / friend of my father's who drove / each summer from denver to / st. louis / with some different / white

woman." The abandonment of the black woman by the black man is the bold angle from which Shange broaches Mapplethorpe's portraits. She looks at these men with admiration and lust. "look at me pretty niggah," she says. Is it whiteness and homosexuality he's leaving her for? Is that what she's saying? She moves on to "even tho yr sampler broke down on you," a poem that mumbles in your ear as its eye grazes the rushing landscape: "(you know where my beauty marks are / all / over / HARLEM)."

In *intermittent celibacy* she rears up with "all i wanted / was to be / revealed. "abstinence / is not/ celibacy," she explains, "cuz / when you filled with the Holy Ghost / every man/ in the world / can smell it." *if i go all the way without you where would i go?* is as formidably persuasive on sexual abstinence as it is wildly Whitmanesque about its opposite. "i open / deep brown moist & black / cobalt sparklin everywhere." In *chastening with honey*, she further expounds wiseguy spirituality: "like the Passion of Christ / which brought us Lent & we give up meat." Who are *we*? Whose poetry is it, so supremely confident, that its "I" or "we" can finally vanish into the nightmares of the urban landscape, from there smiting the reader's sensibility with simple reportage. Ultimately, she's taking on the work the media won't do. And she's written an unconditionally sex-positive book which suggests that having control of both the yes and the no switch constitutes real power.

I dialed her number and a message which I heard several times before I reached her warmed me for this interview: "Apparently Emmett Till was, uh, physically challenged and could not possibly have said what he said to whoever he said it to and therefore died for no reason. For the same reason Clarence Thomas might be appointed to the Supreme Court. We won't dwell on that. Leave me your coordinates. I'll get back to you as soon as I can, given the desperateness of our situation. Thank you."

EILEEN: How do you feel about living in America today?

NTOZAKE: It's hard to get out of America. Where are you going to go? The only places left are under siege. The people there don't have enough food for themselves so it's not very good to go visit. Click. Hold on I've got to get my daughter's pizza. Click. I was reading in *Granta* that there are these travelers going through the heartland of America using the same kind of language as Conrad, like "wasteland" and "emptiness" and "the natives." In a way, living in America is like living in the rest of the world for a change.

EILEEN: In New York they're shoveling up the homeless, like in Tompkins Square Park.

NTOZAKE: Oh, they're locking up parks now?

EILEEN: Yeah.

NTOZAKE: It's just abominable.

EILEEN: Particularly ones where people live, or underpasses. The highway, developed places where the homeless have fixed up electricity. The thing that's weird is they're acting like it's not India and it is.

NTOZAKE: The hostility of the Republican government—to be so heinously oblivious to people suffering all over the country—is astonishing.

EILEEN: What do you think the artist's job is?

NTOZAKE: To keep our sensibilities alive so we aren't numbed by our struggles to survive. That's what I think our job is right now. To keep people alive so they know they can feel what is happening as opposed to simply trying to fend it off.

EILEEN: Are you happy with how you're doing it in your work?

NTOZAKE: I'm doing things I like to do in my own eccentric way. I'm doing a performance piece on the Ben Franklin Bridge [in Philadelphia] that's about urban female rituals with my mother's bridge club. I'm running the bridge and I'm having female deities— Sounds in Motion and Urban Bush Women—doing oblations for me as I run by.

EILEEN: Literally, your mother's bridge club?

NTOZAKE: Yeah, they're going to play bridge while I run around.

EILEEN: Are you getting any public funding?

NTOZAKE: Oh, no, no, I'm sort of funding it myself, because it was a whim that I did it on and it was less cumbersome for me and I don't have to explain or ask anybody.

EILEEN: Is this a feeling you have about this particular piece or do you have any sort of politic about that?

NTOZAKE: I don't want any money from the National Endowment right now. I don't want to get engaged in a conversation with somebody about whether my work is valid. I'm not having that conversation. That's not how I'm spending my time.

EILEEN: How has your work changed? You came into prominence pretty young.

NTOZAKE: Yeah, I was 25. I've gone back to being more like myself. I'm not taking commissions to write plays because I don't write plays. I don't want to write plays. I'm working on my poetry with musicians and dancers like I originally started. That's one reason I'm happier than I was for awhile. When I do things for theater I make sure I'm taking as long as I need, as opposed to doing things in one season, which is simply not enough time for me.

EILEEN: How old are you?

NTOZAKE: How old am I? I'm 42. I don't know why you want to know.

EILEEN: I'm curious. I'm 41. It doesn't have to be in the piece. At the front of the book they have a list of where you publish your poetry and it seems that you make very specific choices about where it lands.

NTOZAKE: I don't have a great need to be the one black feminist writer in something. I spent my whole educational life being one of something. I find it very isolating, in some ways embarrassing. I like being surrounded by work that supports mine. I don't want to be next to people who believe that black people can't read or write. I don't want to be next to people who believe that. I'm not exceptional. I'm just like all other black people. It's a kind of appropriation I don't want to experience.

EILEEN: I was confused by something you said in your introduction. "Our behaviors were just beginning to change when the epidemic began."

NTOZAKE: I meant that where women could actually be sexually adventurous, be demanding or even know what we wanted to feel—that was beginning to change. When AIDS crept up, then all that got pushed away again, because if you know too much about it then you've been doing something—you're dangerous. Our pasts have become liabilities. I've had people ask me the most strange questions. They go through these litanies of names of people who they've decided have led reckless lives. Have you had anything to do with these people? Then you want to creep back into your virginity, or something to make yourself safe in love.

EILEEN: One of my favorite lines in your book is: "we colored & in love / we in mortal danger / i don't bathe in wildflowers / for nothin."

NTOZAKE: That's the other half of *Boyz n the Hood*—all the murders and all the pain. They're not having sufficient ritual. They're not having beauty to sustain themselves through it. That's why I bathe in wildflowers. So I remember there's something precious about me and those around me.

EILEEN: How did the Mapplethorpe poem happen? How did it work?

NTOZAKE: They asked me for a poem and they sent me all these pictures, hundreds more pictures than they used. I saw a lot of pictures that you all didn't see.

EILEEN: Part of your poem seemed to me to be about black men abandoning black women. Then I thought about you looking at Mapplethorpe's photographs, which were black men, through the eye of a white male photographer.

NTOZAKE: I like Robert's work a great deal or I would never have agreed to do it. I get very indignant when people suggest to me that there's not virility in black gay men. That's one of the reasons that I wanted to keep it in a sexual reading where I felt very comfortable. I also wanted to let us know that just because somebody doesn't love me doesn't mean they're not black or that they're not a man or that some sense of loss can't be acknowledged. To acknowledge loss, to acknowledge reality seems to be a pretty reasonable achievement that we can all enjoy without having to feel left out.

EILEEN: There's a lot of good work in this book but the "crack annie" poem—you can't stop reading it because it's completely frightening.

NTOZAKE: Very scary.

EILEEN: The story, was it something you heard or was it something you made up?

NTOZAKE: There were two newspaper articles. One in the Newark newspaper and one in Detroit. In Detroit, there were two women who had three children between them who had given these children away to dealers regularly, and in Newark there was a mother who only gave her child to her drug dealer. I thought if I see two separate articles in one season you know it's going on all over the place. I felt compelled. And secondly, they were such little tiny things, tiny kinds of articles that make light of our lives and trauma that I wanted to give them breath, till we would really have some understanding of the vicious situation these women and children are living in.

EILEEN: It's not the kind of poem that makes you want to talk about poetry. Actually, it seemed to create a dialogue about being in the world.

NTOZAKE: That's what art should do. When we listen to music we don't sit around thinking about how you play saxophone. I would rather you not think about how the poem's constructed but simply be in it with me. That to me is a great compliment. That's what it's for, not for the construction, even for the wit of it. It's for actual, visceral responses.

TALKS

(1999)

HOW TO WRITE AN AVANT-GARDE POEM

I found myself thinking about a water fountain. In maybe 1982 my neighbor Chuck was cleaning his apartment and he showed me something I had to have. Actually Brian knocked on my door and said I'm sure you're busy working on something really important but you ought to go see Chuck's water fountain.

It was green, that green-flecked-metal that maybe x-ray machines are made of. It shimmered in a dull way. It was a corolla of petals in the shape of a big serving bowl and it peaked in the center. It had a plug. And it was ready to go. Watch he said and poured a coffee mug of water over the top. Temporarily, a screeching sound emerged from the bowels of the metal flower. Errrrk! Like it was really trying hard. Then a spout of water emerged from the top. Then it was weirdly cascading from all parts of the flower, spouting proudly from the top, but whirling around, plummeting in small rivulets, whorling around and all of it, the water, falling neatly within the perimeter of the bowl. It was an indoor water fountain. A working class one. It was my grandmother's said Chuck. One of the family jewels. And now I give it to you. You're kidding. Do you want it, he asked. Absolutely.

It became the sole entertainment in my apartment that year. People would come over, generally to get drunk. Everything else was broken, stereo on top of broken teevee. Basically, I had couches, my bed, and this wonderful fountain. Once I had someone come over

to cut my hair. Let me show you something great, I said, slightly embarrassed to show an outsider the poverty of my home. I poured the cup over the top and it was very slow that time. It strained hard, screeching low and desperate. Uh huh she said, unpacking her scissors. Hang on. All I could see were the walls of my apartment, the noises in the halls, and this. Green. The reluctant miracle. The water triumphed and came twirling down, wetting the dull leaves. So what are we doing today, she asked, looking at my head.

When I first started writing poetry I thought it was a miracle that I could stay home and tinker all day with two words, or three. The absolute minimalism of my project made me think of Thoreau. There was a grand and humble freedom, something utterly wild and private about not going to work, and if the phone rang work stopped and I could go out for days and return to the miracle of the poem emerging word by word on my typewriter. Poems stayed.

Because the light poured on the sheet of paper and at night the poem hummed under the kindness of a single light bulb it always struck me as a live thing, this invention, the avant-garde poem. Synonymous with the day, or night, exactly as long as me. Interruptible and pure, the form being as complex and simple as my experiences. No thought was too grand to commingle with the street, if someone came by and offered to take me to breakfast. The point of interruption, I learned, was the body. That if I kept thinking too long, the poem would get buried in decisions, it would lose its precious access to breath. Down the stairs the legs would go, and I imagined us, my companion, as stars in a movie, an independent one, and we'd eat food and I'd go home, filled with new thoughts, and my accounting would continue, or begin, fresh.

Sometimes I stayed in for days and days, and what renewed me was the precise dimensions of the buildings I lived in, in New York, first one in Soho, then another in the East Village, both very cheap. After having grown up in the suburbs with one set of noisy neighbors

who intrigued me and the years of loudness and then silence in my house I now was the overjoyed witness to urban immigrancy up close. Howls of my neighbor's procession of boyfriends, the band practicing downstairs, the syncopated groans of our plumbing. And later, birds, years and years of them as I lived next door to a cemetery, and someone smoked upstairs on the fire escape and chatted softly with someone else and the toilet flushed. All these sounds were riveted in my heart for moments and years and years and they became the emblems of my freedom, sameness and silence. A distant dog.

What I liked was the rectangle of my window. There were two of them, but I only remember one now. Once I looked down into the cemetery and it was October and I had lived here since May and I had just fallen in love with a girl, and the leaves had fallen in the cemetery and a statute of the Virgin was looking up at me, her hands in prayer position, and a chill of destiny and acceptance echoed through me. I unified poetry with prayer. And sexual destiny, in that moment. I've never understood how anyone could write poems separate from their sexual persuasion, with anything else, in fact. At the same time I can't imagine how my lesbianism would separate you from me, no matter how your sexual energy squares itself with the world. If you follow the exhortation to Kandor, which I believe.

The day is square, long and thin, like a window, or door. Across the cemetery was a wrought iron gate, and a street, and as I mention leaves blocked my view, and even they in some seasons were interrupted for one small stretch on Second Street and I viewed that small patch of absence and fullness, a square or two of concrete from my bed. Flicker of car, hands held, laughter. Ukranian bells.

And always leaves, leaves, leaves. There is one primary source of light and heat on the planet earth. It is the sun. It's a big bowl of

hell, an eyeball, a snoop. It preys down on earth, and the earth spins and in relation to its gaze the earth certainly in the North American part that I know responds with leafiness, and I still don't understand the wind, but the leaves come and go; the presence of leaves jounce in the wind, causing the experience of the day to flicker, thus in the twentieth century, we got film, the art experience that most approximates movement.

In the century that kills the most, that's ready to end, that invented systematic annihilation of one part of its own species and then another, dropping bombs, incinerating people, methodical slaughter, then invented malls, Banana Republic, Toys R Us, we have also duplicated life so that we have the technological capacity to preserve the voices of the dead, and for instance my aunt with the home movie camera made us stand still in front of churches and then wave while the traffic moved, and of course she's gone and my cousin sent us one of those compilation videos of my family with Barbara Streisand singing *Memories* as my Dad who I haven't seen for 38 or 39 years, he's the absence for most of my life, Dad walks by.

The division between the famous and the ordinary is slightly gone. My friend Tom comes from a family of actors so when he watches *The Searchers* his whole family, his dad, his grandmother, his uncle, Paul Fix, are all galloping by. I used to think how strange to see your family, or even yourself as forever young. How many times last week did we hear young John say on television: I am aware that I share my family photo album with much of the world.

In Provincetown I have a long rectangular window. As usual 3/8 of it are trees. Trees, trees, trees, yay trees. The paws of the part of creation that haunt me—

When I was in my 20s at St. Mark's Church one of the original Beats, Ray Bremser, in late middle age, probably mine now, 49, was barely sitting on a chair, then tumbling to the ground, getting up again, and beginning to incant his poem again: I am a tree, I am

a tree, I am a tree. He was so drunk, and all of us, in our poetic babyhoods, were thrilled and chilled. He was us, he was my father, he was everyone. Some part of all I'm talking about, and I don't mean alcoholism, though that's part of it, I mean the fragility of the tree outside my window, the gentleness and the power, all of it is unprotected.

Just like John went plunging into the sea like a needle, and a friend of mine, a guy named John and his girlfriend Judy, were riding in a car one day were inconvenienced by a truck carrying a load of wood and their windshield was smashed by lumber that broke from its lashing and Judy was driving and it hit her in the head and she was brain dead and then Judy died.

There's huge fear in the middle of my life that I must button something up and I can't. I won't. It stays open as much as I can.

At the A&P I bought this pink and yellow and green and blue seven-headed pinwheel on a stick and I plunked it in the window and it spins like a tiny film, it's a toy it's terror.

We used to go to Walden Pond when I was a kid. We called it Lake Walden. I was never much of a swimmer, but still I'd go out with my friends to the rope. Those red and white things bobbing up and down in the pond. My friend Mary had a really big nose. You know that drawing of Kilroy. It's like this. [Draws a straight line, draws a little head, and a nose hanging over. It says "Kilroy was here."] What does that mean? My father brought it home from the war. I would open my pad to show him my drawings and he would look and go hmm and then he would say Eileen can I see your crayon. He would make this drawing again.

So Mary and I are treading water and I see Kilroy in her. Her huge nose bobbing on the surface of Walden Pond. It was like my whole life came together at the moment. The tourists we had seen for years walking the path around the pond instead of swimming

like us. We knew that they saw *us* as "the local people." They were walking to the hermit's house. We were swimming in the brown waters of the pond that would be closed in a year because it was dirty. Mary Hill's big nose. I was drowning. I was laughing so hard.

What's the matter she said. I was gulping water. How could I say your nose is so big, you're Kilroy. I gulped more and more water. I was dying laughing. This was it. Mary was laughing too. She was such a strong swimmer with her WSI and everything. She couldn't save me. I was going down. She screamed help help. She was laughing, I was laughing too. I was saved. What were you laughing at she asked, when I was panting on the towel. I can't tell you, I said.

Nature's not real to me. We had trees on my street when I grew up in Arlington. Big waving lilac trees up and down Swan Place. There was a park I went to and I saw butterflies and we'd kick the bushes on our street and catch grasshoppers. But it was all divided up, it wasn't profuse. I'd read in books about Nature. The planets and the stars, rocks. I never dreamt of getting close or having work inside nature, milking cows, or else walking in the mountains, having lunch in the hills, long days in fields that never ended in the past.

That was the 19th century, it seemed to me—nature, the place that had it. It seemed the past made myths to organize the profusion of it, the scary thing of animals and people constantly dying at the hands of it. Nature was a big beautiful dangerous thing. We saw it in movies. It wasn't real.

Despite the fact it had nearly killed me, and I had watched the death of my father, or maybe because.

We'd go to the beach in the summer. Even near Cape Cod. We could go out on the rocks and at night in our beds we could hear the sea, but we had to go home, to Arlington. To our parks.

Actually we went to Cape Cod once a year. We'd drive over the bridge and almost right away my aunt would go, there's the Kennedys. And once Aunt Anne actually went into the trees around

their backyard with her movie camera and her telephoto lens and shot them having a party on the lawn. We have Jack Kennedy's brown head. Plenty of leaves it's fuzzy and then the head again. She got stopped, but they let us keep the footage. When I heard about the Zapruder footage, you know those few accidental feet of John F. Kennedy getting killed, I thought oh great. My family's got the footage where he lives.

The thing I'm getting to is that a poem is nature. Part of my mind, that whirligig that sits by the window and spins. Continuous. I looked the word whirligig up and indeed, it's a turning job. But I mean your whole life becomes a turning job, not just the poem. The poem is just a little piece of that. The guy falling off his chair going:

I am a tree

I am a tree

I am a tree

And I took a piece of that.

One of the things I have to say about the 20th century is that everything is recorded. I don't want to go into that, but it's a big part of the meaning of the avant-garde. We know abstraction in some ways has to do with the camera. Because we can just take pictures of something, artists decided they should be making pictures of something else. Expressing a different relationship to the world. I'm talking about seeing, but it's also true of hearing and if it's true of the camera, well it's true of the telephone, and the tape recorder too, seeing and hearing both: movies, like I said.

The earlier poet had this idea of a lyre in nature, a stringed instrument that nature strums. Wind hits the strings. I am also that.

But I am recording and editing.

I told you about my long gone building in Manhattan. The sounds of twenty units tattooed on my skin. And that's an abstraction.

A 20th century abstraction. More than needing any of those sounds ever again, I have recorded them.

I have this rectangular window on Cape Cod. The 3/8 of trees, our house on a slight promontory, so all we see is roofs, wires and antennae. Sky and clouds. I begin.

Avant-garde means do it yourself. It's ironic, of course, if you consider the antipathy in America to experimental art, to the avant-garde. Yet every fool wants to build a house, has a Reader's digest book about doing that, Martha Stewart, it's so American to think you can figure it out alone. With a little help from your famous friend. Buy some book at the A&P. Where everything comes from.

I read this talk by DeKooning once where he said that because he was European and was depressed by the notion of guilds of painters, and salons, clubs which controlled the dissemination of knowledge, skill, and prestige he was now in favor of the notion of amateurism. That an artist should never become professional. I agree.

The American tradition of do it yourself, of permanently insecure and self-taught.

In graduate school where I went for ten seconds I learned in my Linguistics class about dialects. Our teacher was making room for black American dialects. I don't know if this was a black American idea, or a white idea of whose dialect we would acknowledge first. This was 1974. She said that black dialect was English too.

Also in New York I heard poetry. Poetry that spoke. Frank O'Hara sounded queer, and ultra-intelligent. He said "Lana Turner, we love you, get up."

The same part of my mind that didn't want to tell my friend that she had a big nose and looked like Kilroy, that would prefer drowning, would also not want anyone to know what she sounded like. Who she was. Like home movies of my voice. But if it was good to be black, and sound it, and alright to be an urban queer like Frank O'Hara, then it was probably even alright to be from Boston

and talk like that. Andy Warhol sounded dumb. And that was good. I had language. The avant-garde tells you to use what you've got. That's why we've got a lot of sculptures made out of driftwood around here.

And after I learned about dialect I learned about idiolect. Among the black people who had a dialect there would even be a family and they would have their very special family black English. In this I learned that the baby talk we had practiced in Arlington—see in idiolect, the baby rules—in our house my sister couldn't pronounce "p"s and we had a word, "nakin," with which you wiped your mouth. My mother and sister don't speak at all today and if I asked my mother for a nakin over dinner I could definitely make her cry.

An upper-class version of all this is "Yaddo," which is merely baby talk in that family which endowed the artist colony that bears that name. I think about the way lovers talk in bed—and sex talk, all of it, how the repetitions get you higher and higher, and then the profound silence, even briefly at the end.

I live with the situation of a one-year-old dog: no barking. Every time someone walks in the driveway, Hoover runs to the fence ruff ruff ruff and Karin says no barking. She'll be standing on the porch on the phone. She'll be like, if I can send this to you tomorrow morning, no barking, thank you so much. Yes I do too. Click. Hoover no barking.

Now let me put this whole situation on the beach. I was dying to go to the beach today so maybe in my talk I can go.

Though maybe for one second I'll talk about John Cage, who probably next to Gertrude Stein is the most important man in America. Ever. Well maybe Thoreau. And Rube Goldberg. Do you know where I'm going—these cranky machines—my made-up language—a made-up nature?

John Cage used everything. After college he played piano for a bunch of dancers. For one thing he noticed they liked his new

compositions better than composers did. And that's avant-garde. Playing to a different audience. Even with the wrong instrument. Your own profession might give you awards, but other artists, other people will hear you. Which do you want.

Both, probably. Immediately John Cage imagined bodies when he wrote his music. So he used them. Did you ever see a John Cage performance. Or a score. Those utterly calculated pieces where at 15 seconds a man drinks a glass of water. At 32 we hear the tinkle of ice cubes. He orchestrated the chaos we see and hear everyday. He literally understood his materials. But the John Cage genius was silence.

He was at Spoleto at a festival, performing one of these theater compositions. At 47 seconds—see, he created a huge and intricate map for his piece, the score—at 47 seconds a radio was turned on and absolutely anything would play. That's a large impulse, right.

It was a festival however, and everyone went long, really long, so by the time it was time for John Cage's piece, 47 seconds into that the radios were turned on, it was after midnight and all that was on was silence.

And he let it play. That was key. You have to bear silence in the 20th century. It's the only lyrical note. Perhaps it's our gift to the future.

(2004)

EVERYDAY BARF

I don't mind today, but the everyday makes me barf. There's no such thing. Puking would put something on the sidewalk of the everyday so it might begin to be now. And what do we think about writing now. I was asked to write a political sestina for someone and once I did they sent it back all numbered and pointing out I had not done it correctly. Not only had I not gotten correctly to the envoi, but harrumph I had also done something with the six words, something bad. I had never written a sestina before and I was fairly proud of it. After a few pissy exchanges I was declared hateful by this guy because I suggested he was conservative and even censorious. It simply strikes me that form has a real honest engagement with content and therefore might even need to get a little sleazy with it suggesting it stop early or go too far. How can you stop form from wanting to do that. I wrote my sestina on a boat. I was living in P-town this summer in Mimi's house where she often pointed out that Charles (Bernstein) had also lived with his family. Each time I left that house to go to New York or California I took a quick boat and this one time it was the week of the RNC and I thought well I'll write the fucking sestina on the way to the reading in New York. It's a political reading, so I'm thinking that way. The boat bucked and rocked. I thought the poem was incredibly boring, the words forced but for some reason I had nothing better to do I kept plodding along, peeking at my scheme. I was teaching a workshop that week at FAWC; do you know what FAWC is.

Later in New York I was standing outside of Fox (unrelated) with a group of activists and we were screaming Get the Fox Out of Here. Get—the—Fox Out of Here. Then we would go: O-Reil-ly. O-Reil-ly. This Bronx cheer made me a little nervous. Certainly O'Reilly's a conservative prick but are they laughing at him for being Irish. Are they invoking some working-class dialect, some familiarity or something because of the sound of his name. I have never watched this guy. Does he play the regular guy? What's his voice like? Who are the activists who have written the cheer? I was glad when they went back to the Fox one. Get the Fox out of here!

The experience of arriving at an activist event you've only read about—one you've selected from an online calendar of them. And maybe by now standing there with your friends. Holding a hot pink unemployment sheet. Standing in Union Square knowing that a line of you reaches down to Wall Street and up to Penn Station. Just being an arm in a performance piece. Just being a voice, like being in some week-long workshop all over New York against the Republican party and you can just kind of dip in. When O'Reilly got in trouble recently I thought about standing outside his job yelling his name. I mean I didn't feel bad or anything but now there was a release—like whatever discomfort I'd been feeling now slammed up against a good solid scandal so the screaming at last felt right.

The boat jogged my poem and I got to New York and read it in a large room and it was hot and I felt like I had done my poet job. I sat back down with J__, increasingly my ex, who nodded and squeezed my arm. "You did good." I took the boat again a few weeks later. I was feeling a little sad this time since I had been trying to get my mother who lives in Massachusetts to come back with me to P-town, but maybe I really didn't want that, and she didn't know if she wanted that either, but somehow I felt I had failed. The boat bucked and waved. The boat was rocking so badly that finally no one was allowed to be out on the deck. They had to come in. I saw a girl out

there in a hood with her boyfriend. Maybe her hood was gold. I had one of those. I used to wear it under a tweed suit jacket. Or maybe it was *his* sweatshirt that was gold. Was it raining. It was stormy. It was almost too stormy for people to ride boats. And the man next to me began puking. Urp, he went. Splatter, right into a paper bag. I think he was a fag. He was with his lover. Wha Wha Wha. He gagged. The woman next to me & I looked slightly at each other. This is gross. She was sitting with a man, but she chose me to share the feeling with. We were disgusted. Maybe a little bit scared. I didn't want to puke. Not like this. No place. I never want to puke. Hate puking. Haven't puked for years. Then behind me a woman began. Really gagging her ass off. Heaving. Again, and again. Little coughs of puke. Getting it together. Puking again. We were sick. The whole bunch of us were rocking with the gags, praying to fucking god we wouldn't start puking our guts out too. You could also smell the stuff. And the rain splashing against the glass windows of the boat. The boat tipping, aiming up. Have you noticed how tipping is in the news. For a while things were spiking, they were ramping up and now they're tipping. That's the word we like, it's what we see and I saw the boat rolling and tipping. Barf. It seemed my mother wouldn't have enjoyed this trip. She's 83. How would she receive a boat full of puking adults. I think she would have gotten up and moved. She wouldn't have just sat there. I began to think I had done the right thing by not getting her on this boat with me. I wasn't so wrong. Opened my notebook and started celebrating the fact. What fact. My séance. My sitting there on my ass on the boat in the middle of all these people puking. You think of kids, I always heard that kids in you know like first grade have this serial puking. I hear it as a story in families too. Suddenly each kid one after another started puking their guts out. Mom and Dad mopping up, occasionally lowering their own heads into the toilet. Blah. Adults do it too. I imagine my relatives coming over from Europe

puking on the floor of the boat in between fucks and bites of jerky. Bites of their belts or their shoes. Whatever they ate. Sucking on the tittie. Whatever. From this primal scene I wrote my mother a poem. The puking I do. This. Dear Mom. Blah. My whole life shooting all over the windows of the boat. Dear Mom Blah. The stuff streaming word-by-word across the lines dripping down the page of my notebook. A black and white composition notebook. One of those spray theme covers with a nice rectangle of ownership saying who I am. Eileen. This is my book. Dear Mom. I stopped apologizing for not bringing her. I understood she would have gotten sick. There was a logic. Perhaps I'll read the poem. In it I shared my fear of dying with my mother. There's a kind of dying that lives in my family. An accidental clown death. My father died like that. Fell off the roof. Splat. I think I had just been robbed in Los Angeles. I had been at the delightful Pho Café in a crowd of art people standing around rubbing their bellies satisfied while another crowd popped my trunk and stole my computer and all my clothes including my new digital camera I hadn't figured out yet. Utterly gone. There's one of those 30-second videos on it. Me standing inside my camera telling a joke. My trunk's wide open like a complete asshole. Nobody noticed it happen except me. I was poking my head out the door of the restaurant and there's my trunk wide open. I'm not upset. I'm numb. I'm a little destroyed. I got my notebook, I continued my dinner with Simon. Later that night I went to Judith's where I was staying and though she told me she lived upstairs the downstairs door was open and I walked right in. It looked wrong; the art, something. Suddenly this guy is coming towards me, scared. Scared like he would pick up a gun and shoot me he was so scared. Dear Mom, not only have I drowned today, but I was robbed and then I was shot. Bad luck. All these thoughts teeming as people around me go whaa. It hasn't stopped. It's normalized. Once my girlfriend moved to Paris, like 1986, and I took

her to the airport. Then I got on the train I think and went home. It was a big deal but I wasn't upset. I walked into the bathroom and began shitting and puking at once. I felt like a worm. Like there was no difference between me—and anything. It was just this force flowing through me. Loss. I must be feeling bad I thought, sitting on the can leaning into the sink. What must I be feeling. She had wanted to go to Acme, a restaurant on Jones Street. What did we eat. Chicken fried steak. Maybe that's what it was. In my poem I start telling my mother about the kids outside the window. I guess I was writing my poem throughout the puking. I even tried to read. There was this great book *Chronophobia* which was about time. Like what's not, right. I can barely tell you what it was about yet I feel all these systems kicking in. Like when you hear your computer shift. The book was just so right. People driving in cars on unborn highways, people blowing things up in deserts. A woman Bridget Riley going to see a collector who turned her work into a dress. I thought you'd like it, he said. She got blamed for Op Art which they continually tried to link to her being some kind of Irish domestic servant, and she responded by negating her sex. Feminism was splashing up around her like vomit and obviously that's the problem. I remember in junior high we would walk across the street to the high school to get our lunch. One kid would hold the door open for hundreds of others and that kid would announce every day what it was. He said, vomit. The door was reddish kind of clay-colored. He stood on a cement block and it made him taller than us while he held the door. I remember thinking oh vomit for lunch. I didn't know what that was. We would "throw up" when I was a kid, that's what we did at home and maybe around 6th grade the word *puke* came in. This is like 1961. I sat down at the lunch table with my orange tray. On the plate was a pile of little brown meatballs in a light brown gravy. In retrospect I guess it was Swedish meatballs. I think that would be its name. I ate the little meatballs. They were

not bad. We got back to class and the nun asked us what we had had for lunch and I said *vomit* quickly, feeling smart at once. A new Swedish word. I remember standing out in the hall that afternoon, being punished for *the word*, remembering the raucous sound of the classroom laughter. Even I joined in, feeling entirely out of control, humiliated, but the enormous release the one word had triggered still made me snort and gag with pleasure. Alone. It wasn't so bad to be totally wrong if you just didn't know and it was so much fun. There was something Bob Dylan didn't know and I can't remember what it was. It was about moving. I totally devoured that book, his autobiography. Amra asked me what I had been seeing lately. Like what was my art month. It was the show at the Hammer, I liked that painting show, *The Undiscovered Country*. I suppose I liked the title more than the show. I mean I liked the show. But the idea of a painting show being named after death seems just brilliant. I mean it's so fucking coy. Is painting really so far away. From who? It's just a crazy idea, but Shakespeare's line is so damn good that you can hang anything on it and it works. Bob Dylan said if you write while you're moving, it's good. The painting becomes really alive in the land of dead words. In the dream of death. Death is so great because it's the attachment you can never open. I mean you can force it open, but is that really yours. I saw *Tarnation* and I'm not sure what I think. Who could not love that kid doing drag at 12 or 13. Who was not scared for that kid. But the whole story was not a good idea. I hate the whole story. I hate it with a passion. Which is why I loved Bob Dylan's book. I had been prepared by another idea I had about him. J__ gave me *Positively Fourth Street*, this other Bob Dylan book, and I thought why do you think I care about that but this summer in P-town I simply read one book after another that she gave me. It's hard to live with someone *and* read the books they give you. You'd rather ask them why they gave it to you and be done with it. Though in their absence you read. Bob Dylan used to tear

pictures out of magazines and arrange them on the floor and then kneel over them with his guitar and write songs. It seems so perfect. Now that I think about it, it seems like jerking off. I'm not sure if it's jerking off like a man. It might be jerking off like a woman. In his own book *Chronicles*, Bob describes coming to New York and hanging out and singing his songs. I mean he was singing other people's songs for a while. I think his first song he pretended it was somebody else's and he slipped it in with theirs. He loved Woody Guthrie and he went to see him every day in the hospital when Woody was dying. It seems like a man thing to do, to visit the great guy dying. I really don't know who the great woman is, so where would I go. My mother would always try and make us look at the sky. Look at that sunset Eileen. It made you really want to look away. It just ruined it for me. It was all about her. And that's what I saw when I looked out the window that day. All these words were living. The boat was rocking and the people were puking and it was her gift to me. So I say what our president said when he was told how great it was to have god in the White House. He said thank you. He thanked them for how beautiful they were. It was good to be here.

UNIVERSAL CYCLE

I was wondering if all commencement speakers feel compelled to address their own college experience. I'd rather not. I wanted to focus on you guys, even just for a little while, I tried to get some statistics from the school about who you are—you know boys and girls straight and gay racially ethnically economically and age-wise. I bet you're not all 21 years old but here it is May 16th and I never found out. You have these outfits on but that's all that's the same. One-by-one you know who you are. I bet a few of you are depressed. Not everyone feels good at graduation. Some of you feel great, some of you are worried, someone's sick, someone's in love, someone's mother died this year. Maybe not. I hope that's not true, but it happens. Everything does. I have some photographs of myself graduating from college, I didn't bring them, but those pictures replaced any memories I might have had of that day. I see me from the outside walking down an aisle in a white cap and gown in Boston and that's all that I know. I'd like to be here with you.

You have given me an honorable job. I didn't know what I was going to do with my life when I got out of college. I'm 48, I'm probably a lot of your parents' age, more or less. I haven't had any kids, I mean I definitely won't, it's a very hot year, 1998, the earth moving closer and closer to the sun and me going through menopause, so I probably wasn't going to have any kids anyhow, but now I definitely won't, but I teach a lot, and I have a lot of

friends in their twenties and I like your generation a lot, I feel very close to you, and you'd probably like my poetry if you read it, it's basically just like this talk, it's something to do. Being a poet is a job, but it's a made-up one. There's no job description and that's what I like. I liked the vague feeling of being in college, it may not have been that way for you, well it wasn't for me. It was exciting, I discovered that loving literature could be a job and then I decided I didn't want that one, and I got depressed and a lot more happened to me when I was in college but what was wonderful about college as an institution is that it encompassed that—everything that I felt, it held me for awhile, and people would say, what do you do and I'd say that I was a student and they'd say great. You couldn't go wrong, it was like washing your clothes. No one argues with laundry, or the identity of a student, it's a cyclical thing, you just have to go through and I did.

I mean it's a little like riding a bike. You just keep pedaling, and the wheels go round and round and you get someplace. You can't help it. And you see someone you know and they say what are you doing and you say riding a bike. I mean you could have just robbed a bank, but it looks so innocent.

This is a nice place. It must have been nice to go to school here. It's a beautiful place. The thing I found about being outside of college, is that you have to figure out when everything stops and starts. You walk into the bank and you get in line. You may not like it, but you stay. You don't have to. You go into a restaurant and you get a cup of coffee and the coffee's bad and you get up and walk out. You go home and you call a friend. Then you think, I wish I called someone else. One day you're standing in front of the Eiffel Tower and you think this is great. It is exactly the way I expected it. I had that feeling at least once in my life. Some things are utterly satisfying. The Taj Mahal on the other hand was a total disappointment. India was not. But the Taj Mahal was not so good. Life

is so incomplete. College isn't. It isn't at all. It's just you. So I just got out of college and I've done an awful lot of things but basically I started traveling and writing poems. I like traveling because I like an activity, but you really don't know what you're going to get. Russia, for instance, just kind of ruined my life. I didn't know that was going to happen. How would I know that. I wanted to change my life. Now I've got to wait a few years to see exactly in what way it ruined my life so I can write about it. Basically I've been writing poems. I got out of college and they just came pouring out of me. They're all over everything. Napkins, stationary from so many different jobs. Notebooks, notebooks of all sizes.

Actually I was looking at a big box of notebooks the other day and I pulled one out of the box, 1964. I was fourteen. In the notebook I would talk about school, and I would talk about what I ate, and how Janet felt about me, but there was this one thing, it would go March 5th: C+ day. Then it would be a not bad day: B minus. I was rating the days, that's what my life was when I was fourteen. I couldn't imagine living without saying how much. How bad, how good. That's what I did. I looked around. I had stopped praying by then. But I looked at time, rows of it, days and days, the ones I was in, and I said bad, good, okay.

But I don't do that anymore. See a poem is a tiny institution. I just write lots and lots of them, and it gives me a way to be in the world. It's actually a very worldly job, there really isn't a wrong place to be, a poet kind of goes with anything, any kind of decor, indoor, out. Presidents like to have poets next to them, we're sort of like a speaking wreath, the kind of poet you pick tells the kind of president you are, the hell of dating or marrying a poet is that certainly we will write about you, so if you don't want to be seen, don't date a poet, anyone should know that. Because really a poet has nothing better to do than look at you. A poet's best friend is her dog, because instantly the dog will take the poet on walks, the

poet is like the earth's shadow. The sun moves and the poet writes something down. I felt so happy to be invited here by the class of '98 that I bought a new suit. I guess by now you've gotten the idea that I am your poet. So I feel good, and I look good, and now I'd like to go a little further, simply doing my job.

The notion of leadership changes every few years. Right now we like to have a leader that we don't mind looking at, whose antics we may not approve of, but we know about. We like to know everything we can about our leaders today. We don't care much about their private lives. We're excited by a leader who likes to live publicly. I think we're living in a public moment and that's why poets need to come back. While we're all living on the outside we need someone living on the inside, to watch themselves and then us, to bring our inside out. Do you know what I mean. Our time needs a shadow. We know this, but we have to hear it too. I'll tell you about the history of this.

About 300 years ago there was a poet in New Spain which is what they called Mexico then and her name was Sor Juana Inés de la Cruz. I'm sure some of you have read her, have heard about her. The man who was her biographer, Octavio Paz, died just a couple of months ago. Anyway she was indeed the first poet of North America, even before Anne Bradstreet, and she was world famous—a big library at that time in the world would have about 400 volumes and in that library would be her books, everyone in the world who read, read Sor Juana Inés de la Cruz. Now this is a poet who did not travel. In fact she didn't even go out. Her work did, of course. She lived inside a convent in Mexico City and because she was friends with a great many powerful people in the church and the government she would be invited to write the important poems commemorating the events of her time. To do that public thing. I bought a refrigerator the other day, the first refrigerator I have ever bought in my life and the man in the store,

Gringer's on First Avenue, asked me what I do and I said I'm a poet. Let's hear one he said. I balked, maybe feeling a little cheesy, you know like I should entertain him while I'm buying a refrigerator, like those cab drivers or waiters who flirt with women while they work, so that you're reminded that you're never really a customer, you're always just a woman, or a poet. I recited one— not well—I kind of stuttered. It was short. He looked at me blankly. Do you want to hear it again, I asked. No. I think that one went over my head he said, and turned his attention to the next customer.

When a new Viceroy, a new leader arrived in New Spain, the local government would commission a ceremonial arch and the Viceroy and his wife would pass under it with much fanfare. Think about that when you look at arches, that they describe important moments, that someone commissioned someone else to make them, that supposedly an arch celebrates an important moment, that someone passes through. The greatest sculptor would design the arch usually with images of Poseidon, and cherubim, and vanquished Indians, and beautiful women, whatever was chic, and the poet would write a poem to be read as the procession of glorious new people would walk under, going from this moment to that, it's a history you can see, like what we're doing today. Most poets teach, I do, and school just ended everywhere in the world, and towards the end of the semester, I find myself getting continually more kind of woo woo and risky, wanting to go out into the world with my writing class, mostly I've already told them everything I know and I want to have an experience together so we went to see some art, we took a trip up to 112th street, to St. John the Divine. Inside one of the small chapels that line the cathedral walls there's an installation by the video artist Bill Viola. It's a triptych and though the contents of his piece are extremely obvious, they really work. The first panel is a woman giving birth. A youngish, maybe

early thirties, white woman who is cradled between her husband's open legs. It looks like the ideal birth—both of the people are calm and beautiful and there are midwives hovering, and the tape is clearly edited, but we get the whole experience. The infant's head is pushing out from between the beautiful suffering young woman's legs, the middle triptych is a man floating underwater. It might be Bill Viola, he's wearing a flowing robe and there's a wire that he's dangled on and the robe is rippling and it might be anyone, some lonely baby in the middle of his life—hopelessly connected and submerged in "it" whatever the substance is, and clearly alone. The final panel is an old woman on a life support system and she finally dies. Turns out it's Bill Viola's mother. The entire installation cycle lasts 30 minutes. I found myself sobbing at the moment of the birth. It was so riveting, I knew I was going to do it, I've been crying all over the place lately, and this was such a good cry, the cry of birth.

Later we sat in a little garden outside the cathedral. It was a class after all, and isn't this the definition of academy—a grove of trees? We sat around another sculpture, a big sunflower, and we talked about Bill Viola and the Walter Benjamin essay I had asked them to read for today and it was really perfect, because the essay was "The Work of Art in the Age of Mechanical Reproduction" and here we have birth and videotape in a church—all of us were enjoying each other's intelligence and the nice weather and then a beautiful pea-cock stepped into our midst, a real one, and it sprayed open its feathers, hundreds of eyes like old teevee. I told them, "NBC" and then we got on the train downtown. I rode downtown with two students, Allison and Tanya, and they told me about the altar of the church which I hadn't looked at, and how there was a great man for each century, and the spot for the 20th century was empty, and also it was the final century so how could that spot be filled, it was so ominous. We had a moment of silence for the 20th century. I

suggested Gandhi, Gandhi's great, we agreed. But if the 20th century is the final spot on the altar, shouldn't it just be the gateway to all other centuries, not just the last. And what great person could do that. We couldn't think of any great women—great in the right way, there's Mother Theresa and Gertrude Stein, we discussed the scandals in both of their lives. I suggested the woman giving birth. It's just a great act, that great act makes all the other ones possible, it's an act of allowing, of not destroying, of giving, letting life pass through, and I thought I should bring this to you, what a frightening thought, a woman's body being the archway to the future, and as we stand here, and some of you will be giving birth, or being there, and holding her, and some of you have already done this, and here are your kids, they sit in their seats today, graduating from college. This is greatness, to pass through and know, to know that it's happening to you, to be awake at the moment of birth.

A friend of mine, Susie, is a death penalty lawyer. I guess I should be frank with you. You may or may not have been obsessed with graduating from college this Spring. But I have. When you invite a poet, you are inviting someone who is obsessed with you, who has nothing better to do, who wants to be your arch, I do weddings and funerals. In 1992 I ran for president. It was the right thing to do with that year. So all Spring while you have been thinking about graduation, or not at all, I've been gathering things for you. I wondered who you were, I saw the moment of birth at the cathedral and I thought that would be great for the class of '98, I was in Hawaii this Spring, I was invited there to do a reading and a talk and I was taken for walks in the national park and I saw the form of worship they have there, you will see in holy places in Hawaii a pile of rocks, it's called a *helau* and it simply notates a holy place, three or four rocks, sometimes a flower and a toy, a can of pop, and no one disturbs these piles, it's a site of worship. I was giving a talk at the University of Hawaii, it was called *How to Write*

a Poem, and I guess in my illustration, I was unwittingly doing the same thing, telling them that the poem could just be a pile of things, for instance—and I grabbed a young man's can of juice, I mean I asked, I said, could I have this for a moment, he said sure, and I said that the poem could be like a red chair, can of Hawaiian Punch, man's leg—that whatever's next to each other counts, the assemblage makes the truth, the truth of the poem. I met that young man later at a reading and he told me that he liked my talk very much, but there was one problem. You never gave me my juice back. I looked at him. I was thirsty he said.

All Spring I've been gathering the most important things I can think of and putting them together. When I was a child I would take these long walks, before I could write, before I had language, and I would come home and my mother would say empty your pockets. And there was my poem: a piece of bright glass, a stone. A little piece of wood. Susie is a death penalty lawyer and when I told her I was coming to talk at your graduation she said I think this would be interesting to you. We went to the Supreme Court in Brooklyn last week. We are all sitting in our seats. Here's the courtroom. Over there is the jury. A few white people, mostly black and Hispanic, the courtroom is so small. Susie said that's bad. The jury is right on top of the prosecution. The DA is a woman, named Heidi, she looked familiar, we made eye contact right away. She's very smart, the judge is female, white. I don't know what happened to her, says Susie. She has no patience, watch her. Our client is going to fry, if she has her way. I'm sitting on the left. I'm sitting with Susie, and the defense. Again, we're all white. On the left side of the courtroom, I mean the audience side, is the family, the relatives, mother, brothers of the people who died, the massacred, the victims, the slain.

Here's the story. Darryl Harris, a young African American man, the one sitting right in front of us in the court room, he worked at

Rikers Island, a New York City prison for many years, he was a hero, he saved at least one man's life in a prison riot and was decorated by the City of New York, he began to smoke crack cocaine and eventually he lost his job and then worked as a security guard for a while, and lost that job too from smoking dope, and one night last year he was hanging out in a social club, Club Happiness, in Brooklyn. Darryl Harris flipped. No one denies that. He shot four men he knew in the back of their heads. He made them lie down. The young DA in the green suit questions the detective who came to the scene of the crime that December morning and counted the bodies and helped create an overhead drawing, a diagram of the social club, and the DA questions him. Did you see a pack of Newports on the bar? Yes. Can you point to that place on the drawing? Did you see a white baseball cap? Yes. One woman was slain. She watched the deaths of all the others, she begged for her life, she had five children, and he chased her, there was a struggle, he repeatedly stabbed her, and her body was found outside by the detective, he was directed to her body by a homeless man, she was lying on an abandoned mattress outside the club. Is this photograph accurate the DA asked. Yes. And later you identified her in the morgue.

It is so emotional the courtroom scene. Clearly we are being brought through this scene step-by-step so we will feel horror, slow creeping horror of how one of us can, has, Darryl Harris has, eradicated five other people's lives, and here are their families to my left and there is the jury peering around, guilty themselves, there is the judge in her white hair. Often the defense and the judge and the prosecution have to get up and go into the judge's chambers and say something that the jury can't hear, and Darryl Harris sits there alone at a long table and he's wearing a green sweater, and he's a handsome man, he looks sweet, I kind of want to touch his head and forgive him, because the horror of all this is that everything has happened already, every horrible thing has happened already, that

is the truth and now we have to decide whether we should destroy Darryl Harris, who lost his mind one night, and though he is a man in a green sweater, with a teeny gold earring in his ear, looking strong, looking vulnerable, murderer, even looking sad, laughing softly for a moment with his lawyer, clearly we should put him down. He did something incredibly wrong, and this courtroom scene is tense, is a frozen greasy portrait of his life, probably the end of it. But the drawing was the most emotional scene, oddly. It all came true, when they pinned it to the wall. When we had a plan, a layout. The man I spoke to in the hall agreed. He's a *New Yorker* writer. Do you come to a lot of these? No, he smiles. It's an important case. It's amazing, he agrees. It quickens it. Not exactly art, but an order. It says we must be here.

Where are we now? I don't want that man to die. Do you? It made me want to be a lawyer, I thought I've done everything wrong, I want to go back, to go to law school, to take part in this rite of confusion and justice and race and narrative and drugs. Of family, and language, and truth. Awkward parts of it, life. But I won't go back. Not unless I've got something to write. This I finish. The trial will end. I hope that Darryl won't die. Not because he's good, but because he's alive. I wanted to drag every little thing I could think of this Spring onto to this platform with me, because birth is great and then it ends, the little head of the person is part of the world, with her weakness and her privilege, and the first grass of her life.

I woke up out of a dream the other night. I don't know what's going to happen to the class of 1998, but I'm happy to be alive with you. That's what I thought. I had this dream. I have to tell you about it. There was a caravan of beetles crossing the floor of the room I sleep in. They streamed over my dog's bowl which was on the floor. And I started singing a song, not the words, just the music. It was the *Star Spangled Banner* and suddenly I was remembering late

night teevee in the sixties and we would see caravans of men on camels crossing a desert, and then jet planes would soar over a mosque and we'd hear that song, and it was scary that before the teevee went out in America the station needed to say that we ruled the world. It gave my brother and I a chill. And then we went to bed. My dream just made me laugh and laugh, that beetles in my apartment could mean the same thing, and I wasn't alone, I told it to you, and she listened to me. I hope you all find yourselves sleeping with someone you love, maybe not all of the time, but a lot of the time. The touch of a foot in the night is sincere. I hope you like your work, I hope there's mystery and poetry in your life— not even poems, but patterns. I hope you can see them. Often these patterns will wake you up, and you will know that you are alive, again and again.

A SPEECH ABOUT ALLEN

Allen was more of a star than a homosexual. His great triumph was that you forgot he was gay. One of the ways we think about a human who is a star is that a variety of things, equally important, in the case of Allen say his poetry, his Buddhism, his homosexuality, his mother, his view of government, his capacity to eat at Christine's, his taking pictures, his capacity to read the newspaper at a table full of young poets who wanted him to pay attention to them, his lips, his voice, all constellate to yield one thing only which was Allen Ginsberg, again and again, and so when you try and see him as gay, you only see him as Allen. One thing I can say about being queer in America today is that for instance if you are already famous you can say you are gay and quickly that can become all that people see. On the other hand you could be famous and everybody knows you are gay and you never say it, and people watch you in the public sector and it's like the silent partner, your homosexuality and everyone watches you and wonders when you will stand up for them, why won't she come out, but they also admire you for being famous and forgive you for wanting to stay there, all glossy and bright and understand that you don't want to lose your seat on that wonderful promontory of fame for being queer. Allen was nearly thrown out of Russia for being queer, and I think part of his pleasure in being famous was adding that one thing in all the time, so that if they forgot Allen Ginsberg was queer,

which was easy because he was so many things, then he would remind them that he liked to suck young boys' cocks and the honor that was bestowed on him, the acceptance, would be nearly taken away, and the nearly is really important, I don't know the story up close, I just remember the incident and the boat of State shaking, light and full of drama, shaking really hard like something was going to happen, Allen provoked that by saying who he was, and then it was just true and the boat arighted itself. Allen knew how to stay with it. He "put his queer shoulder to the wheel."

I think about being gay in America right now and how for instance for a moment our president stood up for us, briefly, wanting to make it okay for gays in the military, and everyone knows the military is loaded with queers, is it only gay people who know that any same-sex organization is intrinsically more gay than straight, girls' schools, camps, Scouts, gym, and all these conventional places where the culture celebrates wholesomeness and youth, gay people just laugh and remember sneaking around and lusting and fearing exposure and craving it in some way, the fear of exposure—and even the fact that things are often the absolute reverse of what they seem in these wholesome places, that's exactly what's hot. Almost being caught is hot. So keep that in mind, the exciting fear of exposure, playing it close, and think of the famous American poet Allen Ginsberg who lived by exposure, who loved to sing about losing his cherry to HP in Provincetown, who stood naked with Peter, and later went even further, becoming a member of NAMBLA, the most reviled gay organization, even gay people hate NAMBLA, whose members assert their right to love young boys, the hope of America, and again it's those same wholesome places that are being invoked, openly, not as the playing fields of goodness and character but as gay shrines of desire.

Nowadays NAMBLA watches videotapes of junior high school basketball games, and public service announcements about Scouts

and boys' clubs and street kids, good looking ones like him and him and him and NAMBLA uncomfortably points out that our whole culture is pedophilic in the way it celebrates youth, we can barely look at youth without eroticizing it, and then NAMBLA takes one step forward and says I want to eat you, and for this even gay culture wants to throw them out.

So the way things wound up in the military is that the ship of state started rocking again, and, see, the problem is, our president isn't gay. He couldn't stay out there. He had to back down. The solution in the military was that you can do anything you want, you just can't talk about it, and no one can ask you either, and the responsibility for homosexuality is put back on the queer in a very strange way, as if the compulsion to tell were the irresistible part of being gay, as if coming out was the thing that has to stop, and no one really minds women fucking women and men fucking men, and if we would just do it quietly like heterosexuals do, then every-thing would be okay. And then you turn on the teevee and there's a cute romance, and then you change the channel and there's a show about a young girl coming of age and liking a boy, and then you watch another show about Seinfeld having a naked woman cleaning his apartment, and its really funny and of course you're bombarded with images of heterosexuality all day long, the man in the deli flirts with me, he just assumes I'm straight, and all the women in the clothes catalogues are eventually in a canoe with a man, if you're successful eventually you have to find a mate, it's just part of being human, to not stand alone, to put one next to the other one, and everybody applauds. But what if we stopped that, if we suggested for a moment that, yes, it was okay to silently mate and breed, and come of age and think about the opposite sex, but no school dances please and no proms, and no weddings, and no cute blind date plots on teevee, no rock n roll, no movies about love, and no Valentines Day, and no in-laws, and no tax breaks, no

celebrations of what you do, no songs, and no schools for your kids because we don't know how that happened, why should we pay for it, and no health insurance for more than one person in your house because then we'll have to think about what you do, and the fact that we are essentially paying for you living together and doing it all the time, is really disturbing, as if we should take care of that, your "love" as you call it, your lifestyle, two lousy bodies lying in bed in a house for years and the offspring of your shame, kids three and four of them, hundreds and thousands of them across America, forcing everyone to think repeatedly about you copulating in your beds at night for years, the loud bed creaking, a culture built around the repetition of that love, and Allen Ginsberg insisted that he was your baby. He stood there singing, beautiful and goofy with his little suitcase, at the door of the ship of state, for forty years, and he said that he was home.

(1998)

THE END OF NEW ENGLAND

It's a lot easier to write things on your computer than by hand, but the problem is the hand withers, finally you can't read a word the hand writes, notes to yourself are even useless and the body is outside, disconnected apart from its thoughts.

Which supports this thing I've heard kicking around, that the body is stupid. That was the motto I heard in a talk by Avital—Ronell about five years ago. Do you know her—she's a theory person she was very stylish at the time and I particularly remember her talk at the Drawing Center in Soho because the woman I was on my last date with though I didn't know it yet had been a student of hers. After the talk the woman I was with rubbed the palms of her hands on the back of Avital's black shirt, she rubbed her hands lovingly and I know in some way I was thinking that's what I want, those nice warm hands but Avital Ronell was referring to this notion that the body is stupid, she wasn't saying that she thought it, but was musing on the way we, our culture, thinks that, and I kept waiting for her to refer to class, she did talk about race the feeling that people who are not white are not as smart as white people because they are more embodied but also that women who are of course being more body than men, being the body that is wanted rather than the body that is important the body that bears another rather than being he who is borne—anyway woman as that subjugated vessel body—women are stupider than men. Nobody believes this is true, not

officially but it's still up there on the wall where all the secret thoughts of our culture are written in invisible ink, and it also says—this is what Avital Ronell never got around to—that people who work with their bodies, I don't mean artists, but people who lift things, people who say move the huge sculpture from there to there, I'm talking about the working class, these people are stupid. Those people are dumb. They speak in shorthand these people, they say: hey behind you. They say, on your left. The world of the service job is ordered by the rhythms of these people's language. Working class speech. There's a joking way of life. You have your head in your hand. You're leaning on your register. Your co-worker smiles as she walks by and sings: working hard or hardly working. If this happens in New England you would hear the subtle distinction between the dropped "g" of "workin'" as in "workin' hard"—and please, please, please can we spend a moment on the sweetness of the pronunciation of h-a-r-d, hard, the soft "a" sound that the "r" gets subsumed in, and the "d" becomes something that is so quick, just try it, if you say hard with a hard r then your mouth has been sliding towards that "d" around a little corner of "rrrr"s and you almost pop the "d" but in the New England working class hard the "d" is almost more like a "t," the tongue hits the back of the teeth so quick and birdlike, and the whole facial expression is entirely different when you say that word. Within the same language people look different when they speak which probably underlines class differences. To say "hard" my way, I open my mouth you see teeth. "Hard." More body, ever the working class speaker is condemned to the animal realm.

But back to working hard. The second part of the cliché is hardly working. And that's when you hear the "ing." People want that ring. They can say ring. The continual absence of the "g" in gerunds in working class speech does not signal an inability to make this sound. The phone rings. Someone has zing. The sound is not

absent from New England working class speech. But it's used for poetic emphasis. And more than that it's used to express an idea. "Workin' hard," refers to a job. "Hardly working" is both a joke, a moment of success, there's more energy, there's more presence, the speaker is on her way out, she's high, it's like the Friday of the expression. I'm out of here. It's the king. I'm hardly working. I'm like Cambridge people, the people who go to Harvard, they don't work at all. Hardly working. The nuanced poetry of working class speech is so embedded in the sound structure of the language—it has been worked on for so long by so many anonymous speakers for decades and even centuries, one maybe two yet it's a poetry that passes the keys of the kingdom to those who use it, just like the internet handing a message from computer to computer around the world and your inability to access this speech pattern will perhaps still guarantee you okay service on your boiler if you're a nice guy. He's a good egg. It's the soft "e" of the correct pronunciation of my mother's first name which is Gen. Always we are guided towards the accent of the middle class, never to the blurred cadences of the workers—unless you want to act.

In *Sons and Lovers* Paul Morel, D.H. Lawrence's narrator goes to pick up his father's paycheck at the Mining Company. He sticks his head in the window and breaks into his native dialect. He makes a joke with the man inside, a white-collar worker, and the envelope is slid his way. It was a window within the book about how most of us who write about it, class, and/or utilize the dialects that link one with one class or another, and in some ways I'm thinking about all writers who are essentially always engaged in this act of translation every day, turning things into symbols, are typically moving between one language and another, for instance—shuttling between the literary language which is written and more affiliated with the middle class and up, and the working and lower classes whose story is generally spoken, it is a language of pleasure, adjustment and use.

By its very nature it's a language of repetition, shorthand, working class speech is incomplete. Heads up! Whatcha gonna do means something vastly different from What are you going to do? The first is a shrug, expects no answer except its echo in a culture that knows exactly what it means. What are you going to do is a guidance counselor, a human being demanding a reply from another, not a human looking at another human looking at a machine, the job, or the bigger machine, which is life.

My mother was a secretary in a high school in Arlington, Mass. and she liked to come home from work and imitate the speech of the teachers, particularly one who had a PhD and her face would change when she mimed him, but most marked in her performance was the incredibly burdened diction, the way each word was oh so carefully pronounced, with no contractions, seemingly no levity or humor either, except that everyone learned my mother's first name right away, and they would carefully say that wrong, the teacher would go, oh Gen, and they would get the vowel wrong, the heart of the matter, it wouldn't be soft and low and flutey, the soft "e" of Gen, as in he's a good egg, it would be a nasal "e," it just sounded wrong, they just didn't know her, and that one little shorthand in the whole repeated teacher's speech, their intended reaching out to her was the real sting of it all, that the only casually directed word in what was essentially a request or a direction and rightly so because she was their secretary, it was the ultimate one syllable word, her job, to fufill their request, yet only one word in that request had even the slightest air of daily use, and it was her name. Said wrong. My mother's version of the teacher's talk was odd and funny because they said every single word. Right? Oh Gen, she would mime. Translation: What a jerk.

I was sitting outside today having a cup of coffee with my friend, it was the first real day of Spring with jackets off and lots of people out on tables in the street. A guy on 43rd St. at the little pie

shop across from *The Vagina Monologues* had his parrot on his shoulder and it was like no one had ever heard a parrot before, it was the funniest thing in the world, and this parrot had sort of a sarcastic female voice and it kept going good-bye, good-bye, you felt the parrot was insulting you, it was the voice of a very polite woman who is sneering you out the door, but meanwhile being very sweet. It was the absolute riot of human speech, that was the riotousness of the parrot today. It wasn't really the parrot's joke, but it felt like that. We have taught an animal to laugh at humans, to laugh at how we speak. This precious thing we do, communicate, can be taught to a bird. Then a little brown bird, a brown bird with some red on its feathers came sailing into the day, hopping around on the flagstone the metal tables were standing on. It was speech too. Women were walking away from the parrot who kept saying loudly goodbye, goodbye. One of the women looked at my face, any human face she could get further reflection from as she walked away. This is just total mania and joy. And look at this, it's Spring. My friend and I smiled at each other and looked out into the street. You couldn't talk after that. I think the part of working class speech that I'm aiming at today that I most warmly recognize and elide with the very heart of poetry, is this willingness to throw the words away, to let the situation speak. Continually the language gets cropped by reality, the center, in the same way that a good postcard would have the church or the historic building framed neatly in the middle of the card, the center of any linguistic use is use and closing the distance. The language is always communal, each speaker must convey meaning in a depth of other bodies in space who will see the same sequence of buildings and tables and birds. Who already do. Do you know what I mean. Are you with me? I'm thinking in a disaster depicted on teevee the newscaster is standing in front of the fire, or some image of the bombing in the Persian Gulf. The immediate reality is complete in a picture somewhere right behind the speaker

or is teeming all around you. Take lovers in bed. I pull you close. You use some fragment of my name. Leen. Very few words get used perhaps for hours. One of the lovers grows thirsty and lifts a bottle off the floor or night table. She says Water? A boom occurs in the street. First we face each other in silent shock. What was that?

A lot of my thoughts about speech come out of the experience of being entirely outside of my language. In Russia on the rare occasion that I was on the inside of the conversation and someone else was flailing in the realm of panic and gestures, I will never forget a woman named Alla listening to us, continually slapping her thigh going, Sto? Her pounding and demanding was humorous and intense. I was being interviewed. We would laugh and I would tell another story and everyone would laugh harder and Alla would feel further and further out on her little Russian raft in a sea of language. Sto. She was calling for help. Let me in. Sto. It meant what, like what are you talking about. And I learned Russian that way. Her urgency. She would lift her hands, crumple her head on her lap. She actually entered the conversation by means of all that acting and the emphatic use of one tiny word. Do you know what I mean by class? Frankly I don't know what class I am today. I can tell endlessly all about my family and how much money we had and education and what were the things inside our house. But class I think is utterly not about content. What's inside the house or the poem. I mean yes there was a movie called *Joe* with Peter Boyle in which the working class family ate a discount pie for dessert and I remember eating an awful lot of pineapple pie from A&P because it was always on sale. I knew who we were by that pie. Watching that movie. I got the sign. But I'm thinking about today. Yes on Cape Cod, here, but more so in speech and inside and outside the poem if there is such a distinction. I always think of what happens in the writing of a poem as similar to running to catch a train. A really important train that there will be huge consequences if you miss and I only

know this situation too well because I did miss that train on that same trip to Russia and I was running for my life it seemed and I was dropping things, I lost a jacket and I think I even lost my ticket in the cab on the way to the station, but I only discovered that later and it seemed like nothing mattered in the world except that we get on. I think of that race as class, or moving through time. It's poetry. A lot gets dropped. And assuming you succeed, what succeeds with you and how will you know yourself? In our beautiful country of immigrants and pilgrims—of hundreds and millions of pilgrims of all kinds—our constant sad and beautiful and even fatal American immigrancy where people drown in the Rio Grande, trying (I say "trynna," why?) to get here, and whole boats full of people are sent back to die in the camps during World War II, that was America, and famously one entire boat full of Irish immigrants in the 19th century like in Thoreau's *Cape Cod*, this is the monumental image at the beginning of his book, the beach at Cohasset is covered with Irish corpses, a mother holding her little drowned child, and she's dead too and her sister is standing over the corpses, she had been waiting to see her sister and her child, and she's completely wailing out of her mind, probably saying the same thing over and over again, Mother of God Jesus Mary something like that or nothing at all because Thoreau in his book was very good at using a ton of detail to conjure up silence, the vast silence of emotion, of awe, there was a huge wad of it at the head of his book and Thoreau of course has changed American literature again and again. He handed that silence to John Cage, and that's the silence behind my talk. Is it the big old huge sea, the killer and the giver, the site of immigrancy, language itself.

Some people say Cage's silence means gay. If not it certainly means gay power. It means discomfort. Ouch, it's a little tiny tear. It even means birth again, separation, the moment is real. Silence is not allowed on teevee or radio. It's too expensive, there's so much

fear, there's no real space in public time, it's too political. Also the people must not be confused, or alone, the ordering master voice of the culture must not let up. You hear the voice in Disneyland, in Barnes and Noble, in school. This is not the end of my talk, late middle maybe a little further than that but I'm hitting my stride and getting a sense that I will be able to say what I need.

In poetry is it the ordering or the disordering voice that you like, which speech. Or like Paul Morel, a variation. Cause that's class.

I was writing in New York at a giant table in my terrific home I am being forced to leave at the end of May, but so what I am one of the lucky ones and I have another home and I will go there soon with a little less stuff I will be forced once again to say what matters and surround myself with what I imagine I am today, which things, less of them, but I'm looking out my window in New York at this gorgeous building which is Port Authority it's so perfect and all around my neighborhood where I've lived for a couple of years I've watched people wheeling their stuff and lugging it and buses come and go through the thick glass of the building across the window from mine, and I watch people go up and down the stairs actually its been a perfect place in mid-life to think about things like speech and poetry and the sea I'll throw some more waves in—then I went to Maine this week, a couple of days ago and there I'm looking out on a frozen pond or river or something, a bare tree and I blew off going to Jennifer's Oscar Wilde class to continue in this way, but one moves through life continually leaving things behind and that's one definition of class, the degree of one's loss is also the degree of one's vitality, one's ability to sustain small constant amounts of loss.

Remember when you caught all those grasshoppers and you hid the jar in the bushes outside your house and the next day you realized they were dead because you had forgotten to put holes in the lid, they had no air. Language is like that, it is this incredible code for immediacy and my mother that wonderful secretary the

queen of language tried very hard to get us to speak correctly so that we would fit into America and advance but my neighbors spoke pretty poorly or I loved the way they spoke "bare naked" taping words together, really making the point, heiney, a million ways to be dirty and there were eight of them so you heard it again and again, I guess you call it an idiolect. My sister said "nakin," she dropped the "p," I miss her, I miss my family, it was another way to say us. Nakin.

Everyone in America is moving and dropping things, it occurred to me several elections ago when we faced another man named Bush that only the Bushes were leaving nothing behind, that they could bring their entire linguistic family along with them, one didn't need to change or drop things as they moved through life, one was at home because it was their planet. Yet he might begin to talk like me, I'm thinking like George Bush senior, not me literally, like Eileen Myles, but a politician might develop a panhandle accent because you want my vote, and his son so stupid might become an upper class caricature of a panhandle person, he thinks the lower classes are stupid, well I'm stupid, vote for me, that is a pitch. Because at a certain sad moment in history the lower classes begin to believe in their own stupidity, claim it as an obscene kind of truth, but I'm not having it. Mr. Bush, you are at home everywhere essentially you own the country.

Thoreau said at the end of his book *Cape Cod* and he was talking about Provincetown, that famous line: here a man can stand and put all of America behind him. Can we? See I see poetry as an opportunity to change the locks, continually. To say in words that I live here, and I drop as I go, I move close, I would like to fuck you, not everyone but some. I still think of my freedom, part of it as being allowed to say that word in public. We stand as one people going slow and moving fast, talking to god and breathing. Is it true. They say a liar always tells his story the same way. I'm thinking a poetry that speaks strictly in the modulated business language of

the middle class in inherited cadences from England upholds the law and even suggests the sea is safe and is invented to win poetry prizes and make sure the poet does not incite the body politic.

Do you remember that scene at the end of *Silence of the Lambs*, well very close to the end, the scariest part when Jodie Foster was in the dark and we could see her feeling her way through the killer's house, you know like this, grasping occasionally, using your sense of touch, the feel of the wall, the texture, the temperature, absences, the absence of sight, familiarity, the presence of danger—writing a poem is exactly like that, but perhaps the poet is the luminous actor not the observed victim, maybe we're in the hands of god, and though we haven't read it, we know there is a script.

Samuel Delany says that all sexual relations are class relations and I'm saying that all classes borrow from the working class and the lower class, always have, the change occurs at that level, the language we know is a pulsing fabric of immigrancy, the English language grew that way, you let the Vikings and the Saxons and the Celts, you let the vandals in and we will come anyway, and of course we are also tourists—art always plunders the other—art *brut*, mentally ill patients, the poems of kids, so-called primitives, females and queers, the other culture even as you are educated into misunderstanding your own home as that, my family becomes the beloved, the other culture and lends excitement and even verisimilitude to the cultural body. I think of Rudy Vallee telling the young Frank Sinatra that his secret to singing was to put some dick in it.

I'd say put some pussy, too, but I'm saying the erotic component in American poetry today is the gasping immediacy of absence, to do what John Ashbery describes as acting in the writing of the poem as if the reader or the listener were in the same room with you. Put some there there. Imagine the body.

(2001)

INTRODUCTION TO KAY'S TALK
AT WHITE BOX

Certain expletives: fuck, nigger, dyke, fag, kike, get used used by people outside the group one way and by people inside the group another way. It's one hallmark of our time that some people are sensible to the subtleties of these usages, and some aren't and some are sensitive to a few of them & not others: whole communities appear and vanish under these arches.

Kay Rosen is a visual artist adept at moving the furniture around, looking at words in the deepest fashion—in that they are all expletives ultimately, corpses of a moment that's already passed.

Brecht said it too: the word is at the end. It's the thing's dead body. It's not supposed to be more than that, though as the animals who invented language, we mean to be more.

I've written about Kay's work a couple of times and I used some big language, as in: she's the most interesting or the best artist working in language. I meant she's my favorite. That's really all I know. It's hard to write about an artist without waving a banner. And immediately I think you cover the artist. Cause what about Lawrence Weiner, Ed Ruscha. What about Barbara Kruger.

There I went, arching away. But to use my favorite expletive: I think she's the poet of the art world in more than one way. I think there's a zipper through all our experiences, holding everything together through a number of quick impressions—some are visible, some are not and when an artist of any genre narrates this

zipper people say he's the *poet* of the west, cinema's only living *poet*, she's the poet of an empty frozen land. I've got to tell you the poets all go grrr as everyone marches under that arch. That's *our* expletive. But really it isn't. There's a place of many operations occurring in language, sometimes it's about stepping out of the machine, flying overhead. Sometimes it's about lying down and playing possum. There's no single way to catch the existence of words. Except that language is some kind of living myth we made up and somebody one at a time has to show us that. One of the things that I thought about seeing Kay's work at MOCA and Otis a couple of years ago was that our institutions are inadequate to what she's up to. In that she's investigating I think the materiality of language and so each venture of hers should come over you ideally as if you were just driving down the road. The world her work exists in is very open, even homeless in a way. She's tearfully great and so is our time so what better way to spend this New York night than listening to her.

(2000)

MR. TWENTY

I was a little concerned last Monday night about reading my poem, "Mr. Twenty," at St. John the Divine. After all, it's a church. Some of the group I read with that night had gathered there two years before, for an event called *Planet News*, which had been organized to celebrate Allen (Ginsberg) as a political activist, and I covered his gay activism that night.

It struck me that Allen did his activism in language. Just when the world wanted to celebrate the great poet Allen Ginsberg he would say the wrong thing. I loved him for that. I described Allen pretty graphically at the *Planet News* event as one who "liked to suck young boys' cocks," and Bob Rosenthal, Allen's long time assistant told me that the only complaint the church received about the *Planet News* event was about *my* remarks and now here I was again, that woman, about to read something else disturbing: my poem "Mr. Twenty" is full of scatalogical language.

I would be reading to a room full of lefties and beatniks. Who cares, you might ask. But if you've never realized it before, let me tell you: most women live their lives with a fear of being considered "out of control." The irony of living with this fear in a context of political activism, of poetry, and gay activism, a context where excess is sort of a given, is, of course, huge … but it's the kind of irony you glimpse for a moment on your way to a bigger hell. Maybe the hell of "female difference." So on the night of the second event at St. John

the Divine it occurred to me to "direct" my shit. Send it in the right direction, joining a larger craziness, a larger discontent. I dedicated my dirty poem that night to a couple of men. One was Rudy Giuliani, New York's wonderful mayor. Because of his remarkable way of mowing down his own citizenry—what a great guy, I laughed, and the other person I flung my dirty words at was Andrew Sullivan.

Did you see his article in the Sunday *Times* about testosterone? You did? Sullivan's a gay conservative who is HIV-positive and so he has health reasons for taking the hormone, and that's good—I'm glad to see anyone doing and being able to do what he needs to survive and thrive ... but along the way, Sullivan has delivered a completely inane piece of journalism—an article entitled "Why Men Are Different." Right away I knew it was going to be troubling to read, and especially to see on the cover of the *New York Times* magazine. "Different" is a word that was used consistently in American intellectual life for more than ten years, especially from the mid-'80s to mid-'90s, and "difference" came to mean the condition of being female, black, queer, poor—really anything other than Andrew Sullivan. Let's face it, "difference" is over. When men, or especially a man such as Andrew Sullivan, gets to be "different," then we know the jig is up. The moment resembles the one in which "political correctness" entered the vocabulary of George Bush, or when "civil disobedience" became part of anti-abortion rhetoric, when Topsy Turvy began to rule.

Sullivan's description of living with testosterone moved four different ways: he explained his own use of testosterone, then offered a bit of official research on testosterone, and then for the bulk of his piece he actually performed kind of a testosterone diary, talking about how testosterone feels inside of him. It's a highly personal report and that's all it is. Because it's still a fact that "we" don't know what hormones are, and the only thing we do know for sure is they are different inside of everyone. I don't pop testosterone and become more like Andrew, I become more like Eileen taking testosterone. It

becomes "testosterone and mc" which would have been a better title for Andrew's article. Anything else is pure fiction, which would be a very interesting addition to the *New York Times*, if they called it that. But they don't, which brings me to the most interesting part of this public display of self.

Sullivan explains toward the end of his essay why we need to hear his impressions of living with testosterone in the year 2000. Listen to this provocative tack: "After a feminist century ..." Now, isn't that something! But, I'll let him continue: "After a feminist century we may be in need of a new understanding of masculinity." Reading that, I feel I've missed something. I didn't know that the 20th century was the feminist century. I consider myself a feminist. How could I have not known about this bestowal of a century and Andrew did? Did it happen at some tiny conservative college in the Midwest? I would have acted differently if I'd known it was my century. I would have acted—well, how does one act when they know the house is theirs, when it's their ball, when their father owns the team? I would have acted differently, for sure.

Because I do remember the 20th century and I was doing okay, but I was struggling. I could have used that extra lift. But Andrew is clearly referring to a century in which women had perhaps a little too much power and success (and he didn't have enough?) and yet where were the articles like this about estrogen, progesterone, and yes, even female testosterone, because we do have a bit, and when we get angry we have more. And when we are successful it also expands accordingly.

At 50, I have definitely completed menopause and during the two years before the end of my periods, during the 20th century, I began experiencing the hot flashes, which are a signal one's estrogen is lowering. And I decided that rather than feeling defeated and betrayed by my body (because I was feeling different, daily) I should write about this phenomenon. (Which is a pretty entitled thought, so maybe it was my century after all.) Do you know what it's like to

have hot flashes? A normal kind of embarrassment strikes you and you feel a little red, you "burn." The sensation goes wider. Then it subsides. Eventually you fathom what's happening to you: you are not losing control of your body, you are experiencing a shift in your system. I thought I should write about my hormonal experience. And *not* for a women's magazine. As long as I only hear about menopause in *Ms.* or *Cosmo* or the *Ladies' Home Journal* I feel a little isolated and nuts. The majority of American citizens go through this recommodification of their reproductive life. And if the ruling minority in American daily life don't get to read about these life transitions, then female life remains that, not human experience somehow, invisibly confined to its own "majority" journals.

Anyway, my piece did not fly. Which is not an unusual tale for a writer to tell, but it's worth recounting here. The editor at the *Times* I sent my essay to would not return my call. I'm sure millions of writers call the guy every week. I kept calling. When I'm hot, I'm hot. I got him on the phone. No, it's not right for us. Louise, who gave me his number, suggested I edit an anthology about menopause. She's a bit younger than me and I resented her suggestion. The *Voice* told me they didn't do personal stuff and the editor I knew at *Out* said she was years away from that (thankfully). No, it's not for our readership.

A few weeks later I remembered that I knew a poet who was an editor at the *Times*. Another door in. I called him and he said sure I'll look at it. Yay!

In my hormonal narrative I had included the wild fact that my ten-year-old Nissan had begun spontaneously speeding up at around the same time I began having hot flashes. Besides being funny and true, I thought that anyone, even a man, would enjoy this correspondence. No, the car and the body thing just doesn't work said Harvey.

Embarrassed, I hung up. I really did begin to feel gross, a little ashamed. I finally published my piece in a small Bay Area paper.

Bob Glück was editing a series of columns called *The Middle Ages*, but when my piece went to an unknown headlines editor it wound up with "raging hormones" boldly printed under my picture. Even in a small gay paper female hormones are both FUNNY AND OUT OF CONTROL. I hear a movie announcer's loud and gaudy voice. That's how it went in my century.

Let's face it, estrogen is not as sexy a hormone as testosterone. It gives us birth, nice skin, and bigger orgasms, but that's about it. There's a whole segue I could make here about women taking T, F-to-M's, but that's a whole other story, one I care about but not where I'm going now.

But let's look instead at the piece that followed Sullivan's in the *Times*. This is thematic editing at its best. Right after the testosterone diary there's the article about an American soldier who raped and killed an 11-year-old girl in Kosovo. Why would an editor put such information, back to back, as if it doesn't mean anything? As if the affect isn't cumulative. Is it supposed to mean: Testosterone, sometimes good, sometimes bad? Maybe that's what the editors had in mind, but another feeling is accumulating, and perhaps it's part of that reeducation program of the 21st century—the "new understanding of masculinity" that Andrew proposes. Now look at the back of the magazine: the *Lives* column. A woman whose sister was violently murdered discusses being on the killer's probation panel. Twice. And the murderer is twice not released and eventually he dies in prison, probably a suicide. The woman feels uncomfortable, her sister is long dead, and none of it feels good, it doesn't feel good at all. Now why did they print that? Do women need to see their perpetrators suffer, some judge asks. I think we simply want the power to ask our own questions in public. I think we want to read about the world and be quickened by the information and its substantive array—rather than feeling an increasing wariness about what "out there" is. What it's becoming.

(2005)

EYE: THE POEMS OF JIMMY SCHUYLER

James "Jimmy" Schuyler wrote with the green loving eye of nature, He wrote a teeny bit like God, for most of his life, though he was not a religious man, but his conscious appraisal of those sentiments were there from his earliest career and by the end of his life—as he approached death he felt on the spot, and something like God was very much in the poems. I feel I've been invited to talk about Jimmy's nature poems. With that in mind I found my self continually circling around the way Jimmy thought because that's what seems most like nature in this man. The structure of his weaving and making and being the poems always seems like their real natural end. It's easy to start with one of his most anthologized poems, and one that only gets better with the reading. It's got a trick, and it works, but it's very subject—intention, nature and memory— becomes more profoundly realized with each rereading:

Salute

Past is past, and if one
remembers what one meant
to do and never did, is
not to have thought to do
enough? Like that gather-
ing of one of each I

planned, to gather one
of each kind of clover,
daisy, paintbrush that
grew in that field
the cabin stood in and
study them one afternoon
before they wilted. Past
is past. I salute
that various field.

The poem is not an act of sentimentality—the sentimental thing would be to have done it, the gathering of flowers and be remembering that in the poem. Instead, the line "yet if one remembers what one meant to do and never did" courts an aching abyss of human loss, perhaps a "slight" one about merely gathering flowers, but none the less an acknowledgent of failure—it didn't happen. But bravely the poet persists: "is not to have thought to do enough?" Could that possibly be true? It's a thought that seems more impossible daily, in a world where being (nevermind being "in a thought") hardly has a place. But let's look at what he would have done, our oddly stoic aching human. "Like that gather- / ing of one of each I / planned, to gather one of each kind of clover, daisy, paintbrush …" It has the air of some kind of rainbow gathering of flowers and the book it's from, *Freely Espousing,* was published in 1969, the same year as Woodstock. There's a slightly millenarian, and weirdly precise, mathematical impulse afoot in the poem—"to gather one of each kind of clover, daisy, paintbrush." The guy does seem to think he's god, because aren't there, invariably, always more sorts of things—more things in nature than we know? Wouldn't his task never end in some way, it's a bit of a creation myth, I think. And it gets fiercer: He hoped to gather the flowers "that grew in that field / the cabin stood in and / *study* them one afternoon / before

they wilted." Again, weird—rapacious. To study the flowers? What the hell does that mean. The impulse seems scientific, and steeped in an awareness of the flowers' doom, of doom, period. So he's a bit of a creepy scientist, an overly dark one to boot. Can I say it too many times, a weirdo. Why does this poem of Schuyler's and a few others seem more schematic than natural. To me it's more of a theorem than an idyll. So why does it live? Let's read it again.

> *Past is past, and if one*
> *remembers what one meant*
> *to do and never did, is*
> *not to have thought to do*
> *enough? Like that gather-*
> *ing of one of each I*
> *planned, to gather one*
> *of each kind of clover,*
> *daisy, paintbrush that*
> *grew in that field*
> *the cabin stood in and*
> *study them one afternoon*
> *before they wilted. Past*
> *is past. I salute*
> *that various field.*

Look at that "Past is past" at the beginning and nearly the end, creating sort of a marred palindrome effect. The tone of "Past is past" is both Gertrude Stein *and* Mom. I didn't do it, the doleful kid wails. Past is past, she huffed back at him, her hands in the sink.

"If one remembers" begins to sound beautiful. It's the narrator of this little movie, the way all the little repetitions in the poem: "Like that gather-ing of one of each I planned, to gather one of each kind of clover, daisy, paintbrush" perform like a wrinkle in time—a

children's rhyme said again and again. One meant to do everything, to save all of beauty one afternoon. If one remembers that one meant to do that, to hold everything—that *does* sound like enough. "Salute" is a very late-twentieth century kind of poem—you simply can't hold "it," but know that you *would*, and right now, today, I, the poet, salute that incredible impossible feeling and somehow, by recording my desire, I've succeeded.

Schuyler I think is so good at describing what's there, the leaves and the trees, the trappings of what we call, nature because it's not what he's after. Take this diary entry from 1968: "Snow before daybreak. The postponed predicted blizzard choked off by cold. Now at noon it's windy and bright, not an interesting snowscape, a kind of gusty glare, the sort of day when the way things look is an illustration of how the day *feels*. Even in the house there are trails of cold air, changing like smoke. One current seems rushing up between the keys of this typewriter, and my fingers feel a little stiff."

I love the family joke quality of the "postponed predicted" blizzard. By laughing at the forecasters, he became allied with the weather. Obviously, we'd rather something big happened, but all it *is* is cold.

Schuyler was living at this time in his life in Southampton with Fairfield Porter's family. He had been, up to that time, a reviewer for *Art News*. Friends described Schuyler's ability to describe what was happening in a painting as "liquid." He told me once that he would take notes right in front of a painting, and put the "prose thing" in later. His reviews were essentially poems later smoothed into prose. I'm mentioning this because what I get from his diaries is an art writer looking at nature. If one can talk about abstraction on the canvas, why not cold in the room. Reading randomly through Schuyler's texts you get the labile quality of his intelligence. A letter describes a dog barking, a diary entry repeats it again and finally the yelp occurs in the poem. It's certainly not planning. The act of

remembering is a repeated action that ripples in front of the reader's eye not because it's "like" life, but it is. It happens once out the window, then in your head, and like a lightbulb when you shut your eyes, it happens again. The degree to which the barks seem actual is the degree to which you're allowing the dog back in. Is the poem something outside the poet, or something he's in too.

There's a Dante translation in *Freely Espousing* and here's a couple of stanzas:

> *I have reached, alas, the long shadow*
> *And short day of whitening hills*
> *when color is lost in the grass.*
> *My longing all the same, keeps green*
> *it is so hooked in the hard stone*
> *that speaks and hears like a woman.*

> *In that same way this new woman*
> *stands as cold as snow in shadow,*
> *less touched than if she had been stone*
> *by the sweet time that warms the hills*
> *and brings them back from white to green*
> *dressing them in flowers and grass.*

I think it's Schuyler liquifying Dante, not Dante himself at all. The subject is Dante I think. But what's pervasive is warmth, temperature. "The sweet time that warms the hills." And that that would be the reason to bring this poem to us, extending a rock of love in the sun, because Dante felt so actual to Schuyler, as he does to everyone.

In nature poems the feelings move, that's all.

I want to look at two poems from *Crystal Lythium*. The title poem is a marvel. More snow:

The smell of snow, stinging in nostrils as the wind lifts it
from a beach
Eye-shuttering, mixed with sand, or when snow lies under
the street lamps and on all
And the air is emptied to an uplifting gasiness
That turns lungs to winter waterwings, buoying, and the
bright white night
Freezes in sight a lapse of waves, balsamic, salty,
unexpected:
Hours after swimming, thinking sitting biting at a hangnail
And the taste of the—to your eyes—invisible crystals
irradiate the world

"The sea is salt"
"And so am I"
"Don't bite your nails"

Schuyler was famously mad, or depressed as one of his psychiatrists told him. Add mental patient to his career of art writer, youthful traveller, poet, and long term house-guest. Of course the jobs overlap.

The first poem I ever saw by Schuyler:

How about an oak leaf
If you had to be a leaf?
Suppose you had your life to live over
Knowing what you know
Suppose you had plenty money

"Get away from me you little fool."

Evening of a day in early March
You are like the smell of drains

In a restaurant where pate maison
Is a slab of cold meat loaf
Damp and wooly. You lack charm.

Loving the poem, sure, [piano tinkling] but what moves it? Who's the little voice tempting the narrator? "Suppose you had plenty money." I think these are little nature sprites, a sparkling illustration of the strange flow of energy that has fascinated philosophers from Aristotle to Bergson to Deleuze and Guattari who were engaged in charting the tiny demons that animate the web.[1] As Schuyler tracks nature in *Crystal Lithium*, as he charts the way snow affects a human inside and out, he's also allowing himself in the experiment—in naming the salt that supposedly relieved his symptoms, and released or identified some thought balloons:

The sea is salt
And so am I
Don't bite your nails.

How should nature speak?
I like two other poems in this book.

Slowly

Slowly
The dried-up pond
fills again. The blackish
verge grows spongy. Packed

1. I think if you read *The Morning of the Poem* with this line in mind you might also think it was directed at Kenneth Koch in a moment when J. was trying to quit smoking and K. was feeling chatty.

with seeds of which some
burst unseasonably into
life: kinds of grass in
tufted rays or with blades
folded in purple
cornucopias—
low-growing bedstraw and
others to you nameless—
pushing out for room,
radiating, starring the muck.
A frail gray flower
flies off, an insect
that escaped the first
combing frosts. It's
not—"the fly buzzed"
finding moods, reflectives:
fall
equals melancholy, spring,
get laid: but to turn it all
one way: in repetition, change:
a continuity, the what
of which you are a part.
The clouds are tinted
gray and violet and shred
the blue in other blues
Each weed as you walk
becomes a rarity.

I love that this poem both is titled "Slowly" and begins with the word. He wants you to hear it. You might not if it was left out there as the title. The inside and the outside of the poem are not so separate. It starts again, perhaps, like nature, slowly sits on the right side

of the poem almost like a piece of music that tells you in Italian whether to play it fast or slow. The speed matters a lot, is the subject of the poem. We know the pond—it fills again. It feels spongey. The erratic side of things is evoked as we learn about the unseasonable bursting—but it's vague—he refers to "kinds of grass" and later some bedstraw is called "nameless." The focus is so on the how of its occurring, the business of the pond coming to life. You can't help feeling that nature is grabby, sort of loved for being unstoppable, and familiar. We know the old pond and its ways: "starring the muck." It's quietly funny that a sophisticated guy would be reviewing, blurbing, taunting the anonymous comeback of a messy cartoon pond but that's the job that's getting done before our eyes. It's dumb stuff: "fall / equals melancholy, spring, / get laid:" another dour laughline. What you do now is get sad. The joke releases the profundity of the poem. "but to turn it all / one way": he means seriously folks, but elegantly said, and now he says it: "in repetition, change: / a continuity, the *what* of which you are a part." There's a grandness to our hopeless entanglement in this scene. It ends so high. Again using an emphasis on the ordinary, the uncategorized growth: "Each *weed* as you walk / becomes a rarity." Has that word, rarity, ever sounded so strange, a brand in itself. It's true because in this moment of your passing: as you walk, you've never passed this weed before. The anonymous weed becomes visionary, a latinized nothing, because of its ecstatic place in this incremental pattern.

Here's the poem's partner:

A Gray Thought

In the sky a gray thought
ponders on three kinds of green:
Brassy tarnished leaves of lilacs
holding on half-heartedly and long

after most turned and fell to make
a scatter rug, warmly, brightly brown.
Odd, that the tattered heart-shapes
on a Persian shrub should stay
as long as the northern needles
of the larch. Near, behind the lilac,
on a trunk, pale Paris green, green
as moonlight, growing on another time scale
a slowness becoming vast as though
all the universe were an atom
of a filterable virus in a head
that turns an eye to smile
or frown or stare into other
eyes: and not of gods, but creatures
whose size begins beyond the sense of size:
lichens, softly colored, hard in durance,
a permanence like rock on a transient tree.
And another green, a dark thick green
to face the winter, laid in layers on
the spruce and balsam or in foxtail
bursts on pine in springy shapes
that weave and pierce
the leafless and unpatterned woods.

It's very easy not to notice that the sky becomes water. In the sky a grey thought ponders. The pun matters. The revelation is yet so loose that you never wonder what this consciousness that holds the poem, the thought of it, is. The simple relationship of above and below accomodates a wish that something were thinking—simply is and quickly we move on. I can't help thinking that this view of sky and earth is a continuation of looking at painting—someone did this, in the same way a smart person keeps in mind that someone

edits and writes the news, it's not merely true, but made. We're quickly on the earth which is "warmly, brightly brown" with leaves. It's a likable place like a popular kid. We're so easily disposed to this shift because of its sunnyness. The poem continues to move slowly, we're looking at tiny leaves considering their relative endurances. What a word. And then time itself is the subject: "as moonlight, growing on another time scale / a slowness becoming vast as though / all the universe were an atom / of a filterable virus in a head /" (are you ready? Get this: "that turns an eye to smile / or frown or stare into other / eyes: and not of gods, but creatures ..."

It seems to me that the time that we experience when we bathe in moonlight, or even become aware of it, is endowed with the nature of change itself. He dips his attention into the rapidity with which the human mind considers scale: tiny, then intergallactic, then looking at the host of this travel, the human brain, as it dances from mood to mood. I feel like I'm constructing prose translations here, when I look at passages in Schuyler's poetry that take my breath away. I'm participating, I find, in an operation not dissimilar from standing in lower Manhattan the first time I looked at the devastation there and my friend and I began reciting like children, "okay a building three times larger than that was struck by a plane ..." Even magic is subject to communal reasoning and the glory of the poetry we're looking at is that it has been made for this purpose too. To be the last piece of awe, to be ritually unpacked, feared or enjoyed, and returned to its pattern again. Each time seeming a little different but going to that place. Like nature.

One of the great joys of my life and why I'm standing here, I'm sure, is that I was briefly assistant to Schuyler as Susan[2] mentioned and the job turned into friendship, mostly a series of meetings in which we

2. Susan Pliner. She was curating a series of readings and nature talks at Wave Hill, a nature conservancy in the Bronx.

walked from the Chelsea down to 10th Ave to have a very rich lunch. Schuyler had a particular pace at that time. He would stop suddenly and point to London Terrace apartments and tell me about a friend who lived there or just admire the prewar architecture. He loved prewar. But we'd stand there in some stillness first—I'll read a short excerpt from *Chelsea Girls* that elaborates differently on this waiting. But in that moment of holding still, before I knew what held him, his huge silence covered the world and his focus held the world in awe. Later I understood it was also pain. Diabetes had claimed several of Jimmy's toes, so he couldn't walk consistently. The stop was part of his way of moving on. Sometimes we stepped into a magnificent florists on 10th Ave and he would name the flowers for me, correcting my admiration. No dear, those are delphininums. It was like standing in paradise with God. Because it was full and seen and in some strange way it felt that ultimately you could know, this knowing was possible now.

Yet it was a respite. Often on the heels of being extremely unsure—for instance, is a description referring to the inside of a window or the outside. Such questions resolve themselves fairly quickly, but the not knowing has also been constructed. Uncanniness is a place that we go.

Noon Office

A snowy curtain
slides up the sky.
Across the road,
dead trees whose
tops a hurricane
snapped off, rise
straight and pallid
out of green honey-
suckle nests. That

big tree, nearest
the house, goes
leathery, elephantine,
stands
on one leg.
The blessing—
the bliss—
of one afternoon:
an infestation
of silence. May God
forgive us. To no
one's memory we
erect dead trees.

There's something childlike in enjoying the damage, letting it turn as it must into something fantastic, the trees becoming "elephatine." Or circus-like, "standing on one leg." It's interesting how dead trees seem more ours than live ones. Pieces of our human furntiure, no longer having their own agency. Here, once we're done with the tree we look at the day holding the tree, same as how we started with a window, now we see another, time. "The blessing, the bliss"—so often he's setting us up: "an infestation of silence. May God / Forgive us. To no / one's memory we / erect dead trees." Something has happened here, a human crime. A particular day. The off-stage fact of this poem is that Ted Bundy had just been put to death. Schuyler decided that to include that fact rendered the poem corny. The anonymity of a man put to death by the state likens him to a tree that is finally ours, beyond itself. Capital punishment perhaps being a horrible kind of art.

"Six something" is the title of what may have been Schuyler's last poem. Last great one. Perhaps because he's newly dead (ten years) there's an awe to his own verge experience. The tree of him still seems

recently struck and when I read this really late he seems in weary anticipation of the event. The poem seems to notate it. While bringing to mind all the big questions. What is poetry, how do we do it, what is it for. Who is hearing me now, and in what sense is God an answer to any of these questions. I think I'm inviting them in the same speculative spirit that Schuyler was. Why do people die? As "Six something" suggests, we get tired. And then we go away. Do we do this alone?

Six something

on June 5th, '90:
closed shops
and well-washed
bluelessness, and
across the street
a man finishes
his polishing. I
count seedlings:
always counting,
cars, trees, not
infinitudes of
leaves. The Veterans
Building hides all
the Empire State Building
excepting
its antennae
rising in stages
first woven then
slim out of thick
to an ultimate
needle taper pricking
the day: its

point a test
of clarity. And
where is God
in all this?
Asleep? Resting?
and if so, from
what? Eternity
is tireless
surely, like:
rest now forever
blessed tired heart,
wakening otherwhere
in bell-like blue.

In my imagining of the bardic tradition, the long gone druid poets who worshipped trees, who spent years memorizing insanely detailed rhyme schemes because they believed these schemes were the pattern of the earth, that poetry was the key, and reading Schuyler there's a sly joy in the realization that as each perception opens onto another one, we still do believe the spell of the poem is a working part of it all. Like he says in *Slowly*, "the what of which you are a part." On Sunday God looks at his creation and sees that it is good. In Schuyler's New York, Sunday is a day of empty polishing, an open hope: "a well-washed bluelessness," something very like a clear blue sky or a page before the poem begins, or the world when the poet is gone and it goes on, this poem, life, without him. Can I say it again? He's tired. Tired of what poets do, uninvited curators of nature, of reality. Tired of counting. I watched Schuyler sit in his chair. In many ways he spent his life in his chair. He travelled as a young man, was in the Navy, hung out in Ischia with Auden & Co. came back to New York, had many lovers, was a quick, lively brightly dressed guy, kind of a dandy I've been told. Despite his earlier assertions that he

had no faith in God, like Auden he turned that way in the end. The title "Noon Office" is a reference to one of the sequence of prayers that move a practicing religious through the day. Schuyler had a very human reason for his late turning to God. Unlike Auden, who has been depicted a severe man, Jimmy was sensual to the end. He believed in love. Tom Carey was a man who very definitely was Schuyler's last great obsession, and I mean obsessive. Jimmy had a poem that at one point just goes "Tom, Tom, Tom" much to Carey's loving chagrin. Tom in a turning away from his own life as a young gay man about town, the New York art world, drugs, and rock n roll, became a Franciscan monk, and Schuyler, doggedly attached, found religion right after him. The way was clear: once Tom knew God, Jimmy could know him too. There always was an abstract loving force that quickly shuffled his natural view into place. Even an urban landscape is as layered as leaves: "The veteran's building hides all / excepting the Empire State Building, its antennae rising in stages …" His description is painterly: "first woven, the / slim out of thick." This vast building, the creation we know, of many men, seems the quick sketch of one man, "to an ultmate / needle taper pricking / the day: its / point a test / of clarity." What does he mean? The building promises to explode the sky, yet another tense transparent surface. "And where is God in all this?" It's another of Schuyler's sudden shifts. We stumble in his vulnerability, a prayer. Maybe that's what God is. The request for him in man's voice. As I grow weak, he is strong. He shifts again, not to God but to God's materials: "Eternity is tireless surely," yet if there is one nature sprite behind it all it is this vast absent parent, this soothing mythical man: "Rest now forever / blessed tired heart, wakening otherwhere / in bell-like blue." "Otherwhere" sounds like a very pan-like fairy place. When one surrenders the act of creation to another poet—God—then perhaps one wakes up in his arms. It's "bell-like blue"—where a color becomes a sound, it rings and rings, and no one hears it, we all sit silently seeing.

TRAVEL

(1995)

BLUE PETERSBURG

In St. Petersburg I was told that the period of time from the middle of May through the first week in July was known as the white nights. The reason being that the advance of daylight becomes progressively greater till by end of the month "night" is only a small patch of twilight and all the rest is bright day. It's an eerie feeling— the evening goes on and on, you've finished dinner, several hours have passed and still the tremendous buildings and spaces are displayed as if it's late afternoon. This perspective heightened the feeling I had about being in Russia and especially this city— according to a local guidebook, "the strangest city in the strangest country in the world."

Several nights before I left New York in June I met Jaroslav Mogutin. One of Russia's only out journalists (the other one being Masha Gessen). My intention last summer had been to hunt down the queer scene in St. Petersburg. Though Mogutin's a Muscovite, it was suggested to me that meeting him would be the place to begin a tour of blue Petersburg. Blue's the color of queer here, not lavender. I wondered what it meant to be out in Russia. I awaited Mogutin at Mogador and all I knew of his appearance was from a slur in one of the initial press releases that he wore earrings. It was true, four, two fat ones on each ear. He came in, a combination of sweetness and swaggering. A tall, fair man. "There are no queers in Russia," he insisted, though he had been essentially chased out for

being one. There is no community, no group as such. Am I late? No I just got here I replied. I grew up in Siberia he told me. My parents were teachers, came there separately—they could have taught in any number of other places, the implication being their choice of such an extremity for their workplace was already a distinguishing characteristic. My romance was that he was like Pasolini. Both men, with a flair for the literary, were professional homosexuals in their country, in a way that maybe Gore Vidal, or Truman Capote, once functioned here, in the early sixties. I was thinking about Pasolini and then Mogutin that only a deeply loved child could brashly hold that position of the queer a culture loves to hate. Only someone utterly loved could stand (and even court) such an honored and assaulted position. Yes, his parents were great people. No, he did not know he was gay in Siberia. I was a child he seriously smiled. It's been a long time since someone suggested to me that a child has no sexuality. Well maybe it's a Russian thing, maybe they *don't*. Mogutin arrived in Moscow as a college student after perestroika. There were at least gay bars by then. He didn't stay around at college, the programmatic reading and learning didn't fill the bill for him. He wound up working as an editor at Glagol, and was responsible for the publication of the first gay Russian novel, *It's Me, Eddy*. It was suggested to me before I met him that Slava was not the best source of information about gay life in Russia. That he was only interested in "scandale." However, he's an excellent source on "a gay life," and especially the way in which a famous gay person is ultimately reduced to any gay person by a homophobic culure. Again and again I was told by Mogutin that he knew nothing about politics, gay or otherwise, and yet he seemed to posess the most useful instinct in relation to power—when to press on and when to retreat. His troubles began when he wrote an article in which he had a conversation with a famous gay performer. In Russia it is possible to be gay, if one is clearly an artist, clearly unique, not the average

person. So he was already breaking the code by having two famous homosexuals conversing in a public place (i.e. print) which suggested a culture, rather than an aberration. Mogutin's piece was plagiarized from by another publication and when he filed a suit the issue became what his article was about, not his right to protect himself. One hits a boundary in a gay life by acting as if one had rights. At some point one hits a wall and that's when a homosexual experiences the limits of their culture. Here it might be violence. Not from the state. The state would simply forget to protect you, or deny that your attackers were fueled by hate. Later when he wrote a piece denouncing the genocide in Chechnia he used a word which essentially means asshole. Since male homosexuality was decriminalized in Russia in 1990 (and female homosexuality was never a crime) the state's denunciation of his writing focussed on his foul language, rather than his sexuality. The word he used is used everyday in the main-stream press, nothing extraordinary. Also an unspoken rule is that a gay person must confine their commentary to the arts and culture, not on power, and must keep their discourse clean. It was at this point Mogutin was urged by his lawyer that he and his lover, Robert Filippini, an American, ought to leave the country or wind up incarcerated. I tried to find out what kind of activism, if any, existed in Russia. Robert and I getting married was the only public gay action I ever heard of in Russia. It was covered by all the national and international papers. But it was on the private level that harassment occurred, late night visits by police. They have many ways—perhaps someone would put a big piece of hash on the table. There are no groups he emphasized, many gay people in Russia are married. I was very different, he emphasized, I knew I was gay and publicized it very early. He had been in the public eye for four years at the time he left the country. To be gay in Russia is to be a citizen of the second or third sort. I was very different, he emphasized. I was singled out. And thus became absolutely typical I suggested.

Luckily Dona McAdams had a friend in St. Petersburg, a lesbian and local journalist who speaks Russian, Lisa Dickey, and she agreed to show us around "blue" Petersburg. (The russian word for blue, "*goloboy,*" is synonymous with queer.) We went to the bar on Mokhovaya #15. Usually there are big open doorways in St. Petersburg leading into courtyards around which apartments cluster. We approached a black door, shut, the three of us, and a brown-haired woman in a jean shirt with several earrings in her ear, very butch, attractive, opened up and let us in. Lisa told her we were from New York. Take her picture, take her picture I urged and finally grabbed Vivien's arm once we were inside. Lisa asked permission and we trotted back to the couryard. She was "Masha," that's all, and made us promise to take no pictures inside the club. Masha told another woman, a cute blonde, that we were taking pictures for some magazine and she immediately began doing chin-ups on the sign. Downstairs was an over-bright bar area with the usual unsophisticated too happy Russian advertising and just a few steps further came the disco sounds. Slavic country western and a flock of girls were dancing in pairs doing that dance where three or four girls line up hip to hip and kind of sway. It must be genetic—not lesbianism, but this tendency of some dykes everywhere to do that dance. I watched, amazed. It was a small room and the walls were covered in flouncy curtains and just beyond was a tiny red room with a fancy lamp on a table. This club is called called Y Pegasa—On Pegasus—which seemed to be a commonly used gay symbol but no one seemed to notice that or could tell me what it meant.

If you want to speak to someone I can translate said Lisa. *Ulp.* I cruised the room. Vivien and Lisa were sitting up against the wall, and I was jutting out on a little stool. Who would I speak to? That one—tall with great little bags under her eyes, who looked like a model, langorously choosing her moves as she danced disengagedly with her long-haired partner who was more keenly

giving it her all. They left the dance floor and walked out to the bar. I followed. Gone. They must have popped into the bathroom so I bought a coke. I leaned in the doorway, glumly. Then the tall girl actually leaned right next to me for a moment. I took the plunge. Could we talk. I asked her to wait—with my finger I called Lisa over. We sat down, the four of us. She is 17. She has known she was a lesbian since she was 14. My straight friends love it. They think gay male sex is obscene. Criminal. Female sex— they can't conceive of it. Do you believe in lesbian marriage, asked Vivien. I'm *dating* a married woman, she replied. The one at the door. Masha? Shhhhh. It is a secret. For a year. A loud speaker insisted that all the women had to leave. It was 11 o'clock, time for the men. Can we take your picture outside. The doorwoman comes up and whispers in her ear. Get that, it's great. *Eileen*, groans Vivien. Masha hands Katya a flip top. She puts it on her key ring. She looks up. It means she loves me. Can we take your picture together. Masha winces. My wife will see. If we don't take your picture it will mean all lesbians in Russia are alone. They laugh. We will say you are not lovers. We asked Katya for her address. She wrote it down, adding underneath in French, "I would like to have a photo of the woman who opens the door."

I was told the art scene in St. Petersburg was very queer and that one of its key figures was Timor Novikov, who was the rector of the New Academy of Fine Arts. We ran up the beautiful graffiti-strewn staircases of Pushkinskaya, a complex of crumbly buildlings which hold a fine funky art scene. In contrast to the New Russia's cheesey capitalism the moldering look of the art world seemed right at home here. At the opening I cornered a big curly haired guy, looking stressed out as hell, and of course he was *the artist*, who assured me that Timor would be back in 15 minutes. When he swept in, a tall man with straight black hair, a toothy impresario with wide Bermudas and a generally LA artist look, I still didn't feel like he was there.

He smiled and nodded that he was the man I met on the phone and he gestured to several galleries which he walked us into and kept doing his rounds of attending to those in the room. We managed to sit with him for a moment in a small back room where he kept lifting catalogues and moving things as if a crucial article would imminently appear and then we could talk. He flung open the door, welcoming Igor, a tall young man in a curly green wig. I think you would like talking to him said Timor, I must return to the show. Igor Pavlov was introduced to me as the former general secretary of the Tchaikovsky Foundation. Is it okay to walk around like that in St. Petersburg. I felt like my mother. Yet, didn't it behoove me to ask the obvious questions? "Now, yes, during white nights quite a lot is permissable. A lot of people have a smile for everyone ... not in the winter, though, when it is only a little bit day, and everyone is more aggressive in their brown clothes." Is St. Petersburg different since the late eighties. Oh yeah sure, lots of people are in a big depression. You see, living in Russia is hard if you're a little bit clever. Intellectuals have a problem. Everyone you meet wants to tell you three things, what he drinks, who he fucks, what he buys. Definitely right now, things are in an uproar, life is mutating in everyway.

Outside again, I asked Timor if Alla Mitrofanova was here, he said no maybe downstairs at Gallery 21. What does she look like. Black hair, big stomach, she's having a baby he said gesturing out around his belly. Before leaving we craned our necks and took in what seemed to be Timor's private office—off-yellow walls, a big slab of bench, and art on the wall which turned out to be Timor's— big pieces of brocade framing photos of 19th century actors, the only documentation we'll ever see of these performing artists. Part of the familiarity and oddity of the St. Petersburg scene is that there's an elegiac overtone to all proceedings, a sentimentality that both exposes and covers a tremendous loss. I guess it's a whole way of life they're mourning, not just their friends who died of AIDS.

We met Arton at the monument facing the Hotel Astoria. It says ACTOPNR. Another creamy night in St. Petersburg. Eight o'clock and the sky's bright white, which continues to around 11. We zip to the headquarters of the Tchaikovsky Foundation in a cab. This is it, Arton says, as we stroll past the facade of yet another massive intensely formidable building. An older women opens the door—Yuryi's mother we quickly learn. Many Petersburg gays live with their parents. Arton does, and they were very proud that he went to the European Parliament and spoke about AIDS though his mother has no idea he's gay. In the cab he says J-A-Y for it, because the word is international and he doesn't want to open himself up to that kind of hostility.

Yuri Yeryeyev tells us the history of the organization. He describes a glamourous warm night in June of 1990 when a 24-hour telethon hosted by the Kirov ballet to celebrate St. Petersburg and the white nights provided the occasion for the group's public birth. An American journalist (whose name no one can remember) and a dancer who was a member of the Kirov announced the new organization, making the first public statement on behalf of gay people in the history of Russia. People were very happy and excited. "I was one of the original founders" says Yuri. His own history includes being brutally beaten several times in the street since the founding of the organization and a rape preceding it for which he was ultimately thrown into prison. These were the events which turned him into an activist. He spent three years in jail. Lost his job at Lenfilm, the Soviet film company. When Vivien tells him she's a filmmaker he jokingly asks her for a job. Most of the first members have left, he admits, since the decriminalization of male homosexuality in Russia. Recently Tchaikovsky has received a huge grant from the European community, so there will soon be salaries and a new facility, perhaps even by the group's anniversary, June 15th. We tell him one of our tour books says that Tchaikovsky was urged to kill himself by

the musicians' organization and that he complied. Was this true? Not at all. Tchaikovsky was part of an aristocratic elite that was entirely accepting of his homosexuality. He died of stomach cancer. It is a myth smiled Yuri. We learned the truth here, I replied.

"Homosexuality is the sputnik of human history," states Zhirinovsky, Russia's famous demagogue, and maybe this country's next president. I pushed this quote towards Yuri as we were heading out the door. I've heard he's queer, I pressed. I'm very strict said Yuryi, holding the door. I never make assumptions about another person's sexuality unless I know them personally. It is the only fair thing.

You cannot tell who is male and who is female. You don't know what I am when you look at me says Andryei Khlobustyin, an artist, who is ostensibly married to Alla Mitrofanova who we've finally hooked up with. It's a wildly scattered interview session. I keep moving my little taped-together casette recorder around the messy table littered with tea cups and art books. Timor bombs in early on. He said he would call at Alla's when he learned we were coming here and he sits down and regales Vivien with reproductions of his very public art. *Banners!*, I hear her remark. Timor informs me that it was him who came up with the idea of calling it the Tchaikovsky Foundation. He smiles. But it's not legal. Apparently the government allowed the group to form but not to use the patron saint of Russian high culture as its name. Iconoclasty can only go so far in Russia. Yes, I was very active, says Timor, but once article 14 passed I went back to being an artist again. We are all one community here, the homosexuals, the women, the artists. All minorities. Many small pockets of artists. We are not arrayed in opposition to the government or any other force. There is no money *and* there is no censorship. But what about the violence Yuri described. That has never happened to me says Timor. Never. I am very out. Alla then says she travelled all over India (pregnant, points out her husband Andryei) and had little difficulty. It is all in knowing who you are,

looking around ... it is how you think about things that matters. I try to tell them about my friends who thought AIDS was in their mind, that by thinking about it correctly, calming down with Louise Hay they could ... everyone is nodding assuredly, that is what they think too. Are you homosexual I asked Alla who is telling me why feminism doesn't mean the same thing in Russia as it does in the west. She explains the different historical position of Russian women. It was probably easier to ask her that than who's the baby's father—probably Andryei. It's a chaotic scene with a calm center, the beautiful brilliant Alla reciting a complicated history I would love to understand, and yet I suspect I'm supposed to be this confused. It is because I'm a seventies western feminist, not because of the self-organizing chaos of the moment in this cool apartment on Nevsky Prospekt. Alla is a cyber-feminist says Kostya Mitenev at one point, and that is a kind of femaleness for Alla that everyone can stand. Though I know I sent her e-mail at that address from New York and my message came right back. Yes, I am a homosexual, I am also a bi-sexual ... *and a ten-sexual.* I think Andryei added that. "What is really interesting is sleeping with animals. Or necro-realism. Sleeping with corpses? Yes, there's a great deal of interest in that."

Last stop was a lesbian one. We grabbed a cab, an official one, some of the cabs in St. Petersburg are visible and some are not. We were a half hour late as usual, but could spot the bench full of dykes from 50 yards away. No one could speak English, Andy our translator was up the street calling us and we squirmed and smiled and twitched for a moment or two, finally fixing my sights on an English fact sheet about their group ("Sapho-Petersburg") which had many goals and projected offerings, the one that intrigued me most being the pink tours. We all hopped on a trolley and headed to Sasha's long room at the end of a multi-family apartment. You can see how hard it would be to out in a situation like this. Are you a lesbian asked Alla (Aleksandra Artemyeva), the leader of the group

and I said yes, of course. The pink tour is for any woman who wants to come to St. Petersburg and be shown around. Pink is the lesbian word. It means dyke. You need to fax them first, try Alla at 7-812-251-0853 and everything can be arranged. Meet you at the airport, bring you to discos, introduce you to very interesting women in Russia, show you historical sites. We could even take you outside of St. Petersburg, to Moscow for an overnight trip. Even Siberia. Have you done this before, I mean the St. Petersburg part? Not officially. But we have many friends. This is what we do when they come. They would pay for a translator, some of the expenses. Andy speaks English with a southern accent, a twang, and he's delighted that we notice it. He asks us for American slang and he gives us some Russian a man can use. "*Ya khochoo tebya*" means "I wanna have you." "*dai mne otsosat*" means "I wanna suck your cock." He describes the fun of being in the Hotel Europe with Rosa Von Praunheim and other Germans teaching them to say these phrases outloud. Finally, sitting on the floor after many cokes and beers I ask Sacha, Alla, Renata, and Natasha what it's like to be a lesbian in Russia. They point out that the decriminalization of homesexuality has no effect on lebianism which was never a crime. One is simply put in a mental hospital. A lesbian has a difficult time, says Natasha, because she's considered even more of a woman. And a woman is a slave, says Sasha. What about work. Sure, she can keep her nose to the grindstone forty hours a week and then she can come home and be a wife and have a baby. She never makes any policy at work. I told them that I met a group of artists and intellectuals who insisted that women are in a place of equal subjectivity in Russia. Andy translates after which there is a brief animated discussion. He laughs and pronounces loudly, "It's a bald-faced lie!" Have there ever been any marches in St. Petersburg. They look at one another. There was a request for a permit to have a public demonstration in March. Two days before the event

the request was denied. It would disrupt traffic. But there were many other marches, Christian ones, many other kinds. They received permits. What if you just demonstrated without a permit. Alla looks shocked. They would come with sticks and you would go to jail. And what would happen in jail. You would be raped. Absolutely. We were walking home when Alla began quietly broaching another topic, sex. Which was really where we began. At the Pushkin statue we were laughingly informed "there is no sex in Russia." They wanted to know if Vivien and I were lovers. Are lesbians in America involved in butch and femme. They asked my age. Have I had many lovers? Vivien told them SM was popular and described a pride March in San Francisco in the mid-eighties in which masters walked their slaves down Castro Street on leashes. Alla burst out laughing and Andy translated quickly, "Oh my god you are so free now!"

(1997)

ON THE ROAD (& AT HOME) WITH SISTER SPIT

All the sofabeds are open and two girls are sleeping on a futon under the kitchen table and I abandoned my bed upstairs and I'm sleeping in a tiny bed in my office, and Ida's in the other office with Lucky and altogether ten people are staying in our house in P-town. They arrived maybe around three in the morning on Sunday and I refused to go downstairs so Karin did, even though she was leaving pretty early to go to work the next morning, the dogs were barking. She went right down there and started unwrapping cheese, and showing them where everything was. Then the dogs shut up and everyone went to bed.

We came into Louisiana one morning a summer ago. We drove in shifts and even Sarah West, my front-seat partner, was asleep and we crossed that bridge over the lake and the morning was so misty and pink. That small house in New Orleans, Chantal's. Her kind of moving things around in a black slip, it was so Streetcar. We brought in our sleeping bags and coffee and dirty laundry and soon occupied every surface, doorway, and porch.

There was Rea's house in Atlanta. She used to live in San Francisco. She was big and tough looking, took us out on the town to the after hours club at the Clermont Hotel and she also warned us, about her neighborhood: "Don't go that way. Atlanta's dangerous." Yeah, well, so's America.

I remember that truck stop in ... was it Missouri, where the food was so good, chicken fried steak, we were all so happy and Sini

was out getting something from the van and she overheard a guy in the parking lot say: "I'd like to put a bullet in each one of their heads." For being female on the road. For having tattoos and primary colored hair. For being a crowd of hungry women. For feeling good, and being loud. A totally American crime.

I toured with Sister Spit last summer. We did 28 cities in 30 days, something like that. I remember driving through the desert in Arizona, a great red desert, then a small park with dried flowers, hard red star-shaped ones and a few of us sent them to our girlfriends. In priority bags and they got scrunched. Sarah Seinberg took our picture with one of those wide angle throwaway cameras and we were all standing there, posing in the desert. Little tan salamanders running around our ankles. In Vegas we were hanging out with pretty drinks in a bright turquoise pool next to a tall hotel and Sini's hair was bright yellow, and Michelle's was blue, Tara was mohair pink. We performed in a club called Double Downs. The promoter was a boy from the slam scene, a Nevada lawyer by day, Dave Figler. The bar was rowdy and ready for us. We got a teeny amount of press that summer but the single mention in *Curve* of the cities Sister Spit would hit, backed up by Dave's efforts, brought out every queer in the state. Double Downs had a very special drink called "Ass Juice," which consisted of prune juice and a shot of vodka. Cost 99 cents. That was the night Ali Liebegott, in a bright pink boa, began crushing beer cans with her tits. The same audience showed up at Double Downs this summer. We drew our culture everywhere.

Sister Spit started in San Franciso about five years ago. Sini Anderson and Michelle Tea, writers, performers, and incidentally dykes, were the instigators of the all-girl open mike that was an answer to SF's boy-dominated spoken word scene. Sini and Michelle's emceeing is smart and gossipy, and totally enthusiastic. I showed up at the Coco Club one night, almost three years ago. I was

in town and I'd been invited by Michelle to do a feature. This open mike was distinguished by a loud raunchy atmosphere in which you could hear a pin drop. All kinds of girls took part: a big-haired biker girl from New Jersey, a sophisticated girl from LA reading "fiction" about depositing a red ant hill on an ex-lover's mound (in a driveway, of course), a tall thin ethereal girl reading translations of a young recently dead Russian poet. And Sherry Bombadier, big and cute, in a baseball cap doing her Elvis-like vulnerable litanies of youthful hurt and pain. And boyish triumph. There's buckets of pain and abuse in the Sister Spit material. It's reality. Many girls do get a dirty deal. It reminds me of early Bikini Kill shows where Kathleen Hannah would offer the mike to any girl who had been raped. I got a piece of e-mail while I write this. Margaret Smith, from Buffalo, reports "Sister Spit was beat … when they got here, but after some serious napping, and Buffalo wings they were ready to rock … I feel like a witness watching these young women each summer as they roll into town. Like a church revival. Lesbian Poets Of Most Precious Blood." Love Margaret. (But you know as a Catholic that bothers me.)

Witnessing is a trope in this all-girl movement. No single style—it's truly "queer." And chaotic. Out-of-control, rough and sweet, encyclopedic lyric pop witnessing. Ears open on both sides of the stage. Finally, an avant-garde for girls. Once in a while boys can come. They call it "Sissy Spit."

Sini and Michelle kept the action going in San Francisco for several years and then wanted to move the show, a piece of it, to the famed Michigan Women's Music Festival which had been known for lesbian fanny pack conservative bare-breasted aesthetics. Again, I was invited. Michelle even thought I'd be a plus. She believed there would be a place for us at Michigan and she was wrong. They lamely suggested that Sister Spit was like a band, and they had a lot of those, and yes, we were literature, but we were not Dorothy Allison, nor Audre Lorde, and also there were too many of us, or something.

That's when Michelle and Sini decided to take it on the road and began gathering everyone's contacts—Tribe 8 being a big source. One member, Flipper, co-owned with Harry Dodge (also on the tour) the Bearded Lady Cafe on Valencia St. and 25th which was the hub of Sister Spit strategy and health food and a place to leave messages. A bunch of benefits took place, mainly there in town, and Sister Spit was like local heros going off to war. (Incidentally, '97 was the butch year. The '98 tour boasted many more femmes.) They raised a ton of money, and bought one van and borrowed another from Tara Jepsen's mom. We left from the Bearded Lady one Saturday afternoon. It was a slow departure—twelve of us at once. The minutes and hours dragged on, and girlfriends arrived, kissed goodbye, friends showed up and finally three hours later we pulled out and the first stop was Santa Cruz and the rest is History.

Boston was the best show—last year, and this year too. It's justice, I think. An amazing promoter, Hannah Doress, organized the show. Hannah has her finger on the pulse of an extremely amorphous all ages punk mostly dyke post-college music identified girl scene which is lit by the presence of such figures as Tinuviel of Villa Villakula records which early on recorded Sleater Kinney, Team Dresch, Ruby Falls, and poetry.

Coincidentally, Michelle is from Boston, Sherry Bombardier is from Boston, I am from Boston, Sarah West's sister lives in Boston. We had a huge number of connections there. Ryles, the now defunct club where we performed, was in Inman Square where my grandmother waitressed in 1925. We're Boston working class. Historically, we're the people who don't like art, we're racist and dumb.

And here were our families, hearing this "stuff." Marci Blackman read an astonishing section from her novel *Po Man's Chile* which in part narrates a lesbian SM relationship and the black girl is the bottom. Nobody knew what to do with that in Boston. Sini

was yelling her poem at the top of her lungs: "Thanks God, Thanks God, Thanks God." A perversely on-target indictment of the kind of piety that turns its back on sexual abuse, and Michelle read one of her stories about being Goth in Chelsea, Mass., a city so poor it almost went out of business, and outside a line of girls were wrapped round the corner and down the street, and many were turned away, sadly. Hannah was the first to point out that Sister Spit is a "movement." Definitely, it's avant-garde. Also, it's the third wave of feminism, which is pure spit.

The P-town show was great of course. Last year we jammed into the teeny Iguana Grille and our audience was not summer tourists, but chic and exhausted townies who included Annie Sprinkle and Kim Silvers, musicians Zoe Lewis and Kate Wolfe, Louise Rafkin. Everyone had their hearts set on John Waters but he wouldn't be around till the following week. It was a sweltering and operatic show, a knock-out, and we headed home to our nooks and crannies—it's really hard to find beds in P-town in the summer. I assured Michelle and Sini that I would have a house this year and everyone could stay. And I would join the tour again. And it was true!

Cookie Mueller keeps being a muse of this scene. Her books are always in the van. She's the absolute right combo of funk, glamour, literature, and escapade. Her stories are pure reportage and great. So much of her publication has been posthumous. Everyone wishes they met Cookie. I did. Because I live in New York, because I'm 48.

Our second night in P-town was an open mike called Spit Back. Many of us read again, with whoever in town wanted to read. Lynn Breedlove (more Tribe 8) and Shoshana stayed home in bed and watched teevee. Kathe Izzo, who pretty much cooked the P-town shows up both years, read her poetry and so did her daughters, Maura, Nola, and Jules. Nola, 8, wore a black boa. These girls were a smash. Everyone decided they should come next year, or do their own tour called Izzo Spit.

Three boys signed up for Spit Back so we put them at the end. A guy named Max read a piece by his mother about being water, leaving this life and whenever you turned a faucet you should think of her. It was Cookie's son. He read another piece about the night he was born. Max Mueller. I start to cry when I write this because the cycle is always complete. He said he went to our show last year too. He said he knew Cookie would have loved what Sister Spit does and everyone was blown away by that, it was so perfect. We just all died, weeping. I talked to him afterwards and he told me he writes a little bit.

A few of us went to the Cactus Garden later that night and we listened to Zoe and Kate play. The door was opened to the street and you could see people pass, and you could smell the sea and it seemed like people had done exactly this for hundreds of years, put on a show and went out afterwards, and heard someone else, raised a little ruckus and then left town the next morning. It was pretty quiet that night, but I left early.

BOX OF RAIN

In 1993 there were so many homeless in Rotterdam that a local politician said well if we're not going to build them housing we ought to at least give them boxes. And so the homeless box was created. Briefly it was distributed to the homeless citizens of Rotterdam, especially during inclement weather. Since then a shelter has been built for them. Only a dozen boxes remain, unused, in Holland. One found its way to New York and I was invited to live in it for a week. I chose to live at the corner of Madison and 73rd, under the watchful eye of *Nest*.

I walked into the office to pick up my home. Two large flat pieces of plastic-coated tan cardboard were leaning against the editorial desk, blocking the computers. I dragged them out into the grey hall of the building. It all seemed so normal—I was going to live in a box. These pieces unfolded to make two 30" x 38" appliance-sized containers with pitched roofs that telescoped, one into the other. The ends folded shut by tucking them in like a cereal box. They were triangle shaped with a small hole for air and a limited view. I got down on the carpet, slid myself into one half, then pulled the other into place with my feet.

Despite the sturdy cardboard, the makeshift joint buckled whenever I moved. I lay inside the box, inside the hall of the building, and breathed deep. Psychologically the close quarters—barely six inches on either side of me, and the peaked roof not even a foot above my nose—was strangely calming and sweet. At that

moment I knew I would be okay, I could spend a night, a series of nights in this thing, even outside, in the world.

It's entirely legal to place a cardboard box on the streets of New York, but cardboard is thin so immediately one looks for an enclosure, an overhanging structure to harbor the box, and that constitutes private property.

The Madison Avenue Presbyterian Church is the only building in this area that actually allows people to place their cardboard shelters on its steps. The place is packed, even early in the evening. I met Miles, a youngish black man, who told me that one of the many security guards who patrol this neighborhood had hit him on the leg. He said his name was Miles because his mother was listening to Miles Davis when he was born. I told him my name was Myles and I just felt like I was standing in his light. In any case there was no room for me at the church so I found a doorway on 73rd, the entrance to a jewelry store. It had a cement ledge with bushes and the look of the place was Indian—the Indian subcontinent I mean. With permission I placed my box there and felt like a prince. A guard had been hired by *Nest*, a man named Omar. We smiled goodnight to each other and I slid into my box.

I bought a turquoise mat at Integral Yoga, a soft, spongy piece of foam to separate me from the chill of the sidewalk. Over this I would lay my royal blue sleeping bag.

My box is lit with a Coleman lamp. It burns a thousand hours, sprays a sunny whiteness everywhere, and I've got a short book by Vivekananda and a mildewy collection of John O'Hara stories. I think I'm safe.

Have you ever slept on the streets of the city. I'm two steps down, the steps block my window so I can't see out. It's sound, the night, pure sound. My guard is across the street so I shove my arm beneath my head as if were home, and I am. I listen.

A rush of sounds, millions of them, cars—bird sounds, then a gigantic garbage cruncher from the restaurant next door and then a monstrous truck heading up Madison, raising the ante, yowling. Just unbelievable, as if it were competing with all the other noise. Then it stops. And everything's utterly still. It's two o'clock. A quick brushing sound that passes, a bike I guess but more wickery, creaking, and I want to sleep and I don't look up.

Cardboard smells like dusty grass. It's a membrane that keeps the rain and the snow away. It hides my identity. It's practically language, costume. It's so thin a home.

Midnight Run a voice yells, distantly. It can't mean me, I'm struggling to sleep. Midnight Run. I come up through the seams of the box—I burst up on a smiling man and his round-faced son. We're Midnight Run—do you need anything. We've got some food, coffee, socks, blankets—are you warm enough?

I want to tell him I'm not me, not it, not one of them—Is this your usual spot, he asks?

No ... I'm new around here.

On the second night I slept illegally in a small alcove on Madison Ave. It was not a good environment, the glowing overhead light was invasive, the traffic, ten feet away, was overpowering and the very sidewalk I slept on shook. I awoke from thick sleep around five to the fair teal sky of morning. I was actually awakened by the soft thump of someone else's discarded cardboard. They had seen my box and assumed this was a place to chuck other pieces of cardboard, so they flung a flattened box between my dwelling and the wall, blocking my view, waking me up. A few cars dashed up the avenue.

Time to decorate my home. I duct-taped the remnant of a Hanuman teeshirt (a Hindu saint, a tall monkey who likes books and gives courage and protects) to the wall and began to take pictures. It's actually kind of nice in here.

On the third night *Nest* encouraged me to sleep on the roof. It looked like it would rain. There was a huge firework display in Central Park and the row of buildings on Fifth Ave blocked most of the excitement but the outer edges of light blared over the row of buildings like bursting streams of colored water. I fell asleep inside the box but had a choking dream around four, so I opened the cardboard cocoon and surveyed the sky. Brown...raining heavy now so I pull out a plastic tarp. The cardboard floor of the box is totally soaked, darker tan, so I kick the tarp underneath and climb back in. The box collapses around me. The tabs are warped and never held very well. I tape the box shut. But the middle is damp and doesn't fit. My stomach is getting wet so I curled into the head end like a dog. The plastic coating makes the raindrops sound tense, not thudding. The rain is constant, hissing—like distant ironic tiny applause.

Next night, raining again. I nestle under the scaffolding around the building. It's a good solid roof. The box is bent, my roof is pinched, the carboard's dented. The literature from the manufacturer says the box lasts a month depending on how you treat it. I brought some flowers tonight. Blue ones. I'm getting a cold. I'm in there with the clock and the book and the flowers and the different blues of the mat and the sleeping bag, and yet all I can think about is my heart. Inside a box you are supremely aware of the next layer of protection. One I haven't mentioned is jeans. I've worn them day and night all week. They're faded indigo, baggy, the right knee torn. They don't stink, but have a damp human smell that feels like having a pet. I close my eyes, obsessed with my heart, opening and closing, it might stop beating. I'm lying on the sidewalk in a box. The downpour is tremendous and I know my box won't survive this night. The red heart in my chest is squinting like a fist. I see green grass and I smell it, like a vision, and I think I'm dead but I realize it's flowers, blue ones, that I smell.

I see my friends crossing the street. They've come to visit. It was raining hard. I put my little house on the sidewalk in front of 28 E 73rd and I placed the lantern inside and it glowed and my friends took pictures. I looked across the street at the guys in their boxes. All boarded up. I would feel really safe staying on the steps of the church said Kathleen. Yeah I know, and it's okay with the church so they have permission. I felt jealous. By now John and Kathleen are circling and critiquing the box. Who designed this? A student, a Dutch design student, Raymond Voogt. I could do better says Kathleen. Yeah it's terrible said Jim, a designer. You would just make a little frame, something light, aluminum, and you would have a few hoops, you could just fold it over your arm. That's a great idea, said John. I'll make a drawing, said Kathleen. You should. Let's go. Everyone's standing shivering in the rain. We were here at the end cheered John, as I threw the box in the trunk of a cab. I was taking it home.

(2003)

ON THE ROAD WITH BJÖRK

No matter what I rarely travel calm. This time I even got in an accident the night before. I was meeting my friend Taylor in Ocean Beach, and after we shook hands and hugged, the night before he was going off to college (Berkeley), we jumped into our vehicles and drove off. Like any accident, I can remember all the choices: should I take the 5 or the 8. Should I turn left on Cable or go straight to Sunset Highway and then turn left. All of my choices brought me to 8 when it merged, one lane dropped out and suddenly all the cars in front of me stopped and I slammed on my brakes (which are not so good) and I did not slam into the car in front but in a moment the car behind me did. Wham, it was a big one. I pulled over to see how the other guy was who went shooting to my left on the ascending shoulder—fortunately not going over. It's you! It was Taylor gaping at me. I was hit by a friend. It felt like good luck, not bad, certainly that we were okay, but even more that we chose to have an accident together. I am still awaiting the significance of this incident.

I was heading to Björk's concert at Red Rocks in August. I managed to get my accident-jarred body onto the right plane and then I took a shuttle from Denver to Boulder. We stopped at a bland condominium development in Westminister where a really nice lady was visiting her son, a college student that she had bought the condo for. She loved everything around us: the mall,

the climate in CO as opposed to Houston. My trip had begun. Once alone with the driver I engaged him. *I'm* not a student, he told me. I throw clay. Turns out he's a drummer as well and the two practices are similar, your fingers are feeling the turning pot—awaiting through a series of taps exactly what the pot would like you to do. Yes, everyone says that I replied. It moved me. I arrived in Boulder and it was raining. Brian was standing in front of the door of his leafy cottage and inside I met Chris (Brian's boyfriend) and Emile who had driven from LA, and Lianne who's South African and a muted activist because these days *that* can get you deported.

In the parking lot at Red Rocks Chris explained how Matmos (who are fags and are onstage with Björk and produced her last two records) does analog, not digital. Analog is filling spaces, kind of patching things in. In digital, Chris explained, one actually composes *into* something. Something moving, turning he said. God, I thought—like the pot.

Amra's here with Pigpen. Amra's how I knew about the concert in the first place. She lives in LA. We all have cellphones, I know where their seats are. Coming up the steps we get frisked. You can't even bring in a camera, and now they are looking at my cell-phone to make sure that's not a camera either. My truck's fucked, I can get a picture of *that*, for this piece. We arrived in our row in the cavernous WPA ampitheater. It's like a huge bowl of red stone, and the audience, about 3,000, has been screaming sporadically during our entire walk in. Every time someone comes out to lift a wire they howl. It's an incredible show. There's Mars says Brian. A tiny red dot is hovering to the right. It won't be that close for 60,000 years. *We won't see it again.* He looks at me. I love to dwell in almost infinitely gross understatement. We feel good. I stepped down to row 28 and there's Amra and Pigpen. Is the journey complete. Nobody even *wanted* to go on this trip a few days

ago. But we're here. I was in an accident I say. Amra goes *no*. She grew up in California. She has like movie star reactions to everything. *But I'm okay*. She sighs, smiles quietly. Pigpen just grins. Pigpen's a new surfer who also builds movie sets. She's a dude. I love Pigpen. I feel he's my bro. We all stand there knowing this is our moment for communing. Isn't it great says Amra. Incredible I reply. Then we have some version of the WPA conversation. About the America that was getting built for a while. Why can't we have it now. There are so many artists, so many people out of work. I'm thinking you could just pay some people to travel to concerts. Migrant audience workers. We talk about the black out. That's FDR too. Power companies were screwing people at the beginning of the century. FDR stopped it. We're just happy to be together, examining everybody's clothes, the hundreds and thousands of people who came here too. Another scream because now the Icelandic string quartet is taking the stage. And Matmos, too, over there on the right. I think I've got to go. We all kiss. Amra glows. Pigpen has a stare and a grin. I always feel like we both know something. We do. Yeah says Brian when I sit back down. This is so exciting. Chris leans forward and smiles at me.

Before music with many people you feel a collective hush, even if it's loud. Björk steps out and I'm trying to see the new hairdo and soon the giant screen is on. It's like a slanted bowl. She's got a big white wrap, like a bunny fur tossed over her left shoulder. A black velvety dress, short. Black stockings, maybe orange shoes. She feels like a baby tyrant, very formal. The circle of Icelandic musicians lift their bows, Matmos start leaning, pulling plugs and *being*, making it happen. They look like a cooking show. On the far left is this harpist I heard about. Who could it be but Zeena Parkins? It is! We know all the songs but it's grand like little pieces from a million operas. That poet word: shard. Shards of songs, and another screen has fish floating by and pieces of arms.

Weird, but good. Art wallpaper. Björk leans forward with the mike, all gallant. She steps back and dances around, skips. She works the lip and the audience screams. Running close to the lip of the stage, claiming it and making it come alive. Zeena's jumping up and down when she doesn't play. Matmos never stops except when it's all acoustic and the Icelandic string band soars. Mars winks. Behind Björk jets of flame spout into the air and later twirling cringles of light, like wire sculpture. Corny, but great. There's a music video to her left, all feathers, that looks like the meeting of Björk and Matthew Barney. Romantic and I'm emoting for them. There's a welling inside the mountain opera house—we're *in* that feeling of excess and civilization and social power and fashion— cause this audience is full of very good clothes. Rough, but bright. There's a collective sensation of sitting in the right culture tonight. God it feels good. Björk says Thank you again and again, very polite. She's our star and she's nice. Shit we *really* should've tried to get backstage. Brian and Chris interviewed Matmos. We have their cell number. Should we call? I'm thinking I know Matthew and I really know his mother, Marcia. Marcia Barney. God look at Zeena. That's so great. Björk feels like Mary Gaitskill AND Holly Hughes, both baby giants. Is Björk small? It's the lightness, somehow. A compact vision that takes everything on. Yeah she feels like a poet. I have an Icelandic friend, Kristin Omarsdottir. She probably knows Björk. After the stage goes dark it looks like there's not going to be an encore. How could that be. Our waiting period is long. She looked a little tired. It's strange to be so far away, and yet close. Walter Benjamin. Yup, he said it all. This show is Björk but it's all about us. We love her for giving us this. She was a child star, Brian tells me. She'll always be our baby. It was miserable pulling out of the parking lot. Not *that* bad. All I could think of was leaving the drive-in with my parents. We got lost on the way home, and then in Brian and Chris's kitchen we ate everything in sight. Amra

and Piggy are probably home by now. In the morning I was walking very slowly along the Boulder Creek thinking I'd probably catch a shuttle at the Boulderado dah dah dah—then glance at my watch. I do the math and suddenly I'm running down the path, cutting around corners down Canyon Street, Spruce, and I missed it. Next I'm in a *very* expensive cab with Nate. And he wants to teach English and travel around the world. On both sides of me I see mountains and hills. I love this land.

BODY

(2008)

LIVE THROUGH THAT?!

I just want to be frank about what you will be really living through.

You'll be living through flossing. Years of it, both in the mirror and away from it, both with girlfriends and alone. Girlfriends will be really excited that you floss your teeth, because they *should* and they think it's really inspiring that you do that and they will ask you if they can do it with you because it's easier that way, bumping their hips and thighs against you while you keep peering at yourself under the shitty bathroom light. They will even talk glowingly over drinks with their friends about the really diligent way you have of flossing and then the little brushes and even how you rinse and you'll look at their friends who look kind of weirded out and you'll be thinking you're just making me sound really old. I mean why do you think I floss my teeth for like fifteen minutes every night. My father lost his teeth at forty and then he died at 44. Before I decided I also wanted to live I was utterly convinced that I would never lose my teeth and I have had tooth loosening and tooth loss dreams all my life, so in my twenties when I had never gone to therapy I decided that I would always privilege the dentist over the therapist and that I was really getting a two in one service when I went to the dentist but still when I drank I would often pass out before I could floss. Then I stopped drinking. I found myself in my thirties leaning into the mirror one night cleaning away and I thought: fuck, is this what I lived for—to floss.

Well, yeah. I mean I don't know about anyone else but when I found myself at the age of 33 no longer spending the majority of my days getting sort of hammered I was to say the least perplexed. I never thought I wanted to DIE. That was not the point of my constant drinking. It wasn't a thought at all. Because there *was* such a thing as drunkenness I aspired to it. I took it, it was there. Moderate friends would wince and even suggest I was "self-destructive" but that didn't sound right to me. Things would happen, that's all. I didn't mean them to be. It was surrounding circumstances—to alcoholism. Which was what my entire family life was too. My father didn't mean to make me watch him die. It just happened. But this next act, the living, this was conscious. This was a choice. Or that's what I grappled with for a very long time. Do I want this. Being sober made me want to die. Cause I was swarming with feelings. About being a dyke. About being poor. About aging. About my inability to connect. About what a great poet I was, but what if—I don't know, first what if I can't write anymore, then what if no one will publish my work. None of these worries are particularly interesting or unique but I found myself in a state of endless worry. And who is this who can't turn the faucet of anxiety off with a drink or a drug. And yet I had a simple urge to preserve what I've got.

To tell you the truth if I am feeling ANXIOUS at night I sometimes think it's a good idea to go to bed without brushing my teeth. No face washing, nothing. It feels kind of wild. And I've slept with women and I've been friends with people who have shared that their secret decadence is the occasional tumble into the sack without brushing or flossing. So I do that too. But you know what, it's more interesting to floss. Because I face my face, myself, and I spend about seven minutes—first flossing, then the little brushes, then brushing the backs of the four molars, then the insides of up and down, then the front and the sides on the outside. I examine my gums. And uncannily at some point during this ritual I begin to feel

better. It's like washing my car and I never wash my car. It's the most intimate expression of care I know. And if I don't do it my teeth hurt the next day. Because get this: when you age your teeth spread a little so food gets caught in the cracks and if you have bone decay (and I do) the food gets jammed down there and almost instantly it produces pain. And miraculously though that pain produces panic and I begin to fear I will lose a tooth what actually happens is after I do a really good flossing and brushing the next night and maybe a little gargling (with peroxide which is really kind of a trip—your mouth gets sudsy and greasy! Don't worry. It goes away) the pain subsides. And I did it. Me! To tell you the truth, good tooth care is more like repairing a bike which I also can't do. Okay so in all these years of tooth care some other things have happened, and I mean I have a mouth full of caps. I have fallen, and teeth have cracked of their own accord—well usually I bit a cherry pit, or a date. Or a kernal of corn, or a chicken bone—snap! A tooth cracks and now you have just dropped a thousand bucks. So my mouth is full of these perfectly stained off-white piano keys that I meticulously clean every night. But still in all these years of care, through a squadron of dentists—all in New York and in New York still—I will not go to a California dentist. I'm not having it. All of the dentists have said *for years*—one day *you're* going to have to go to a periodontist. That seemed like the end. Yet my mother who is in her '80s and has ALL HER TEETH, *she* has gone to a periodontist. How was it, Mom. Awful she says. But then I watch her biting into some food. We are usually eating when we talk and our love of food is certainly part of the issue here. Biting and eating, that's the story. Luckily when the day came—and really the day comes when you have the money—I began to explore going to a periodontist. I've gone several rounds of meet and greets and one guy up there in La Jolla was a monster. He made an obscene video of me with my lips pulled back and the damage revealed in that fashion which was worse than the most

humiliating pornography, worse than dead, and even while he was giving me the instructions to get my lips and jaw into the horrifying poses, he said—what did he say—good girl, or that a girl, something that sounded like I was an animal. And it was going to cost thouands of dollars. So much money. And he would be pulling. And restoring. I would have a mouth full of living, false, not "teeth gone" but something cold. This is kind of the end of my story or the beginning of the next—a second act or maybe the third—live through that and that and that—because I did something I'd never done before. I am not middle class. I don't have sharp perceptions about personal investment and bourgeois self-esteem, or I didn't then. But I had heard about this thing which is getting a second opinion. I don't even know how I approached it. I guess I *went* to my dentist in New York, who I love, Michael Chang on 2nd Avenue across from movie theater on 12th St. I had another dentist before Michael Chang in the exact same location. It was Chuck. And he was great too. And Chuck sold Michael Chang his practice. So I stayed with the building and the view from that particular dental chair. I allowed myself to be part of someone's practice that was sold. I am trying to give you sort of an extended picture of what I am living through. And Michael Chang recommended another man, Michael Lanzetta.

I will only say that I enjoy these men and I trust them—with my mouth and my body. They are sweet guys. Incidentally I am 57. I just want to say something different has happened *about living* in the past few years. Not only am I not "self-destructive" nor am I ambivalent about wanting to live, nor am I unaware that this, all the time I've spent telling you about toothbrushing, this is actually *my life*, my time. One's life is literally that, their duration. And I've seen friends die young, much younger than me, and they keep dying my friends and one day I will too. And how I feel right now about that is a little sad because now I want to live so much and have all my

time and do so many things. So I have to attend to the thing in front of me because if I am not focused I can get overwhelmed by my desire to do *everything* STILL, yet as they say the clock is ticking and I won't get to it all, I can't. And the impossibility of that choice, of the everything when I was young, that choice made me a poet because I could have *some* purchase on everything and do a little bit of it all the day. Just chipping away. And it's essentially the same now and I've made the same choice again, when I decided to do what's in front of me but I probably can do other things too and I will. I just don't need to talk about them here. So—

Dr. Lanzetta quoted me a price like one quarter of what the animal doctor in La Jolla charged, and he was much less invasive in his plan and I was impressed that I had *in my life* held out for something simpler and more comfortable. It was an unique choice in my life. And I celebrate that today.

To hold out, as if I could be like that. To trust my own—no, I think I'll wait. So in the face of the mountain of time I've lived, and in the eye of the mystery of what remains I feel quietly smart and open my mouth widely and slowly tonight and I brush. I examine, I grin. I grin like a skull, but it's cool. Examine, grin again. I'm a mechanic now, doctor, friend. This skull is my friend.

(2005)

JIM FAHEY

My girlfriend had just left and I was in deep shit. I think this is the way it had happened, she left and I had no one so I decided I should get a shrink. I had a job and also I was in trouble at work. The troops were closing in from all sides and I could no longer defend my position. Nor could I call a priest which is what for instance my mother would do. I had friends growing up who were screwed-up and their parents would hook them up with a shrink, but it was clear that those kids were weak and also they were special. They had been inculcated with that idea about themselves, but I was regular. I could go to a priest if I had a problem but I could not go to a priest and I was 36.

Tom told me about Washington Square Psychoanalytic Institute which was on University Place. I had a job, but I didn't have enough money for say a hundred dollars a week. I needed a cheap shrink. The whole thing was beyond me, but I really was in trouble and was willing to pay somebody to be on my side. That was how I felt about it. Everyone was either Jewish or middle-class in New York and they all had shrinks. So I was going into the inside room in the world that I knew. It was not church, it was not God. I was pretending there was an inside of me, and it could be found in a room in the world.

I remember my ex-girlfriend telling me about a shrink who ate a big sandwich in front of her while she talked. Was he fat, I asked. Yes, she said and the sandwich was roast beef. So what did you do. I told him it was gross. It just seemed impossible to me that I could

have this relationship with anyone. In confession you listened to the door slide open and you told this man your sins. It made me sick and I hadn't done it in a long time. I told the form I filled out for intake that I was a homosexual. I guess they couldn't guarantee you that you would get a gay one, but at least I could hope. The man's name was Jim and he was bald. I sort of knew I would get a man, and I never knew for sure if he was gay, but of course he was. I saw him for almost two years, maybe three I don't know, on West 12th Street in a very beige office. There was nothing in it. I sat in a chair.

I remember him saying tell me about your family. It was like the room got rosy and emptied out. Tell me about your family. I almost went mad with joy. This was unbelievable. I had this guy all to myself for twenty-five dollars a week. This is what everyone got? His name was Jim Fahey and he had a paunch. He seemed about fifty. He owned a condo on Corsica (what if this was a lie?) and he lived on the Upper West Side, I knew.

I had amazing moments with him. I remember the morning, honey coloured, the room got mellow and deep when he asked me Eileen can you tell me any time in your life when you did feel safe. It was like a thunderclap. Before my father died. It was like my life folded. I *did* have an inside. I just hadn't been in it for most of my life. I had a home. It was gone. It was devastating. I cried for one split second into an abyss of coziness and love. What a horror therapy unfolded. I wanted him to talk about my gang rape, or even my father's death. It seemed like I couldn't lead him around. I guess the point of my therapy was to have kind of a permanent friend, but one I couldn't drive.

What kind of therapy is it, my friend asked. Are you gay, I asked him. What do you think, he asked back. He suggested I think of him as my gay uncle, he didn't say Jim, it was like Fred or some fiction. But he was absolutely queer. I guess. He seemed to know anecdotes about Tallulah Bankhead, and he recommended I read a

Beckett play *Happy Days* in reference to something we were talking about and he was right, whatever it was.

It was nice to have a therapist who was smart, who knew about culture. He gave me a ticket to a concert at Lincoln Center, a piece by Berg called the Four Seasons which was dark. I did like it, though I don't necessarily think it was so good for me. I mean a therapist is supposed to help and the Philharmonic was the same color as his office and I was alone and the music felt like me, kind of off—yet stately, grand.

I was doing a performance and I invited him. I didn't know if it was right. But I did. And there I was performing and looking down I saw Jim and I'm not sure it was a good feeling. I didn't know if it was right. And when we talked about it he told me that after I performed I looked at the audience and I smiled, but it was an uncomfortable smile. Not open, maybe kind of false. I think I smiled in response to that and he said like that. I felt like I knew what he was talking about but I didn't need to have him tell me about how creepy I was. I mean it was already hard to have this kind of dry heart, or feel you looked that way, like a hard window. It seemed mean, like who did he think he was. Though I kind of loved him. I just can't help it, I kind of get attached to men. Sometimes we had our therapy in the morning and he would fall asleep. That probably happened once or twice. Reciting the boring details of my life and he was snoozing through my twenty-five bucks. That felt gross. I just had my eyes closed he explained. Liar. It's too bright in this room for that to pass. Usually though we met at 3:30. A historic time in my life. In college I had jazz class then. How are things in your young life, Eileen, he would say.

I mean it was cute he thought I was young, but why did I have to respond to a cliché. I wondered how it would end, but it had to all things do. I was having a difficult time with some very dear friends because I was having an affair and there was something

about having the two of them around, a man and a woman that made me uncomfortable. I didn't want the woman I was having the affair with to see them being close to me. Both of these people were very important to me, but I felt ashamed of them and it was troubling. I felt this was a conflict I could bring my therapist. In those years I was always having choking dreams and feared choking in general and he offered me a Heimlich card I could carry in my wallet. It worked for a while. Now I just accept that I'll probably choke to death. I could run out of air.

Why would I feel ashamed I asked Jim. Maybe you have a secret. I guess the affair was a secret, it seems obvious to me now, but I looked for a deeper meaning. Well my secret used to be I'm gay. Well maybe you're not gay, he suggested. I felt appalled. I don't mean you're straight. Maybe you're transsexual he tried. I don't mean you need to have surgery. He was very quick to reassure me. You might just experience yourself as a man in a woman's body. Wow, I said. I just sat there in his many coloured room going wow, wow, wow. It was like dawn. Wow, I'm a man. Wow, I said. It was just an idea, he explained. Okay I said closing the door.

I went around asking every woman I knew who was a dyke who seemed masculine to me if she felt that way too. Oh yeah, I've always felt like I'm a man, Maggie said. I felt that about her. She looked like a guy. I would date a woman like that if I was a woman.

We're men, we're just fucking men, I thought. It's not that nobody knew the word butch at that time, but this was an eye-opener, this felt real. And I hadn't met a transsexual before. So it was just kind of like a landscape unfolding, all my own. I'm a man.

There was an event at a small women's theater company coming up. I was supposed to do some routine … I think I decided to be an author on a talk show, one of those thinking doctors. I had a white lab coat hanging around, I don't know why, and I plucked a book off my shelf. It was Jack London's sci-novel which had a blue cover

with a brighter blue streak of lightning moving across the cover. I taped a wide strip of white paper over the cover and wrote my own title in red magic marker: *Not Gay: The Story of a Transsexual Visionary* by Dr. Elsa Von Myles. And in the center of the cover below the title I glued a small school picture of myself in second grade with braids and a Catholic school uniform. The little girl had a very sad knowing look on her face. No cheesey smile, just little girl brave. She had bags under her eyes because clearly the kid couldn't sleep. I felt sad for what the girl would be going through in the upcoming years. But at least she wasn't gay. She was a man.

But I didn't get to do that part of the show and the book sat on my shelf for the next fifteen years, though the photo went back in with the photos where it belongs. I can't end this story. I just felt weird after a while and decided that his specialty was transsexuals and somehow that was the direction my intake had lead me. Now that I think about it, he did the intake and I remember thinking I would take him and I did. When I ended therapy he cried, which didn't seem normal. It cost me four thousand dollars.

Jim Fahey is a part of my head.

(1994)

A WEDDING IN DENMARK

Sometimes you stay around long enough to see things you missed. Whole decades come back, and this is actually the most orienting thing that can happen in New York, a city that's so utterly about people and time and the prestige certain individuals continually resonate. Jill Johnston, 64, and Ingrid Nyeboe, 46, are beaming, walking up the stairs with a shower of confetti falling down on them. This is all taking place on one of several monitors in a large apartment in Soho one night last fall. For those new in town, Johnston is the author of the anarchic masterpiece of '70s feminism, *Lesbian Nation*. She was also a legendary *Voice* columnist who made a career of being there and writing about it.

The event being communicated to us is their wedding, last June 27, in Odense, Denmark. Odense was the home of Hans Christian Andersen, author of *The Emperor's New Clothes*, who was gay, I've been told. The tape plays on and we see a Flux procession—two blue men carrying flowers. One is Geoff Hendricks, with his pants falling down. There's a batch of strangers in the ensuing crowd, a Great Dane, someone carrying a little red chair aloft, and soon we see the two women in white sitting down in front of some kind of civil servant. Jill says (I think) "I am" and nods. Ingrid says something in Danish. Later they're in an art museum, and the happy couple sit in a blue Volkswagen that looks like it's going nowhere. They do look happy sitting there, waving and waving.

What's going on? The party called "Wedding Party" in Soho was, like I said, one of those nights you're glad you stayed here for. People

kept walking in, Beth the young video artist and Lauren her sculptor ex-lover (what are they doing together here?); there was Pauline Oliveros, Andrea Dworkin (omigod!), and numerous people from every walk (mostly art world) who qualified in some way as Fluxfriends or FOJs (Friends of Jill). An ex-lover of Ingrid's spoke up too as the evening swept us along through recordings of bells from Riverside Church and poet-conceptual artist Alison Knowles did something with bread. Geoff Hendricks, Flux-meister (still blue), had a star shaved in the back of his head ("Stars for Jill and Ingrid"), and Jill got up and read a piece ("Deep Tapioca") that reminded me of the pubic secrecy of her *Voice* columns but glimmered also with a confirmed poetry as solid as stone. Then all of us got up one by one and had a Polaroid taken of ourselves standing with a really silly knit hat on in front of a picture of a statue of Psyche. We handed over our wishes on pale green index cards that were then pinned over the classical image of love, and it was a confusing and sweet and inclusive-feeling night in New York.

The domestic partnership announcements had been beaming into my mailbox all fall—Laura and Elizabeth's full-color snapshot, Cydney and Val's black-on-beige card stock. Over at Carmalita Tropicana's, I saw Peggy and Lisa's stuck on the refrigerator. How do you feel about lesbian marriage? I asked her. She gave me a long rambling speech about "rights" and then interrupted herself. "Look, I'm trying to date, honey." In general, "marriage" is not a lesbian thing. Of the 11 couples who got hitched on October 1, 1989, the day marriage (or partnership) was legalized for homosexuals in Denmark, all of the takers were men. Else Slange, head of Denmark's gay organization, says she "has a personal ideological opposition" to marriage. And it's not so much different here. The Mattachine Society had marriage on its agenda from the get-go; the Daughters of Bilitis were only just deciding to "come out" in the '50s. You could say dykes are slow, but I think it's more than that.

Today Tom Stoddard, lawyer and director of Lambda Legal Defense and Education Fund, who spoke at Ingrid and Jill's wedding party, is at the helm of pushing marriage to the front of a national gay agenda. But Paula Ettelbrick, policy director of the National Center for Lesbian Rights, expresses a fear that a progressive agenda would be lost if marriage became "the" gay issue and suggests that "those who are most acceptable to the mainstream because of race, gender, and economic status are the most likely to want the right to marry."

Her language begins to make marriage kind of heinous, referring to it as an "impenetrable institution that gives those who marry an insider status of the most powerful kind"—which does ring true, not just in terms of my married friends' heterosexuality, but how they get kind of close-mouthed about things after they tie the knot. One feels a little out forevermore, at least until they part ways. Despite our sordid reputation for moving in after the first date, lesbians are cultural loners, flinging ourselves into relationships because we know all too well how it feels to be the "odd man out." In general, lesbians often identify with (or are) economic outsiders, who would have little to gain from entering into this venerable institution, and many lesbians are simply suspicious of a society that protects couples.

Denmark, according to Ingrid and Jill, protects every citizen. "I did it for the benefits," laughed Jill one Saturday when I visited the two. "I could go there and be a baby." As a spouse of a Danish citizen, Johnston immediately qualified for a slew of benefits including a medical card, which in a socialist economy means a lot. The country longest occupied by Germany during World War II, Denmark managed to save 80 percent of its Jewry. The famous gesture of the Danish king putting on a yellow star is part of the national psychology, I'm told. Though it had colonies into the 20th century, Denmark's moment as a true empire was over by 800. Today it's a Lutheran country with a long tradition of compassion and caretaking. "Standing out is not good," says Ingrid, who came to New York at 21, on the heels

of her gay brother, to study theater. "If you do something great, you are congratulated but also reminded that you are still one of us." Appreciation of this flip-flopped status resounds through Jill's wedding poem: "The [Danish] queen must be a little like the Japanese emperor—a man with no family name and no passport who can't vote or run for office. The people in these places have all the privileges."

Ingrid's brother died of AIDS in 1989. Then Jill urged her to go back to Denmark where she hadn't been for 10 years, her parents having both died in 1976. AIDS is cited again and again as *the* contributing factor in gay marriage, both in relation to inheritance, visiting rights, and leases, as well as being part of a larger emotive move in the gay community toward forming more permanent relationships—getting familial. "As soon as I got involved with Ingrid I became a better mother," says Jill of the new friendship that's developed with her now adult children from a marriage in the '50s. And Ingrid had been married too, back in the '60s.

I went to a dinner party last weekend with seven lesbians, our ages ranging from late twenties to mid-sixties, and six out of the seven had been married. To help someone get a green card (maybe even making some money along the way), or for conventional reasons, whether seriously embarked upon or vaguely considered. Marriage, the institution, as it sits pretty in so many women's pasts, is almost the polar opposite of coming out, which is still so much about pushing away from the walls of the, okay, I'll say it, Patriarchy.

"Women in prison, that's who like to get married," says Carmelita. What do you mean? "Women marrying women. It's very popular in jail." For months I've been polling friends and acquaintances, dykes. What do you think of lesbian marriage? "It's an oxymoron," said Patty White. "Why can't we just make our vows to the rocks and trees," shrugged Nicole Eisenman, "why the State?" "So we can stop having sex, like *them*?" said Sarah Schulman. "Everyone knows that's what happens to people who get married." "Or live together," I added. "Right, that's why I never live with my girlfriends." "You'd

think they'd encourage us to get married just to stop us from having sex," I suggested and we both laughed and got off the phone.

Hawaii is not that different from Denmark. Now there's a ludicrous statement. But let me keep going, okay? There are only minorities there (in Hawaii), no real majority, so their democratic tradition is structural. When Jerry Falwell came to town, they formed the Moral Majority of Hawaii with progressive goals and tried to sue him when he arrived for using their name. Sound familiar? It's very much like putting on a star. In Hawaii the question is being framed in relation to gender rather than homosexuality—if a man can marry a woman, why can't a woman? The state court will have to have a good answer for that.

According to Jill, the gates were wide open in the early '70s and thousands of women were rushing through, coming out, and then they closed up by '76 or so. I like her kind of history. The sweeping lives of individuals shine like symbols—"they appointed certain people," she explains. Later, when I sat with her and Ingrid and watched their wedding on the monitor again, I suppose it was like sitting with any couple over their album. Then we're looking at a map of Denmark, and it's explained to me that Ingrid's family drove five hours from here to here—she points on these fish-shaped slices of land that mean "nation"—and I'm shocked, I suppose, that cultures are so different that one country in the world, and then one state, could open the gates to such a basic human privilege, the ceremony of belonging (or owning), whether we want it or not.

Meanwhile, at least one of the new domestic partnerships is making plans for a more formal ceremony. Cydney Wilkes (or Cydney and Val), a choreographer, wants to "score" her wedding, with lots of women kissing on cue, and several other mass gestures, just across the river in Brooklyn, an event rivaling Ingrid and Jill's Fluxus parade. And me—I've gone around since the end of the year asking every lesbian I know if she wants to get married and of course it's been a confusing proposal.

(2003)

MY SISTER'S WEDDING

Last May, the following message appeared in my AOL mailbox:

> *Hey Eileen:*
> *Judy and I are getting married Saturday morning. Isn't it*
> *wild? I never thought this would happen in our lifetime. Finally*
> *an advantage to living in Massachusetts!*
> *Love and Kisses,*
> *Ann Marie, Future Married Woman!*

Now I won't say that my sister and I are not *close*, but looking back on my files, I find her wedding announcement among other messages from her with subject headings like "Best Chicken Joke Ever," and maybe a bunch of political e-mails, nothing that would indicate that despite the fact that we shared a room for 18 years we are now intimate friends. Though Nancy and I are some kind of friends, maybe friends that have been trying and failing for years to stay consistently close, but truly what I most often say about my relationship with my sister to other people is that we are gay. A few years ago I had a girlfriend who owned a house in Massachusetts, and we invited my sister and her girlfriend for Thanksgiving and when they came I realized that I was the only person in my crowd who had a gay sibling. It was so great. Part of the practice of our sisterhood at that time was her coming to P-town with her girlfriend and spending

Thanksgiving or weekends with us—though actually my girlfriend didn't get along very well with my sister and her girlfriend. It turned out my sister and I were in lesbian relationships that didn't necessarily fit with the other's, so that's where our relationship got stuck for a while. Though I remember when I was on the Sister Spit tour in New Orleans that same summer and I took a ferry across the Mississippi River and I called Nancy from there and that felt close. I remember standing on the pay phone at Algiers Point and telling her I wanted Jell-O and I knew she would know what I meant. It got better when my girlfriend and I broke up, but nothing's really pushed my sister and I to another level till this announcement. Cause what would I do? I mean of course I would go. My friends in California just married and they had a big party and their families came but in some ways it was difficult. I mean for them with their families. But it was still a big dyke party, an opportunity to stand outside at night and eat and talk about out new haircuts and again, I was glad I had gone. I had had something else going on that night, a reading, but naturally I cancelled. I wasn't going to miss my friends' wedding party, though in the event of their wedding, the wedding itself wasn't the issue at all. It was the fact of it that was important. I actually needed to *go* to my sister's wedding. *It* was different. When I e-mailed her back that of course I would come she was a little shocked, but "thrilled." There had never been something I could give my sister. I mean in college there was a Peter, Paul, and Mary concert I should have gone to with her, but I cancelled to do something with my friends. But we were adults now. What could I do for her? Change my will? I think about that. I have some kind of insurance and sometimes I think I would give some to my girlfriend, and some to my sister—and what about my brother—and his sons? Yes, what about his sons—both of them. Are wills when you express relationship—or what? I have gone to weddings when people invited me for the hell of it. And I went because I just wanted

to say I like you, or else just what fun to fly to Denver. And another time, no twice, flying to the South both times to go to the weddings of my girlfriend's college friends, but all of these people were straight. I was there as a date, a lesbian date, sort of a freak at a heterosexual wedding, my girlfriend looking like a normal woman and I her man in a suit, a woman, getting looks as I walked into the ladies' room, always returning to a cluster of men flirting with her, then eyeing me weirdly. Weddings are a trial, always reminding you of what you're not, being occasions for the married folk to say how healthy they are, by including you. Though they can't. They never truly can. You're like the thumb. At my sister's wedding I was like a pun. I flew to New York, finding the cheapest fare I could, and then I drove. Getting out of New York took hours, and then I had to pull over I think, just being so exhausted, and yet too exhausted to sleep, waking back up, finding a Dunkin' Donuts, buying a couple of those mugs because it's hard to find good ones. My sister and Judy Nietzche were getting married at the Northampton Center for the Arts. They got married with nine other couples. It was funny because they are not really dykes with a community, instead they point at houses in their various neighborhoods where odd couples of women lived and died, and identify with those women who lived together and alone for years. None of their friends who came to the wedding were lesbians, mostly women that worked with Judy and none with Ann, or Nancy, as I call my sister, so I was the sole representative of our side, and I got there before anyone and saw all these other lesbian couples with a little bit of family, maybe a fag or two. Actually the event wasn't intended to be all dykes, just a group wedding, but no men applied. It was a plain enough room on the third floor that I walked up and down. I had two disposable cameras, and the room was full of chairs so I started draping my possessions, figuring that I could save space for us, that's what I could do. The front row was for "the brides" and there were pieces

of paper on each seat, and one said Judy and one said Ann and that's when I began to cry. I really shook, I felt very alone, and happy for my sister. *She's really doing this*, I thought. *It's real.* I couldn't get over it. For a moment I was mad at my girlfriend, not because she didn't want to do this. But because she wasn't here. It was a very moving moment. My heart was jumping out of my chest. *What if I die?* I kept looking out the window and finally they came. There had been a lot of talk about outfits. Nancy and Judy might have gone shopping and they looked funny in everything they put on. I strongly advised my sister to go as herself. She has some class things with Northampton lesbians. I insisted T-shirts were right and Nancy's I think had Wonder Woman on it and it was bright and Judy's was bright too. They were like adamantly silly. They go camping. They like birds, and nature, and kind of keep to themselves. Why would such women wear suits? For who? They liked the minister, a woman who had agreed to marry all of them. I met a bunch of their friends. I felt famous and charming, glad to be me. It seemed like such a good time to be butch. In my way I was the butchest thing in the room. It wasn't like I was so tough. It was just that I so belonged to my lesbian sister, her proud lesbian brother, and now I could have all this love toward my lesbian sister-in-law, Judy. I could ask her to take care of my sister, which she already does, but there was never a moment where my older sisterness was allowed to ask for that and receive a grin and know that the conversation fulfilled a need for me and for this other woman to agree that my sister was worth taking care of and it was happening. It was like an occasion had been constructed to give me a place to acknowledge my sister and my relationship in relationship to theirs. If there had ever been competition between me and Judy, there had never been a place to put it aside. I was glad my girlfriend wasn't here now. When the ceremony started all the women said in unison that they would do what the minister was asking. *Will you hold her all the days of your lives?* "Yes,"

said 18 tearful women. My sister was crying, Judy was crying, I was crying, Rachel, Judy's daughter, was crying. She had lived with them when she was in high school and it was not easy. But this was easy. Because Rachel was there too. It was more like a confirmation than a wedding. It was also funny. Because the minister had asked the women to say something and they all said it and cried. And now the minister asked "the other women" to say something. And everyone laughed. Because there were no "other women." Everyone had already said yes. It was a group agreement. It just didn't have to go back and forth. That would have made no sense. But my sister and Judy had lived together for 14 years, which is a very long time. I thought about how sad it would be when one of them died. Too sad, really too sad to think about but it's in the ceremony. It asks you to think about that and you're there all alone with it, one by one, very serious. And then you go to the party, very serious eating of food. I was exhausted. And none of Judy's sisters came to the wedding, but they all came to the party. That was all very nice. Her mother did-n't come either and asked that my sister and Judy not put their names in the paper and not have their picture taken so they told the newspaper photographer that, which was a little sad. They weren't in the group portrait. It was Judy giving her mother something. Can you imagine that thought being at the other kind of wedding, that the mother would ask the daughter to assist her in her shame? Though I'm sure they do do that some other way. Just the fact that she's marrying a man. It's almost like those weddings happen for an entirely different reason. It's like history, an opportunity for hetero-sexuals to create it, but for my sister and Judy history had already happened. The wedding was a moment to celebrate their past. It wasn't the bond.

I got a letter later on from my sister saying she was never sure I cared about her and now she was.

(1998)

HEAT

My car seems okay. The tiny adjustment the mechanic made to the ac switch on the carburetor has stopped the scary acceleration I'd been experiencing for almost a month. I spent the winter on the Cape—and I'd get on Route 6 for the weekly trip to Orleans to do my laundry (there's not a single laundramat in town), and maybe fifteen minutes into the ride my Nissan Sentra would start jerking and shaking, finally of its own accord surging up to 65 and 75 miles an hour. I'd lift my foot off the pedal and it'd be climbing to 85. I watched the trees whip by and I gazed at the other cars wondering if it looked as strange on the outside as it did in here—my car was driving me. I began to apply pressure on the brakes, eventually slow-ing down, but even in town where the traffic on Commercial St. was often moving at a meditative 10 or 15 mph I'd be riding the brake with my entire body weight.

One night I was coming back to New York and I accidentally got off the main highway and found myself in Wareham, Mass. There, I encountered my first stop light and I did not. Well, I stopped more or less. I applied full force to the brake and still my Nissan lightly tapped, maybe once or twice, a brand new shiny anonymous looking car occupied by what looked like a gang of high school girls with big hairdos, one of whom had definitely been given the car to drive to school her senior year and now some lunatic was bumping her from behind, not once, not twice she insisted when I

met them all at the police station in Wareham, but five times and brutally she insisted.

"You are not hurt," I replied.

"How do you know," a girl in the back shrieked, clutching her neck. "I don't see anything," said a cop we encountered in the parking lot. "Let me see your license and registration," the girl demanded and politely I supplied it. It was dark out and it was pretty late. I was still in Massachusetts.

But what does this have to do with lesbian mid-life. Well, I'm a poet and nothing in the universe happens alone. I don't like metaphor, but things lie next to each other pretty nicely, especially in real life. I'm 47 and, see, frequently I'm hot. "Are you hot," I ask a friend, often my girlfriend who is twenty-nine. "No, I'm cold." she replies and I go, "Huhn," and get quiet.

It's been happening for about a year maybe two. It got clearer last spring, same time things started happening with my car. I'd be re-living some moment of embarrassment. The kind that brings a little heat to your face. I'm running on the stairmaster at the gym. I get hot too quick. It's a flat kind of heat, like wearing a cheap shirt in the summer.

The air can't seem to get in. I haven't been exerting myself all that much, so it doesn't make sense. The embarrassment goes further than it should, the blush lingers and I've got to get up and walk around. Throw open the window. My body seems to be running without me like my car. We're hot.

"You don't understand," I said to the high school girls in the parking lot. I didn't hit you."

"Yes, you did," said the girl behind the wheel. Her car was brand new, god, did it shine.

"I had my entire weight on the brake. I was waving my hands at your car to explain my innocence. Didn't you see?"

"Oh sure," said the girl. "You drove away."

I am thirty years older than this girl. I could be her parent. Despite my black glasses and my torn jeans and my older car (I'm cooler than her) I'm going through menopause. Actually it's not menopause till you're done. I'm in periomenopause. Perio means surroundings. Like the hills surrounding the great change. Sometimes I go to parties in New York and people tell me I'm the only woman in their forties they know. I've never dated women my age, never, so naturally I'm alienated from "their" bodies, ie my own.

"My foot was on the brake," I insist.

"Your car shouldn't be on the road," the driver said.

"I'm driving home," I say to the girls from Wareham. "It's eleven o'clock. I live in New York."

"Do you have insurance," she asked.

"Yes," I replied. She put her hand out.

It actually made me happy to think of my car wildly accelerating like me. Then it stopped for a while. It's November and sometimes it's hot in the mornings so I kick the covers off. It's back. The mechanic on Lafayette said I shouldn't have any problems now. If you do, said Tom, throw it into neutral, and then turn the key like this, he said, nudging it *away* from the driver's body. It'll stop, he said, smiling at me. I should do that when I'm on the road I asked. Yes, he nodded. When I'm in a slow lane. Well yeah he agreed. Now I have something to do. I'm growing fascinated even comfortable with this raging hormonal shower, which every woman I talk to in her late forties is going through, it's the flip side of adolescence. When you haven't had a period in a whole year, then the storms recede. It's not like you *get* a new car. It's not like I did, I thought patting the dash.

(1996)

A RECIPE FOR LESBIAN BRAIN

Luckily, I still have the clip. *New York Times*, Nov. 2, 1995. The name of the article is "Study Links Brain to Transsexuality." It's a really odd title, come to think of it. With a criminal overcast— blame the brain, it seems to imply. Anyway, let me quote from it a bit. "Researchers in the Netherlands have discovered that a region of the hypothalmus, located at the floor of the brain, is about 50 percent larger in men than in male-to-female transexuals. If smallness of this brain structure is at all correlated with the feeling of being a woman, the results raise tantalizing possibilities that transsexuals may in a sense be more female than females." The things that intrigue me in that last sentence are "tantalizing" and "in a sense." Perhaps this is where our recipe should begin. I mean, "tantalizing?" What is the turn on for these researchers that there needs be something more female than a woman. I mean it's incredibly competitive, of course, to be so hell-bent on demonstrating that. And in what "sense" could it be true. In the sense that I feel like a woman and that my small brain contributes to that feeling? It's an amazing suggestion that being a woman is only "a feeling." Obviously whoever has the biggest feeling "like that" wins, and is thus the most "female." What a world! Glad I don't live there.

You can't help wondering who they captured for this study, and happily the *Times* tells us that too. "It was performed by dissecting the autopsied brains of transsexuals, homosexual men, heterosexual men,

and heterosexual women. Because transsexuality is rare, it took the scientists 11 years to collect six transexual brains." No lesbian brains were hanging around, evidently. Or F-to-M transsexual brains, either. What would we find out if we slapped a few of those down on the pathologist's table? Thud. That the lesbian hypothalmus is even bigger than the weighty state-of-the art heterosexual male brain? Hmm is that the fear? Or is it tiny, tiny-tiny, the lesbian brain? A brilliant little chip. Underlining perhaps the slow evolutionary accidents that have resulted in these lummoxes who wander among us with big packed heads, feeling terribly male. Though that is not a feeling, but a fact.

Naturally the reason we're not hearing about the cerebral source of "male" feelings and the corresponding studies of those homosexuals who have bigger brains and the transsexuals who have even bigger ones, feeling really really male, is because maleness is a given, both "human central" and something else. That Spanish word, *duende*, kind of a strut. Maleness is a sheen on the coat of the male animal, that something extra, the presence not the absense of horns. It evades analysis, it's what makes the world tick. And this is all making me incredibly hungry. I don't know what a hypothalmus is. Do you? I don't have such a good dictionary, either. I mean not for this kind of thing. But here goes. "A basal part of the diencephalon (I hear two-sided brain in that, don't you?), that lies beneath the thalmus on each side, forms the floor of the third ventricle, and is usually considered to include vital autonomic regulatory centers and sometimes the posterior pituitary lobe." Now I don't get too much out of that. I hear growth and all the things you can't control—breathing and sex, basically.

I've been eating spaghetti and meatballs like crazy, lately. It was my favorite dish as a child and it remains that way. There was a show called Howdy Doody in the fifties when I was walking around in white shoes and small sneakers and vests with fringe and perhaps a gun in my holster and on that show was an animal named Flubadub which was not one animal or another but all of them. Giraffe, dog,

whatever you want. And Flubadub had a theme song, a small red record spinning round in my house and it sang incessantly, "Meatballs, meatballs, meatballs and spaghetti, I'm always ready for meatballs and spaghetti." My dinner with Shannon just kind of caved in. There was a blizzard today. So I came home to a message from her accepting my dinner invitation but that was hours ago and now I was ravenous and carrying in my food. Which was very good fresh spinach pasta from that place on 11th Street. I think Spinach pasta sort of suggests that red sauce is out. It just looks bad. But I used it, a little Aunt Millie's Marinara from a jar. Plus a few splashes of sauce in which are suspended the three meatballs I bought at Village Deli Restaurant on First Avenue between 2nd and 3rd. I also bought fresh parmessan at the Italian store. The guy was downright nasty. It was January 2nd, I assumed he had a hang-over. Anyhow, the parmessan kind of upscales the whole dish. It melts, it just gives it a snowy, sentimental quality.

The recipe continues with potato chips and the dregs of a bottle of Manhattan Special, a syrupy high caffeine drink. I called her. She said, are you already eating. Yeah, potato chips. Sorry. So we had our get together on the phone while my water for the pasta was boiling. There's a brain dish in South East Asia that centers around a table with holes in its surface. Live monkeys sit underneath it and their skulls are lopped open by sharp swords. One then eats their brains while they are still alive. I would think that the monkeys would scream. I saw a great movie on Christmas night called "The Kingdom" which was a Danish soap. There was a brain surgery going on and the method of anaesthesia was hypnotism. At one point the patient, a black man, appeared to wake up. Everyone became very afraid, including me. It's very easy to imagine what it's like to have scalpels or even forks and knives digging into your brain. Perhaps it's the worst pain in the world. My friend David had the best brain I know. He wasn't a dyke but he liked to hang with

us. His brain had a tumor which killed him. In the hospital after the surgery I walked with him over to a window, I held his hand and he had a large mushroom shaped bandage on his head. He spoke very softly and it was so eerie. I suspect there's something wrong with assumptions about brain size and power, bigness and smartness. The smaller female brain (when you put it that way) always sounds somehow less important. Yet consider all that autonomous activity going on there in the hypothalmus, and women do live longer, survive better, can endure more. We know this. So it seems to me that it's a successful little organ, the female hypothalmus, seemingly more evolved I would think … like the most desirable portable anything. I stick my fork in. One meatball on my plate was certainly smaller than the other two. I actually thought of it as male. A little testicle. I take a bite. I imagine the brain would have a dense protein-rich but somehow internal organ consistency, if you sat down to one. They are obviously not ignoring lesbians, but thinking we are beside the point. The one piercing into the brain, looking, looking. I think of Antonin Artaud's suggestion that we wear our organs on the outsides of our bodies like jewels. This is my exhortation, my recipe for the lesbian brain. You're living in it. You're reading it here. Bodies and books, all our gestures, large boring gatherings and small strange meetings, sexual encounters, splashes of light across our faces and bodies in apartments, art on the wall, tapes on the screens, words out loud. These are the elements, ingredients, a recipe for the lesbian brain, the sky overhead, the endless night and the food we eat, the way we dress, everything that shows, a radiant secrecy, the whole aching collection, the gamut of us. It's the living upside of our notorious invisibility. Our virtual intelligence as we put it out. The indestructible ghetto. I throw my weight with everything that will never turn up in the gaping head of a dead cadaver. The surgeon's scalpel prods a small bump, goes hmm what's that. Check the jar on this one, Eddy. Looks like a dyke.

MOVING PICTURES

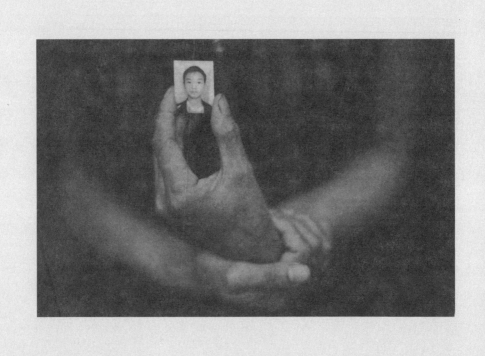

(2003)

REUNION

Maybe the truest ecstasy of looking at *Pull My Daisy* from the angle of the 21st c. is the experience of merging with its overhead camera and witnessing for the next 28 minutes what will constitute an exquisite and irreversible number of meetings. Of light and dark because that was, or is, film. Of men and women—the men being the heroes of the Beat legend: Allen Ginsberg, Gregory Corso, Peter Orlovsky, and the females, well the women are written as largely empty canvases for beaming the men's Beat truth upon though "they" are not actually shot that way. Delphine Seyrig, variously referred to as "the wife" or "the woman" has probably more screen time than anyone else in the film as well as being the only person on the set who was not playing "herself" to some degree. (Though Alice Neel and Richard Bellamy play characters, part of the fun of the film is whispering "That's Alice Neel." "Really?")

Delphine Seyrig was a complete unknown, a student at the Actor's Studio. This was her first role and she would go on to have an amazing career working with Europe's best directors, directing a number of films (including the 1977 *Look Beautiful and Keep Your Mouth Shut*) and starred most prominently in *Last Year at Marienbad* and *Jeanne Dielman*. But now (1959) she merely holds up half the sky of the film: she plays a young mother; a painter opening the windows of her studio in the morning. Soon the guys will be loading into the loft, her son will wake. She is the austere, beautiful,

moralistic, labile-faced wife; the perfect foil to the angelic hi-jinx of these men; cultural heroes in their youthful prime. In a way *Pull My Daisy* is the first music video. Except that it's film and music conspiring maybe for once in history to cover poetry. The slight plot of the film is the off-center meeting of these hipster guys with the straight, uptight people: a bishop, his mother and his sister. "The woman" of course is the gateway to the encounter, having seemingly arranged it. Even the kid (Pablo Frank, Robert's son) soon becomes part of the irascible male crew. The film is shot a little like a play, waiting for the action—in part perhaps because it was based on a play by Kerouac called *The Beat Generation* which was this film's original title except that Hollywood beat the beatniks to it with a film of that name that very year, 1959. I vividly recall that year's calendar, a folksy cloth one, hanging in my mother's kitchen being more or less the same age as that kid. Unlike Pablo the rest of us would get prepped for "the life" by the mass produced versions of beatness on teevee. *Route 66* in 1960 was about a couple of guys driving across America in a Corvette. *The Many Loves of Dobie Gillis* had teevee's first beatnik character Maynard G. Krebs ("You rang?") Yet remarkably in Robert Frank's film the artists are actually playing themselves, the inside of our outsiders show, the Archie Andrews and Jugheads at the center of the gone world.

Kerouac's play had pretty much described an actual encounter of the same gang of poets (including Neal Cassidy) with Bishop Romano, a prelate of the liberal Catholic church. Kerouac himself was no fan of the Catholic church. *Pull My Daisy* refers to a g-string being dropped away but the emotional underpinnings of this film make it more like a red flag being waved at a bull. The meeting (in California) was a rowdy and disastrous one. A drunken Kerouac proclaiming I love you, Bishop. I love you. Kerouac was a drunk and drunks, of course, are often repetitious. The mind falls down on itself trying to keep its feet. Repetition also constitutes the beating

heart of Kerouac's score. Like notes dropped in a river repetition is time performing itself in language: one picks up its ropiness and plays it for a while. Kerouac was a performer as well as being a stylist supreme. This film is the meeting of two parts of him. He had worked with jazz musicians in clubs and even on teevee, but here we get to watch the fact of the man working, though invisibly. Let's face it, language is invisible. This is not *it* here, exactly. Kerouac was also always an inspired explainer of his own craft. He called what he did "sketching language" and the arbitrariness and the uniqueness of each subsequent take of writing was key to his idea of bop prosody. Writing was performance. You begin with something familiar. Something almost anonymous in its familiarity. (Which is a touch-stone of Robert Frank's oeuvre. Homeless people, movie stars. What's the difference.) But a musician uses a standard, a piece of the rock. And as you play you blurred the outline, stray and noodle and then come home. That's what a standard was for. To abandon, like a wife, then return. Jazz had its own kind of black face built in. Jazz crossed over when it sang *your* song like you (no matter who you were) had never heard it before. Jazz went right under the rope. As if there were no rope at all. Kerouac took a small slice of his own play: the meeting "the bishop" story, one his own gang probably knew. Many of them were there. So their job for the period of filming would be to reoccupy the familiar script (of life) which went this way or that, and then imposing on that the script of the script that went that way or this, the script Jack wrote, and then armed with cigarettes and wine and time and money ($18 a day, not bad in 1959) *and* the opportunity to make myth with their friends the shoot began. Kerouac himself is one of the two key presences in the film (the other finally is Delphine Seyrig) because of the fact that Alfred Leslie banned him from the set to forestall the chaos his pres-ence would produce. Kerouac didn't mind since the last word was his in spades, though the last last word always goes to the filmmaker,

who kept recording Kerouac in between takes, nabbing anything Jack said so that the outtakes were the intakes and so on. The famous "up you go, little smoke" sung when the child went to bed was apparently one of these caught rabbits. The entire film from moment to moment is a form of collective breathing.

There was an extremely rich and awkward screening of *Pull My Daisy* this past spring at Walter Reade after which Robert Frank was to have one of those public staged un-staged conversations with the journalist who wrote about him in *Vanity Fair* so he (the journalist) foursquare sat himself down in one of the red chairs to facilitate this historic event. Not! The journalist instead seemed to be in an altered state, playing crazy Jack to Frank's Frank. For starters the journalist dashed onstage wearing patriotic (red white and blue) slip-ons and threw himself into a chair then cannily shot at the distinguished filmmaker so how's your asshole. The room thickened palpably. Frank was still and the conversation sputtered and ricocheted from there, the man's jazzed up inappropriateness spurring a little abjection from Frank:

"If Jack Kerouac didn't write the text of *The Americans* you probably wouldn't be sitting here today," said Mr. Fox.

"Probably not," Frank replied.

"But why are *you* banging his drum," Frank quickly added.

The journalist seemed momentarily deterred then tore off on a campaign of praise just as stifling as the "asshole" approach. But the excess of the younger man flapping his wings occasioned Frank to issue several sallies of greatness, of presentness. I was so impressed I took none of them down. I found myself pondering an artist, Robert Frank, who either thrived or simply found (is it possible?) himself surrounded by craziness, of every sort, all the time. Take the much

palpated schizophrenia of Peter Orlovsky's brother Julius, the subject of what I think of as Frank's crowning achievement *My Brother and Me*. That film is a quasi bombardment of photos, institutional records read aloud, enactments recordings, performances, stand-ins, and just pictures great and small of Julius and of a million other people all of which made me think of about the last decade or so the epidemic of pictures in the paper of people holding pictures of people who are lost. So that in our time the picture of the picture has become the international symbol of loss and this trope is a room Frank has only been stepping deeper and deeper into through the decades of his career.

In the after party at Walter Reade when Mr. Shoes leaned against the wall with his girlfriend I wondered who will talk to him. Certainly Frank would. In fact he would probably enjoy it. I entered a circle that surrounded Joyce Johnson. Joyce Johnson told us that for years she has been unwilling to write a Kerouac biography and now it just seems like it's time. I know how they (Kerouac and Frank) met Joyce beams.

Jack was in with his editor and I was sitting outside on a chair she says. In comes Robert Frank with his portfolio. I need to meet Jack Kerouac he tells the receptionist. Why do you want to meet him asked Joyce. She winds up looking at his photos with him, the ones in *The Americans*. Joyce tells us of a highway. I can even show you the picture, she says. I mean if I *had* the book here. We all looked around. It's me, Mark, and Joyce. She shrugs. But that was *it* she said wide-eyed at us like we were the picture. That's Jack's road.

Long after one learns to read don't you still want to hold a book upside down like a baby and feel all that negative power rushing by like a train. Janine Pommy Vega a beatnik girl was on the scene back when she was 18 and I'm sure dated one of the men, maybe Peter, but she also had an enormous speed habit that *drove* her writing and she once described keeping copious journals during those years, writing so fast that the bulk of what she wrote back then is unreadable. Pages

and pages of a wavy line. One could call this tragedy, or stupidity, but I call it the heart of the matter; the fact that I write is more important than what I have to say and being unable to reconcile the time I spent saying it with any particular meaning is the outer limit of what the 20th c.'s project was all about. And the prescient glow of the 21st. And it's also the locus of Robert Frank's films. All of them. It's the girl hanging outside the concert in *Cocksucker Blues* talking matter of factly about taking too many drugs and living on the street and though Frank has astonishing footage of the Rolling Stones at their height, his dizzying carousel effect requires (probably legally) that he turn, turn, always turn away. To enter the bedrooms of the roadies almost more than the stars, and there look into the eyes of a girl so gorgeous and so doomed shooting smack into her leg, passing by the room where Truman Capote and Bianca Jagger and Andy Warhol hover the way the famous do bouncing the light back and forth but Frank's outside clutching his microphone and listening to the thick and homely and desperate groupie outside and now she's at the center of the story. God is a circle whose center is everywhere wrote Sor Juana Inés de la Cruz (a 17th c. Mexican nun).

When Kerouac looked at the moviola he was chanting. A jazzman, he wanted to do one take on the soundtrack and that's all. He did two more in any event. *Pull My Daisy* was not his, though it was "about" him. Maybe he was a little feminized by the project. And that's a compliment.

In 1959 a film was still a procession of tiny pictures establishing movement, a flipbook of ecstasy. Puppetry too, it seems to me. You ventriloquized your friends, I would tell him. You're a kind of hamburger helper. When Kerouac's friends sat talking for hours and a filmmaker distills it into a cloud of smoke and their anxious intense young hands waving and close-ups and you lean into the microphone that's facing down on the smaller screen. Picture this in 1959, a little moving portrait of your friends (Gregory Corso,

Allen Ginsberg, Larry Rivers, David Amram, Alice Neel ...) a shrine. In the filmmakers studio you go "baba ja babba ja babba." What is that. Is it baby talk, is it mockery. "Early morning in the universe ... The room's a mess. There's her husband's coat on the chair. Been there for three days ..."

The tone Jack Kerouac uses to "tell" the movie is like an older sibling looking fondly at an album in his lap. The photo angles are vernacularized instantly. In the two-man show of a comic book style. He's captioning, internalizing and performing the filmmaker's styles. Finally they're editing. But his voice is the last outpost of familiarity before the scene passes into the world and history. He's what lets "us" in. His friends, their rooms, their lives in their past-ness. We meet *him* uncannily in nostalgia. So much of this 28-minute film is accompanied, is companioned by quackery, clack-ery: "coffee cockroaches, stove cockroaches, city cockroaches, spot cockroaches, peanut-butter cockroaches, cockroach, cockroaches" and the voice reading the film sometimes pulls back and delivers with great relish almost in the voice of another man like when a dog rolls back his lips and emits a deep whine: "cockroaches mirror BOOM BANG" or in dirty talk like you use in bed when it occurs to you alone as an adult that at this crucial moment of lovemaking if you said this crazy irrational thing your partner will be coming and screaming right out of her mind, and uselessly and terribly you are right. An Italian critic, Sandra Villa, pointed out that the actual *sound* of cockroach, cockroach cockroach has a specific effect, and I mused on how English, a rough tongue probably, could sound to nonnative speakers like maybe German or Gaelic sounds to us. More animal somehow. And I thought for me it percussively balances the other sweet part of this movie, a riff I've held onto for years for why a poet might want to score a film. The moment is bright the lights are high. In the kitchen and we (still being the camera now) are exploring the appliances and the young men's

unmarked white faces like sails only just now heading out on a voyage that will cover many years grow gnarled and twisted and ultimately dead. But now they are flesh and the room is open too. "Are holy flowers holy, is time holy, is glasses holy, is all the white moonlight holy?" And you know it's the kaddish of this, it's a variation on the coda of "Howl" so he's quoting his friend behind his back, no to his face. Dude, I am covering you. The result is exceedingly high. I also love that "the woman" has never said a word. All the men are silent but hers is the most profound I suppose because of her skill. He puts words in all of their mouths but hers don't stick; cause still she's apparently thinking more. Her thoughts have never even been touched. And she might have been the only person present that day, those days of filming, that knew moment by moment that she was in a film. It made me so mad when I was younger that this was the condition of the one person who I remember as being the only female in the film. But her troubled face and her pervasive awe, which is as natural as breathing, it is what actors do that poets don't. David Amram was listening, sitting in the room when Kerouac was registering the three tracks he recorded that day. David listened to the rhythm of Kerouac's voice and began composing right there on the piano to the same pulse of it which is why the musical score is so good. Everyone was in there when it was happening. It's "a situationless play for future people," Kerouac once said. At some moment, at many moments it's where we all met. There was a James Frey type uproar apparently in the press of the time because despite the fact that the film acts as if it's "true" there *was* a script, huffed critics, and they shot for three days, not just one half hour, and you know *this* is no more authentic than any other film. And that my friend, is a lie.

(2001)

THE UNIVERSE IN MY BACKYARD: RUSSELL CROTTY [1]

Each book has a different feel. One is just the belts of Jupiter. That's probably the most intense book I've ever done. It's like a hundred and eighty six pages. I'd work on it five days at a time and then leave it for a while. Do something else. I took all my observations of Jupiter and I just looked at them, and then just did it out of my head. That's true of a lot of the astronomical images, you can't do a globular cluster and make it look like a globular cluster. It's almost an impossible thing to do. I take from my observations the shape of the thing and the rest is sort of like creating it from the process of drawing. Like the Jupiter belt—it was spinning, it was like a flattened planet sphere, a version of the planet spinning. Actually on certain nights at opposition time when Jupiter rises right at sunset and sets at dawn you can see the whole planet rotate cause it rotates so fast—that was the idea, to get that going. It's not a flip book. It's not that fast, but it was quick enough where you could turn this, and get a sense things were moving across the page that was really quite cinematic and sequential.

It's a minimalist system with a maximalist process. There's a lot of information going on. Donald Judd would turn over in his grave if you

1. Russell Crotty built an observatory up the hill from his house in Malibu where much of his observations are conducted. He makes LARGE scale drawings of various "items": a nebula that looks like a dumbbell or a creepy pumpkin. But his obsession is to make bigger and bigger star atlases and planet atlases, my favorite being a big flip book of Jupiter's gaseous bands.

filled a big blank beautiful book like this with this stuff. I like his systems. In a way I'm kind of exploiting that. Agnes Martin is one of my favorite artists. I was using that grid system. I thought it was beautiful.

I started collecting these books and reading them, historical stuff. Here's a guy, Pannekoek, that drew the Milky Way by hand. He and his wife would just go out and camp. He'd do it in the dark, maybe by candlelight. Completed in 1928. It took him thirty years. This is Krieger, a German, who drew the moon. He worked himself to death. Half those amateurs up there in the mountains are probably ex-hunters. You can't hunt as much as you used to so they've turned to the astronomic field.

They do get something there—the reward is incredible when something comes into field of view, you fall off the ladder looking into the eyepiece. On that ladder alone up there I feel actually creeped out. I feel like I'm looking at something I shouldn't be looking at. That light—there's something sacred about it. It's travelled so far—should I be doing this? This is amazing, like eavesdropping.

I'm resisting much of the technology. I think it takes away from the observation, what your eye can pull in. Experiencing Saturn through the eyepiece. You can't believe it's real. It's so perfect. Looking at a supernova around there in Cygnus in the summer time—it's like a very faint veil of gas. You can't put it in words but I can attempt to draw if I really want to try. It's almost a feeling. Like the really old light, this faint object, something cataclysmic that we can't even imagine that happened 40,000 years ago is just drifting through the galaxy and it happens to look really beautiful.

I think the text I use has a way of bringing it back, the reality of this kind of stuff. Weighting and unweighting, I think that's how the books function—they sort of breathe that way, you can go from a density to something really light. That's the challenge with the book, I'm doing a huge book for my New York show at CRG next year. It's going to fold out to 8 x 13 feet, a sculpture basically with

drawing—massive. I'm going to have to build a bridge in my studio to draw it, to get to the middle of it—that's scale again, push it to the limits. You heard I was doing a drawing of the universe. That's so great. I'm doing two other books. The books will have these squares—fifteen inch squares. Sections of the Milky Way. All of this will be notes and diagrams of fields, whatever I'm observing, then you turn the page and then there'll be this big square, almost like an engraving, of that section of the sky.

This is the finder scope just to see where you are. Open the roof, pull the truck up right there, drop the tailgate, have coffee, snacks and stuff, and people just come over and hang out. Point it up. The ideal viewing for any observatory in the Northern Hemisphere is facing south. So you get the ecliptic where all the planets travel. The moon. This is aligned with Polaris, the North Star, so it tracks. It counteracts the Earth's motion so we stay on track, on target. We look at different stuff. Depending on the time of year like right now it'd be galaxies we'd be looking for, little later in the evening the Milky Way, the edges of the southern Milky Way would be coming up and we'd see globular clusters which are on the fringes of the galaxy, that's another aspect. I call it location but that has a lot to do with my thinking and my work—just knowing about these things like knowing by midnight on a spring evening you'd be able to see globulars because they inhabit this area around the halo of the galaxy and the galaxies are starting to come into view. That's why in August if you're out in the country that's the Milky Way right over head. But in the spring because of the way the earth moves around the sun we're looking out, away from the center of the galaxy. It's all about movement time and location. Location on a massive scale and location on an intimate scale, I think that's the fundamental thing really and sort of finding yourself in it somewhere. You're up on a ladder and you've got a clipboard and I have red flashlight so you don't hurt your eye, and I have the little flashlight I'm holding in my mouth and I'm sitting here drawing, like that.

(2006)

REPEATING ALLEN

*who lit cigarettes in boxcars, boxcars, boxcars racketing through snow
toward lonesome farms in grandfather nights*

Whenever I teach *Howl* I jump on this line. It's my favorite because
the thingness of the word (boxcars boxcars boxcars) is exactly what
you see at a light while a train is passing—all throughout this poem
Allen wrote cinematically but never more succinctly as he did in
this line. Boxcars, boxcars, boxcars. It was what you saw, is all.
Howl is remarkable because Allen did the complete thing—he
wrote both a poem and a culture to put it in. Poetry went to the
movies here and it never came out. I think the poetry world (some-
thing that probably shouldn't exist) is ever more cursed with public
events that ask is poetry political, relevant, over, commercial,
popular, etc., because in this poem it was all those things at once.
Many of us write poems that are some of those things for *some*
people, we write for "a" culture, not for "the" culture. Allen wrote
Howl, that's who he was and *Howl* changed things. How? And I'm
looking *in* the poem, not out and around it because the poem is the
theater of *Howl*, the movie theater I mean. It's replete with trailers:
"who sang out of the windows in despair, fell out of the subway
window, jumped in the dirty Passaic ..."

Somebody knows how many "who"s there are in *Howl* (and
someone even knows who all those who's are. I considered calling

Bob Rosenthal, Allen's longtime secretary, or Bill Morgan, the archivist/painter who sold Allen's papers to Stanford to find out who was that guy "who jumped off the Brooklyn Bridge and lived." I remember the story and people laughing that there actually *was* such a guy, like he was even pointed out one night in the bar: That's him), but my point actually just is that the poem functions so often literally like a trailer. The announcer voice of the poem keeps folding all those lives in as preview of the spectacle the poem will produce, meanwhile it's producing it NOW and so much of the excitement of *Howl* is its capacity to produce those two effects at once. You're rubbing your hands as you read: ooh this is going to be really good, but the experience is already happening.

And were all those whos poets, or poet-like people? It seems to me that Allen actually pluralized the identity of the poet by means of these wavelike lines, announcing the poet's arrival again and again. He (or she) wasn't exactly a poet, didn't need to be. The poet came in this cascade of people. Allen made the poet's identity something vague and postmodern. He was one of them, not which one. They were more like the barnacles on the poet's boat as he surged forward carrying them, or them carrying him, because they "who drove cross country seventytwo hours to find out if I had a vision or you had a vision or he had a vision to find out Eternity …"

Well it's a little Pete Seeger, isn't it, the singer in the broad room inviting us to join in, cause whose vision is this after all? Or maybe Mitch Miller, *America Sing Along!* Authorship (or poet-ness) seems really secondary in the poem/spectacle that everyone seems to be writing here (in *Howl*). It's Allen's identification bringing all those lives in close that works, and it also occurs to me (and Allen I think said this often) that it works a little bit like it did for Christopher Smart, Ginsberg's other great literary predecessor, besides Blake (and Williams), and I'm thinking of the Smart of *Rejoyce in the Lamb* that begins:

For I will consider my Cat Jeoffry …

Rejoyce in the Lamb is a long (about 800 lines) and obsessive poem which goes on in a stiff but attentive evocation of cat-ness:

> *For he rolls upon prank to work it*
> *For having done duty and received blessing he begins to*
> *consider himself.*
> *For this he performs in ten degrees.*
> *For first he looks upon his forepaws to see if they are*
> *clean.*
> *For secondly he kicks up behind to clear away there.*
> *For thirdly he works it upon stretch with the forepaws*
> *extended.*
> *For fourthly he sharpens his paws by wood.*
> *For fifthly he washes himself.*

Later the poem ends like this:

> *For by stroking of him I have found out electricity.*
> *For I perceived God's light about him both wax and fire.*
> *For the Electrical fire is the spiritual substance, which God*
> *sends from heaven to sustain the bodies both of man and*
> *beast.*
> *For God has blessed him in the variety of his movements.*
> *For, tho he cannot fly, he is an excellent clamberer.*
> *For his motions upon the face of the earth are more than any*
> *other quadruped.*
> *For he can tread to all the measures upon the music.*
>
> *For he can swim for life.*
> *For he can creep.*

Christopher Smart was living in a madhouse in restraints when he wrote this poem, never published in his lifetime. I mention it because it's entirely structured of repetitions, a poem in chant form, much like *Howl*, and the cumulative effect of the slightly recoiled paw of the final line, is the cat practically moves. A poem that uses repetitions throughout, a standard of religious verse (which both Smart and Ginsberg's poems are) ultimately has the effect of being a flipbook, a kind of low-tech predecessor of film (as Ginsberg knew it, and increasingly not as we know it now—since film's gone digital), and an equally good producer of altered states, and bliss. Like when you jumped up and down in childhood saying taxicabs, taxicabs, taxicabs, the words start to sound strange, but you also got "high."

I turn to Kenneth Anger too in search of this mode, a euphoric one, considering *Scorpio Rising* (1963) to be another epoch-changing work of art. Anger's method was referred to in one description as "semiotic layering" which works just as well for *Howl*. Kenneth Anger was relentlessly cultish, and though his accomplishment and influence wasn't any smaller than Allen's maybe the scope of who he was aiming the work towards, audience-wise, was more precise. But his film employed the same biker boy references, fanatical love for a number of American subcultures of the '50s, was homoerotic, and in the context of the film, the effect of its culture was totalizing, in the extreme. The building repetition of belt buckles, motors, flashing signs and flags finally produced a world that triumphed by its end— the case was made. Allen's ambitions were messier and planted more wildly. *Howl*, like a Brian De Palma film ends again and again. And even in the mostly nonspecific and linear-feeling Moloch section:

> *Moloch in who I sit lonely! Moloch in whom I dream angels,*
> *Crazy in Moloch,*
> *Cocksucker in Moloch,*

and later ...

> *Moloch who entered my soul early, Moloch in whom I am a*
> *consciousness without a body, Moloch who frightened me*
> *out of my natural ectasy, Moloch whom I abandon!*
> *Wake up in Moloch,*

then finally:

> *Light streaming out of the sky!*

Where did that last one come from? Allen was such a diligent student of ecstasy and vision that he knew that as the swastikas, and belt buckles flicker, something happens, the road opens and a space opens up as well inside the poem, the cat creeps, or perhaps you just stayed up all night, praying to Moloch, and dawn is its mystical reply. *Howl* is a poem full of miracles, and events, not the least of which is its own machinery. Because you are in it, witness, and you watch the poem grow. The only promise in this poem is more, and it makes good, not in some other world but in this one that you read in.

Yet, aren't these all photographs—or stills?

> *With mother finally ******* ...*

What do those asterisks mean? Fucked? fried? What? Such a place to begin a stanza which then turns into a passage of endings:

> *and the last fantastic book flung out of the tenement window, and*
> *the last door closed at 4AM and the last telephone slammed at the*
> *wall in reply and the last furnished room emptied down to the*
> *last piece of mental furniture, a yellow paper rose twisted on a*
> *wire hanger in the closet ...*

All those "lasts" feel like the sorts of things you'd see in say the Holocaust museum, or a museum of the American Indian, or even in the anonymous family album that turns up in a thrift. Tragic, or no, after each of these "lasts" I hear a click of the shutter—it needs to preserve. William Carlos Williams, in his preface to the City Lights version of *Howl*, makes passing reference to the resemblance between this poem's hell and that of Jews in the last war. I never thought about *Howl* as a holocaust poem, though I've been aware rereading it that it has holocaust phrasing, the trauma of the holocaust is all over it. So why not allow the overt thought to surface, that maybe this poem forced America to experience, in an indirect fashion, something it otherwise felt compelled to refuse. The sheer madness, the total horror of the holocaust. Pictures of emaciated corpses, the same pictures again and again is one version, but what is the invisible horror of *Howl* that all the angel headed hipsters are running from, is it the world we now know? Allen drops the loving leash of friendship around his own neck when he repeatedly promises his institutional war buddy, Solomon: I'm with you "in Rockland / where we hug and kiss the United States under our bedsheets the United States that coughs all night and won't let us sleep ..."

Carl Solomon is a Jew and he sounds more and more like Allen's mother ("you've imitated the shade of my mother"—who Allen may've needed to affirm his attachment to and her own stay in a mental hospital. Through Solomon, he did).

I haven't touched the especially poignant and relentless flavor of Allen Ginsberg's misogyny. There's so many incidents of it here: "the one eyed shrew that winks out of the womb" actually all three fates are pretty bad. And elsewhere in the poem women serve as opportunities for male bravado:

you've murdered your twelve secretaries

or holy self-abasement:

you drink the tea of the breasts of the spinsters of Utica

Yuck, right? And he must've been singing the hipster virility of Neal
Cassidy when he referred to someone "who sweetened the snatches
of a million girls trembling in the sunset." I guess male = sugar. No
sweet pussy on its own? Not in this man's howl. In the Beat canon
in general (see Kerouac) thanks to birth we're blamed for life. It's a
belief that might be as old as Buddhism, or Judaism. At best, we
(females) are occasions of reflected light, practically the walls of the
womb itself, the home and the office. You light up my life, we sing.

Yet in reality, Allen was (to me, for example—I knew him for
twenty-five years)—Allen was to my own female self a generous
friend, though I admit he liked the fact that when I was young I
looked like a boy. I passed. And still he tried to fix me up with his
boyfriend, Peter Orlovsky. The bonds of sex and family were all
mixed up, in a way that used to be considered good.

All of this somehow brings me to the boxcars line again. If
women at best reflect male light, what is the entire concept of
America doing in *Howl*. Isn't it some big moon, too. An imaginary
space. In a poem or a country where female agency is repressed or
erased, doesn't it return as structure itself. The poem is a woman
we're gathering in? What is this dream?

who lit cigarettes in boxcars, boxcars, boxcars racketing through snow
toward lonesome farms in grandfather nights

I keep wondering about those grandfather nights. The "lonesome
farms" of course are a case of attributing how you feel sitting in the
car to the farms, and they're *out there*. But "grandfather nights"
seems very old. Older than America. I wondered if this poem's train

isn't speeding through a night in which people are being yanked out of their beds, never to be seen again. Are on the train being carried to an unspecified destination. America? A country of incarcerated black men and smiling blonde women. Is the pederast the new Jew. Ask Nancy Grace. For Ginsberg pederasty was just another one of his happy crimes. Yet look at the Michael Jackson trial. Right now it's the only one, pinned mostly on homosexuals, for Christ's sake, though statistically most pederasts are heterosexual dads. The train is traveling through time, the effluvia of *Howl*, taking pictures as it goes. It's a gift to look at this American poem at this moment in time, to wonder where it was really coming from, and where it went.

(2008)

BROTHERS 'N' SONS & FEMALE HEROES: MIKE & GEORGE

I remember once reading an interview with Francis Bacon in which the interviewer sets us up for the conversation by telling us that Bacon had that quality of all great artists in which he knew when to pull back and when to go forward. Like stop and start were great seismic moments that affected the destiny of the work. It maybe suggested that great art was the result of great will—subtly calibrated to respond to the push and pull of the self, the animal driving the creativity bus. The Kuchar brothers, especially outside their own proscribed area of expertise, are presenting us with a small but glowing body of work: drawings and paintings, in oil watercolor and tempera and all made from an entirely other kind of spirit—I think—George says he makes paintings ambiguously, I make em cause I like painting, he paints them when he's sitting in a motel room in Oklahoma—enjoying the weather and also waiting for it to change. There's no grandiosity whatsoever in his talk about this work yet the further he went in describing his process the richer the work became. And I was already a convert. He and his brother Mike went to art high school in the Bronx where they grew up. The push was towards illustration, getting a job. I don't think it had that result at all for George. He said he learned about oil paintings from the Walter Foster books you'd find in Woolworth's as a kid. He liked that old guys did this kind of work. He was already making films that were screening at the

Underground in New York with Warhol and all those other guys, and painting was just something extra he did. I forgot to ask him if these paintings have titles but the big orange oil painting of a man and a woman looks like they are watching television and George confirms, indeed they are, they were *always* watching television. The painting was a gift to Lane and his mother and when he showed it to them they just changed the subject. Years later Lane wanted the painting, after his mother had died and George went to Lane's home and "it was horrible." Giving or even selling a painting to a person is inextricably linked for George to whether the person is going to give the painting a good home. If someone pays a lot for a painting his assumption is the painting will be safe. The subjects of his paintings often come from special sources. One of my favorites is a woman with a beach ball having a tug of war with a purple creature with very well formed thighs. It's the New Jersey Devil George tells me. The creature haunted the New Jersey pine barrens of the '60s and also would occasionally leave a hoof mark on a roof. George researches his paintings. Looks for stories he wants to do. I enthused to him that his paintings look like movies. They're very similar, he replied. I pick characters, and I'm used to working in a box. I was looking at him in a beige room with a window and a dog. It was a train. But otherwise the box being the frame of the canvas or paper, the screen or even a comic strip. Art Spiegelman was a neighbor in San Francisco in the '80s and that's how George got into doing that, through their friendship. His paintings are filled with heroines. I like women he explained. They already paint themselves and women are attracted to emotional situations. How do you like feminism I ask. It forced people to take sides. He likes it better now. Not so much anger. It was rough, especially at school. Then he tells me about Joyce Wieland, a Canadian filmmaker who recently died whose work he thinks I'd like. I thank him, and will check her out.

One painting of George's which stands out for me is a luminous back—of a young man I assumed. Maybe seen through a greasy lens, or by a hungry paparazzi. I was in a motel in the panhandle says George and this former student came into the room takes off all his clothes and lies down on the bed. Yeah that painting is special. I'm glad you like it. I was already in an altered state, he explains. Was the student Curt McDowell, I suggest, being smart. No but Curt *was* in the room at the time. Most of George's paintings are from memory, but I forgot to ask if this one was. Neither Kuchar brother has shown or sold his work much. Bruce Hainley got George to put a couple in a show at Casey Kaplan's in New York and they were snapped up in a flash. None of this work has been produced in the last couple of years. If you sell all these you'll just make more I cheered. That's not how it works he informs. I paint because I like to paint. And I *don't* like to paint my apartment. These cover the walls, they cover a lot he laughs. So the paintings are even painting of yet another sort. Then he makes a beautiful distinction. For film I get very involved in creating the lighting. Painting is about going where the weather is, astonishing places like Oklahoma in the spring, and painting in the light.

Mike Kuchar's body of work is largely commissioned. Unlike the world of Francis Bacon's bull. His will. Mike's work, in fact, is as postmodern as it gets. A roommate had a friend who needed art for some gay publications. Mike did a few for them, got paid, and the word got around that he was good. *Gay Hearthrobs*, included here, is one of them. It's amazing that these are extensions of stories long gone, that Mike's drawings have outlived those forgettable tales. And carry them too. I ask him about these big hunky men with peaceful eyes and elongated tits. One stands like a surfer on a dinosaur's back. The dinosaur, of course, is hot too. I find myself thinking of Nicole Eisenman's masculine women and Mike Kuchar's guys pushing through fountains of testosterone seem like feminine

men, all their bold poses seemingly for show. Seen to be scene I thought. "Classical Hodgepodge" is what he calls his arrangements, men holding up clumps of the earth like Atlas, or underwater, swiftly ducking a shark. One man is holding back a red sail in a sexy (and absent) wind. They're juicy cartoons Mike adds. I like flowery stuff, a lot of curves. I don't care for too much macho. I like cuddly; sweetness. Mike has shown even less work than George. I mean in galleries, not in magazines. Maybe only one gallery show, but significantly another show was held in a sex club. Beneath the drawings were pillows and couches. If you like what you saw you could just get down and illustrate the stories yourself. Which seems the highest kind of praise for art and the best way to install it. Not "in" a meditative stillness, but encouraging active praise so that any modeling on the wall could be improved on today. Mike calls his work pulp. I *embellished* the stories he states firmly. Every time you draw you get better, from each job my work became more refined. I was working towards a deadline. I would take care of *it* and they, his pinups, his action characters, they just went out into the world.

(2002)

MR. POOLE[2]

I think this guy is wringing out his towel his dick is so huge. I just think he's standing in the shower, he's ringing this long face-cloth out. His dildo looks like a dick. The pants are so tight. Everyone looks like a lesbian, I mean a pretty guy in tight pants packing. I was having sex the other night, it wasn't the sex I was meaning to, and so some third part of me, my mouth, kept kissing and biting her face and that was the genital more than anything. I see the pussy on the tip of a dick. A fat little smiley face. I would look up and watch, I liked watching him pound it into me, that was more interesting than anything. Later I would adjust us to where it actually felt good. He asked me why and I told him it felt good. He said I thought you liked to watch, I said yeah but that's not the same. He said, really. I said yeah you're knocking on my door. In one I noticed that the more absurd it got, the gauzier, the prettier the lights, the more atrocious and ornate the music got the more amazing and actually feelable it seemed to watch him jam it in the other guy, really driving it in good, fucking pounding it. She said I'm kind of like Frank Sinatra, a cool even stroke. Unrattled. The thing is unwittingly you're opening up other rooms. It seems that all the prettiness and the strangeness, for me, opened up the room of sex so big and good.

2. This piece is an homage to porn pioneer Wakefield Poole, best known for the first gay hardcore feature, 1971's *Boys in the Sand*. My personal favorite is *Bijou*.

He was just pounding it into the other white guy. At the end of the road they made a star. A star box. Course it's about as big as his. Fat and pink, the see-through kind. Though my smaller one works better. I was biting her face and I was thinking glory hole, glory hole. Poking into another room, to get sucked and slobbered on. I do that in a second. Since you can't jam a pussy into a wall, I guess you could drop it through a floor. You've got to take the angle and drop it. But I was banging it, a moat of dick and fur, against her pearly stomach, smashing the wet tongue up against her hip, a pup, her drum top tummy. She was knuckling my tits or some shit, I was biting her face, inspired by that fucking glory hole, I brought it to bed, a fat futon someplace in the dark upstate, with very soft damp swirly sheets. With the dogs squirming, the movie flickering, going to get uncorked. He turned on his transistor in one, he pulled that mile of hose out of his tight pants. We wake up in this immense world of machines, men in tight jeans sitting next to immense wheels. Dangling up there in space, fags ogling these guys in hats. These guys the original occasion of heckling of pretty juicy girls walking down the street. Some fucker. He is slim, too thin to lift a sandwich to his lips, never mind open a lunch pail and with a paw full of meatloaf yelling about some pussy ass. This is like an uneducated (but handsome) lesbian putting a doctor's coat on and the worst little uptight cunt opening her legs because this slim faggot with a monster in the shower in his hands is a simple construction worker who snatches a dead girl's purse, a drag queen in a fur coat, really, and winds up in some dumb fucking bijoux in pink and purple lights just pounding about two feet of hose between some handsome hippy's ass cheeks. I have one friend whose whole family's in a famous cowboy movie *John Ford* and it relaxes me. When I watch a film or a movie on teevvee when I can move my consciousness over to the idea that Henry Fonda is someone's dad and he will be handsome in this western forever and it dazzles me, think

of it watching daddy be young and fucking him, jerking off for years to this video of your father, and this guy, his family's home movies are famous and everyone is in a scene, and someone another one is just sitting alone on the porch. Though they're not jerking off. The two brothers who made it, I thought of one as baby bear. It's so beautiful that hot moment in their twenties, which happened about twenty years ago, fucking your fucking brother permanently as permanent as anything is, just flickering in the air. I liked the guys finding themselves, exactly like the web, bunch of guys just telling a bartender what they'd dig. Not telling a web page, putting in an ad, answering one I guess. Everyone sitting on a fluffy couch. Who's not going to get fucked. It's like a murder movie. You quickly decide just by how he's framed, who the victim's going to be. I find I like a guy in Wakefield's movie because he's not going to be fucked, he's just the guy that just works there or something, he's part of the crew. Yeah well the crew fucks a car. That's what this cute normal looking guy always wanted to do, suck off his car. It's so corny out there on the mesas, the manly man guys with the short haircuts, their dream of pulling it out on a pile of rocks their pale tight jeans and then being transposed to a roof-top, this is again very lesbian, the south-western motif, eyes of god, shake shaking in the window, and then someone wrapping their lips around his pipe, I like the rooms folding into another one, it's like when you run and it starts off so fucking boring, and slowly you begin to smile, you agree to be carried by this thing, the register begins to change, something is elevated now, and film, the films of Wakefield Poole seem edited to me to record this exact synapse something changing inside, the level has been achieved, and now we're heading, fuck head, now the increase in intensity, the shift in what kind of tree sap seems to be flooding into your crotch, only seems to be communicated, by plunging our actor out the door of the theater, grinning, a car hits the girl and he steals the purse, the slim guy acting just like he completed a dull day

of work and he's just heading home to pull on his towel, steals her purse, and opens it up. I might've slept with my cousin once. It was summer, we woke up, we were both lying naked on my bed. We had come in trashed, we might have forgotten who we were. I meant to have sex with everyone again, so why not her. She certainly did play with my tits. The two brothers had heard about how hot the other is. Bout time to see. Guy. Finally everyone walks through the hole in the room and the movie spits them out, but in between that moment and now we'll fill them holes, we'll jam our fingers in and our tongues. We'll feed it, we'll taste it. We'll fall right into the dark. Hello, Wake, it's me, pound, pound, pound, open up.

(2006)

PISTOLARY, THE COMPLETE FILMS OF PEGGY AHWESH

The Story

Jordan Marsh, a department store in Boston in the '50s, used to have a really great contest—you just filled out an entry blank and the kid who won got to tear through the toy department for five minutes just before Christmas taking anything she wanted—filling up her shopping cart. The scope of this annual opportunity made me crazy with desire. I used to go to Jordan's toy department in the weeks before Christmas just to pace out my steps. Then I'd lie in bed late at night rerouting the plan: "No, no, just a few board games, some sports equipment, then the little theater, some doll clothes, bike and a scooter, Winchester rifle, a telescope, a chemistry kit, a train set, a huge stuffed lion ..."

After a while, it got that there were no real things anymore in my plan, just a feeling of tingling enormity, of absolute possibility, the freedom of simply having won already and the world was yours and you wound up very very still in your bed late at night, (eyes under the darkness of lids racing all over the world) really wanting nothing—sick with joy. Naturally this kind of super-charged nada ultimately produced melancholy and thought. Let the movie begin.

Guns Blazing

She Puppet (2001), Peggy's re-staging of the mega-popular Tomb Raider video game, has Lara Croft, guns blazing, boring down corridors of blue animated ice. I hadn't seen this game before, but Peggy has stealthily charged in, giving us just the peaks of the experience, then tweaking them, revealing Tomb Raider in all its absurd glory: Lara swimming with the angelfish (to a brand new opera soundtrack), Lara shoots big sled dogs, fights huge bare-armed partially-resolved prison guards—these lantern-jawed guys slug her and Lara falls and screams—boy does she scream—girls are screaming in all of Peggy's films, it's like a stalagmite dripping down from a single ceiling, the sound of a constantly plunging female cry of excitement, terror and joy—and thanks to the escalating Leni Riefenstahl-style perversity of Peggy's editing Lara keeps dying—or does something that sounds like "Uh-huh er-whap." She bites the dust hard at least a dozen times. Lara is felled by a tiger, an MP, a man in African native gear, an Arab-looking guy and a cop. This mythical *She Puppet* writes the textbook on disaster—she gets us feeling real chummy with the color of infinity. Which is a bizarre kind of relief. Because we are pretty used to women dying in movies—in like maybe the first scene—a dead girl always helps get the film's blood moving, and then at pithy moments throughout. Watching Peggy's *She Puppet* I realize I've often not appreciated the irony in action films because I was usually on the wrong end of the gun, or camera. In this truthful act of animation, Peggy gets it right.

Cartoon, in fact, means something like design, the bare bones of a complicated picture. Weavers used cartoons to transport value from tapestry to tapestry. Peggy's genius in her many films is that she imports meaning from all directions. In *She Puppet* a sublime Fernando Pessoa line pops out of Lara's mouth. "Why did they give me

a kingdom to rule over if there is no better kingdom than this hour in which I exist between what I was not and what I will not be?" In Peggy's hands it seems Pessoa (via Tomb Raider) is asking a profoundly female question.

Sex Talk, Yawn

In *Philosophy of the Bedroom* (1987–93) a straight couple are sitting on a bed talking about sex and this balding guy with a smug radio announcer voice can't keep his paw out of a big bag of potato chips while he's trying to convince this sort of slutty looking woman how he can satisfy her. Watching it, you think, Jesus! Then the movie pitches into green, sprays sparkles all over the place (hand-processing—you'll see it everywhere in her work. It's like Peggy clawed the moment with beauty cause these people were sort of bugging her) and then in a new scene a woman (Sally Greenhouse) as tedious as the potato chip guy is rambling on to her boyfriend who's variously crumpled on the bed next to her and later he's sitting upright in a chair. Here Peggy's camera is this whorling thing, pulsing in on these guys, pulling back and moving in dreamily. Then it just collapses—movie's over.

Gross!

In *The Scary Movie* (1993) two girls in greasy painted-on moustaches and side burns are laughing and shrieking. More weapons—an aluminum covered cardboard knife. There's creepy music playing in the background and the floor is crowded with musical notes. Girls stomp on them in their big high heels. I feel dropped into a history of make-believe, of play. But the play is mean and vicious, it's *so fun*. Peggy feels that people need to be documented, even when she's invented (like here) the situation for them

to express in. She's not exacting performances from people, she's easing them up to what they know. Almost like crowning them for their suspected knowledge. There's lots of creepy petting between the two girls, not sexual, but like an imitation of sex before you knew what it was. How gross people in movies making out used to look. Huge people with their mouths pressed against each other rubbing. Martina and Sonja are laughing, laughing, laughing at us, like birds we taught our language to and now we get a manic reading of our loneliness. They are gasping with pleasure. The titles at the end of *The Scary Movie* are handpainted Goth, I mean S-C-A-R-Y, everything is "kid," and for one cool weird moment (well, nine minutes) we are all totally free.

Captured Dignitaries

What we're free of, or maybe outside of—in the realm of the Ahwesh film is the suffocating grip of culture. Peggy says she's using form against itself. The animated chick flick, the horror film, porn. This is a quietly violent project by a very benevolent person. In a backwards world she is setting things right. The film-maker explains herself as an amalgam of Appalachian and Middle Eastern stock. She tells me her father installed carpets, he was a craftsperson and a laborer. She describes her family as "good works" people. In her films I always feel like she's trying to say something very light and subtle with a dense and unwieldy sub-stance. She'll have a baby reading Lacan. In *The Color of Love* (1994) she uses Astor Piazzolla accordion music behind a volup-tuously hand-processed incredibly lame porn movie (two girls eating passionless pussy over a passed-out man) and in *Nocturne* (1998) she constructs and then dives through a million-veiled essay on the texture of texture. The shadows of leaves in the sun wave sentimentally on the back of yet another naked dead man (it

is such female pay back!) and suddenly her *Nocturne* becomes an allegory of film. Or is it Peggy pondering a skull. She tells me Kodak used to accompany each roll of hand-processed film they developed with a patient explanation that she "did it wrong." It's easy (and even enjoyable) to compare Peggy to Andy Warhol, the other "difficult" filmmaker from Pittsburgh because she makes so many of the same moves as Warhol did though to such different effect. Whereas Andy would let his actors run themselves into the ground, Peggy offers her people the olive branch of closure. She describes her films as installation, but I think it's more like "shrine." She's gift-wrapping her friends. In her punk filmmaker days in Pittsburgh there was always a lot to document. "I was never a peacock," explains Peggy. She qualifies. "I'm the female peacock." She produces the ones with excessive feathers, she's collaborating on them, she's allowing their confessions. "I'm fascinated by captured dignitaries. Like Xenobia, an Empress from 100 AD who ruled over a tiny country, Palmyra, which had its own language and coinage and Xenobia was later brought to Rome to be put on display, where she quietly and safely died."

Martina and her friend are hollering and gamboling around a roof in Lower Manhattan. They run close to the edge. "I'm really going to do it," the kid screams. Maybe this is why kids for Peggy are such great objects of obsession, they always really mean it. This is in *The Fragments Project* (1984–95). Next we're standing in a glowing cavern. Water drops timelessly into a green pool. The red stalagmites drip. Kids stand around with their families. Then the number codes for film stock blast us vertically into the next scene. Shaking globs of blue hand-processed flowers. Then she escorts us to Warhol's grave. She holds the frame shaking, colors change. It's a time code written in stone. Peggy's shot is just long enough. By quasi-normal standards that's either too long, or short, abrupt. It's shaky time. We say goodbye to Andy.

Martina—whose life she's shot since babyhood, I guess Martina is her Starlet—along with Renate Walker, a classically beautiful kind of abject European woman—and Peggy's best-known protege, the filmmaker Jennifer Montgomery, these are her stars. Her boyfriend and collaborator Keith Sanborn is her star. They are all intimate subjects, interlocutors, band members, and targets of her film. Keith pretends to be a goofy anthropologist in *The Fragments Project*. Jennifer makes a pass at the camera, a pass at Peggy in *Martina's Playhouse* (1989). She's pulling her pants down and Peggy suggests she stick the lens up her ass. While she's already doing it. Shit, Peggy! Jennifer looks into the lens Peggy points at her and desperately laughs: "We wouldn't even be friends if it wasn't for the camera!" Jennifer's holding her young filmmaker's elation out like a wet rag. She retreats: "Wow, everything you do is accompanied by a little ghost of nostalgia." In that same film Martina, a baby in 1989, convinces her mother, the performer Diane Torr, to drink from her infant nipples: one is milk and one is juice. Peggy never recoils, she only cuts. She'll build build build up to a piece of information, only to stream that same vertical column of snapping film numbers. Nobody gets what they want. But everyone gets to move along. Renate Walker's tits are tumbling out of her dress. Sally Greenhouse's tits are falling out. We can never forget in Ahwesh's films that the female is an animal. A beautiful wild pathetic, straggly thing. Begging to be shot. Walker stands in a torn brown dress she describes as her wedding gown (one she never wore) explaining elegantly: "All my life I've identified with male heroes and I've become a monster." It is so Garbo. She has not played and she has not been traded. The anonymous female is Peggy's hero, a monster if you read her one way, a deity, a captured dignitary if you read her another.

The Camera My Father Gave Me

Peggy's eating a turkey club sandwich, iced tea. She clacks her drink down on the worn formica table. "So what's your interest?" I asked her. "What is it about us?" I've decided I can be an alien too. Peggy shrugs like a zookeeper. "The way women function is a mystery," she says this like a doctor, a family member, a truly weird guy, and then she laughs. There's something impish about her entire operation. "We're a mystery to ourselves." Peggy totally grins—"a mystery that tips over into the fantastic."

A brightly lit banquet table full of women are toasting one another, carousing and dancing. This one's called the *vision machine* (1997). It's a mythical scene, with Greek names. Finally, one of the women at the dinner table urges the others to draw close so she can take a picture of them. She's going to use the camera her father gave her, she announces. She pulls back towards the camera that's shooting the film and over her shoulder we watch the still and exaggerated configuration facing her, ready for their shot. Suddenly and violently and gorgeously, she pulls up her dress and shows them her cunt.

(2003)

THE TIME OF CRAFT

I came to Penland last summer to do some wondering and searching about craft. Robin Dreyer, editor of Penland's newsletter, handed me a little article about the potato and the Irish. Robin thought I might be interested. The article talked about the Irish before the English came around—it said that the Irish were great cattle raisers, and loved riding horses. They were not nomadic people, but they also did not make much about whose cattle were whose. Thus no fences and the cattle roamed and the cattle were led home. I like to think of the route of the cattle and the place they held in the life of the Irish people. I don't know but I am inclined to call that place an imaginary. It's a little like the way I think of my own "studio." Where I do my work. It's no place and everyplace and it's made out of language and goes where it goes. So that maybe rather than thinking about myself as a poet, I should be a herder, a shepherd perhaps. Of words. To say they are not my words, it is not my language, but believe me I take care of them. I further the herd, and within it I have pets. A string of relationships with language which is how I move through the world. My attachment to language attaches me to my community and my landscape and my culture and of course I began wondering as I looked at craft—well, how does it happen here?

Lately I've been obsessed with allegory. In Latin it means roughly, "other hand speaking." In Chaucer's time that meant that since each

stone and each plant had a meaning assigned, i.e. opals are bad luck and lilacs mean "first emotions of love," then all a poet had to do was say what's there and the secret significance of a poem would just become clear as she walked us through. In a way, the world was the poet's hand. And she borrowed it to write.

Let me tell you how I got here. I was speaking in a bookstore in Chapel Hill. Writing a novel, I told the people in the room, is in essence no different from editing a film, or even making a quilt. Do you really mean that, asked Sherri Wood. She was a youngish brunette with very bright eyes. Mean what? I was feeling defensive. The workshop was over and I had given a lot. About quilts, she gleamed. Well, yeah. *Yeah*, I think cutting up and arranging text, making a pattern, seems similar to quilt making to me. I loved it, she assured enthusiastically. *I'm a quilt maker!* There's a school in North Carolina where I teach quilt making. Maybe you would like to know about it.

The next fall, very shortly after September 11th I was driving past that woodsy sign that says Penland. I was falling asleep as the road went round and round. Robin was driving. Does this get easier I asked him, grateful that he was behind the wheel. Oh, yeah, he said. Because you go faster, I asked? No, because you don't stop so much.

In the morning after standing with my coffee over a valley that looked like a bowl of smoke, I was the guest in Sherri Wood's class called improvisational quilt making. She opened the class with a song by Le Tigre. Everyone danced between the piles of cloth and tables and chairs and then we sat down and began. We were now energized and focused. So how did *you* get into this, I asked Sherri. She told me that she had been in Divinity school and was intending to become a minister. She was having a hard time writing her thesis but when she proposed she make a quilt instead they agreed. Which was the turning point for her, and she didn't think about becoming a minister anymore. The deeper connection was made.

Sherri's class was composed of people of all ages, mostly female, mostly under forty, but not all. Steven, a DC policy-maker, was spending his vacation making quilts and his bad-geometry bright green and soft blue quilt hummed and thumped like jazz, and filled me with a maddening desire to own it. I think he enjoyed my appreciation. He quietly explained that he was making *this* quilt—and he tugged another of his projects closer—as a gift for his cousin who had lost his lover to AIDS last June. This one (the one *I* wanted) I will hang on my wall, he smiled. It will remind me of the time I spent here. *And it will relax me.* The quilt itself was a mantra. Steven's eyes took on a glow as he mentally catapulted to another time in which he would be needing the attributes of this time. One associates quilting with rural, female, communal, and probably economically disadvantaged citizens, white and black. What kind of time is that?

I was waiting for my latte in Starbucks yesterday wondering who would give their friend a gift certificate for twenty-five dollars from here. I was impatiently reading the menu, reading the walls, reading everything. Or $100 certificate from Music Warehouse. What's the significance of giving that? Too bad you can't give someone an actual month. Not a month we anticipate or know, but an extra month that could be directly attached to their year. Or how about three years. Or even a week. A day, just an extra day. Steven clearly had bought himself some time—a poorer time? A female time? Or a priceless time? A time he wanted. And apart from whether he paid for the time or someone got him a gift certificate, the nature of the time one dwells "in" is pretty much determined by the materials they choose. One arrives there by accident, or through someone they know. I'm thinking about the medium of teaching, by which a person infuses another with a love of material. There's something impossible about it, it's the fulcrum of all communities, and continually it works.

My favorite metaphor for teaching is the occasion when my dad put me on the seat of my first two-wheeler and with one hand on the handlebar and one on the seat, he ran. I had the feeling of flying down the driveway of my home. And then he let go, and I continued, gloriously riding on my own. He gave me the escalating feeling and it caught. You *can* teach love. What I mostly discovered on my first trip to craft time was the primacy of love— the necessary attraction to materials. I was teaching a workshop to a group of students from a variety of media at Penland. I did my thing. I told them how I came to my practice and what I thought it was, and I asked them then to explain who they were and what brought them here. Their answers were direct: I'm *metal*, I'm *wood*, I'm *glass*. Everyone, I think, was aware of how funny these self-descriptions were, they delivered them with a grin: I'm clay, and still the descriptions held. The glee was about abandonment to materials and the time the materials demanded. Taking a road and finding out about it.

I returned to Penland nine months later. It was a little harder like a second date. I had spent months now telling everyone I knew about this amazing place in North Carolina where many people smoked cigarettes (a giant ashtray sits outside of the glass dining hall that faces that same bowl of morning sometimes afternoon smoke in the valley) and look like they're in rock bands or work in natural foodstores but in fact they are making metal chairs and funky bowls and blowing glass. Turns out everyone knows Penland, it's many people's dream. A woman I know having her second kid gets all dewy eyed and assures me she *will* get there and has been religiously receiving their catalogue for years. Hey, is there a scholarship for Kate? One that includes child care?

The sound of metal was leading me up the path. And heavy metal music. The iron studio loomed with its corrugated roof and a pirate's flag perched on top. Elizabeth greeted me—a tall woman

with her hair swept up, a string of pearls around her neck and hiking boots planting her firmly in the ground. I will show you our gate. The gate will tell you a lot about who we are in the iron studio. The whole studio moved up here a few years ago. But right away the glass people—you passed glass, right, on your way up? Glass started complaining about our pile. They're so transparent, I thought, but I didn't say it. Elizabeth opened the big brown gate and walked me along the side of the building to a commanding and surreal and black heap of scraps, bent fencing, candelabra, warped bells, signs and doors. Our scrap pile is more than just a pile of junk. It's a teaching tool—it's ideas, it's material. She picks up an odd-shaped clump, like a little shoe. Things too cool to throw away. They wanted to know if we could move this incredible pile somewhere where their people wouldn't see it. We wanted to keep it close. Well, we like contests at Penland. Games. A few years ago we challenged the other studios to a croquet match. But each studio had to make their own wickets. My first wicket looked like a ribbon. She picked up a wiggly piece of metal, grinning, and throws it back on the pile, *clang*. So—in dealing with our pile, we decided to make it our own people's project to make this big gate. Something really fancy and crazy and cool that would hide the scrap pile AND give us an opportunity to come together as a group. Sort of like a benefit for ourselves. Elizabeth opened the mammoth gate, and we stepped outside as she spoke. We wrote to all our people and everyone brought pieces. They drove up here with great stuff in their trucks. We still haven't used it all. Now I see that the gate's incredible. I mean her story did it too. It's tall stripes of metal, a big G-clef, wreathy twists of cold black shining bands of stuff. Elizabeth leans on the gate. The thing is about working in metal—she pauses, almost politically. I mean, you can make an artistic statement and it will last three weeks. She shrugs. Here we make stuff that lasts. This gate is part of our history. And we have tools. Look at this 50-ton

hydraulic press. You don't have to sit around with a little spoon going tink tink tink. She smiled at me. Weight is time.

I decided to continue with light. My friend Marco Breuer was teaching a photography workshop without cameras. Which was perfect. If I had to pick something instead of language to be "mine" I felt sure it would be light. Marco gets his students to crumple photographic paper and stick it in the bushes during a lightning storm and see how that turns out. He showed them slides of someone who turned a washing machine into a camera, another who turned a package into a camera and sent it through the US mail photographing its journey. I nearly wept at the pictures that can be taken "without" camera. Camera means room in Italian. No stanza does. Maybe it's Spanish. Anyhow, I feel like that camera which is not. I'm excited that Marco's work is craft. I'm tremendously excited and I start describing my process (which is to write an article about craft—which is easy, because I love it.) I begin:

> *This is a great notebook*
> *First I unpack my bags*
> *putting underwear into drawers*
> *hanging shirts*
> *Placing dirty socks in a plastic*
> *bag and throwing them*
> *in the corner*

I close the notebook. See I had planned to become a part of Marco's workshop, I wanted to, but then Steve Miller invited me to come to his book craft workshop and talk to his students who were making books out of handmade paper. Their first assignment had been to write a poem—so would I come and give them a few pointers. So I missed Marco's class that second day, and I never went back. Steve's class met on a porch. The chainsaw down below in wood was

incredibly loud and making everyone crazy, but some people thought it was good. Steve's people were sitting in a circle, each holding their project-in-progress. Someone would be in the middle of her explanation and the chainsaw would begin and everyone would sit there looking at each other while the talking stopped. The chainsaw grew silent and the speaker would begin again, and the chainsaw would start up. It was different for each speaker—some people plowed right through uninterrupted, others bravely tried to talk over the chainsaw, some refused, making us all wait and they were most frequently interrupted. Some people just had luck. You could see it. Steve was passing things around, pictures, books that he thought would move everyone ahead—or let them know what was possible. There was a book by a master printer who had died— I think. And all the people who had known his work for years had collaborated on a beautiful book. Steve made admiring but almost scandalized faces at the lengths to which these people had gone. This is just to show you—I mean this is really; he chuckled, kind of maniacal. It was a beautiful book. Green with the master printer's name on the cover and his face in an oval. Maybe the guy had invented a font. And lots of things were still done in his way, in this ancient revered method. This is almost scary Steve said. You watch him quake with cringing joy. It's perfect. Perfect is a problem in a way. He held the book up, shaking its heft. So …

While we looked at the students' projects-in-progress, Steve explained the concept of the resting page. You need to give the reader a break. You don't want to overwhelm them. You want to lure them in. You want to keep them going. So you want to occasionally have a page where *very little* happens. He drops his fingers through the air like a conductor. So they can have a sense of space, once in a while. It's nice he explained. Not too much, he said turning the page of someone's book. Steve was masterful at keeping materials in a kind of momentum. Once in a while as we were looking at things,

he would say: Switch. And we'd reluctantly pass what we had to someone else and we'd see something new.

I told the guy in wood that maybe I could come down after dinner and see what the racket was all about. I think maybe the yoga people were the only ones who really complained and yoga's not a craft. The wood guy was a good guy. He and his wife lived upstate. I did go to his studio one night when the light inside and outside the wood studio was incredibly bright on the newly opened wood. It was yellow like paper. Everyone was proud, and freshly opened logs with only a few significant nicks were lying outside on the lawn. It was just kind of a visit. All of it was: it was letting the story unfold.

I was always sitting outside with the instructors after meals and everyone was talking about moving, which everyone hated and everyone was buying, or looking for, a house. Usually there was a perfect one they just missed. Somebody else got it. I was in the middle of buying a house that summer and I was always running to the office to see if some fax had come, or else borrowing Dana's car to go to the Bank of America in Pine Hill to be sure I could send the escrow money electronically. Then I'd seep back into the time of the craft, thank god.

When I came in the fall I heard about a man named Norm who'd had his studio burned down. I figured I'd go and talk to him. I did. It seemed like a good story. He's some great ceramicist so in the fall he was in Chicago getting an award and some local kids decided to go look at his stuff. His ceramics studio was a desanctified chapel up in the woods around Penland, and supposedly it wasn't even *his* chapel they were looking for. The kids had heard that the people with the chapel were devil worshippers. Anyway, they set Norm's studio on fire so while he was receiving this award for his life's work it was all getting melted to the ground. Norm seemed amazingly philosophical about it. They just wanted to burn

something, he explained. And the kids got caught. They returned to the scene of the crime and someone saw them. Arsonists like to come back and see their work, he explained. Making art and a crime are not so different.

Tell me about your work, I asked. Cause he still had his house and his old studio, and he was building a new kiln in the woods, which he showed me. It was a Japanese kiln and each little step had a meaning, and the stones were laid perfect, each with a goal in terms of controlling and maintaining the temperature. I asked him about clay. He looked at me clearly. He said it was mud's mouth. He had studied philosophy as a young man, but clay really spoke to him. I like mud, he explained. And then he went on to explain the Earth's magnetism, and why clay does stick together and it's about ions and stuff. And there are specific muds, or clays. For instance, this: red. Deep deep beautiful red. Albany slip. I stand there in awe, slipping around in worlds of specialization. The endless details, but the Earth is a big wad of it, mud. And that would be a huge start, to know that you liked it. There it is.

BLOGS

2004–2006

BROWSER ART

When I went to Wolfgang Tillmans show at the Hammer in LA I instantly coined a phrase I might be sick of already but "browser art" describes to me what Tillmans does so well in this exhibition which is to simply render how he moves through the world. Which stuff a hand or an eye might alight on, what kind of people do we like to look at. I remember thinking years ago when I first saw a show of Jack Pierson's that it looked like a group show—Jack's photos, big letters, a desk. I was excited by this new possibility his work suggested that anyone might start to look like a group. Which was then accomplished then by *kinds* of stuff. The energy of the artist took many forms. Wolfgang's stuff (mostly photographs) is on the wall and on tables so you can leaning peruse it, like in vitrines. Our movements seemed to give his photos dimensionality. I like how political his work is too. One clipping—and again he includes grabs from magazines texts etc.—was someone talking in a piece about a la carte rights. How a culture might say freedom, yay, or modernism, uh huh, but for instance we'll take out the gay part. I like it. A la carte rights is a term I can use. For some reason I just want to mention another German artist I like a lot. Imi Knoebel. He once described hiding in an attic during the bombing of Dresden and how the flashes of bombs filled a triangular shaped window in the room he was in and the experience contributed to his love of simple shapes. Is that love or merely imprinting. It was simple and strong and one is forced in a way to see the world the way it *is* shaped. Art becomes a memory more than anything else. A kind of chooser. It shows how we were touched.

THE EYE OF THE CRATER

I'm thinking of craft as the culture part of art—an art opening and all it entails—from drinks to fashion—as opposed to what happens in the studio and how you hold that in your head. Because I'm a poet I function in the halls of a career that is essentially all craft. Most poets make their art come alive by standing there reading. Fittingly a press in Seattle[1] has decided to celebrate that by organizing the Poetry Bus which is currently on a two month journey around North America. I jumped on in Phoenix, then at Roden Crater, James Turrell's big earring in the desert, and finally in Las Vegas in the Brooklyn room of New York, New York. Part of the poet's job when she steps up to the mike is to make the unusual usual. I said Las Vegas felt like being in a tattoo. That got a laugh. It does. Approaching the lights from the desert is always an emerging dream, and you never arrive, I don't think. You find yourself moving through the jangling flashing casino and you're in the midst of a very wide hypoglycemic attack. I was grateful to be able convey the pharaonic reality of standing at Roden Crater the day before. Think red. Dull postmodern red composed of rough grainy stones and you're walking uphill to the edge of the crater to look around. And it's dusk. And you look back at the circle in the bottom of the crater that does feel like an earring or the loop you pull to release a genie from the earth. We were lead down into a room they referred to as the eye of the crater. Overhead it was open to the sky and we were told that the black circle of granulated stone at our feet covered a drain for snow and rain. We hierophants stood around it reading a collective poem, one that had been written by a few of us (not me) in the month before. I can't remember what it said but it glued us to the spot the way words can some time and I will simply say it worked. We took Jim's grandeur down a bit, he took us up.

1. Wave Books.

DOG CRAFT

Because I know there's a musical called *Urinetown* I don't feel shy about my topic, or much of what it contains which is pee. My dog, Rosie, sixteen point five years old is slowly but inevitably dying. I drove up to LA about a month ago because JP has something called Craftnight at Akbar in Silverlake every week where she brings in materials, this night yarn, and people sit down with drinks and cross-stitch across the face of a cat or a dog and then after a few hours, dance. JP introduced me to her DJ. I said hi. Then I drove home. Little bits of brightly colored yarn are all over my house as well as a mop and a bucket and piles of old towels and a procession of fluffy mats and the washing machine is always on. Part of dying is being helpless about peeing. You drink, it comes out. When I'm home I jump when I hear her unsteady legs struggling to get up. I leap ahead of her opening the door. She uses the front yard and we're done. But for instance the night I drove to LA I came in with my unfinished dog pattern and she was lying on her soaking mat looking sad and there was a big puddle near the door. I begin our ritual. Washing her ass first. With a small silver bowl and warm water and special dog medicated shampoo so her belly and legs and ass won't get red and sore. I rinse her next, pat her ass dry, settle her down onto a clean mat. I do this again and again. Dog, water, soap, mat, mop, bucket. Dog craft is as close as I get in my life to devotion. Which is made of love.

SADIE

For those who have not had the major pleasure of experiencing Sadie Benning's work you ought to jump on a plane or a donkey and get to the Wexner, where *Suspended Animation*, her first museum

show, is. A high orange wall ushers you into a gallery of giant portraits of people gazing, drumming, skateboarding. It's a human landscape of close-ups, delivered with love and simplicity. One feels the purpose of these drawings is to put you among these faces, in their condition, in their time, ours. Sadie, incidentally, is famous for making short complex videos when she was a kid which propelled her to a kind of stardom that she has not disappointed since she's only changed shapes by her own accord ever since, painting and drawing, being a founding member of a influential band, Le Tigre, only to slip out and go off on her way again.

What is Sadie's way? Step into the crowing achievement of her show, a 28 minute "video" called *Play Pause*, in which a cavalcade of drawings move slowly, as if you were on a sidewalk that slowly nestled into parks, gaybars, airports, domestic spaces, and wind up listening to a squirrel eating nuts against a chime of soccer cheers. Her city goes on and on as if living were music. My gut says that Sadie's subject is the invisible. The terrain of poets who say this plus this minus that equals life. One's eyes tear up a bit to know you are there and it is so fleeting. Invisible or not she takes on "the public thing" at this very certain moment. Republic or Empire? We're fucked!

IMPRESSIONISM

I had my picture taken by a famous photographer about thirty years ago and I've probably milked it for as much as it's worth already. Probably all that remains is for me to sell the photograph but for that to be worth the effort *I* would have to become more valuable in order for the photo's value to rise. So I'll leave it alone, which generally means it hangs on my bathroom wall wherever I

live which has always seemed the right place for a young picture of yourself by a famous photographer. In terms of anyone else walking into your home. To have it up at all feels a little vain, but up in the bathroom is a little funny so it's okay somehow. I consult with her a bit, the person in the photograph, as to whether I'm doing okay. Suffice it to say something a little sad happened lately and I just couldn't look at her anymore. I mean not for a while, not in this house. I took her down and on the wall were this series of scratches. I have a friend who is a photographer[2] and she told me about taking pictures of the wall after she had gone through a breakup. They had taken their art down from the walls of their house already and now she was making a record of that. It's almost like speech, these recordings of how art moved this way or that before you decided this wasn't your home. Though you might still say it's your stuff.

BACK IN REYKJAVIK

I wandered into the closing moments of Magma/Kivka an exhibition of Icelandic design at the Kjarvarlsstadir. Though five designers had been invited to do special projects for the show only one really jumped out: a decorative grid, like a fence, that functions as a source of radiating heat that changed colors when its temperature budged. That struck *me* as Icelandic since heat like water here is so abundant and can be imagined loosely and not so still. Next I saw the single item which impressed me most: an elegant prosthetic device from Ossur, a lovely foot, and there was a great knee as well ("The Unloader"). Many other things seemed prosthetic: a

2. Kaucyila Brooke.

table with hooves. Maybe not so much a stand alone, but a little bit miraculous. There was a wax table for lovers with a wick in each corner so they could promptly burn their love at both ends. There was a painfully sad candle (wax was abundant in the show—and in Iceland—as an analogue for lava or energy—who knows?) in the shape of an auk—an animal that became extinct in the 17th c. not like the dodo because of the desires of the rich for feathers but out of people's hunger for its meat. Iceland was a poor country and the candle instead of being silly or cute was profound. Icelandic design draws itself up at a time when its long separation from the main-stream has stoked a fervid kind of wealth that flows presciently along a path that's being watched and elaborated on by others. Offerings include volcanic candies, cake tins like hubcaps, stuff so oddly attractive like a flea market of metaphor not gone wrong, but taking a surprising tack even to itself.

THICH NHAT HANH

I schlepped down the freeway with three students in my truck and one had grown up here so she knew where to park to avoid the crowd. He was speaking in a giant arena. It wasn't full, but still thou-sands were there. Behind him were rows of Buddhists in brown robes like his. I forgot my camera. The Buddhists sang and I worried about what my students felt. Are they bored, I thought, trying not to turn. Thich Nhat Hanh talked about breathing and you could hear the people in the gathering cough. Everyone in some fashion lives in their throat. Their connection to the room. Breathing connects the mind to the body. Simple enough. He said the mind was the body's home and that was interesting. He talked a lot about people who had cancer and how after being told they would die in six months they

sat with his group in France or in Montreal or Escondido and now they are still alive forty years later. But you have to go to the doctor too he added giggling. I wondered if he was sick. He looked frail and a woman from behind kept pushing his jacket back around his shoulder. It kept sliding off. At the end people asked how we could teach mindfulness to our leaders. Well first you have to teach it to yourself he smiled. He had a gentle voice. Sometimes he needed to hear the question again and one of the nuns whispered the question into his ear. There were two giant screens on the stage and she was up there with him just like this friend of mine in Los Angeles when the person she was following in her car got one of those photos in the mail that showed that she had gone through a light. And in the car driving behind her was her friend. I don't know why it was my favorite moment when gently with a light in her eyes the nun repeated the words to him that somebody else had said. He thought about it some more. To teach mindfulness to our leaders? We should write them a love letter he said.

MARTIN RAMIREZ (1895–1963)

I was getting sicker and sicker while I was at the American Folk Art Museum with Myra.[3] How is it you know you're getting the flu—or you fear it. Tiny shivers run through your body like you're an unstable image on a teevee screen not you walking around looking at art. What we take for granted, health, has been intermittently denied me since the middle of February. I keep doing what I am doing but it feels slightly like a grim performance. We bump into two friends and talk about the show with them. I don't want to ruin our pleasure by

3. Mniewski.

saying: I feel sick. But it's under everything and it more erodes than ruins. Martin Ramirez came to the US about age thirty to work. Pretty soon he had a psychotic break in the street and was pretty much kept away in California for the rest of his life. He wrote letters home to his family and he would mail them his drawings—many of the animals that he had loved. Apparently he was quite a good rider and at one point his family told him that some of the political reshuffling of property in Mexico had destroyed his former way of life. The farm wasn't the farm. In the institution he drew the world he knew. Not the farm, not his family, but a constant world of trains plunging through dark interiors. Sometimes a little boy held a tiny string deep within there. Other times a '50s housewife would be making an elegant gesture inside a drawing—it would be a collage like she was cut out from a magazine. I'm just wondering what provokes a man to go crazy in the street and abandon his life and never come back and draw a deep inside world of trains and gods one day it all winding up on the outside in a museum in New York—his pencil, his spit, the decorations on the church walls he looked at as a boy. All gone and all here. What drives that deepening train.

TWITCH

I don't know what makes puppetry great for kids but for adults it's those fingers wriggling the strings. J.P. Parr, the art director of *Sunset Chronicles*, says that most importantly you have to get a rhythm going with your twitching to make a character believable who doesn't have moveable legs. The puppeteers themselves are visible (in Gepetto-like aprons) above the knee-high toy town set designed for the two weekend run of this poetic noir LA history puppet show in the charmingly dumpy theater in West Adams a

neighborhood below downtown and you can see the towers of greater LA looming from the street while you're waiting outside to enter the theater. Everything about this production screamed community from the dilapidation of the neighborhood, to the funky stylish audience milling before and after to even Martian the CalArts student (getting an MFA in Puppetry, yes!) who passed out programs in drag (sort of).

Jen Hofer, writer, and one of the puppeteers made a mean poppy seed cake for the after show as we strolled to the back garden to see the rabbits. Yes there were rabbits too. We were up in LA for the weekend and this event was the final touch that made us know that LA was a real place, a slick city with nicks and crevices where odd groups of people gather. But those fingers once more. The audience, aged about 25 to 55, art-going, screamed with delight as the hands made each puppet character, woman and man, hop onto the stage in their particular way—flying in so to speak, scaring the other characters with a signature twitch. Making us laugh. Puppetry is primary animation, the spirit is injected by those deft hands pulling it right, making it breathe. And we are puppets too. The show succeeds when we gasp and guffaw—feeling silly and glad we came exactly here this afternoon, and that they made it for us.

ONE THING I WAS THINKING ABOUT IMPERFECTION

is that it's exactly enough. It's the beginning of something. I was in New York this weekend. I was with a couple of friends seeing *Notes on a Scandal*. There was a pleasant even pathetic off-ness about Judy Dench's stern manner in which she conducted herself in the halls of the grade school she taught in with Cate Blanchett. Though it was clear that Judy could handle it and Cate could not. Cate was new and

Judy was old. The students were young. The school was old. The imbalance of all these features was beautiful and adequate to my interest. Judy could walk into Cate's erupting classroom and with a few sharp words bring order to the wild boys fighting. And we could also study Judy in quiet, in her lonely life, her funny outfits. She had arrived at this state of tool-hood, of being a human who could through a process of time passed, among people but essentially alone, handle "it," and you admired her and actually didn't feel sorry for her I don't think. It seemed a life well-honed. Not distinguished in the larger world but full of characteristics and tones. And I guess I'm talking about Judy the actor as much as Judy the character. Within the agreement of the film, the place where it happened. All of this was enough for me, and I wish it was new wave, or even old wave. That this imperfect nothing could have continued again and again, the old battle-axe encountering the young beauty again and again. A kind of study. But the wave we're on, the one in which films get made with big stars (Judy, Cate) required that Judy become monstrous—in her deceit and her desire for Cate and Cate become feral in her desire for a young boy and later became a punked-out hysteric in the makeup of her teens once she gets caught for her crime and the crowd outside her house is howling, well she's howling too. It's like imperfect music isn't enough. It has to get truly horrible, louder than the world, I suppose.

THE PURE LAND

is what Dan Flavin has on his tombstone and it's actually the "place" where the Buddha of infinite light resides. I mean in Buddhism—there's a lot of Buddhas each one having his job, and Dan Flavin decided I suppose to join that guy or you know, *was* him?

LA is so not pure so it's the perfect place to have the Dan Flavin retrospective. I think of Flavin as a New York artist and in the heyday of Soho there was a place called the Neon Gallery and it said on the outside let there be Neon and eventually it slunk down to Tribeca while it was still sleazy and LTBN resided next to a strip club and now I think it's gone. But LA is constant light eye candy. Every night you drive past what is at least one of the components of Dan Flavin's oeuvre: sleaze. But it's drive-by sleaze not for foottraffic. You could pull in but mostly you keep gliding by in the night enjoying the show. So Dan Flavin combined the high and the low, the high being the modernism that informed his work. At first the lights seemed like genitalia on the outside of his canvases—I mean they were literally fat light bulbs. And then the light became the purest art—all frame. That looked like the beginning of it and it went on from there. Leaning, standing, crossing and waving. Articulating space and becoming it. You need sunglasses for this exhibition a guy yelled and the rest of us turned and smiled. We were not supposed to use our camera phones but we did again and again. It seemed like a sneaky homage that I could scrape some light off the hem of his gown, take it home and send it to you.

WACK! ART AND THE FEMINIST REVOLUTION AT THE GEFFEN CONTEMPORARY IN LA

I took part in a walk through which was made up of twenty-five female art experts talking about the piece of their choice. There was also some awful headphone thing we were trying to do so you could hear our tour from anywhere in the museum but it didn't work.

I picked Ree Morton, who had a short art career, its public aspect being from 1971–77 when she died in a car crash. She specialized in

bright and saggy things like wee Oldenburgs—frozen bows made of canvas that she actually baked in the oven. All her work is home-made looking, drippy and written across in a sort of script you might see running across a pillow or a cake. It was kind of an abject feminine thing she was doing, and her own ideas and talent were over-ripe and slightly misshapen, art being turned to after she had some kids, got that done. Life had had its way with her. Her things feel tossed, accumulated, but also very light in the way that hard won freedom can be light and wriggle forlornly but powerfully inside the day. Rather than staying for the next twenty-two talks I ran with Maggie[4] to the LA Opera to see Brecht's *Mahoghanny*. He wrote it with Kurt Weill when they were both fairly young. I'm certain Brecht had never been to America yet there *it* was on stage with its tornados, and rampant capitalism, and boyish swagger. The Americans were large and dumb. One of the opera's heroes was put to death at the end of the show and he was just dead and you could do anything to him now they all sang. Such darkness at the beginning of his career, Brecht's and the shrill and homey brightness at the short end of hers. I imagined Ree Morton hanging out with her kids before anyone cared what she thought or did and picking up a toy in the afternoon light and thinking deeply.

JOKE PIECE

I was basically sneaking into San Francisco before "Pride" to see some friends and Bob[5] steered me to the Paule Anglim gallery to look at work by Jerome Caja. Jerome was a great artist and a great drag

4. Nelson.

5. Glück.

queen who died of AIDS in 1995. His work inspired instant *like* in me. *Fierce* like, I believe. I wanted to hang out with his pieces, to have some tea. To get nervous and walk around and laugh. His work is massively smart and queenie. Arch, arch, arch is what I mean.

"That's what I'm *doing* … I'm having a conversation with myself. I'm having a *private* conversation," says Jerome in an interview. His pieces, each of a different set of chosen and seemingly "random" materials: eyeliner, nail polish on hubcap, bottlecaps, a styrofoam cup, an oil container, are all chattering wildly. One feels they are peeping in on the works somehow. Like when you catch an intimate expression moving across the face of a stranger talking on a cell. Or you see dread animating the profile of the driver in the car next to yours, his private dread. But these are San Francisco works not much about cars. But windows, moments, days things found in the street while you're walking. Art made while you were getting dressed. I don't mean to overdo the fun aspect of the work. Cause the levity, the speed of his materials, the profundity of eyeliner and all it accompanies is what I think he truly means … He used ridiculous materials to make impossible feelings flicker for a sec. A price tag is stuck on one painting's surface like a signature. A buck fifty. If you *do* buy it your contribution will be donated to a special Visual Aid artist's award in Jerome's name *and* to Visual Aid's Artbank for the purchase of art materials.

TODAY

I practically woke up on a porch. I've moved downstairs in my house and I had roommates move in upstairs and now I practically live in the yard and invisible birds are having a conversation right there and a tiny bug is walking across the floor. I have several important

decisions that I don't have to make today but I've sort of set it up so it would make sense to already know them and tell everyone else and that's when light kicks in and begins doing the work of the profound, while I'm quietly looking and thinking it's filling everything in, creating kind of a frame so that later on, thinking about this decision, the day had a look.

I saw a reproduction of an Edward Hopper painting and it was a room but a bar of light was moving across it and the room was all honey-colored and I remember thinking I was glad that he did "abstraction"—light being the subject or maybe the action in the painting. It had already gotten *there* when he decided what the painting was and there was either a time, or a way of arranging the room so that rather than having a bright yellow rug you had a bar of light that went that far and it held the room in a kind of stasis that maybe represented a moment for him, so to what extent was abstraction just a story getting told while all that was outside was light. I think when you make decisions you often go through the same conditions you lived with when you were making them. You wore those shoes again or everything looked that way. We think of light as scenery somewhat. I think in the future we will learn it is alive and that it knew us and felt our dilemma. Not god, but simply our friend.

PUBLIC SPEECH

Last night we drove up to Scripps Pier because there are three nights of Jennie Holzer in San Diego to celebrate the opening of the MCASD (Museum of Contemporary Art in San Diego) and the most stunning night I believe was Saturday when Holzer's words dropped off the building and into the water and though you couldn't read it so well there was something about language getting

lost between swells and rocked around that was uncanny. Maybe reminding you of learning language, and the belief before you understood it that the letters were "doing something," and we forget that sensation as we go. So last night we stepped down onto the beach near the Scripps Pier and it reminded me a little of New York in the '70s—when you would go out somewhere to see art "show up," i.e., that guy[6] who lived outside for a year who somehow announced his appearances to a small gang of avant-gardians who assembled on a kind of funky cove that shouldn't have still existed on New York's waterfront and now it doesn't. La Jolla's pretty posh but at night cliffs and houses lose their particularity and Jenny's[7] words flickered across the cliffs. Here are some of them. It was very slow: I SHELTER YOU I RUN FROM YOU I SLEEP BESIDE YOU I KEEP YOU CLOSE. One walked around the beach exploring the words from all views. As it began it was inky and animated. The letters dark and surrounded by light revealed the unevenness and the moving coloration of the cliffs. There was a slight breeze. It did seem like a form of speech and a respite from control in the public life—to watch the intimate words splashing into sense and then leaving the light to rest & recompose in the dark.

WHAT'S LEFT?

I got this picture in the mail the other day. It's a still from a video I sat watching under the dome of Fritz Haeg's Sundown Schoolhouse in LA. People show up one day a week (Tuesday) to do a range of activities that includes yoga, daily manifesto-ing, eating student-

6. Hsieh Tscheng.

7. Actually poet Henri Cole's words.

prepared vegetarian meals, and participating in the range of classes provided all fall by a diverse group of visitors—today being me. I offer "writing" yet to be frank I am really not wanting to teach so instead I was attempting to offer an explication of "writing design." Not how to write, but the craft of it without the production because that is the downside of teaching. You want them to do their work but you don't want to read it. So instead I tried to create the space of it happening. To manifest the writer's studio. To that end everyone brought as well as paper and pen some *stuff*: an outsize pair of wooden dice, perfume, an ancient stuffed bunny (mine), and someone (Pablo) brought this DVD of a road trip. My actual intention was to do more than create the ambience of the writing space. Ultimately I was thinking: The World. One works in a small space to secure something larger. The knickknacks on your desk become the dashboard of your car. Intertwining the front of the road, the sides and your daily teeming thoughts, all *that* craft, yields a kind of living shrine. And that's what I mean by writing. The construction might sound a little stilted. But I actually saw this freeway move.

SPACE

Negotiating space in New York (read "real estate") is as heavy as it gets but Lia has a way of making it light. Last night was the closing party for Participant Inc.—a space that many of us think of as "our" gallery in New York. Lia Gangitano came to New York by way of Boston, having been a curator at ICA, Boston, and then she was at Soho's late great Threadwaxing Space, a huge cavernous space on Broome Street that really did smell like thread and wax. Even in the '90s Soho still bragged buildings that smelled like manufacturing. One of the great shows I remember there was Beck

and his granddad, Al Hansen, an artist of the fluxus movement, so this was really avant-garde history that is to say it got personal. Travelling through families, even. And Lia opened her own space next. Participant Inc. is in the lower east side. Her stable ranges from Virgil Marti of the amazing chandeliers to Kim Gordon of Sonic Youth to Antony, the international songbird of the post avant-garde. The point is that Lia has the knack of being in the middle of everyone and even though a very historic temple abutting her building collapsed some time last year and even though she did a stunning renovation on her own groovy little space her landlord said the rent must go up and up and up. So back to Soho she will go, just when Soho is so not chic that Lia will make it work again. She's found an abandoned fish store on Broome St. and it's an even bigger building, a better setting. How anyone can open up an independent art space without zillions of dollars behind them is one of the great mysteries of the New York night and the collective fact of friendship. Frankly if you want to invest in the future of art in the world just web search Lia and ask how you can help because then you will be part of it all. It was a great night, by the way. Inside the space and out on the street. The nights just getting warm. People were laughing, saying hello. Participant means we all take part and share the wealth for as long as we can.

VERNACULAR

In New York last weekend there was endless material to write about but I felt a little cranky and disappointed. Not in New York but in art. I found myself a little tired of the Gordon Matta-Clark at the Whitney before I had even seen it. I felt I had seen the superior show already—Matta AND Gordon Matta-Clark, the father and son art

team—were shown together at the San Diego Museum of Art. It's rare that San Diego tops New York but it did. Gordon Matta-Clark alone seems like New York alone—hunks of walls and teardrop shaped floor-throughs and houses cut in half. It was very smart, but it felt like you had seen it before and I had. Also I heard so much about the video footage of FOOD the Soho restaurant that Gordon Matta-Clark along with a few others had opened. I was prepared to see (and did) women mostly working in the kitchen, or women getting kissed, and then women just shot kind of stylishly like background even when they were in the foreground whereas men were like great meaningful bears filling chairs and tables just kind of being what restaurants are *about*. Culture, not nature to be succinct. Could it be that when I saw Gordon Matta-Clark exhibited with his father it wasn't like he just came out of nowhere. It put an additional spin on the art. Maybe I'm sick of art alone, or New York alone.

Believe it or not we then went downstairs to *Summer of Love: Art of the Psychedelic Era*, with lightshows and vintage photographs. It was silly. In Cambridge there was a kind of store in the '60s (Truc was one, pronounced "truke") that basically sold garrison belts, and beads, and cool buttons. I wasn't ashamed to be in those stores because I was in high school but today I was a little ashamed to be inside a museum so I went outside. The street wasn't under-inflected, nor was it wanting to make sure we had a good time. It was sure of its material and we grabbed a cab and went downtown in the rain.

MATERIALITY

Yesterday I met perhaps the oldest oak in the world. It's on the Pechanga reservation in Southern California and the tree is maybe 1500 or 2000 years old, nobody knows. The roots go down twenty

feet, about four people can wrap their arms around it together. The tree is big. The branches dip then run along the ground and swarm up like snakes. You stand under this tree in awe and in the middle of the day it's dark. I took some pictures. Minda Martin, the film-maker who brought me, says that at dusk some light does manage to wrestle through the branches and it lights the underneath just fine. The tribe had lost possession of this tree for a while and then the land was returned to them with the exception of this tree (until recently) because Earle Stanley Gardner who wrote all the Perry Mason novels had bought the land, and still owned the tree. Legend has it he would come here in the afternoon with his girlfriend and a dictaphone and it's where he wrote all his books.

DESIRE

Whoever wanted to come did and the spectacle drew a motley crowd. Young Hollywood actors and actresses, desert rat artists from Joshua Tree, video artists who teach in universities up and down the coast—though now we were fairly far inland, 29 Palms not far from where the Marines rehearsed for the Middle East. I got there at about 4 PM and it was at least 104, and I drank water—I followed the motions of Adrienne Jenik, who has a place out here. She has a way with a group. She's one of those tech-type artists who wires entire buildings and gets scientists to perform inside their labs, and convinces everyone else to hang outside for hours watching flashing screens flipping the inside out at will while LEDs scroll messages that writing students were punching into their cells in the dark.

The same Adrienne Jenik assembled us in Joshua Tree to watch the Perseid meteor shower. It felt very wrong (wrong people, wrong mood, wrong time of year) until it became entirely right. We all

lumbered around looking up at a very spectacular and clear night sky crowded with stars and gasses and every time I turned my head someone yelled: that was a great one. So a number of us feared we'd simply miss it. Which spawned World Trade Center stories about where were you, mostly about missing the events of that day in various strange ways, and finally *no one* could miss these stuttering streaks of light. You'd see a white head and the tail would seem really hyphenated, a bit and bit and then gone. The peak moment being from 2 to 4 a.m., everyone placed down their mats and sleeping bags, pulled up beers and partners and water bottles and we became voices to each other, maybe about fifty of us at *our* peak, and in the dark our styles were gone, just our voices. The meteors came three at a time, then one every twenty seconds. *Whew* we would cheer collectively. *That was an eight. Please don't rate them* someone yelled. *Hello Hello* another group of people arrived.

FINAL FANTASY

What the French meant by concrete art in the sixties was recording the sound of rain and calling that result music. But the subject was rain not media. Allan Kaprow on the other hand when he invented happenings thought that concrete art was the connection between each thing. I mean in a happening it was the film the painting the body the sound. Not the intervals but the how as if that were a kind of line. The latter word multimedia really spins the idea apart. I almost think art funding ruined art. It had categories, like holes to push the art in and the money out.

Last night at the Wilner I went to hear a guy named Owen Pallet. He is "Final Fantasy" which is him playing a violin or an electronic keyboard and singing a high note into a microphone.

His voice is soft and boyish but he can also go fairly low. His songs are very simple and repetitive and very arch. He's a composer for sure. The words are slight in a way, but the arrangements are so elegant the songs have a kind of grace. He's Canadian and in one of my favorite songs he calls his country Canadoo, which was both silly and made it a kind of fantasy country. Meanwhile a woman on stage with him was moving images across a screen like a brightly colored silhouette show. Birds and skulls danced through his songs. My eyes were tearing with joy. His work makes me happy and his set was short, under 45 minutes because the big act was Bloc Party. Then everyone was wild, the place was packed and people were lifting their camera phones up in the air like it was a Melanie concert. Then they would gather around the phone and see what their friend got. The little pockets of friends were warmer than the show and when I came down the 5 this morning listening to Owen I found myself teary-eyed again, holding the steering wheel at a red light. Looking outside at each thing in front of me, traffic, hand-painted power boxes, a San Diego specialty, and palms swaying though someone brought them here, they are not native.

ART SCHOOL PROVOCATION

So I was telling my students that yes they *could* write their notebooks on their computers but wasn't there something great about pencils and pens and hands moving across paper. There was a danger I proclaimed in being so attached to our computers that we would lose the evidence of the special relationship between hand and eye and the moment when they collaborated on an impulse. It seemed to me that in the future people would see things we had

written by hand and know how we felt that day precisely. I mean like if we all only write on computers—here I felt like I was getting a little sci-fi on them though didn't part of me think it was true—maybe later generations—not your kids and maybe not your kids' kids—I didn't really want to threaten them too much—I didn't want to be saying your kids will wind up deformed—but they might not even have *fingers*. They might wind up attached to their computers like little cyborgs. Everyone laughed. The class was pretty much over. "I don't know …" shot back this girl in a purple sweater in the front row. And this was a large lecture hall, a little ampitheater. I was at the bottom. A precarious position of power. There were about 100 of them I was lecturing to. "I mean we can probably think of some other kinds of things to do with our fingers instead of writing in our journals. Don't you think," she smiled, closing her bag.

Well, yeah, do you mean—did you all hear that? I couldn't tell. She had thrown me for a loop—was she right, was she wrong. She had sexualized my lecture, which was *my* risk to take I thought. I was dumbfounded. I had been thinking today about the privilege of youth. Indeed it was theirs. And how dare I threaten them about the future of their bodies. Or their children's. Even their great-grandchildren's. It was all theirs.

JUST A SHOT AWAY

I imagined a nice photograph of the open road. The music was a little dated I think the Rolling Stones right but someone considerably younger than me (Tamara)[8] had it on her iPod and we

8. Tamara Llosa-Sandor.

were someplace in southwestern America with wings of desert on either side of us. I had been sitting in a dome last fall—Fritz Haeg's in LA, not that far from here, and one of the people in Fritz's schoolhouse scene had brought in a videotape of the open road and we used it for inspiration in a writing class. I took a still of it and maybe we can use it again because I didn't take a picture this time I was simply in it—tumbling down the road with a van full of women some I've known for years and a bunch I'm just meeting and we're staging a replay of a post-punk female performance road show: Sister Spit. Just the name suggests it's something different from feminism and it was. It was girls and girl/boys, variations of women performing and writing. I think feminism was just a given, but still it felt like a new idea then, 1997, to put that show on the road. This year's show is called Sister Spit: The Next Generation and in some ways this crew is much less wild no fights in bars and maybe a lot more focus on media—most of these girls draw *and* tell stories flipping slides as they go yet I don't think I would describe them as tamer. They're really tough. They just don't need all the violence. At a college show a boy interviewed these newer girls and asked what to your mind's the difference between then and now. Robin's[9] answer was quick: we're at war.

DR. LAURA

What's most evocative is going outside your category—for anyone. One of my current tour mates has a piece in which she tries to explain to her girlfriend why she bothered calling Dr. Laura for

9. Robin Akimbo.

advice. I guess everybody in the world knows that Dr. Laura is a right-wing talk show host who is profoundly anti-gay. Nicole J. Georges is an artist, writer and pet portrait artist. She does a zine called *Invincible Summer* as well being in a band, Sour Grapes. You might wonder when she has time to have problems but she has a family and that often entails difficulty. So sincerely or entirely tongue in cheek she called Dr. Laura who gave Nicole terse answers and kind of acted like an animal trainer in that she repeatedly insisted Nicole slow down, *slow down*. Nicole played a recording of their conversation during her performance. I could see the appeal, since it was like human car talk. It was entirely obvious to Dr. Laura what Nicole should do and what she shouldn't bother feeling along the way. And I think Nicole was a little grateful for the advice though during her performance she projected drawings of Dr. Laura and while one was gleaming up on the screen she described Dr. Laura's hair as looking like fins and the audience roared then Nicole showed another slide and then likened Dr. Laura's entire demeanor to that of her favorite dinosaur on some kids' show that everyone in the room knew. It provoked an even louder laugh. And I loved that *that* was the end of the story.

The judgment was clear. She looks like a cartoon dinosaur the room had known for a very long time.

HER FAME

When I arrived in the airport in Philadelphia I quickly took a left into the bathroom, which had a beautiful frosted window I think facing the runway so it was probably the most illuminated airport bathroom I ever saw. I filmed it but I didn't shoot it. I felt slightly

paranoid because taking pictures in the bathroom might possibly unnerve some women and airport photography in general is probably illegal by now. The transitional moment itself from plane to terminal to the next plane is often both fraught and otherworldly especially when you don't have much time and had just been sleeping your way across the continent. Which added up to a sense of gratitude for one of the most uniquely lit ladies' rooms I've ever seen in my life and now I've got some footage of it.

I reconnected with my tour-mates in Newark, Delaware. This Newark is pronounced new' ark', not new' ark like in New Jersey, and I just learned that both words describe a new ark. Another little piece of the prevalent religious sentiment embedded in the landscape names across America. We are now in colonial Williamsburg, home of the College of William and Mary, and who should be visiting here as well as the group I'm with but the Queen of England. Our joke is that Helen Mirren is here and sadly there are Burger King crowns lying around in the van from yesterday when they were purchased for a bit of road cheer. I throw one on as the daylight fades in the careening van and roads are blocked cause she's down there and now she's *there* and *there*. She cannot be seen but that does not mean the queen is dark. In fact she's shrouded by light.

MENOPAUSE, THE MUSICAL

OK when my friend invited me I kind of cringed. People "like me" avoid the mass culture versions of art and liberation that include The Blue Men, *Vagina Monologues*, Chippendales, *Chorus Line*, *Cats*, *The Heidi Chronicles*, *Stomp*, *Rent*, Erica Jong, *Les Miz*, *Phantom of the Opera*, and anything anything by David Sedaris. (He fits

because he's small and mean and hysterically funny and "appropriately" gay—by "appropriately" I mean small and mean and hysterically funny.)

David Sedaris and everything on this list finally feels touristy. How can I agree to feel funny and touristy about menopause with a room full of women *apparently* much older than me, or slightly younger like my friend Alysene who proposed the trip and had already seen it and who I would go anywhere with, even here. How can I not stare (in identification) at the handful of freaked out men sitting among the gangs of gals out for a good time—laughing about "the change," flashing, or "the sweats."

The show in many ways was worse than bad. They had apparently bought the rights to every song that sounded like "change": (chain, chain, chain, chain of fools …) giving it funny menopause words instead. It was like having your food prechewed. They brought us here and they left us, I felt. Yet people had a lot of laughs, formed relationships with the actors in a teevee way: the big girl with the Madeleine Albright hairdo, the tall black exec who did a mean Tina Turner imitation when the occasion called, the small wiry blonde with plenty of face work who worked on soaps. These attractive women have gone through menopause just like all of us the show proclaimed. The hot ticket in America more than ever is this kind of normalizing art, that locates discomfort and creates a medicine show: a laughing confessional that capitalizes on the continuous knowledge that women in America will and must assemble at the drop of the hat, to admit "it" socially (be it an or orgasm or a hot flash) and then go out and have dinner which is exactly what we did. Cause Alysene just wanted to hang out with me too.

OUR COMMUNITY

The line of action was incredibly complex. Bob[10] came to read here on Thurs. We had lunch in Balboa Park—skirt steaks at the Prado then heading over to the Mingei to see the Eva Zeisel. I *checked* my doggy bag of skirt steak at the front desk. And forgot it, of course, which gave us a good laugh later on. I returned today with Cathy[11]— to see the Annie Leibovitz across the street but returned to the Mingei first to see the end of the Eva Zeisel film (*Throwing Curves*). Everything about Eva Zeisel is wonderful: that she is alive and 100 years old, that her husband Hans was sort of a grouch, that she was jailed in the Soviet Union for 16 mos. in the 30s, and that she describes her life's work as a "playful search for beauty." Since her twenties she's been designing plates and furniture, teapots and tiles. It's been endless (well maybe a thousand) projects conducted with love and vision. She laughingly says of an ill-fitting lid, sometimes it fits, sometimes it does not. That's life. Each line of hers ends with a lilt. A squeak or a toot but delivered with power and ease. It's always right. Some of her best lines were just thoughts, looks, her head turned aside, away from the continuing and unnecessary action that we call our lives. Once she was urged by one of her manufacturers to make something "Greenwich Village-y" and she created these biomorphic salt and pepper shakers called shmoos. The cartoonist Al Capp (L'il Abner) picked up on them a bit later and filled the world of his comic strip with them for years. Shmoos were moody and tasted like chicken when cooked. And here were the originals under glass. I didn't ask the woman at the desk about the steak I left the day before. The movie about Eva emphasized she was the last of her

10. Glück.

11. De La Cruz.

time, her line, the last of everything. At the end of the movie she was kicking leaves in front of her house, explaining her design. She claimed that she had never become an adult. Despite the fact that she was old, it had just never happened.

FOAM

No one wants an art experience to overcome them and stay that way. Yet it's terrific to see something for instance I went to the Jewish Museum in New York to look at Alex Katz's Ada paintings. It was wonderful to be in that space and think of all the curious things about a relationship—about loving a woman for a very long time and her agreeing to accept that love on canvas. To be cut out, enlarged, viewed upside down—for good. Next day I went to the Whitney. I have no shortage of admiration for Kiki Smith's work. I think she's busily myth-making. Alex Katz is too, but I didn't think that about him when I was in there with the work. Kiki rarely filled the space, yet she conquered it with awkward brass stars, small and large. Legs made of brown wrinkly paper. A girl stood with her knee bent—all white, made of plaster, and then her eyes were penciled in and so was her hair. Kiki swept me every time with her wrongness. A drawing called daughter had a beard. To go to MOMA on Friday night is to get in free. To stand with tourists and cute young people waddling in line till you arrive inside of a department store. MOMA is our kind of Louvre. It's very New York. And here's Brice. I liked the early ones the best, and the first wriggling marks while the paint was thin. Today in Chelsea before I got on the plane to go home (if that's what California is) I spent about forty minutes inside A.L. Steiner's photo barrage called "one million euros." Her work seemed to say something best. I mean she's chipping at the heft of a career.

There was a panel going on and the room was so hot and the idea was that you could buy one million of her photographs for one million euros. You had to affirm her work and that was that. The work was without exception photographs of girls—like Alex, ones that she'd loved. Each photo was a pop of endless foam. A.L's archive remains open.

THE WORLD

I have a cat named Ernie and when I travel to LA from San Diego and vice versa I don't keep him in his case because he's so charming. Instead I have him around in the truck but what he does is dash from window to window excitedly. He's a black cat, a meaty tom and he's like a cartoon, his frantic joy seeing traffic: watching the cars and the road and the trees moving around. I mean I think that's what he sees. So when I was traveling home from the East Coast last week and the pilot said something that I ignored I wondered why people were leaping up on both sides of the plane looking down. I thought huh they're acting like Ernie. Grand Canyon yawn or whatever. They kept it up and then I, I became Ernie too. And down below us was the 4th of July—in spades. First it was a lot of pinpricks. Teeny dots of light everywhere you could see. I saw it rise and open up like a radiant flower. Red, white, green. A handful of explosions in one spot and then they'd die down. Another. That's South Bend my neighbor said. We traveled over an entire city this way, then a region, then it kept being the fourth of July all across America. Out there closer to the horizon. Down here in puddles. Pop Pop Pop. The year of the bicentennial I did acid and watched the fireworks through binoculars on someone's roof. Thirty years have passed and this was so much better. Then I remembered. We

are at war. I was Frances Scott Key, again and again. Oh what would I say about this spectacle. That it went on for hours. That it was beautiful. What does it mean. I could see but I could not hear it. Distant and invisible like our war. Let it be just this once, then it happened again.

THE ART ON MY WALL

including my calendar expresses a place I want to go, something I need to remember. And I'm thinking about the wall in the place where I work, and I have just moved the bulk of my possessions up the coast to Los Angeles and there are things I see again for instance this calendar of southwestern landscapes: a nice butte against a deep blue sky and a crackle of distant lightning to lend some drama to the photo and also give it depth. It's a scale thing. Since the butte is not as big as a thumb the uplifting jagged bars of electricity are most likely thirty miles away and you feel the distance when you look at the view. I have a postcard of Courbet's *The Origin of the World*. We won't dwell there. Otherwise there's a photo of a manual typewriter and it's the imaginary cover of a book when the right person decides to become my publisher. I imagine the typewriter reproduced hundreds, thousands of times, waved and bobbing in the hands of people lining up at some signing cause this is the book they need. I have a nice cartoon skull on hand, in fact I have skulls all over the house. Is the skull in the artist's studio a grinning cat lick at death—or a recognition of structure. That what holds this thought or that gesture is a container of bone that will conceivably outlive its master, like the luggage outliving the traveler which it so very often does. Pawn shops are a pile of soft skulls that say who walked in. Why do I

keep *these* skulls around. What do we want? It's a face-off of sorts, a challenge. I know I don't want to be a head of bone with a candle melting down my brow on the desk of whoever in the future feels jokey and cynical. The stuff on my wall is related to this, it's no longer art—even if it *is*. It's a stuttering attempt to illustrate a thought that can never be seen. A lot of it keeps growing deeper, wanting to be known, seen. But it can't. The skull always wins.

PINA BAUSCH FILMS AT THE HAMMER

Does everyone in the world know Pina Bausch. She's the German choreographer who's run her company, the Wuppertal Tanz Theater, for thirty years. Her work is "weird" and Wuppertal's a fairly small place so of course the locals initially walked out and slammed the door. But once people began popping in from all over the world and the idea got to the townspeople that Pina was huge, local pride grew. At the UCLA Hammer this week they presented a bunch of Pina Bausch dance films. It's fun to see her early dances in which a chorus of people in their day clothes are ordered to strip and then they're on the floor and next they are rowing with their bare legs like kids. Just when the moves grow frightening, or fascist, the gestures grow surreal or silly. Just when it's entirely oppressive a naked man with a white fox around his neck steps in with a very strange expression on his face. It's costume, *and* facial gestures (not normally a component of western dance), and swift animal moves, and much glee. These aspects pile up (even a pile of red flowers, a giant pile of them in which people frolic) to liberate us from the stalemate of adulthood, of business, of war and everything else. There's no violence in her performance, there's no bloodshed, there's no death. Though chairs (and women) are thrown (and caught and thrown

again) and people shout. Is the material of dance *bodies* or some-
thing else. How to name whatever's (in Pina's work) always
disrupting our ongoing sense of what bodies *should* do. We had seen
her work for the first time so long ago and forgot how brilliant and
shocking it was then and how much it still makes us want to play
with our friends, even now, to roll around and be silly. Because that
is our job. As a people. To not believe ourselves so much. But to
believe our bodies.

ADELA LEGERATTA RIVAS, STRUCK BY A DATSUN, 1979

This photo by Enrique Metinides graces the cover of the book by
Veronica Gonzalez. I haven't finished reading it so I can't say that
much except that I felt excited by the flat droll energy of the
book. The beginning is about a teenager who feels cruised by a
baker while she's looking at the pastries in his shop. She's repulsed
by the man and yet pretty quickly she's driving with him very fast
apparently heading out of town. She's scared and seems to be
wondering how she got there and then she recounts some of the
sweets she bought from him in their earliest flirtations in his
shop. I don't really want to get out of bed to plug my computer
into the DSL in the hotel room to get more information. Not
about the book or even the photo on its cover but more about the
photographer who took the picture. I think I remember he was a
crime photographer, a journalist in Mexico City then some LA
gallery picked up on him and his photos once daily scenes are
getting known kind of broadly, as art. I'm staying in a hotel in
Ann Arbor. I did get out of bed but I don't feel like I need that
information anymore. And now the DSL is down. It is the photo

I care about. Because it's not a Greg Crewdson staged scene. It's real. Which fills me with awe. I think I was at Veronica's book party a couple of weeks ago. I know I was and then I heard her read at the Hammer. The book was new, and Veronica was just getting wound up, learning to blow. With a dress on, and was swaying a bit on stage. But Adela is forever looking into space at the moment of her death. Her last thought was probably a clutter of snapping images, trees falling down all over the world. Whether Tony's blackout on *The Sopranos* was the end of his life or the end of the show is nobody's business. But I want trees falling down all over the world for Adela, my puny offer in exchange for her almost bored and permanent look. If the damn DSL would connect tonight I could send this to you, I could go to sleep, wake up then in a forest.

THE FUTURE

Harry Dodge and Stanya Kahn showed three short films last night at the Hammer but a final piece at the end (*Altogether Now*) was long (and getting longer—it's a work in progress). I just have to inject for a moment that EVERY place I've been this summer we've been talking apocalyptically. It keeps coming around. We're worried. No water, no oil, no leadership, no economy. The pinball machine of our time is screaming tilt and the balls are moving madly. Or frozen. The longer film at the end of their screening featured kids. Not constantly but a little guy named Lenny (Harry and Stanya's son) showed up at the end crawling on Stanya's sleeping form on a hotel bed. He was clean and she was dirty. She was deformed and he was perfect. I usually barf when people describe the future as something that needs to be safe for kids. Here kids

seemed like beacons. A moving light that said that we would be okay. I've not described much. Bronzed foragers are moving below buildings in LA, breaking up concrete near creeks under freeway underpasses, gathering batteries off the ground of the parking garage facing the Gehry, stealing wires from under cars and winding up at The Standard Hotel in downtown LA with their own water source (buckets filled from a stream, lugged into the hotel) and ways of hooking up electricity. Their culture is entirely "found" and works around what's there. The inhabitants look like those guys in Geico ads. Though not so well dressed. A kid named Cerus was in with the adult performers (Stanya Kahn, Amy Gerstler, Eileen Myles) and it seemed he was the master electrician, connecting the dots on a control board, turning on the teevee to *Yellow Submarine*. I felt like the Beatles had written this film for all of us in this sore spot, running through the corridors of an imaginary hotel, knowing each room had nothing, and plenty of it, and all we could do was sing. Sky of blue and sea of green. Every one of us, lives next door …

TO BE SOMEONE

Last chance (goes down Aug. 26) to see Mary Heilman's buff retrospective at the Orange County Museum of Art. Mary's show starts with some student sculpture she did at Berkeley. Fake nature, a few branches with aluminum foil—buds brashly relating to spring. Her show reminds us too that she began as a ceramicist a more forgiving discipline than painting as it relates to color and line. I mean I think of heat and chemicals as the action of ceramics so what happens when this person—schooled in the 3D force of imperfection—a California born person, so someone not really so

oriented towards the past anyhow, what happens when she does encounter painting—and why would that person even want such a blind date. Mary Heilman, as a young artist, had the experience of not getting in some important ceramics show and rather than getting down about it she decided to take a punk road out and did instead the most abstruse (for the '70s) and outré thing of all—to paint. Mary's retrospective is called *To Be Someone*, which might be what anyone would want. These are not feminine paintings—I don't mean that apologetically, but to open the field of style to the painting that is … Mary's: bold, blunt, wild, pathetic, droll and hot as only a cool Californian can be. All her work has the relaxed passion of a long ride in a car, radio blaring with your best friends. A landscape could be a scarf, a title might squeeze a painting into a poem of sorts and songs abound. The world before cell phones, all present time, blaring and proud, before the road drops off into pure sky.

for Rosie

1990–2006

ACKNOWLEDGMENTS

First thanks to the Warhol/Creative Capital foundation and panel for picking this book in its first art writing grant cycle. Liz Kotz for inspiration and encouragement always. Then of course Hedi El Kholti and Chris Kraus at Semiotext(e) and everyone at MIT. To Diana & Annie's front porch where I wrote the title essay and Vermont Studio Center where I had to decide. And so many editors and friends: Greg Masters at the *Poetry Project Newsletter*, Stacey D'Erasmo & M. Mark and Lisa Kennedy in the heyday of the *VLS*. Jennifer Liese, at *Art Forum* AND P-town Arts & of course Chris Busa. Michael Carroll at Schoolhouse Gallery where I was poet in residence in 1998, Kathy Izzo for getting me there and Dennis Rhodes inviting me to the P-town Poetry Festival. Jason Shinder and Denise Oswald at FSG, Faye Hirsch at (then) *Print Collector's Newsletter*, Betsy Baker at *Art in America* for asking me questions I didn't really get until much later. Everyone at *Index*: Bob Nickas, Cory Reynolds, Amy Kellner, Jesse Pearson, Ariana Speyer and Peter Halley. Matias Viegner & Christine Wertheim of Séance, Jen Blauvelt and Amber Phillips who decided I should be Hampshire's commencement speaker, and Stuart Horodner at Bucknell Gallery, Bim Ramke at *Denver Quarterly*, John Cheim (then) at Robert Miller and Nathan Kernan for organizing the Walser panel. The Wexner Center and Cornell's Johnson, Richard Goldstein who urged me to go to Russia first, Slava Mogutin for all the tips. Bob

Rosenthal for including me in *Planet News* and Danny Schechter who asked for more. Amra Brooks and Ali Liebegott's sliding scale therapy anthology. Bob Glück and *BAR*, Amy Scholder, of *Cooking With Honey/what literary lesbians eat*. Sabrina Chapadjiev of *Live through This*. Andy Levy at *Crayon*, Henry Flesh who got me to write gay male porn, Bettina Funcke at *Parkett*, Susan Pliner for inviting me to talk on Schuyler at Wave Hill Conservancy and Henry Abelove's Schuyler panel at the MLA, Margaret Tedeschi's 2nd Floor Projects in SF, Kate Horsefield and Video Data Bank. And Penland School of Crafts, one of the greatest places in the world: Jean McLaughlin, Dana Moore and Sherri Wood's improvisational quilt making class. Thordis Adalsteinsdottir for that word, and Jack Kimball at Faux Press. The great Nate Lippens and Peter Gaucy who edited *OpenforDesign.com* where all blogs appeared. Matthew Stadler for his boundless energy and generosity at *Nest*— Joe Holzman and Carl as well. Matthew Stadler also at the *Stranger*—and Dan Savage who okayed *The Importance of Being Iceland* and then took all the Iceland out so we had to change the title, requiring that I write this book. And finally remarkable friends in Reykjavik, Glenn Barkan and Thórhallur Vilhjálmsson. Ruri, Kristin Omarsdottir, Haraldur Jonsson, and Hans Ulrich Obrist who invited me there to *Do It*. And Michael Pollock for bringing me to Beat Day in Reykjavik in 2008, a story not yet told.